THE NEUES MUSEUM BERLIN

E. A. Seemann

THE NEUES MUSEUM
BERLIN

Conserving, restoring, rebuilding within the World Heritage

STIFTUNG
PREUSSISCHER
KULTURBESITZ

S M
B Staatliche Museen
zu Berlin

⬛ Berlin Landesdenkmalamt

Senatsverwaltung
für Stadtentwicklung

Bundesamt
für Bauwesen und
Raumordnung

Imprint

© 2009 by E. A. Seemann Verlag of Seemann Henschel GmbH & Co. KG, Leipzig
www.seemann-verlag.de

Edited by
Staatliche Museen zu Berlin – Stiftung Preußischer Kulturbesitz (SMB, State Museums in Berlin – Prussian Cultural Heritage Foundation)
Bundesamt für Bauwesen und Raumordnung (BBR, Federal Office for Building and Regional Planning)
Landesdenkmalamt Berlin (LDA, Berlin Monument Authority)

Publication concept and professional advice
Olaf Asendorf, Ph.D., BBR; Professor Jörg Haspel, Ph.D., LDA; Norbert Heuler, LDA;
Gisela Holan, Ph.D., SMB; Eva Maria Niemann, BBR

Text and picture editing of the German edition
Oliver G. Hamm, Berlin
Text editing of the English edition
John Ziesemer, Ph.D., Munich; Melanie Newton, Munich

The editors particularly wish to thank Wulfgang Henze of BBR and Martin Reichert
of David Chipperfield Architects (DCA) for their valuable support in co-ordinating
the texts in the chapter "Realization".

English translations
Michael Robinson, London
Annette Wiethüchter, Witzenhausen
Karen Williams, Rennes-le-Château

Cover design and layout: Gudrun Hommers, Berlin
Type-setting: Steffi Kassler, Leipzig
Front cover: main staircase hall. *Photo: Johannes Kramer/BBR*
Back cover: south façade with new corner projection. *Photo: Johannes Kramer/BBR*
Reproductions: Bild1Druck, Berlin
Printed and bound by: Offizin Andersen Nexö Leipzig

For detailed information on this publication in the catalogue of the Deutsche Nationalbibliothek,
please visit http://dnb.d-nb.de

Printed on cellulose-based, ageing-resistant, chlorine-free bleached paper.

Printed in Germany

ISBN 978-3-86502-207-3

Contents

8 **Foreword**
Hermann Parzinger, Michael Eissenhauer,
Florian Mausbach, Jörg Haspel

10 **A Word of Welcome from ICOMOS**
Michael Petzet

TOPIC I: HISTORY

14 **From Building to Rebuilding – the Early
History of the Neues Museum**
Jörg Haspel

22 **Architecture – Décor – History of Ideas**
Bernhard Maaz

31 **The Neues Museum from Destruction
to Reconstruction 1945–89**
Gisela Holan, Günter Schade

38 **"Core Form and Artistic Form" – The Art
of Construction in Prussia under the
Influence of Industrialization**
Werner Lorenz

44 **The Widow Levy's House as an Obstacle
for Development of the Museum Island**
Birgit Tuchen, Peter R. Fuchs

TOPIC II: CONCEPT

50 **From Invited Competition via
Consultation Procedure to
"Master Plan Museum Island"**
Barbara Große-Rhode

56 **The Neues Museum
Architectural Concept**
David Chipperfield

60 **The Neues Museum
The Restoration Concept**
Julian Harrap

65 **The Neues Museum
The Museological Concept**
Dietrich Wildung

69 **The Museum Island's Pathway
to the World Heritage List**
Norbert Heuler

TOPIC III: PLANNING

76 **Organization – Co-operation – Process**
Eva Maria Niemann

82 **Historical Building Fabric and
Contemporary Usage**
Gerhard Eisele, Josef Seiler,
Klaus Steffens

90 **Ground Freezing for Soil Support**
Wolfgang Orth, Gerhard Eisele,
Josef Seiler

95 **Special Developments in Construction –
Restoring the Extant Windows and Doors**
Anne Hengst

101 **Issues of Construction Physics in the
Reconstruction of the Neues Museum**
Axel C. Rahn, Matthias Friedrich,
Thomas Riemenschneider

106 **Technical Services**
Hans-Peter Thiele

TOPIC IV: REALIZATION

118 **A Survey of the Historic Finishing
Materials and Methods Used in the
Neues Museum**
Claudia Vollmann, Ayten Güleryüz,
Stefan Schiefl, Larissa Sabottka,
Peter Besch, Martin Pomm

128 **Samples and Specimens for Restoration**
Wulfgang Henze

131 **Restoration Work –
Devising an Approach**
Gertrud Matthes

133 **Restoration Work – Legal Grounding
and the Tendering Process**
Wulfgang Henze

136 **Pre-existing Structural Shell, Rebuilt
Structural Shell, Façades and Colonnades**
Michael Freytag

138 **Existing Structural Shell/Colonnades/
New Structure**
Tobias Mann

140 **Restoring External Façade Plaster**
Klaus Ricken

143 **Stone Façades**
Max-Florian Burkhardt

145 **Stone in the Colonnades**
Hermann Graser jr., Volkmar Hillig

147 **Stone in the Interior Spaces:
Columns in Spaces 2.06 and 2.07**
Peter Besch

148 **Stone in the Interior Spaces: Repair of
Column 04 in the Mittelalterlicher Saal**
Andreas Klein

149 **Tests on Selected Stonework Materials**
Gerda Schirrmeister

151 **Groups of Rooms – Plaster and Décor
Restoration Work**
Anke Fritzsch, Martin Reichert, Eva Schad

154 **The Vestibül and the Vaterländischer Saal**
Wolfgang Gärtner, Günther Dürr,
Julia Feldtkeller

156 **Spaces 1.04 to 1.06**
Dunja Rütt, Annette Sturm

158 **The Gräbersaal and the
Mythologischer Saal**
Anette Schulz

160 **The Haupttreppenhalle**
Michael Bruckschlegel

161 **The Bacchussaal and the Römischer Saal**
Uwe de Maizière

163 **The Mittelalterlicher Saal, the Bernward-
zimmer and the Moderner Saal**
Olaf Schwieger

166 **The Nordkuppelsaal**
Lars Schellhase, Carsten Hüttich

168 **The Niobidensaal**
Alexandra Skedzuhn

170 **The Eastern and Western Kunstkammer-
saal, the Majolikasaal and the Three
Adjoining Small Galleries**
Katharine and Wieland Geipel

172 **The Sternensaal**
Sonia Cárdenas

173 **The Roter Saal and the Dienerzimmer**
Eberhard Taube

176 **Flooring**
Anke Fritzsch, Martin Reichert, Eva Schad

177 **Stone in the Vestibül and in the Korenhalle**
Peter Besch

179 **Terrazzo Floors on Levels 1 and 2**
Larissa Piepo

180 **Terrazzo/Plaster Screed, Geological
Identification of Aggregates**
Gerda Schirrmeister

181 **The Marble Cement Floor in the Nordkuppelsaal**
Larissa Piepo

183 **Stoneware Mosaic on Levels 1 to 3**
Peter van Treeck

185 **French Parquet in the Majolikasaal and the Sternensaal**
Jens Osterwold

187 **New Terrazzo, Level 0**
Peter Antonioli

188 **New Mosaic, Levels 1 to 3**
Reinhard Böckenkamp

190 **Art in the Building**
Anke Fritzsch, Martin Reichert, Eva Schad

191 **Stucco Relief on the East Tympanum**
Thomas Lucker

192 **Cast-Zinc Relief on the West Tympanum**
Georg J. Haber, Maximilian Heimler

194 **Metal Architectural Sculptures**
Georg J. Haber, Mandy Reimann

195 **Natural Stone Sculptures on the Corner Projections**
Alexander Bankert

197 **The Schievelbein Frieze**
Thomas Lucker

199 **The Bellermann Wall Pictures in Space 1.02.2**
Elke Renner

201 **Metal Structural Decoration**
Georg J. Haber, Mandy Reimann

202 **Wall Pictures in the Vaterländischer Saal**
Wolfgang Gärtner, Karl-Heinz Petzold, Julia Feldtkeller

203 **Wall Pictures in the Römischer Saal and the Niobidensaal**
Uwe de Maizière, Alexandra Skedzuhn

205 **Wall Pictures in the Nordkuppelsaal, in the Dome of the Apollo Niche, in the Ägyptischer Hof and in the Roter Saal**
Carsten Hüttich, Eberhard Taube

208 **Special Subjects**
Wulfgang Henze

209 **Removing Murals in the Vaterländischer Saal**
Wolfgang Gärtner, Karl-Heinz Petzold, Julia Feldtkeller

211 **Mineral Reduction for the Nordkuppelsaal**
Wanja Wedekind, Annett Baumeister, Lars Schellhase

213 **The Wire-and-Plaster Ceiling in the Bernwardzimmer**
Wulfgang Henze, Peter Friese, Andreas Protz

216 **Galvanoplastic Copper Cladding for the Main Portal**
Wulfgang Henze, Georg J. Haber, Maximilian Heimler

220 **Ceiling and Architrave Papers in the Mythologischer Saal**
Thomas Lucker

223 **Marble Cement (Door and Window Jambs)**
Jörg Breitenfeldt

APPENDIX

228 **Authors**

230 **Index**

239 **Project Team, Companies and Restorers**

Foreword

In the mid 1830s Karl Friedrich Schinkel had just re-designed the area around the Lustgarten and Kupfergraben with his buildings, thus combining commerce and art in a conciliatory fashion. Then his pupil and successor as court architect, Friedrich August Stüler, submitted the "first Museum Island master plan" in 1841. What it contained was a brilliant realization of Friedrich Wilhelm IV's vision of turning the whole site "behind the museum into a 'still, richly endowed sanctuary for art and science'". Between 1843 and 1876 the Neues Museum and the Alte Natio-nalgalerie, fringed by colonnades, emerged from this over-all concept as an impressive ensemble of buildings, later complemented by the Bode-Museum and the Pergamon Museum to form the so-called Museum Island.

Friedrich August Stüler created a new museum type, using the most modern technologies of the day to build it. With the Altes Museum, Schinkel gave shape to his idea of uplifting viewers through art by designing a long columned façade in the ancient style, an imposing front flight of stairs and an impressive rotunda. In contrast, Stüler was aiming at the cognitive force of science and the history of civilization in his planning for the Neues Museum. This developmental idea was expressed in a well-proportioned, symmetrical main building with a symbolic pictorial programme on the rendered façades, and inside by the grandiose staircase and lavishly decorated exhibition galleries.

The eventful history of the Neues Museum's use, marked by several modifications in the 1880s and between 1919 and 1923, illustrates the rapid development of sciences and the growth of the collections as a result of generous gifts from patrons. Furthermore, excavation and acquisition were increasingly based on scientific principles, and visitors to the Neues Museum could now follow this in the collections.

The Neues Museum was badly damaged in the Second World War, like all the buildings on the Museum Island. Its unique staircase hall collapsed as a result of direct hits in an air raid: the famous Kaulbach frescoes were lost for ever. The Egyptian Courtyard, parts of the linking corridor to the Altes Museum and the south dome were also hit by high explosives. Even though work on

clearing up started in this building as early as 1946, the Neues Museum remained a ruin for about four decades, before it became possible to embark upon making safe and preliminary work for rebuilding the museum in 1984.

The Staatliche Museen started trying to bring their collections, divided by the war and post-war developments, back together as early as August 1991. As a result, in the "concept for the Museum Island" it was mutually agreed that the archaeological collections would be housed in the Altes Museum, the Neues Museum and the Pergamon Museum. The basic ideas were set down for using the particular groups of galleries in the Neues Museum across a number of subjects to display collections from the Egyptian Museum, the Museum of Pre- and Early History, and also involving the antiquities collection.

Along with creating the governmental and parliamen-tary buildings for the organs of the Federal constitution, the general refurbishment of the Museum Island is one of the most important national building projects undertaken in Berlin after the fall of the Wall. The Neues Museum was probably the largest national monument building site in the capital in recent years, and certainly one of the most complex conservation and construction tasks in Germany as a whole. The Neues Museum took on some-thing of the character of a laboratory for building and restoration practice, working on developing and testing preservation and maintenance measures aimed at caring for existing building stock. Rarely can the monument conservation aims of damage-free structural diagnosis and preserving building without reservation when securing a war ruin and making it fit for purpose have been pursued with comparable meticulousness and consistency as they were for the Neues Museum in Berlin.

This publication, appearing to mark the handover of the restored museum, is intended to serve a dual purpose. One the one hand, the editors are discharging a kind of chroniclers' duty in dealing with monuments, especially as we are dealing with a cultural institution of international calibre and a key building of the Berlin Museum Island World Heritage site. In this spirit, the authors – all of whom were involved in the project – are recording the

different phases of the work and the main results of the restoration and structural completion of the Neues Museum at first hand. The working reports provide an account in words and pictures about the background to and implementation of conservation and construction measures, in order to reveal the building's extraordinary architectural and artistic quality to the interested public.

On the other hand, the documentation of building and monument status moves beyond the Neues Museum and the Museum Island and is intended for the specialist world of building owners, architects, engineers, technicians and experts in the field of monument conservation and restoration. In fact the publication provides a record of an unusually rich set of experience and knowledge in the field of servicing ancient monuments, that it has been possible to acquire over the last 20 years on the Neues Museum building site, and that can now be put at the disposal of cases that are in need of similar care. This extraordinary conservation and construction project required a whole range of innovative solutions. In practice, it produced numerous solution patterns that could prove instructive over and above the Neues Museum as an individual case in relation to preservation and refurbishment projects in the monument field that are working on a similar basis.

The scrupulous treatment of this museum building, which had been in ruins for decades and was at a high level of risk, along with the ambition to rebuild without destroying what had survived, required countless special developments to ensure that the fragile building stock of this monument could be preserved and stabilized using the "art of the smallest possible intervention", and revived to fulfil its original function as a museum. These include carefully prepared invitations to tender and awards, especially for the highly sensitive restoration work. They were prepared by setting up comprehensive preliminary studies in terms of materials and processes, and also by using test phases and trial restoration work; accurate costing and quality assurance were guaranteed by a sophisticated evaluation and control system. A large number of innovative technical processes for assessing and retrofitting the listed building seem to be models that could set a precedent. Ultimately this applies to the fact that all the surviving ceilings and historical structural elements were preserved, that domestic services and air conditioning were installed without damaging the surviving fabric of the building, and that all the historical structural components of ancient monument calibre were preserved and retrofitted within the existing building stock. The main requirement for such high-calibre solutions in individual cases was the inclusion of proven experts, specialist institutions and firms, in the fields of experimental statics, material testing and construction work, for example, or their use in developing, testing and certifying monument-friendly processes and materials.

The Neues Museum as a conservation building site served as a test-bed for researching and using innovative methods and technological processes for securing and strengthening historical building stock. The experience and outcome of the complementary restoration of the Neues Museum should not simply be stored away in the knowledge pool of those involved; it should be made available for comparable construction and restoration work. The documentation provided in the present book is also a suitable information source in the field of refurbishment and restoration technology, and the editors and contributors would be pleased to answer questions in order to promote knowledge and technology transfer of this kind.

In dealing with this building project, the David Chipperfield Architects practice has changed conflicts that had remained unresolved over the years into public dialogue. As the result of mutually confident cooperation by all those involved, the Neues Museum has successfully been restored to a high standard following the principles laid down in the Venice Charter, and has been complemented by high-quality new buildings appropriate to the museum's architectural and historical calibre. The editors would like to thank Prof. Dr. Wolfgang Wolters of the Technische Universität Berlin and Prof. Dr. Adrian von Buttlar of the Landesdenkmalrat Berlin: without them as guiding spirits, a great deal of the project would not have been possible.

Today, 16 years after the "closed competition to plan the rebuilding of the Neues Museum and construct complementary and linking buildings to bring together the Archaeological Collections of the Staatliche Museen zu Berlin – Preußischer Kulturbesitz on the Museum Island" was announced, we are now ready to hand over the keys to the building.

Prof. Dr. Dr. h.c. mult. Hermann Parzinger, president of the Stiftung Preußischer Kulturbesitz

Dr. Michael Eissenhauer, director general of the Staatliche Museen zu Berlin

Florian Mausbach, president of the Bundesamt für Bauwesen und Raumordnung

Prof. Dr. phil. Jörg Haspel, state conservator and director at the Landesdenkmalamt Berlin

A Word of Welcome from ICOMOS

Michael Petzet

The Berlin Museum Island was granted World Heritage status in 1999. The UNESCO World Heritage Committee expressly included the Neues Museum, which had been severely damaged by bombing, then made safe after 1945. Ten years after this status was granted we are able to celebrate its reconstruction with additional features. The decision of the bodies responsible certified that the ensemble of monuments on Berlin's Spree Island has an extraordinarily high degree of historical authenticity and visual integrity. This ensemble can look back on over a hundred-year history of building and adaptation, and also of rebuilding. This also applies to the fragmented Neues Museum, whose torso offers intact interior decor from the time the building was erected, and is at the same time a highly impressive record of the island's fate during the war.

The Museum Island is unique and can scarcely be compared with other monuments and historical sites on the UNESCO World Heritage List. In justifying its inclusion ICOMOS, the International Council on Monuments and Sites, which advises UNESCO on World Heritage matters in the context of the 1972 Convention, saw the site's global significance mainly in the fact that "the Berlin Museum Island is a unique ensemble of museum buildings that illustrates the development of modern museum design over a period of more than a century," and that it represents outstanding examples of buildings based on an art museum concept that goes back to the age of the Enlightenment. Thanks to the vision of Friedrich Wilhelm IV, who intended to recreate the entire site from the Lustgarten to the tip of the island "as a sanctuary for art and science," this unique location at the centre of the capital was chosen, thus emphasizing the particular status of this museum landscape as a counterpart to the Berlin Dom and the Arsenal, as well as to the site of the Berlin Schloss.

All five Berlin museum buildings – from the Altes Museum, Schinkel's neo-classical masterpiece, completed in 1830, to the Pergamon Museum, which opened a hundred years later – are products of different museum concepts. In the case of the Altes Museum, these can be traced back to the tradition of Alexandre Lenoir's "Musée des Monuments Français" – created as a haven for furnishings from architectural monuments that had become victims of the French Revolution's vandalism. But they also exercised a world-wide influence over the approach to new museums and collections, as for example the concept developed by Wilhelm von Bode for the Kaiser Friedrich Museum (Bode-Museum), which involved showing works of art in combination with some of the original furnishings, which then became broadly accepted in the form of so-called "period rooms". Overall the five museum buildings, of which only the Alte Nationalgalerie, which is expressly devoted to German art, is evidence of nationally directed art policy, still serve the preservation and presentation of the world's cultural heritage in the broadest sense. So this complex of monuments, which has grown over decades, housing famous monuments such as the "Pergamon Altar" within its walls, along with remains of other monumental buildings, has of course taken its place on the World Cultural Heritage List also because of its unique collections.

The Museum Island suffered very badly in the Second World War, and it has still to overcome the consequences of the division of Berlin and the shifting of collections this brought with it. In comparison with the museums on the island that were rebuilt after being damaged in the war, the completion of the bombed ruin that was the Neues Museum, set in train only after the fall of the Berlin Wall, represents a special chapter in contemporary monument conservation, a late contribution to the subject of post-war monument conservation in Germany. Even before the World Heritage nomination, those responsible took account of the Neues Museum' special significance and the problems of rebuilding it, and invited experts from all over Germany to make preliminary comments. Their "Plea for complementary reconstruction" of the ruined monument for museum purposes, published in

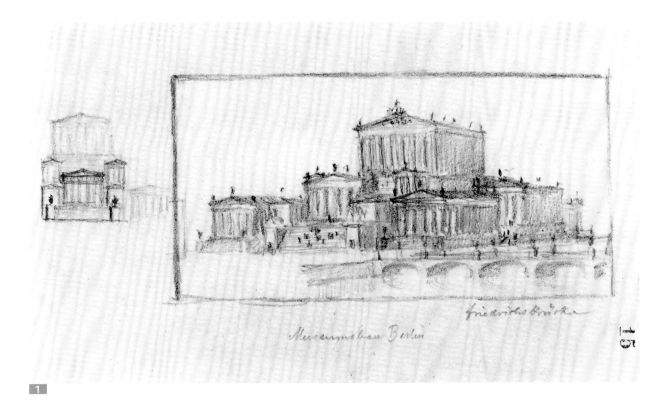

1994, stood the test of time as a useful conservation model, both as a framework for future competitions and commissions and also for the application procedure for World Heritage status, formally started in 1997.

When World Heritage status was conferred, the appropriate bodies from the Stiftung Preußischer Kulturbesitz (Prussian Cultural Heritage Foundation) decided upon a "Museum Island Master Plan" agreed with the building and monument authorities that was to guide future developments. The intention was to find practicable solutions, based on modern approach to museum requirements, for this enormous museum complex, while at the same time maintaining the respect for the fabric of the historical buildings, a matter that should be self-evident in a World Heritage site. This involves model curatorial treatment of authentic remains of the original decoration and furnishings that may have survived only in fragments, and also preserving traces of damage, documenting what was lost or, in memory of the original concept, carefully reintroducing works of art – possibly even historical plaster casts – to their former place.

World Heritage status also requires that the "buffer zone", extended by the ICOMOS initiative when the Museum Island was added to the UNESCO list, is respected, in other words that possible disturbances around the Museum Island can be prevented with the aid of building and planning law and the Berlin Monuments Act. The building projects currently under discussion, an up-to-date entrance building for the ensemble of monuments

and also the reconstruction of the Schloss façades for the Humboldt forum in the immediate vicinity of the monuments, certainly offer opportunities for tradition-conscious urban repair in central Berlin and for developing the Spree Island into a modern museum landscape. But without going any further here into questions that have been frequently and heatedly discussed in the past on the basis of the Berlin museums, for example restoration, new buildings or reconstruction, I am certain that the Museum Island as a World Heritage site has taken a good road towards the future.

One of the accepted principles of monument conservation and museum work is that conservation and restoration measures carried out on the historical cultural legacy should be carefully recorded for later generations and made accessible to interested specialist groups. The "International Charter for the Conservation and Restoration of Monuments and Sites", passed in Venice in 1964, also concludes with an article about the duty to document and publish. The present publication about this monument conservation and restoration project, now successfully completed, confirms the high standard of expertise and the principle of excellent relations with colleagues across disciplines that those responsible have applied to preparing and realizing this important project for the Museum Island World Heritage site.

1 Friedrich Wilhelm IV: sketch for the Berlin Museum Island ("sanctuary for the arts and sciences"), pencil, c. 1841. *Source: Zentralarchiv der Staatlichen Museen zu Berlin*

→ Photos pages 12/13: Nordkuppelsaal (space 2.10) in February 2005 and in March 2008. *Photos: Johannes Kramer/BBR*

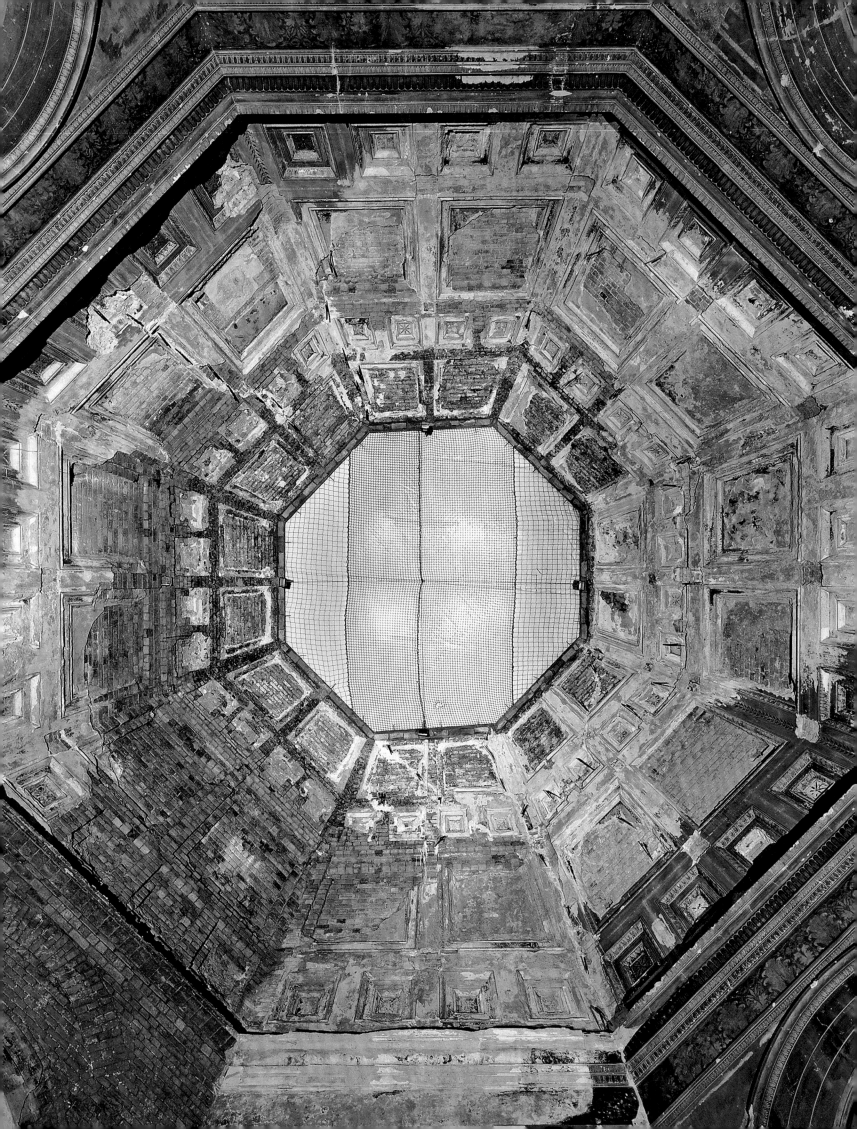

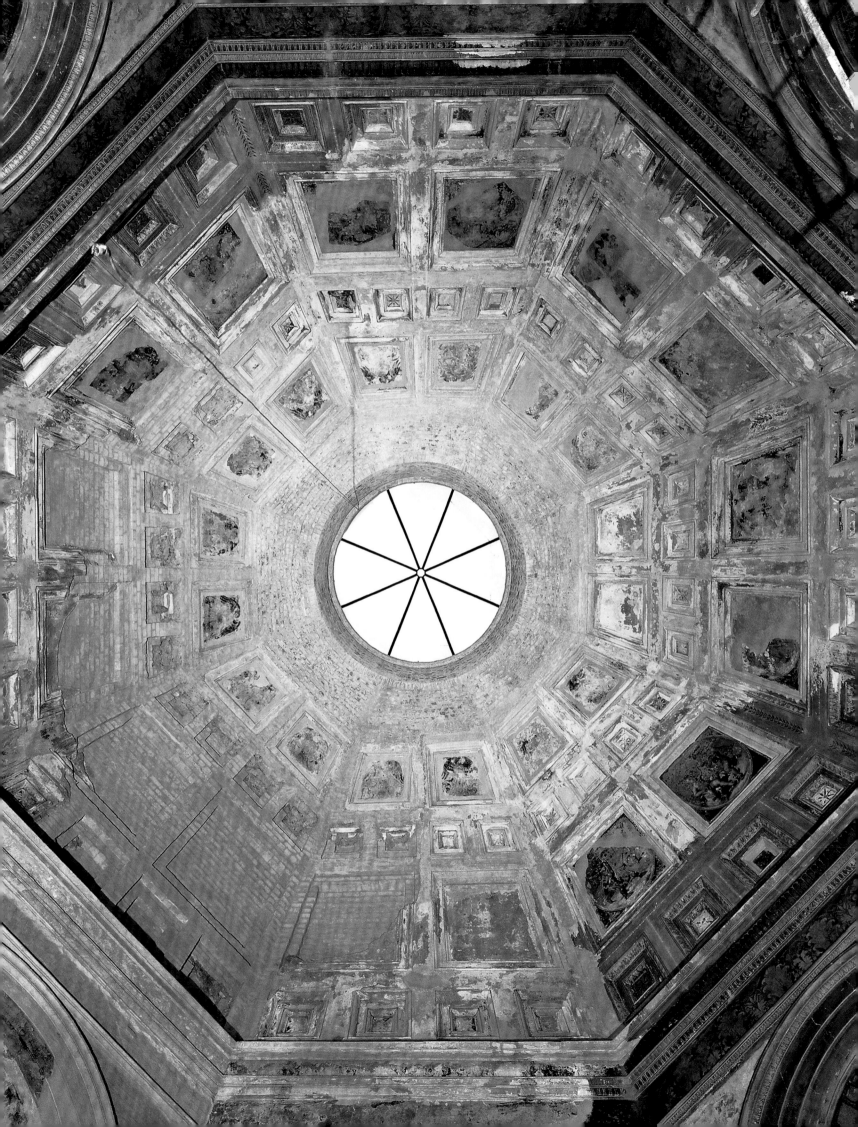

From Building to Rebuilding – the Early History of the Neues Museum

JÖRG HASPEL

The Museum Island World Heritage site is on the northern part of the Berlin Spree Island. It is immediately adjacent to the site of the Berlin Schloss, which together with the core area around which the city grew, Alt-Cölln, takes up the centre of the Spree Island, followed by the Fischer-insel further to the south. There is documentary evidence from the 15th century of a garden on the area enclosed by the two arms of the Spree north of the medieval fortress, and also of an orchard and kitchen garden for the court created from 1573, as the castle was being developed into a Renaissance building. The new garden laid out on the northern Spree Island in the Dutch style by the Großer Kurfürst (Great Elector) was christened "Lustgarten" (Pleasure Garden) in 1646.

The Lustgarten and the Schloss dwindled in social and prestigious significance for the royal household when the Prussian court reoriented itself, concretely with the development of the residence in Charlottenburg, the new plans for an urban residence in the Friedrichsforum and finally with the lavish residence projects in Rheinsberg and Potsdam. This left scope for new efforts. The fact that the Lusthaus (garden house) was handed over to the merchant classes to establish the Berlin Stock Exchange (1738) or to set up the Packhof area (1748) on the site of the demolished Pommeranzenhaus (orangery), underlines this loss of function and the importance given to new activities intended to promote trade and commerce, which were operated from the northern Lustgarten from the 18th century onwards. In the 19th century the northern Schloss garden site acquired an important function as a location for arts and culture, which settled here in the first place in the immediate vicinity of and probably also in competi-tion with the industrial and financial institutions.

Early history and planning history of today's Museum Island

When a green, rectangular garden square was laid out on the north side of the Schloss – this was the Lustgarten in the more restricted sense, as designed and executed in 1828-1833 to plans by Karl Friedrich Schinkel and Peter Joseph Lenné – and Schinkel's new museum (planned from 1822, built in 1825-1830) opened by the Lustgarten, the former garden site on the northern Spree Island had been given the impetus it needed to develop as a museum location. Further plans emerged in the reign of Friedrich Wilhelm IV (1840-1858) to develop the land on the north-east Spree Island that was not used by the Packhof's loading, warehouse and office facilities for art collection and educational purposes. Friedrich August Stüler's Neues Museum was the first building to be erected as part of this concept, from 1843-1847, behind Schinkel's Altes Museum.

Any further development came to a standstill in the next twenty years as a result of general developments in Prussia, until Johann Heinrich Strack's Nationalgalerie (now the Alte Nationalgalerie) was built from 1866, on the basis of preparatory work by Stüler. After another inter-ruption lasting more than two decades, in the reign of Wilhelm II, the Kaiser-Friedrich-Museum (Bode-Museum) was built from 1897-1904 by Ernst von Ihne, and the Pergamon Museum from 1909-1930, started to plans by Alfred Messel and completed under the direction of Ludwig Hoffmann. This meant that the original development target for the northern Spree Island had been met with a few extensions after about a hundred years. In the 1890s a start was made on gradually moving the Packhof facilities off the Spree Island, ending with the demolition of the remaining Packhof administration buildings on the Kupfergraben. So in the 1930s the northern Spree Island became a Museum Island pure and simple, and space was created for new expansion, as already planned by Messel and as now being realized in the form of the new entrance building. The Neues Museum (1843-1855) occupies a very special place among the five World Heritage museums on the northern Spree Island, because of the history of its emergence and its fate in and after the war. Schinkel's extension of the Altes Museum (1825-1830) as a "sanctuary for science and art" was based on a vision by Friedrich

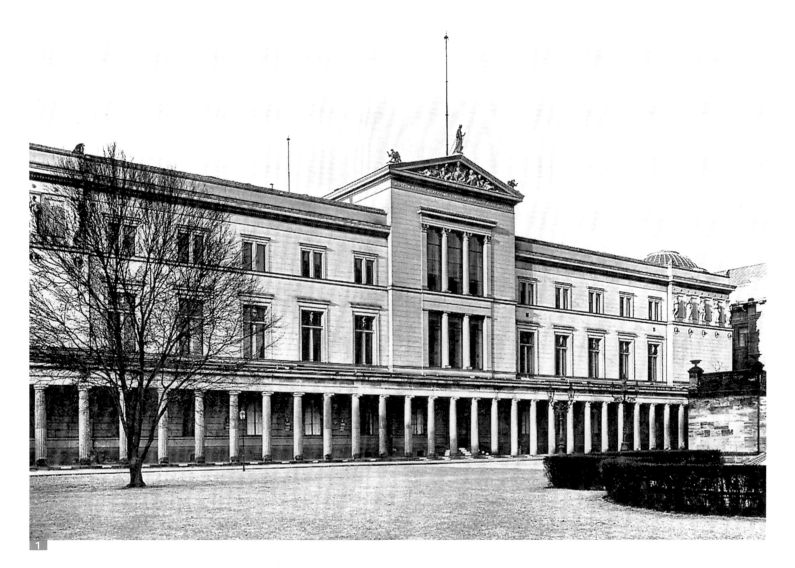

Wilhelm IV, the "Romantic on the Prussian throne". Plans for completing Cologne cathedral took significant shape under his protectorate, but that was not all: he also created the essential basis for developing the northern Spree Island into a museum ensemble of international calibre. Just a year after he came to power, the king took up ideas for extending the museum and setting up a cultural and scientific forum. This was to come into being east of the Packhof site by the Kupfergraben and be directly attached north of the Altes Museum by the Lustgarten, in other words would become part of the residence site on the Spree Island. This monarch, talented artistically and highly ambitious in terms of building politics, also provided his master builder Friedrich August Stüler with sketches from his days as crown prince as stimulating material. These showed a kind of temple city composition based on the Forum Romanum, and included Schinkel's existing museum building in a new group of buildings on the banks of the Spree.[1]

The first "master plan" and the Neues Museum

In the very same year, Stüler developed an ideal urban development plan for the north-eastern tip of the island. This was to become a kind of "master plan" for the coming decades, and was, in modified form, to give a sense of orientation for the further development of the Museum Island well into the imperial period. The first step towards extending the museums and the planned "sanctuary for science and art" was the building of the Neues Museum, which was connected to Schinkel's building by a bridge. It was to be the main work completed by Stüler, who was appointed "King's architect" in 1842, making him Schinkel's successor. Similarly to its predecessor building, the Neues Museum project was organized as a solitaire construction, built to a ground plan around two closed courtyards. The centre – instead of the Altes Museum's cupola – was formed by a stair hall rising through all floors and occupying the full depth of the building. This was reminiscent of Schinkel's design for the Royal Palace on the Acropolis for King Otto I (1834),

1 View of the east façade (without south dome) of the Neues Museum, with colonnade, lawn, flowerbeds and the stair stringer of the Nationalgalerie, 1930. *Unknown photographer. Source: Zentralarchiv der SMB*

History
14|15

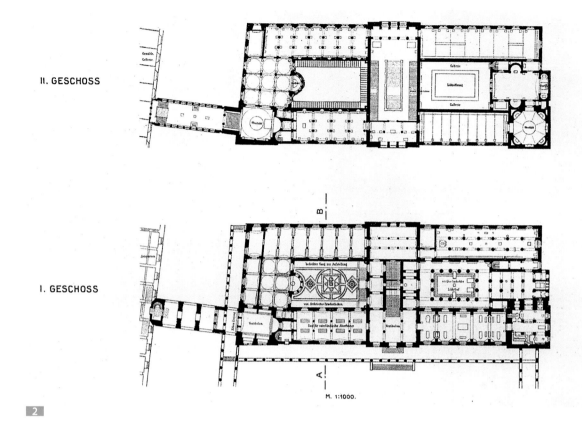

II. GESCHOSS

I. GESCHOSS

M. 1:1000.

decorated with quotations from the Erechtheion and culminating in the Korenhalle (Caryatid Hall) as the crowning glory of the topmost pedestal.[2]

Monumental murals by Wilhelm von Kaulbach drew their subjects from important stages in human history, graphically supported by the upward movement of the steps. They started with Babylon and Greek Antiquity, then passed via scenes from the Crusades to the events of the Reformation. Unlike the Altes Museum with its domed hall dedicated to an ancient ideal of beauty that is timeless, both the configuration of and coloured paintwork in the Neues Museum stair hall symbolize a historical principle of evolution in a museum, implementing an idea of human history developing onwards and upwards, influenced by Hegel's philosophy of history.[3]

The architectural sculpture and paintwork in the exhibition galleries, large and small, which extended in chronological order from antiquity on the ground floor to the presentation of medieval and post-medieval art works on the top floor, served to illustrate history didactically and provided complementary information about the context of the works on show.[4] The so-called Ägyptischer Hof (Egyptian Courtyard), which – similarly to the adjacent exhibition galleries and objects – was based on contemporary excavation and research by Richard Lepsius (1842-1846). It was one of the particularly striking creations within this museum architecture, providing comprehensive interpretation and staging.[5]

Stüler's building, as well as introducing the historical principle into museum architecture and the symbiotic linking of museum design and museum presentation, was also a considerable achievement in terms of technology and construction. He made the difficult subsoil of the Spree Island into experimental ground for the use of steam-driven construction technology and for trying out innovative building materials and iron structures in Prussia.[6] Wide spans using iron bowstring girders, light clay cylinder structures and even early versions of Rabitz vaulting (and perhaps the oldest wire lath and plaster ceiling to have survived in Germany), represent progress in construction technology that was soon to find its way into other museum buildings. Behind its markedly reticently designed late neo-classical rendered façade, the Neues Museum did not only give its visitors a glimpse of an innovative perception of history and museums, culminating in the creation of magnificently decorated galleries. The building also offered scope for a whole range of innovative approaches to engineering problems that themselves acquire monumental status today as high-calibre achievements in construction and technology.

First modifications

Many years were to pass from the solemn laying of the foundation stone in 1843 until – interrupted by the revolutionary events of 1848/49 – the last collection opened

2 Friedrich August Stüler: Das neue Museum in Berlin, 24 plates, Berlin 1862, plate 2: second storey for the display of plaster casts and first storey. *Source: Zentralarchiv der SMB*

in 1859; and then some years again, namely after the foundation of the German empire, before the first collections moved out (the Kunstkammer and the Ethnographical Collection) and some modifications were made to the building. A generation after it was opened, the new building acquired an additional mezzanine storey, which was invisible from the outside but changed the proportions of the courtyard rooms (1883–1887). After the First World War came far-reaching modifications to the so-called Greek Courtyard in the south section to accommodate the Egyptian Museum's Amarna Collection, which also entailed radical changes to the access structure and the design of adjacent galleries (1919–1923). Removing the "apse" that protruded from the Flachkuppelsaal or Medieval Hall into the Greek Courtyard, taking away the steps, raising the floor level and finally the installation of an iron and glass structure to roof the courtyard lent the southern courtyard a new character. In the late 1920s the museum received a second northern bridge link to the Pergamon Museum, which was just being completed. The building closed when the Second World War broke out in 1939, and its holdings were taken into safe keeping.[7]

The building was badly damaged by incendiary bombs in 1943 and then again in 1945, and parts of it burnt out completely. The damaged building remained untouched in the following years, with only some of the less damaged rooms being used for storage purposes. The staircase, which caught fire and was badly damaged in 1943, was not protected and closed off from further loss by the weather, and neither was the south-eastern projection, hit in 1945, nor the badly damaged rooms on the west side with their shattered ceilings. Measures taken to render the building safe and to prepare for construction work concentrated in the 1980s on pulling down other ruined parts of the building and on removing and rescuing valuable decorative elements. The final remains of the Egyptian Court and the Korenhalle in the stair hall were also removed in the course of these late safety and preparatory measures. The extended preparations for a comprehensive repair of the ruin's foundations and measures to stabilize the above-grade masonry work culminated in a solemn laying of the foundation stone for the rebuilding of the museum in September 1989. As when the first foundation stone was laid in 1843, none of those involved could have imagined that many years were to pass before the project was completed.

When the Berlin Wall fell a few weeks later and the city was reunited in 1990, the state museums and their collections came back together as well. The torso on the Berlin Museum Island, marked by war damage and its post-war plight, provided evidence of the deficit accrued by 20th-century German history. Unlike the other war-damaged buildings on the island, Stüler's museum was neither refurbished on a conservative basis (like the Bode-Museum) nor rebuilt to suit modern purposes (like the Altes Museum). Instead the wreck of the Neues Museum had to wait for almost two generations after the end of the war to be restored to its original functions as a publicly accessible home for the archaeological collections and exhibitions.

Heated discussion about the form rebuilding should take

In the months after the fall of the Wall in 1989/90 the decision to rebuild the Neues Museum and to return it to its historic museum function was greeted enthusiastically by all those involved, or at least tacitly supported. However, the question of how to approach rebuilding, which was designated "reconstruction", unleashed heated discussions between the museums, architects and monument conservationists involved. There was no dispute about restoring the exterior on historical lines, and it was equally generally accepted that the east wing and the better-preserved sequences of galleries on the two main floors should be retained, and reconstructing the burnt-out and cleared hall with staircase on the basis of old plans and other documents was also pursued by majority verdict – against some self-critical objections from the conservators' camp.

Of course, this compromise agreed upon by the responsible parties in the GDR in just the last few months before reunification masked stubborn differences of opinion about the objective of retaining the building and the design options in the interior. The courtyard galleries, which had suffered greatly in the war and from later losses, and the partially destroyed rooms in the south and west wings, were particularly crucial sources of argument. The conservationists tended to stress the value of the surviving sections on the basis of the losses already incurred, so put the case for consistent retention and restoration on the old ground plan, but the building side and some of the users were in favour of taking the opportunities offered by the extent to which the monument had been damaged and opting for a fresh start and a consistently modern solution. Putting exhibition floors in the museum courts to improve the usable area and installing air-conditioning and other technology in the courtyard galleries, was discussed, and so was further decimating the existing building fabric with a symmetrical arrangement of access cores with stairs, lift and WC units in the south and north wings, to replace the Flachkuppelsaal, for example. There were also suggestions to swap historical ceiling panels in favour of load-bearing

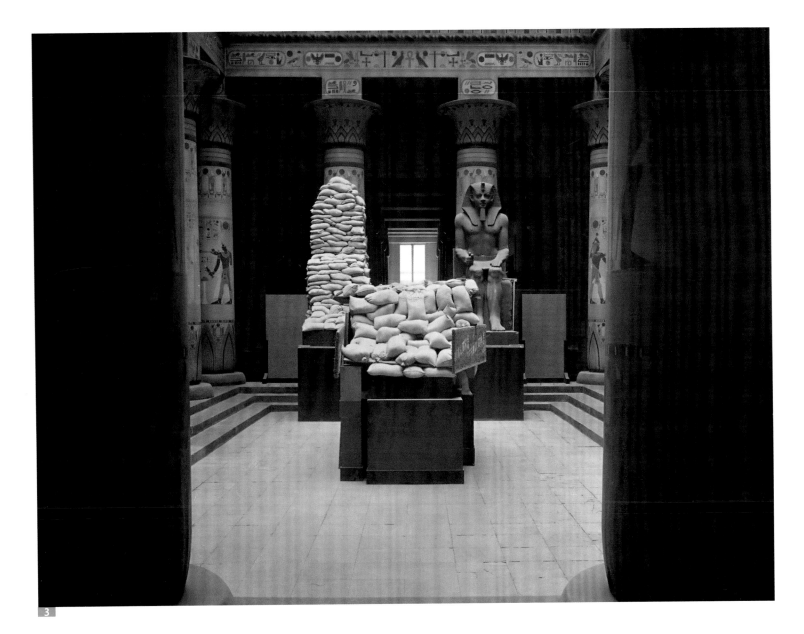

structures that could take more weight and to manage without reintroducing load-bearing elements and structural components that were in store in the south section of the west wing, which was lost with the exception of the walls enclosing it.[8] Early discussion about the Neues Museum revealed at an early stage that behind the term "reconstruction", as used by urban developers and monument conservationists in the GDR, lay a whole spectrum of problems and sources of conflict that was also to pervade the debate in the united Berlin.

But in the 1990s the role of the Neues Museum as a mirror for war- and division-related developments in Berlin was to stand out even more starkly than in the 1980s – perhaps also after the impact made by the opening of the "Iron Curtain" and associated talk about the "end of the Cold War". In the space of half a century the ruined and fragmented Neues Museum had acquired a new and

unexpected layer of meaning. The state the Neues Museum presented itself in around 1990 was not just the result of the story of building and rebuilding before the Second World War that has just been sketched out; the torso, especially in its empty spaces, also offered an impressive image of the destruction caused by the Second World War and its consequences. The war ruin had become a monument in its own right, a shattering reminder of transience and decay, side by side with surviving galleries that still radiated the authentic splendour of the past, and in the vicinity of other museum buildings whose exteriors had been recreated largely in their pre-war versions after 1945.[9] About a third of the building was considered totally lost around 1990 as a result of war damage and material removed in the post-war period, an estimated further third had been reduced to main walls and other shell material and the rest had come through in a reasonable state,

3 The Ägyptischer Hof before its destruction, c. 1942, with colossal statue and sandbags as a protective measure against bomb damage. *Photo: Ägyptisches Museum. Source: Zentralarchiv der SMB*

including the artistic coloured paintwork and other decoration that had survived in situ.

Given the extraordinary importance of the Berlin museum buildings, above all in terms of the totally disparate state of the Neues Museum as it stood, and the particular complexity of the restoration task, the Berlin Monument Council (now the Landesdenkmalrat Berlin) recommended even in the early months after the Wall fell that a nationwide monument conservation commission made up of building researchers, restorers, conservationists and art historians should be set up to devise guidelines for a planned reconstruction to international standards. The Senate department of urban development and the environment, the directorate of the Staatliche Museen zu Berlin – Preußischer Kulturbesitz and the Federal building directorate (now the Federal Office for Building and Regional Planning) took up the suggestions and set up a seven-man expert commission including Ernst Badstübner, Hartmut Dorgerloh and Wolfgang Wolters from Berlin, then from Baden-Württemberg the chairman of the Berlin Monument Council August Gebeßler as well as Helmut F. Reichwald, and from Bavaria Thomas Mader and Manfred Schuller. Wolfgang Wolters, also a member of the Monument Council, agreed to chair and speak for the group of experts.

Agreement about "complementary restoration" of the building

The recommendations of the expert commission, about whose deliberations the Monument Council was also regularly informed, were intended to provide guidelines for the longer-term handling of the building and its surroundings regarding conservation and architecture, and were in the short term to become part of the invitation of tenders, already planned, for an international architecture competition for rebuilding the Neues Museum and creating an entrance building. After some debate, heated in parts – for example about reconstructing the apse thrusting into the Greek Courtyard since direct hits in 1945 had severely damaged the section built between 1921 and 1923 for the Amarna Collection, or to rebuild the lost old bridge to the Altes Museum and the more recent link with the Pergamon Museum, which had survived in rudimentary form – the commission, which met from 1990-1992, reached an agreement about the basic features of the restoration programme for the building,[10] which were published in 1994 and entitled "A conservation plea for complementary restoration" by the Berlin State Conservation Office.[11]

As an example of the basic conservation approach devised by the expert commission, take these notes on dealing with the stair hall, which was a shell with minimal remains of décor: "Reconstruction of the stair hall is out of the question because of the irretrievable artistic and personal quality of its parts ... For this reason it seems essential to repeat the old principle of access stairs and landings: long, austere flights, structuring and dominating the space ... The stair hall should remain independent and reflect the fate of destruction, loss, emergency safety measures and revival ..."[12]

Also included among the principal recommendations:

- immediate securing and documentation of all historical surfaces, technical installations and elements of artistic décor surviving in the building, and also protecting them effectively against weather and wear,
- bringing back all the structural elements and décor features rescued and stored over the decades, including the architectural-sculptural decoration and the colonnades, and reinstalling them in the original location and visual context,
- respecting and including historically typical effects of modification to the extent that they have survived in the building and are capable of making a statement (e.g. mezzanine storey, c. 1885),
- using a differentiated restoration strategy by considering the condition of surviving galleries, courtyards and stored structural and decorative elements,
- meeting no demand to reconstruct structural sections and room décor that are seen as totally destroyed and irretrievably lost in terms of their artistic character (such as the staircase, the Egyptian Court, the Armana Collection rebuilding phases and so forth),
- distinguishing between old and new in additional work and repairs for the building, for example by different treatment of the surfaces; here priority in discernment should be accorded to visibly aged historical components when juxtaposed with new constructions,
- complementing the ruin in the volume and proportions of the historical building and the urban closure of the ensemble,
- recreating the damaged access and room structures to include the existing stock in the basic disposition of the future museum,
- concentrating new technical requirements and modernization (lifts, sanitary facilities, domestic services etc.) in the new sections of the building.
- creating a subordinate new building to replace the lost Packhof between the Kupfergraben and the Neues Museum as an urban frame for the ensemble.

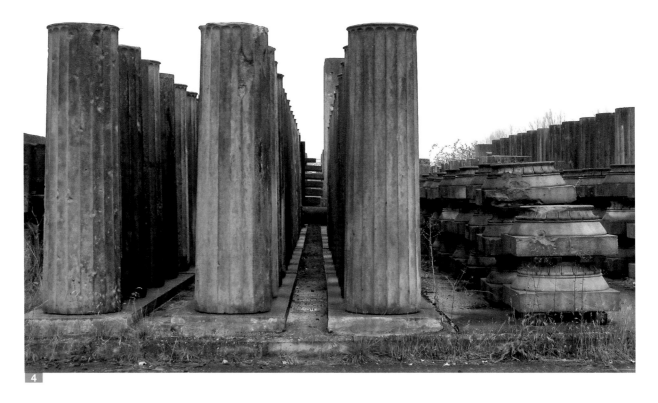

At first, the results of the international architecture competition carried out with the involvement of conservation experts in 1993/94 and won by Giorgio Grassi came to nothing.[13] A two-tier expert consultation process between the best-placed architects in the competition finally led to a commission for David Chipperfield Architects to recreate the ruined monument as an archaeological museum. The discussion among the public and publicly acknowledged experts about an appropriate conservation and restoration concept for the ruined monument became increasingly heated during the preliminaries to the granting of World Heritage status to the Museum Island.[14] UNESCO agreed to add the Museum Island to the World Heritage List in 1999, and the Prussian Cultural Heritage Foundation submitted an overall concept for access and for developing the museum ensemble, and this was presented as an exhibition in the following year as the "Museum Island Master Plan" as part of the preliminaries to the solemn presentation of the World Heritage document.[15] The "master plan" made it possible in particular to remove the burden of highly frequented access functions from the best-preserved existing sections of the Neues Museum, which were most in need of careful treatment, and by introducing an "archaeological promenade" as an under-

ground link between the buildings allowed the buildings to stand freely as an ensemble of solitaires.[16]

Also at the turn of the century, a series of workshops with those responsible for preserving and completing the Neues Museum resulted in the detailing of the expert commission's "Plea for complementary restoration" and a "rough conservation concept for the individual rooms" (1993), devised by the State Conservation Office. Here the building's very different states of preservation provided the starting-point for an extremely differentiated approach. Julian Harrap was brought in as restoration architect, and the first step was to devise a set of "conservation guidelines" in several stages (11 February 1999). The next planning documents were the formulation of a "restoration strategy" (16 September 1999) and eventually a "restoration concept" (20 October 2000). These provided the approaches to restoring all the rooms and parts of the building. All three documents were signed jointly on the building, museum and monument side, and formed the basis for planning the actual work.[17] Rebuilding work started again in summer 2003,[18] the topping-out ceremony took place in September 2007[19] and the reopening is scheduled for September 2009.

4 Columns at the depot. *Photo: Johannes Bennke/ David Chipperfield Architects (DCA)*

1 Cf. Eva Börsch-Supan, Dietrich Müller-Stüler, Friedrich August Stüler 1800–1865. Edited by the Landesdenkmalamt Berlin, Munich, Berlin 1997, esp. pp. 64–67

2 For the design planning cf. the historical portfolio by Friedrich August Stüler dating from the late building phase: Das neue Museum in Berlin (24 plates), Berlin 1862; for the "rediscovery" of the building and its reception in the late GDR cf. Martin Muschter, Das Neue Museum von F.A. Stüler in Berlin als ein Höhepunkt der klassizistischen Architekturentwicklung. Ein Beispiel für neue Baugestaltungs- und Konstruktionsziele des 19. Jahrhunderts, 2 vols, diss. Technische Universität Dresden 1988

3 Cf. Eva Heinecke, Das Treppenhaus des Neuen Museums. Die Architektur Stülers, master's thesis TU Berlin 1997

4 Hartmut Dorgerloh, Die museale Inszenierung der Kunstgeschichte. Das Bild- und Ausstattungsprogramm des Neuen Museums zu Berlin, diploma thesis Humboldt-Universität Berlin (unpubl MS), 1987; same author, Museale Inszenierung und Bildprogramm im Neuen Museum. In: Berlins Museen – Geschichte und Zukunft. Edited by Zentralinstitut für Kunstgeschichte. Berlin, Munich 1994, pp. 79–86; Eva Heinecke, Studien zum Neuen Museum 1841–60. Baugeschichte, Verantwortliche, die Nordische und Ägyptische Abteilung, Geschichtskonzept, diss. TU Berlin (unpubl. MS) 2007

5 Cf. Michael Zajonz, "Ein Abenteuer von ungewissem Ausgang – Vor 165 Jahren reiste Richard Lepsius für drei Jahre mit einer preußischen Expedition nach Ägypten." In: Der Tagesspiegel, 21 September 2007, B 7

6 Cf. Werner Lorenz, Stülers Neues Museum – Inkunabel preußischer Konstruktionskunst im Zeichen der Industrialisierung. In: Zentralinstitut für Kunstgeschichte (ed.), Die Museen in Berlin, Munich 1994, pp. 99–112; same author, Konstruktion als Kunstwerk. Bauen mit Eisen in Berlin und Potsdam 1797–1850 (Die Bauwerke und Kunstdenkmäler von Berlin, supplement 25). Edited by the Landesdenkmalamt Berlin, Berlin 1995, pp. 74–76 and 319–341

7 Cf. Günter Schade, Die Berliner Museumsinsel. Zerstörung, Rettung, Wiederaufbau, Berlin 1986

8 Cf. Ernst Badstübner, Hartmut Dorgerloh, Zur Baugeschichte und den Problemen des Wiederaufbaus. In: Bildende Kunst, issue 12, 1989. Edited by the Verband Bildender Künstler der DDR, pp. 27–31; Max Kunze, Zwischen Pracht und Bildung – Historisches und Gegenwärtiges zur Diskussion. In: Bildende Kunst, ibid., pp. 31–35; Peter Flirl, Moderne Nutzungsanforderung – historisches Bauwerk. In: Bildende Kunst, ibid., pp. 35–39; Günter Schade, Bemerkungen zu Geschichte und Problemen beim Wiederaufbau des Neuen Museums. In: Jahrbuch Preußischer Kulturbesitz, 27, 1990, pp. 163–195

9 An eye-opening article on this way of perceiving monuments: Wolfgang Wolters, Historische Innenräume. Restaurieren? Inszenieren? Konservieren? In: Kunstchronik, vol. 50, issue 12, December 1997, pp. 672–678, esp. p. 676ff.

10 Cf. August Gebeßler, Berlin. Museumsinsel und Denkmalpflege. Von den Schwierigkeiten bei der Wiederherstellung des Neuen Museums. In: Kunstchronik, vol. 46, issue 2, February 1993, pp. 77–92

11 Ernst Badstübner, Hartmut Dorgerloh, August Gebeßler et al., Das Neue Museum in Berlin – ein denkmalpflegerisches Plädoyer zur ergänzenden Wiederherstellung (Beiträge zur Denkmalpflege in Berlin, issue 1), Berlin 1994; for the conservation aims see also Jörg Haspel, Die Zukunft des Neuen Museums. Erhaltung und Wiederaufbau als denkmalpflegerische Notwendigkeit. In: Berlins Museen – Geschichte und Zukunft. Edited by Zentralinstitut für Kunstgeschichte. Berlin, Munich 1994, pp. 139–144

12 Ernst Badstübner, Hartmut Dorgerloh, August Gebeßler et al.: as note 11, p. 26

13 Bundesbaudirektion (ed.), Museumsinsel Berlin – Wettbewerb zum Neuen Museum, Stuttgart, Berlin, Paris 1994; for the level of discussion about the monument after the disputed competition result see the contribution by Eva Börsch-Supan, Das Neue Museum in Berlin. Über den Umgang mit einem Baudenkmal. In: Die Denkmalpflege, vol. 53., issue 1, 1995, pp. 5–21

14 A good example is the lively exchange of opinions in the monthly journal of the Verband deutscher Kunsthistoriker, "Kunstchronik", at the turn of 1997/98, with contributions by Adrian von Buttlar, Erhaltungsziel Museumsinsel (issue 8, August 1997, pp. 391–396), Dietrich Wildung, Der Denkmalbegriff eines Denkmalpflegers (issue 12, December 1997, pp. 679–681) and Achim Hubel, Der Denkmalbegriff eines Archäologen? (issue 1, January 1998, pp. 45–46)

15 Masterplan Museumsinsel Berlin. Ein europäisches Projekt. SMB/SPK exhibition catalogue, Berlin 2000

16 Cf. Frank P. Hesse, Die Denkmale der Museumsinsel. Konservatorische Aspekte der Gesamtplanung und Einzelprojekte. In: Masterplan Museumsinsel Berlin, as note 15, pp. 39–47, esp. pp. 40f. and 47

17 For the conservation problems and aims cf. Frank P. Hesse, Neues vom Neuen Museum. In: Die Denkmalpflege, vol. 58, issue 1, 2000, pp. 19–32

18 David Chipperfield Architects (eds.) provide a succinct and vividly illustrated account of the architectural and restoration-related rebuilding concept: Neues Museum – Dokumentation und Planung, Berlin 2003; for detail cf. also the internet presentation by the Bundesamt für Bauwesen und Raumordnung www.wiederaufbauneuesmuseumberlin.de

19 For an interim assessment cf. Norbert Heuler, Wiederaufbau und Restaurierung des Neuen Museums auf der Museumsinsel in Berlin. In: KUR Kunst und Recht, Journal für Kunstrecht, Urheberrecht und Kulturpolitik, vol. 9, issue 3/4 June–August 2007, pp. 67–70; Jörg Haspel: Heile die Wunde – Zeige die Wunde. Rebuilding Neues Museum. In: Jahrbuch Preußischer Kulturbesitz, vol. XLIII, Berlin 2007, pp. 189–210, esp. 195ff.; Zeige die Wunde und heile die Wunde? Von der ergänzenden Wiederherstellung des Neuen Museums in Berlin. In: Das Denkmal als Fragment – das Fragment als Denkmal. Denkmale als Attraktion. Jahrestagung der Vereinigung der Landesdenkmalpfleger und des Verbandes der Landesarchäologen in der Bundesrepublik Deutschland und 75. Tag für Denkmalpflege 10.–13. Juni 2007 Esslingen am Neckar (Arbeitsheft 21, Regierungspräsidium Stuttgart – Landesamt für Denkmalpflege), Stuttgart 2008, pp. 301–317

Architecture – Décor – History of Ideas

BERNHARD MAAZ

Protagonists and ideas

The short inscriptions on the sopraportae of the Niobidensaal (Niobides Hall), the best-preserved gallery of the Neues Museum and one of the interiors containing the richest programmatic iconography, may be regarded as the essence of the philosophy, on which the entire architectural design of the building and its rich interior decoration with its wealth of imaginative details and ornaments were based. All this emphasized the singular significance of art for humanity, and the role creative artisans and artists play. One sopraporta carries an inscription, which translates as 'Many amazing things prevail, but nothing more amazing than man', and another reads 'Prometheus created every art for mortal man'. Prometheus as the passionate hero and willing sufferer had become the epitome of artistic imagination and creative martyrdom. On the one hand, the inscription invoked Prometheus as an Olympian and, on the other, man's incredible creativity. The builders of the Neues Museum – Friedrich Wilhelm IV of Prussia, the inspiring client; Friedrich August Stüler, the designing architect; and Ignaz von Olfers, the representative of the museums who participated in the design – held firm to the intellectual complexity as well as to the mythical and historic references of their project. As a creative "triumvirate", these men were responsible for erecting one of the most unusual museum buildings with the richest collections in the 19th century – a century which saw the creation of a great number of new museums.[1] The wealth of ideas, designs, collections and connections involved resulted in a pioneering architecture full of inspired details, allusions and references. The present text wishes to outline these different aspects and study the Neues Museum in terms of its exhibition concept and decorative scheme. The enormous complexity of the subject requires conciseness; nonetheless the inevitable briefness of this text allows the author to trace the main lines.

Apart from Ludwig Persius, who died young, Friedrich August Stüler was Friedrich Schinkel's most prominent student and influenced generations of architects with his late classicism. He confidently mastered the difficult task of designing and building the Neues Museum and solved every problem with amazing assurance – from the unstable foundation soil to the irregular cut of the site (hemmed in by neighbouring buildings). He succeeded in creating a singularly harmonious mélange of classical forms, an iconography familiar to the well-educated classes; adequate functionality and modern construction and engineering techniques. The Neues Museum must be considered a building of outstanding significance in architectural history for the way Stüler mastered these multiple "splits".

Stüler engaged a great number of artists who contributed wall paintings and architectural sculptures to the decoration. Though many of them are little known today and the list of decorators does not include any names of innovative and imaginative painters such as Adolph Menzel, the fact that less prominent artists were commissioned had the advantage of facilitating the implementation of the pictorial agenda imposed by the "triumvirate".

Ignaz von Olfers, from 1839 director of Berlin's Royal Museums, was close to the King and had a profound knowledge of art history, but was very conservative in his attitude to modern art. Shortly after King Friedrich Wilhelm IV had acceded to the throne, he asked Olfers to draft a memorandum on the prospective development of the Berlin museums and contributed his own ideas to the concept of the Museum Island as a "sanctuary for art and science", drafted by Olfers and Stüler (then Prussia's highest-ranking architect) in consultation with other institutions such as the Academy of Arts and the University.

Of course, apart from the "triumvirate", which might be described as a threesome of legislative (the King), directive (the director of museums) and executive (the architect), a great number of people, among them members of the "Wissenschaftlicher Kunstverein zu Berlin"[2], contributed to the design and planning process – albeit as a rule only on matters of detail – and may be characterized

in modern terms as a professional public. This was an important factor because it meant that the final result was a democratically legitimized royal museum. The Neues Museum matched the prevalent 19th-century definition of what a museum should be and thus became the ideal expression of "a place dedicated to learning, the sciences [and humanities] and the arts" as stated in an encyclopedia of 1846.[3] Today's visitors need comprehensive knowledge of many fields, in some cases even the approach of a scientific historian, and always the readiness to decode the meaning of the different pictorial ideas and their original purpose and meaning.[4]

Structural division and use

Schinkel's Altes Museum, the first museum to be erected on the Museum Island, was opened in 1830. As its permanent collection was displayed on two gallery levels, it was the expression of a bipolar theoretical construct. The paintings exhibited in the upper-floor picture gallery, i.e. the art of modern times, literally rested on the art of antiquity, at the time presented on the lower gallery floor. Schinkel's Altes Museum thus reflected the dialectics of then and now, antiquity and modernity, and bore witness to Winckelmann's influential theory that the art of modern times should not only draw level with, but even outmatch the art of antiquity in terms of greatness and significance. However, the theoretical and practical parameters for the Neues Museum were much more complicated than that.

Each of the two buildings has a central entrance area (a rotunda in the Altes Museum and a main staircase hall in the Neues Museum) enclosed by four wings around two interior courtyards, but a different floor-level division. The Neues Museum had three gallery levels and had to accommodate not only two collections, but a whole phalanx of collections of different characters and of different archaeological, historic and art-historical origins, relevance and presence. Thus the Neues Museum became a multi-focal repository of national archaeology, Egyptology, classical archaeology, prints and drawings, and of the "curiosities and wonders" of the royal Kunstkammer (literally: art chamber) – and thus moved between archaeology, the history of civilization and the history of art.

Some façade sections were covered with iconographic indicators of the collection contents behind them, but even more the façades revealed the interior spatial arrangement. On the west and east façades, the central projection marked the position of the staircase, whilst the

Friedrich August Stüler, Das neue Museum in Berlin, 24 plates. Berlin, 1862, plate 4, showing the east view of the Neues Museum, detail. *All photos: Zentralarchiv der Staatlichen Museen zu Berlin*

Friedrich August Stüler, Das neue Museum in Berlin, 24 plates. Berlin, 1862, plate 10, showing a section through the Neues Museum and the north elevation of the Griechischer Hof (Greek Courtyard) with the central section of the frieze by Hermann Schievelbein, detail

façades of the four wings with their large windows indicated the different floor heights and thus also the rank in the collection hierarchy of the exhibits inside.

The ground-floor interiors were partly shaded by exterior colonnades – an effective element of urban architecture – and contained the galleries of national archaeology south of the staircase hall, and those of the Egyptian collection to the north. The main level contained the collection of over 1,000 plaster casts, which traced the history of sculpture from classical Greek and Roman antiquity through the Middle Ages and the Renaissance to contemporary sculptures by Bertel Thorvaldsen, Ludwig Schwanthaler, Christian Daniel Rauch and others. Since Gottfried Herder's times, sculpture had held primacy over other forms of fine art, and this collection represented an excellent overall view of the development of occidental art.

South of the staircase the third gallery level contained the Brandenburgische Kunstkammer with a broad range of objects: models of medieval buildings; miniature monuments, which expressed the dynastic importance of the portrayed; glass paintings; sacred objects such as reliquaries; Prussian uniforms and court dresses; curiosity cabinets and musical instruments that had once belonged to the Hohenzollerns; ethnographica and travel souvenirs; curiosa, rare books and varia. The northern half of this level contained the prints and drawings collection.

As an architectural pair the Altes and the Neues Museum with their rich collections formed a veritable universe. Together they were the last "universal museum" before the first pioneering specialist museums were founded.[5] The problem of how to display the heterogeneous collections inside the Neues Museum was solved intelligently by allocating them to clearly separate suites, of which the three gallery floors contained two each.

Architectural ornaments and collection priorities

The building's façades indicated what it contained. The stone transoms of the main gallery level were ornamented with allegoric figures that indicated the nature of the museum's collections by carrying urns as symbols of prehistory or archaeological finds in the form of vases or torsi as reference to the gypsoplast collection.

In 1854 Johann Friedrich Drake sculpted a stucco relief titled "Artists working and artists teaching"[6], or "Artists studying old works of art"[7], for the east gable of the building, the real show façade of the museum. The tympanon relief refers to the three-fold necessity to study art history and art, and to practise art. In the end, it illustrates the historic significance and educational purpose of the collections and thus makes it clear that the generally desired improvement of artistic quality in

Prussia was inconceivable without artistic education and the study of historic examples. In 1862 the sculptor August Kiss created a die-cast zinc relief for the tympanon of the west façade, an allegory of the arts and crafts, which again gave an idea of the variety of the museum's collections.

In addition, the east façade was decorated with other "programmatic" architectural sculptures, that is with medallions as well as with larger-than-life allegoric statues of the free and the mechanical arts on the corner projections. The entirety of the architectural sculptures used to decorate the façades of the Neues Museum illustrates the high-class artistic schooling of their creators. The artists calculated exactly the visual effects of their works mounted high up on the façades, and struck a good balance between careful detailing and summary treatment of the overall figures.

To all this were added two highly programmatic inscriptions – in Latin, which excluded the uneducated classes from comprehension. The east façade (planned to face the courtyard called Forumshof) carried the words MUSEUM A PATRE BEATISSIMO CONDITUM AMPLIAVIT FILIUS MDCCCLV ("the museum founded by the beatific father was extended by the son in 1855"). On the west façade, which faced the middle-class urban neighbourhood and was not detached at the time, the inscription read ARTEM NON ODIT NISI IGNARUS ("only the ignorant despises art"). Whilst the first inscription linked the two museums and thus emphasized the forum idea, the second addressed the educated classes, calling upon them not to remain indifferent to art and to the museum if they did not want to lay themselves open to the reproach of ignorance.

The four figures on the roof, of which only one has survived, represented a cultural and national political programme. Larger-than-life cast zinc allegories of Borussia, Peace, Art and Flora expressed a pacifist artistic programme meaning: Prussia's art only flourishes in times of peace. Thus the complex sculptural programme of the Neues Museum culminated in a statement which – in the spirit of Wilhelm von Humboldt – made the museum itself an integral part of the nation. Due to its sculptural ornamentation, the clearly structured exterior of the building formed a reflection of the interior organization and the nature of the collections. In addition, it reminded everyone of the political philosophy that led to the erection of the museum.

The staircase hall and the historic concept

Initially Stüler's staircase hall with the steeply rising stairs was a mere circulation space. However, it was the murals by Wilhelm von Kaulbauch – a gifted painter of historical

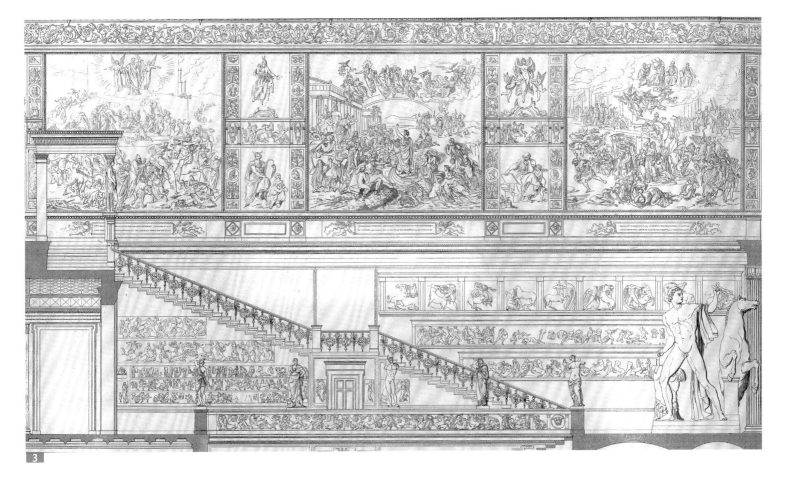

scenes and in pecuniary terms the richest among his fellows active in the genre – that made it into what it finally became: the most impressive interior theme architecture of German Historicism. The exposed roof structure appeared like a late evocation of the early Christian basilicas and may therefore be seen as a secularized version of religious architecture. It was only when the murals depicting decisive moments in the history of mankind were completed that the historically oriented philosophy behind the building was fully implemented, as these murals represented a hierarchically ordered sequence of historical scenes. The pictorial programme unravelled in front of one's eyes as one walked up the stairs. The physical act of "ascending to the height of knowledge was the intention"[8] that had to be followed. During a tour of the museum, attentive visitors walked through thousands of years of world history. Thus, their walk up the grand stairs became part of their individual life story and, as it were, reproduced macrocosmic events in microcosmic format.

As subjects for his richly nuanced murals, painted from 1847 to 1866, Kaulbach chose six defining moments in the history of mankind.[9] Each picture area was filled with a multitude of people, ingeniously staggered right up to the top edge. This imaginative form of composition and confident solution to pictorial problems would have been

sufficient to establish Kaulbach's fame, but his choice of historic moments was an even more important success factor. The first mural showed the destruction of the tower of Babel as the first defining moment of orally transmitted world history. The next one depicted Homer surrounded by a great crowd of poets, artists, scientists and statesmen, and thus not only visualized an ideal state of culture at its height, but also set up an antithesis – with a scene from an exemplary period – to the epochal destruction shown in the first picture. The third mural on the south wall represented another catastrophic historic moment, i.e. the destruction of, and Titus' triumphant entry into, Jerusalem in 70 AD – another brilliant composition, which continues the dialectic portrayal of human history's ups and downs. However, this epochal moment (and the term epochal was indeed understood at the time in the sense of a historic turning point) also changed the course of history because it heralded the triumph of Christianity over ancient Jewish and classical Greek culture.

The fourth mural (on the north wall) again questioned former historic achievements. It depicted a battle between the Huns – synonymous with brutal vandalism inimical to culture – on one side and Romans, Franks and Visigoths on the other. The composition defended western cultural achievements and also expressed the belief that the heartland

3 Friedrich August Stüler, Das neue Museum in Berlin, 24 plates. Berlin, 1862, plate 17, showing the staircase hall of the Neues Museum with Kaulbach's murals and a number of gypsoplasts, detail

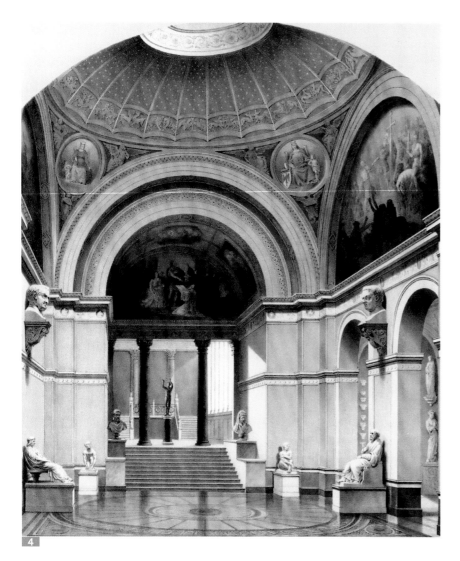

the purpose of the building, i.e. the collecting of art. In other words, the murals dealt with educational matters, with aspects of culture and "cult" as the sum of art, religion, philosophy and history.

Spatial requirements and collection contents

The Neues Museum complemented the Altes Museum. Together, the two formed a "universal museum" dedicated to an all-encompassing concept of history and a broad range of cultural and artistic testimonies. In addition, in order to underline this function, the interior spaces of the Neues Museum were enriched with a wealth of pictorial decorations and architectural ornaments, and the different gallery suites were logically organized to bring systematic order into the multi-faceted collections. Yet only a complete tour of the entire museum revealed the holistic concept behind this reflection on and overview of world and art history. The fact that the archaeological and historic exhibits had previously been kept in the different royal palaces was of secondary importance as far as the displays were concerned, and the fact that further items of cultural significance were kept in the library and the Zeughaus (arsenal) was regarded as negligible for the cultural-historical overview the tour of the museum offered. The tour route led visitors through every suite and from every floor back to the staircase hall, which made the link between the different historical periods and called for concentration on history as an abstraction and a *topos*, and not so much for dwelling on testimonial details.

The three wings on the south side of the first gallery floor contained the collection of "Germanic" or "Nordic" pre- and early history, which is why the the Nordischer Saal (Nordic Hall, also called Vaterländischer Saal) was decorated with motifs from the "Edda" epic and from northern Germany's prehistorical topography, such as the dolmens on the island of Rügen. The northern half of the same gallery level focussed on the ancient Egyptian, that is the southern perspective. The Egyptian department (the best and richest of its time) was inaugurated in 1850 and included large panoramic landscapes in oil of the areas the exhibited testimonies to the history of Egyptian civilization originated from. Here, "theatrical" displays and imagination were combined to great effect, and original hieroglyphs stood side by side with the interior decoration.

On the main, middle level, the north-south polarity of the purely archaeological collection on the first floor was replaced by an art-historical "compendium" of the highest educational potential: the entire floor was dedicated to the gypsoplasts, i.e. reproductions, of ancient, medieval as well as later sculptures cast and collected

of Europe had to overcome ethnic divisions and national borders to defend its cultural unity. The fifth mural dealt with Christian culture as the basis for the crusades and showed crusaders entering the Holy City of Jerusalem. As if religious questions were the real driving force of world history, the cycle closed with the Reformation as the theme of the sixth mural. In addition to the protestant theologians around Martin Luther, it also portrayed protestant kings as well as artists such as Leonardo da Vinci, Raphael and Albrecht Dürer. In this way, the six murals also referred to the fine arts, the interdenominational character of the arts and the deeper significance of the museum's collections. In conclusion, they presented the history of the world and mankind as a "cultural history" which, according to the understanding of the time, was the epitome of "mankind"'s intellectual development'[10].

The six large murals were framed by illustrations of various allegories, gods and goddesses; ornamental borders; friezes of children's figures and personifications of the four arts: architecture, sculpture, painting and copper-plate engraving. Again, all these decorations illustrated

4 Friedrich August Stüler, Das neue Museum in Berlin, 24 plates. Berlin, 1862, plate 22, showing the Südlicher Kuppelsaal (Southern Domed Hall) of the Neues Museum with a vista of the picture gallery in Schinkel's Altes Museum

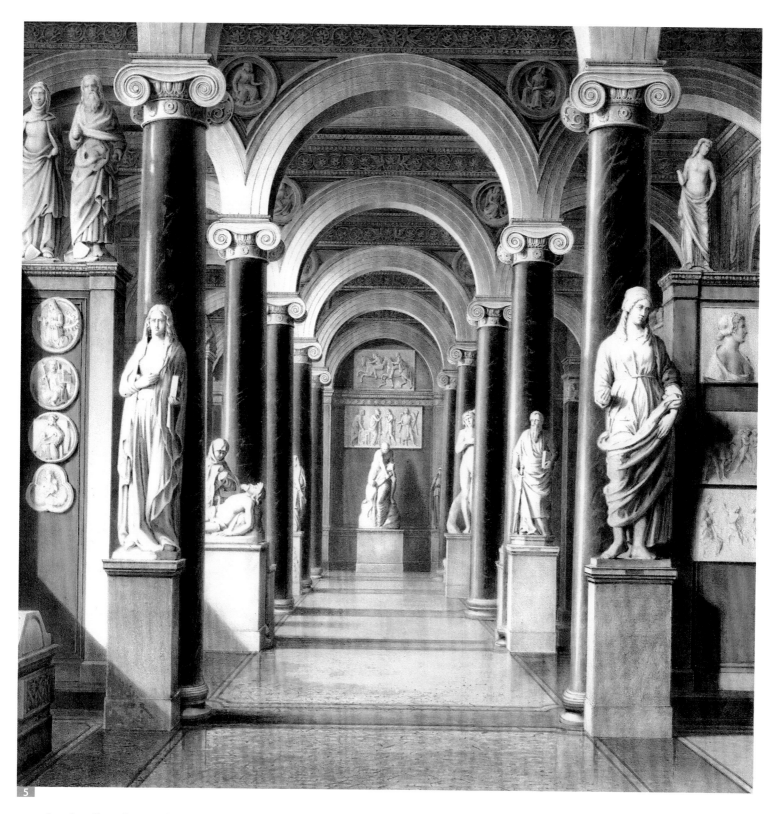

over decades. Seen from today's perspective, exhibiting "copies" seems incomprehensible, but in those days it was a matter of course. Similar to Goethe's times, which saw engraved reproductions of otherwise unavailable oil paintings as a means of making art widely known and of systematizing the history of art, the 19th century regarded plaster casts as valued substitutes for unattainable originals.

Therefore, if a museum wished to teach the history of sculpture, the only affordable way to do so was to exhibit three-dimensional reproductions made of gypsum instead of the originals.

The gypsoplasts shown on the main floor – many of which came from and had been used in the sculpture classes of the Academy of Arts – served the highest educational

5 Friedrich August Stüler, Das neue Museum in Berlin,
24 plates. Berlin, 1862, plate 23, showing the gallery for plaster
casts of modern sculptures in the Neues Museum

ideals. The particularly rich Niobidensaal still impresses today with its murals depicting scenes from Greek mythology and ancient heroes and with the inscriptions quoted at the beginning of this text. It was an ideal space for displaying the legendary group of Niobides that had been interpreted in different ways by different archaeologists. The colourful wall surfaces and frescoes formed a wonderful background, in front of which the pale-coloured gypsoplasts must have appeared to their best advantage, and the narrative gypsum figures in turn must have ideally corresponded with the narrative wall paintings. Both forms of art were united by the ancient myths which formed the focus of their common iconography.

The Römischer Saal (Roman Hall) was quite different. Here, the upper wall surfaces were painted with panoramas and views of buildings from classical antiquity, which actually represented imaginary architectural reconstructions reminiscent of 18th-century Capriccio traditions and also referred to 19th-century panorama paintings. The fact that a whole phalanx of architectural views was shown here, in a single gallery hall, also expressed the idea that it was possible to retrieve the lost greatness of classical architecture and urbanity. Unfortunately, for reasons of space, the reader must do without a description of the other galleries on this floor.

Similar to the first level, the third one was not conceived as a whole, but structurally subdivided into a northern and a southern section. This division did not serve to separate archaeological realms, but rather artistic media. The three southern wings around the Südhof (South Courtyard) were the domain of the Kunstkammer, whilst the northern wings accommodated the Kupferstichkabinett (print room) with drawings and prints which covered the whole of art history in a condensed form. The Kunstkammer suite with its historically inspiring works of art included a strange "break" in the form of the Star Hall in the southwest corner of the Neues Museum, a neo-gothic space with a structurally irrelevant rib-vault, which housed early ecclesiastical objects and interrupted the tour of the late neo-classical suite in a somewhat jarring way. This neogothic "implant" was both an unexpected culminating point and an irritation in the flow of the eclectic decoration and display programme. The Kupferstichkabinett (accommodated in the northern wings of the third gallery level) with its collection of prints and drawings appeared rather conventional by comparison, but amazed visitors with its modern design and the industrial character of the cast-iron columns.

Looking at the wealth of details, information, nuances and facets one comes to understand that the Neues Museum was committed to an ideal and idealistic notion of completeness and was designed to reflect a theoretical, idealized image of history as an "instructive historical narrative"[11]. Art and history were meant to elucidate and explain each other. The existing collections were meant to be supplemented and elucidated by gypsoplast reproductions and by wall paintings of historical events. Art could be experienced as documenting past periods of world history, as something that needed to be explained, and the wall paintings could be used to explain the many testimonies to the history of mankind. The fact that this decorative scheme appeared plausible only in the context of its time and during the first few years following the opening of the museum, did not deter the designers from decorating these rooms in this way – as documents of a very brief historic period and a reflection of history as it was conceived at the time. The wall paintings in these eighteen rooms formed a number of "cycles on historic topography, mythology and religion as well as historic subjects"[12]. They were preserved as the educational backdrop to the objects and now represent unique testimonies to the high ideals of their time regarding education and completeness.

Past and Present

What has been said thus far about the complexity of the interior decoration of a number of exhibition spaces also applies to the decoration of the Ägyptischer and the Griechischer Hof (Egyptian and Greek courtyards). The latter still possesses sufficiently "legible" fragments, high up on all four walls, of Hermann Schievelbein's frieze "The destruction of Pompeii" – another world-historical event to which we today owe unique treasures of antiquity excavated roughly 2000 years later. The frieze shows people fleeing from Pompeii, taking treasured objects with them and, at the very end of the frieze, being received by Stüler and Olfers. Thus the frieze leads into the present by showing that the architect and the museum director created a new home for the archaeological treasures.[13]

In his 1987 thesis, Hartmut Dorgerloh worked out that the architectural design of the Neues Museum reflects Hegel's division of world-historical periods into mythical, classical and romantic ages.[14] This means that the Neues Museum is not only a pattern book of architectural forms and new construction techniques,[15] or an encyclopedia of the history of mankind, but also a philosophical projection surface.

In conclusion, the museum was not really complete the moment it was fully opened, as the pictorial decorative programme continued to be implemented post festum. From around 1870, six marble busts were placed along the exterior colonnaded passage. They portrayed archaeologist Aloys Hirt (an important figure in the early development

of Berlin's museums even before Schinkel); art historians Franz Kugler, Carl Schnaase and Gustav Waagen (as representatives of art history practiced at university and in museums), as well as sculptors August Kiss and Friedrich Drake (who had created the east and west tympanon reliefs and had thus formulated the building's purpose and message). With the placement of these busts, the museum's iconography shifted from the history of mankind to the history of the institution called museum. In some ways, this was an innovation, which, however, had had predecessors in Schinkel's Altes Museum.[16] Thus the encyclopedic function of the Neues Museum was extended by another dimension, as the archaeologists and art historians themselves were historicised as agents of history.

Relevance and reception

The Neues Museum had a far-reaching influence on German intellectuals and intellectual history, which cannot be adequately described in the context of this essay. A few sketchy lines must suffice to give at least some idea of how the building was received.

On 18 September 1850, Dresden physician Carl Gustav Carus wrote to his friend Johann Gottlob Regis: "Returned from a brief excursion to Berlin a few days ago and must send you, dear friend, a few feathers from this flight [...]. Living and working for the surface – although this is frequently *magnifique* – is quite in the order of things, and it particularly annoyed me in the new museum, that in this respect, with all its splendour, it represents an enormous contrast to the British Museum."[17] First objections to the building were thus articulated as early as nine years before the museum was opened. However, Carus's reference to the British Museum is an indication of the standards it was expected to meet.

On 3 August 1865, shortly after Stüler's death, his fellow architect Johann Heinrich Strack (commissioned to complete the construction of the Nationalgalerie based on the designs Stüler had left) wrote a letter to the Prussian Minister of Culture, Education and Church Affairs, which shows to what degree the Neues Museum had by then become a normative reference point: "Many hundreds of artistic inventions are still required, if the building is to be of the same aesthetic and formal consistency as the new museum. Working out the details and supervising their implementation truly demands the full creative energy, love and devotion of an architect over several years. However, the invention of these many forms must, of course, be carried out, through and through, in the spirit of Stüler."[18] Protracted negotiations resulted in Strack receiving the commission as the architect responsible "for

looking after the aesthetic interests, as well as for the artistic ornamentation"[19] of the building. This also required appropriate sculptural decoration. A sculptor by the name of Wilhelm Engelhard sent Strack a photograph, which showed the model of a frieze he wished to create for the Nationalgalerie, and an explanatory printed (!) text about the subject, a Nordic heroic legend.[20] His proposal was rejected, but a few years later it came up for discussion again, in modified form, when in 1868 the model of Schievelbein's frieze "The Destruction of Pompeii" was acquired from the artist's estate for "architectural use".[21] This decision finally made Engelhard's proposal obsolete and at the same time tied closer bonds between the Neues Museum and the Nationalgalerie in terms of content.

The significance of the Neues Museum and its collections was probably never described more graphically than by Jacob Burckhardt, one of the most brilliant art historians ever who focused on the history of civilizations. In 1895 Burckhardt wrote to one of his students: "This city of Berlin possesses treasures which you do not find the like of anywhere in the world: in sculpture the Pergamums [...]. And in addition, in the Neues Museum, the casts of all the important sculptures from all over the world."[22] To what extent the collections – including the gypsoplast collection – led Burckhardt and his contemporaries to form an overall view and a complete-complex perception of history, remains to be analyzed. However, even now we can confirm without a doubt that in the final analysis the concept of universality – as articulated and practised with and at the Neues Museum – did indeed inspire a new, holistic view of world history and art history.

The fact that the galleries of medieval art in Alfred Messel's neo-classical Pergamon Museum were fitted with gothic vaults[23] may document the enormous influence which the ideas expressed by and in the Neues Museum continued to have up until the 20th century despite occasional criticism. Even Wilhelm von Bode (director general of Berlin's museums from 1905–1920 and a pioneering force in museum history) in creating his period rooms, drew on the fund of ideas and display models that had been developed based on those of the Neues Museum. He, too, relied on the effect of ensembles and spatial configurations, though he did not use instructive, illustrative wall paintings. In another way, the Neues Museum also influenced the New York Frick Collection, whose sunken, roofed-in interior courtyard is a reinterpretation of the Egyptian courtyard in Berlin. The story of the influence of the Neues Museum is yet to be written and would certainly be as full of highlights as the interior design by Friedrich August Stüler.

1 V Plagemann, Das deutsche Kunstmuseum 1790–1870, Munich, 1967.

2 "Academic Art Association in Berlin". See: H Dorgerloh, Museale
 Inszenierung und Bildprogramm im Neuen Museum. In: Zentralinstitut
 für Kunstgeschichte (ed.), Berlins Museen. Geschichte und Zukunft.
 Munich, 1994, pp. 79–86, here p. 85.

3 Brockhaus Konversations-Lexikon, 9th edition, vol. 10, Leipzig, 1846,
 p. 75.

4 E Heinecke, Studien zum Neuen Museum 1841–1860, dissertation
 (typescript), Berlin Technical University, 2007.

5 See for example the detailed descriptions in: W Wassermann, Voll-
 ständiger Führer durch die Königlichen Museen Berlins. Berlin, sine
 anno (published in various editions from 1860–1880).

6 R Petras, Die Bauten der Berliner Museumsinsel. Berlin, 1987, p. 62.

7 E Börsch-Supan and D Müller-Stüler, Friedrich August Stüler 1800–1865.
 Munich/Berlin, 1997, p. 70.

8 Ibid., p. 70.

9 M Wagner, Wohin mit der verlorenen Geschichte? Kaulbachs welt-
 geschichtlicher Bilderzyklus im Neuen Museum. In: Zentralinstitut
 für Kunstgeschichte (ed.), Berlins Museen. Geschichte und Zukunft.
 Munich, 1994, pp. 87–98.

10 Johann Christian August Heyse's Fremdwörterbuch. Leipzig, 1882,
 p. 230.

11 E van Wezel, Die Konzeptionen des Alten und Neuen Museums zu Berlin
 und das sich wandelnde historische Bewusstsein. In: Jahrbuch der Ber-
 liner Museen, vol. 43, 2001, supplement. Berlin, 2003, see in particular
 pp. 149–155.

12 H Dorgerloh, Museale Inszenierung und Bildprogramm im Neuen
 Museum. In: Berlins Museen. Geschichte und Gegenwart. Munich/
 Berlin, 1994, pp. 79–86, here p. 81.

13 Idem, Eine Schöpfung von grossem Reichthum poetischer Erfindung. Der
 Relieffries "Die Zerstörung Pompejis […]'. In: Forschungen und Berichte,
 vol. 31. Berlin, 1991, pp. 281–292.

14 Idem, Die museale Inszenierung der Kunstgeschichte. Das Bild- und
 Ausstattungsprogramm des Neuen Museums. Degree thesis (typescript),
 Humboldt University Berlin, 1987.

15 W Lorenz, Stülers Neues Museum. Inkunabel preußischer Konstruk-
 tionskunst im Zeichen der Industrialisierung. In: op.cit. in note 2,
 pp. 99–112.

16 B Maaz, J Trempler, Denkmalkultur zwischen Aufklärung, Romantik
 und Historismus. Die Skulpturen der Vorhalle im Alten Museum und
 im Säulengang vor dem Neuen Museum in Berlin. In: Zeitschrift des
 Deutschen Vereins für Kunstwissenschaft 56/57, Berlin, 2003, pp. 211–254,
 here in particular pp. 243–248.

17 Staatsbibliothek Preußischer Kulturbesitz, Berlin, Department of Manu-
 scripts, acc. Ms. 9796, no. 43.

18 Strack in a letter to Mühler, 3 August 1865; Geheimes Staatsarchiv
 Preußischer Kulturbesitz (GStA PK), I. HA, Rep. 76 Ve, Sekt. 15, Abt. III,
 no 16, vol. I, fol. 109.

19 Ibid, fol. 190.

20 Geheimes Staatsarchiv Preußischer Kulturbesitz (GStA PK), I. HA, Rep.
 76 Ve, Sekt. 15, Abt. III, no 16, vol. II, fol. 31f and 41f.

21 B Maaz, Nationalgalerie Berlin. Das XIX. Jahrhundert. Bestandskatalog
 der Skulpturen. Berlin, 2006, pp. 740–742.

22 F Kaphahn (ed.): Jacob Burckhardt, Briefe. Leipzig, sine annum [around
 1953], p. 556.

23 See for example B Petras, op.cit. 1987, p. 148.

The Neues Museum from Destruction to Reconstruction 1945–89

GISELA HOLAN | GÜNTER SCHADE

When the Neues Museum is solemnly re-opened on 16 October 2009, seven decades will have passed in which the museum was unable to fulfil its function as a location for education and research, as a place for preserving important and unique treasures of the cultural heritage since it was closed at the beginning of the Second World War in 1939. In 1943 and 1945, several direct hits by bombs destroyed a considerable proportion of the building's elaborate décor, including the architecturally significant staircase, rising through all floors with its six large-format frescoes by the Munich painter Wilhelm von Kaulbach on central themes from world history. This did not mean only the irretrievable loss of the centre, the actual heart of the museum. Other exhibition areas, such as the Südlicher Kuppelsaal, the Ägyptischer Hof and the large exhibition galleries in the north-west quadrant fell victim to the war, along with their picture-related design concept.

The other buildings on the Museum Island also suffered considerable damage; the Altes Museum by the Lustgarten burnt down to its foundations on the last day of fighting. It then took about twenty years for the Nationalgalerie, the Pergamon Museum, the former Kaiser Friedrich-Museum (Bode-Museum) and the Altes Museum to be repaired and to open to the public once again. The Neues Museum was then intended to be the last major reconstruction measure.[1]

The last and most elaborate reconstruction measure

This was constantly postponed, necessarily and for entirely practical reasons, because it was to turn out to be the most complex and expensive task in comparison with all the others. One problem was the building's lack of structural stability due to the ground it is built on – over an ice-age marsh bubble up to 32 metres deep that had made laying secure foundations impossible at the time of construction – and the bombing had weakened it further. A second and no less intractable problem was the matter of how to deal with the museum's artistic décor, which showed different levels of damage from total loss to almost complete survival.

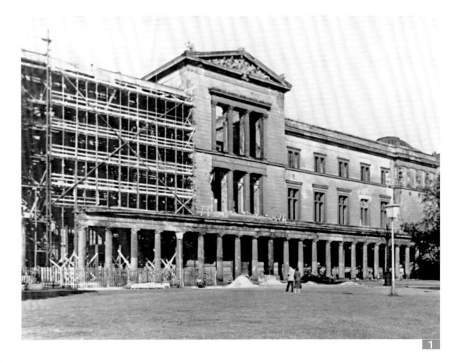

But this décor was considered to be a key element of the museum idea realized in this building by the architect Friedrich August Stüler, which could be restored on sound monument conservation principles only at extraordinary expense.

The museums at no time questioned that the building must be rebuilt; on the contrary, strenuous efforts were made to secure the ruin. In fact, work on clearing the Neues Museum site was among the first tasks to be undertaken from 1946.[2]

Later, suites of rooms on the first and ground floors that had come through the war inferno relatively unscathed were made safe with a temporary roof, windows were blocked off in a makeshift fashion and the heating was repaired. The Egyptian Collection was able to move its inventory that had been in storage to the ground floor, and the building management team moved into offices on the floor above, which were reached by a temporary wooden staircase. At this time, it was not unusual for museums to

1 Neues Museum: east side with colonnades and repair of the window frames, around 1962. *Unknown photographer.*
Source: Zentralarchiv der Staatlichen Museen zu Berlin (ZA)

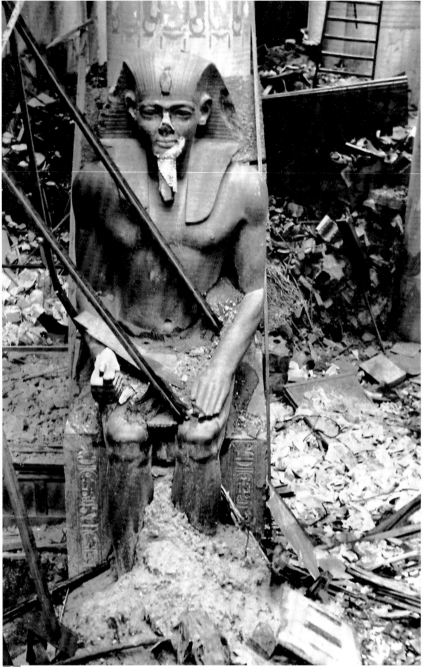

for rebuilding the devastated south-east dome, which was done as early as 1959.[3] Extensive repair work followed, for example in 1960/61 completion of destroyed sandstone frames and cornices at the south end of the east side. In 1965, in close co-operation with the Technische Universität in Dresden, a constructional design concept was devised on the basis of a room allocation plan, and this foresaw completion of the building in 1968.

In the midst of this, the museums kept in mind a general concept for completing all the Museum Island buildings, as invoked by every building plan from Friedrich August Stüler's 1841 "first master plan" onwards. There is evidence of this in the 1965 planning concepts, or in the "long-term plan" submitted by the Staatliche Museen in preparation for the 1971–1975 five-year plan. According to this, entirely in the spirit of the Museum Island master plan adopted as the basis for further planning in 1999, a general concept was to be developed that made it possible to accommodate function and service facilities sensibly, as well as to extend exhibition and storage areas, and also allow public and internal access for all the buildings.

Apart from the rebuilding of the Neues Museum a central entrance building was planned, intended to connect the Neues and the Altes Museum, the Pergamon Museum and the Alte Nationalgalerie. The destroyed access routes linking the Altes and the Neues Museum, the Pergamon Museum and the Bode-Museum were to be restored. A new transverse wing was planned between the ends of the Pergamon Museum's two wings, and a new building on the Kupfergraben was to accommodate the restoration workshops and a café.[4]

The Museum Island as seen by "High Politics"

Even though the Staatliche Museen did not succeed in having the rebuilding of the Neues Museum included in the next two five-year plans for 1966–70 or 1971–75, they continued to work hard on their conceptual preparatory work. So, in 1974 and 1975, parallel to the planning work on redesigning the entrance area of the Pergamon Museum, the collections intended to be accommodated in the Neues Museum were asked to submit precise ideas for new exhibition presentations. Commissions were also issued at this time for structural surveys and plans for rebuilding the Neues Museum, dealing with matters such as the subsoil and ways in which it could be stabilized, and also variant studies for future uses and for the necessary mechanical service provision. It was still assumed that building would begin in 1979 at this point, while in May 1976 the minister of culture gave the director general notice of a start on building in 1980.[5]

housed and to work in the half-ruined buildings on the Museum Island and in the town – until rebuilding work started the Altes Museum, for example, provided space for the general administration of the Staatliche Museen zu Berlin (SMB) in the basement rooms that had escaped the fire.

General concept for completing the Museum Island buildings

The fist planning and projection work was commissioned in the 1950s and 1960s: a report on the current state of affairs in 1956 and in 1958 design and planning permission

2 The Egyptian Courtyard, completely destroyed, 1949. *Photo: Kümpfel/ADN-Zentralbild. Source: ZA*

The museum directorate intervened at the culture ministry and a note about the agreements that had not been honoured, fraught with despair and discontent, was submitted to the Central Committee of the SED by the administrative director – an unusual and courageous step for a leading employee under the circumstances of the day. The answer was that the housing construction programme passed at the VIIIth SED Party Congress in 1973 and intended to eliminate the GDR's housing shortage by 1990 had absolute priority over any other building work. But then the museums were given unexpected support in their almost hopeless situation by the resolution "On the development of the capital of the GDR" passed in February 1976. As well as this, the Museum Island was a destination for large numbers of foreign tourists and a showpiece for foreigners on state visits to the GDR, and thus attracted the attention of "High Politics".[6]

A phase of intensive planning

Of course, the ruin of the Neues Museum, immediately adjacent to the Pergamon Museum and in full view of all museum visitors, was not a positive advertisement for the way the GDR handled its cultural heritage. For this reason the Staatliche Museen were commissioned in the context of the above-mentioned resolution to prepare for rebuilding, with a view to financing and securing the necessary building capacities in the 1981–1985 five-year plan.

This saw the beginning of an intensive planning phase for all concerned. As early as January of the same year the Institute of Monument Conservation had submitted a set of "Terms of Reference for Monument Conservation" for rebuilding the Neues Museum. It fixed retaining and restoring the façades as a basic requirement, and also reconstructing Stüler's staircase and the galleries that had survived largely intact in their original form. But the exhibition galleries that had been completely destroyed were to be restored as structures only, without any attempt to reconstruct the lost artistic design and furnishings.[7]

Priority for the requirements of modern museum practice

In addition to these conservation demands the director of the Egyptian Museum submitted a study in May 1978 on how to use the Neues Museum.[8] Apart from the Egyptian Museum, which had always been housed here, the Eastern Asian Collection and the Museum of Pre- and Early History, which were still in temporary accommodation in the Bode-Museum, were also to have their new home here. This use concept expressly emphasized that the reconstruction was to prioritize modern museum practice requirements over the monument conservation aspects. This demand was important because in the past it had been Stüler's interior design and artistic décor for the Neues Museum that had particularly hindered constantly changing exhibition presentation, which had led to costly re-arrangements and aesthetic contradictions in the exhibitions.[9]

The year 1980, which was now set for the start of building, was especially important for the Staatliche Museen, as it coincided with the 150th anniversary of the foundation of the Königliche Museen. The Staatliche Museen could not have asked for a finer anniversary present, after all their efforts and setbacks. But the time available was too short in terms of planning concepts for the content as well as for the constructional details, as extensive building work for getting the Pergamon Museum into shape had to be tackled and paid for at the same time. The floods of visitors to the Pergamon Museum in the 1970s – triggered by the world-famous works of ancient art – urgently required improvement of the museum's inadequate entrance situation, and also new service facilities such as cash desks, cloakrooms, toilets and rooms for visitor education services. So between 1977 and 1982 a new bridge over the Kupfergraben was built, and an entrance hall for access to the exhibitions in the three collections housed in the Pergamon Museum. The courtyard was also adapted at great expense to match the new entrance situation structurally and architecturally.[10]

In 1979, the ministry of culture decided to concentrate its expenditure on all cultural matters for 1981–85 (about 8 million marks) on the Museum Island. But increased costs and building period extensions for the new Pergamon Museum entrance area, which opened on 8 October 1982, in their turn forced a re-allocation of the funds to the disadvantage of the Neues Museum.[11]

A new contents concept for the Neues Museum and the entire Museum Island

However unfortunate the resulting further postponement of building work on the Neues Museum was, it did gain time for concretizing the planning of content, monument conservation and structural aspects. The Staatliche Museen were additionally commissioned at this time to analyse the structural condition of the entire Museum Island and its buildings comprehensively. It had been acknowledged that rebuilding the Neues Museum would not suffice on its own. Through lack of investment the entire building fabric and infrastructure of the Museum Island had deteriorated to such an extent from year to year that something fundamental had to happen here.

above all for roofs and façades – mean they are increasingly falling into disrepair from year to year, and partial collapses cannot be ruled out."[13] After the ministry of culture as the immediately superior office of state for the Staatliche Museen had accepted the submission in principle, it now also demanded a new content concept for the entire Museum Island, in order to promote overall planning for general reconstruction.

After the war, the individual museums on the island had considerably changed their original character as a result of major reductions in their holdings and because homeless collections had been housed in them – such as the Eastern Asian Collection, the Museum of Pre- and Early History, the Antiquities Collection's Sculptures, the Kupferstichkabinett (print room) and the Arts and Crafts Museum. The general reconstruction offered an opportunity to think for the first time since the war about how the content profiles of the Pergamon Museum, the Bode-Museum and the Neues Museum could be revised. Intensive work went into this new overall concept from the second half of 1983 onwards. A first draft about shaping the content of the Museum Island and the Neues Museum was put to the conference of directors for discussion in early May 1984.[14]

Distinctly different ideas were developed for the Neues Museum, in particular in comparison with the 1978 and 1982 concepts. They were based on the principle that the ancient cultures and the archaeological collections should be interlinked as much as possible in the Pergamon Museum and the Neues Museum, to be displayed to visitors as a coherent field in terms of the history and development of culture. The new overall concept said on this topic: "With the Pergamon Museum, the Neues Museum represents the totality of the archaeological exhibition areas." As before the Egyptian collection continued to be at the heart of the displays. Since 1950 it had been temporarily housed in the empty sculpture collection galleries in the Bode-Museum.

An overall panorama of ancient cultural history

Given the severe depletion of the Egyptian museum collections – caused by their division into East and West, war losses and the removal of some parts to the Soviet Union ("looted art") – the Neues Museum still had sufficient space to allow the Mediterranean and European pre- and early historical collections from the Museum of Pre- and Early History, the cultures of ancient oriental society and the ancient slave societies of the Nile valley, along with the culture and art of the provinces of the Roman Empire – also linked with sculptures and building monuments from the antiquities collection and the Isla-

Construction planning intensified in this respect as well, above all in terms of the basis required for a resolution by the party leadership and the government on the "general reconstruction of the Museum Island and the rebuilding of the Neues Museum". It was only on the basis of resolutions of this kind that funds and capacities could be factored into state economic planning. What was needed were "basic fund analysis and basic funding concepts" (analysis of current state of the building stock and a construction budget) for the entire Museum Island, the general reconstruction of the Neues Museum and the Bode-Museum. The design for a new functions building was also submitted in 1982. These planning documents were rounded off with a revised contents concept for the Neues Museum.[12]

The difference from the 1978 plans was that this new museum concept proposed – on historical grounds alone – bringing the Kupferstichkabinett back to the second floor of the Neues Museum, as in the original design. But this would have made the Neues Museum into a building without a content profile of its own, a structural envelope in which four quite different collections would have shared the already very limited space.

The overall concept for the Museum Island ran to four volumes and was submitted to the minister of culture in January 1983. Its statement about the structural condition, in particular of the Neues Museum, contained the unsparing formulation that "[…] the degree of damage and the unduly low maintenance costs of recent decades –

3 Neues Museum, west side – southern part and central projection, 1988. An emergency roof was added, the façade windows were bricked up and work was started on restoring the embankment wall. *Unknown photographer. Source: ZA*

mic section in the Pergamon Museum – to fuse together on the Museum Island as an overall panorama of ancient culture. But this meant that the Kupferstichkabinett and the Eastern Asian Collection could no longer be placed in this building. In this way, this new concept for the archaeological collections, built on a modern academic foundation, became part of the required political and state resolutions of December 1985 on "Reconstruction of the Museum Island and Rebuilding of the Neues Museum".[15]

This represented a successful conclusion to twenty years of intensive effort. In April 1986, the ministry of culture confirmed to the museums that an investment sum of 51.5 million marks would be made available to the year 1990. The cost of rebuilding the Neues Museum was estimated at a total of 350 million marks, while the redevelopment of the entire Museum Island was distributed over a period of twenty years, at a total figure of 1.5 billion marks.[16]

In order to achieve the greatest possible independence from state-planned building capacity allocations, a separate site management team was set up on the Museum Island with appropriate competencies in the spheres of engineering and planning, along with a pool of skilled craftsmen.[17] This meant that important prerequisites were in place for the start of building work on the Neues Museum. The first step was to carry out important safety measures: in terms of sections that were threatening to collapse this meant either dismantling and appropriate storage for reassembly later on or in-situ stabilization measures. This applied in particular to the west wall of the staircase hall with its gable decorated with statues; it had been wrenched out of its anchorage with the side retaining walls, was on poor foundations, and leaning precariously.

Extensive safety measures and agreements

Elaborate consultancy procedures and agreements with the monument conservation authorities established which parts of the museum no longer seemed suitable for rebuilding (for example, remains of the south dome and the colonnaded Egyptian Courtyard), and which of the structural and decorative elements that were still in existence could be reused. These were removed, secured, stored and documented. This also applied to the colonnade running along the museum. A plot of land was acquired in the suburb of Hohenschönhausen and a hall was built on it to accommodate and later restore the structural and decorative elements that were to be put back in place.

Ensuring the stability of the building was the most difficult task from the outset. An examination of the foundations showed that all the upper parts of the timber pile foundations had rotted so badly as a result of lowered

groundwater levels in central Berlin that they could no longer support the building reliably. The museums took note of, but did not subscribe to, the opinion expressed by some eminent individuals on the construction side at that time, and after the fall of the Wall on the financial side, that it would be cheaper to pull down the ruined museum and rebuild it on secure foundations than to restore it. Instead, both the museums and the conservation authorities always agreed to keep the surviving building stock and accordingly to carry out appropriate measures to repair the foundations.

Then a solution was also found for this in joint work by the museum's structural engineers in the construction department, the GDR Building Academy, the Bauhochschule in Leipzig and the Technische Hochschule in Karlsruhe. They developed micropile foundations tailored to meet the problems at the Neues Museum. This involved installing 2,500 steel-clad concrete piles outside and inside the old foundations, reaching right down to the load-bearing layers of earth below the marsh bubble, which itself is up to 32 metres deep. Stainless steel inserts were subsequently taken through the old foundations and connected to the micropiles, and these now supported the building's load, together with the piles linked by a reinforced concrete anchor. Thus the old foundations had lost their function.

"Laying the foundation stone" for the start of rebuilding

Getting hold of the machines, equipment and materials for this complicated work was exceptionally difficult given the GDR's command economy and shortage of materials, but it was ultimately achieved thanks to great commitment by the employees and institutions involved in rebuilding the Neues Museum. The financial and material difficulties that were becoming increasingly marked at this time also put the funding promised for rebuilding at risk. For this reason, rebuilding the Neues Museum was no longer to be mentioned in public, just "putting the prerequisites in place and securing the ruin". Ultimately it was said that the government could not expect the public to accept deficiencies in the supply of everyday consumer goods and at the same time invest a great deal of money and construction capacity in reconstructing the Museum Island and the Neues Museum.

Despite all this, on 1 September 1989 in the presence of the minister of culture the first pile for the museum's substitute foundations was driven into the ground in the excavation pit for the north-west wing, which was to be rebuilt. This act on this highly symbolic day – the fiftieth anniversary of the outbreak of the Second World War –

was then demonstratively celebrated as a "laying of the foundation stone" for the start of the rebuilding process. This was intended above all to show those powers in the politburo of the SED and in the government that there must be no going back on the Museum Island.

The rebuilding process as a task for the whole of Germany

At this time no one suspected that the end of the GDR and with it reunification – including reunification of the divided museums – was at hand. This made rebuilding the Neues Museum and completing the Museum Island a task for the whole of Germany. Bringing together collections that had been separated for decades required not only new thoughts about the structure of the reunited Staatliche Museen, but also for each individual museum. So the concept developed by the GDR archaeologists for the Neues Museum had to be rethought to work properly with the newly reunited collection holdings, but also with the academic ideas of all the archaeologists. Carefully and seriously conducted discussions by an archaeological working party in which non-ideologically motivated opinions from East and West collided wrestled to find an academic concept for the archaeological collections on the Museum Island that was suitable for the future. In the process of this it emerged that the concept developed as early as 1984 on the Museum Island and passed in 1986 for presenting all archaeological spheres across the thematic board, including the contents policy for the Neues Museum resulting from this, was also valid as a basis and guideline for a new concept, and could be developed further.

Continuing building work at the Neues Museum was first tested against the Federal German planning and building laws, and against the differing views on monument conservation in the former GDR and the Federal Republic. The competition announced in 1993 for "reconstructing the Neues Museum and building additional and connecting structures to bring together the Archaeological Collections of the Staatliche Museen zu Berlin" was seen as a new starting point for completing the Museum Island and reorganizing it with reference to the desiderata in terms of content, function and structure already laid down in a memorandum by Wilhelm von Bode (1907).

But neither the jury's decision nor the continued cooperation with the winner of the first prize up to 1996 produced the desired result. In May 1997 a further revision process with the two favourites was launched as the result of a consultancy procedure with the first five prize-winners, clearly restricting the competition brief to rebuilding the Neues Museum. This finally concluded in November 1997 with a vote by the advisory board and in December 1997 with a decision by the SPK foundation council in favour of David Chipperfield's design. Building on the reconstruction project then actually started in June 2003.

A new architectural and conservation concept

But this delay in work that had already begun was used sensibly in many respects. A new concept was developed in terms of architecture and monument conservation. Instead of the extensive reconstruction of the museum, as planned at the time, it proposed a "complementary restoration", which has retained all the existing original fabric of the building and restored it responsibly. The new additions replacing lost parts of the museum building have been designed freely on the basis of the building's typology.

The story of rebuilding the Neues Museum has become a pan-German story, growing gradually from the story of post-war Germany: from 1946 to the late 1950s the building was rescued from terminal decline, from the 1960s to 1989 the GDR prepared and embarked upon rebuilding, and finally this was continued and completed in a reunited Germany from 1990 to 2009. This means that the Neues Museum has become a major cultural symbol of a united political Germany.

4 Laying the foundation stone for rebuilding with the GDR minister of culture, Hans-Joachim Hoffmann, also the deputy director general of the SMB (East), Gisela Holan, on 1 September 1989 in the Egyptian Courtyard. *Photo: Breitenborn. Source: ZA*

1 G. Schade, Bemerkungen zu Geschichte und Problemen beim Wieder-
 aufbau des Neuen Museums. In: Jahrbuch Preußischer Kulturbesitz,
 vol. XXVII, 1990, p. 169, ill. 3

2 8.000 RM were invested in removing rubble from the Neues Museum
 and making the building safe from 1946–1949. Cf. VA 3631, Akten der
 Generalverwaltung 1950, SMB central archive

3 The Hoch II design office of Greater Berlin, in other words a municipal
 department, was commissioned to do this work. Cf. Akten der General-
 verwaltung VA 5863, 5860, 5865, 36661, ibid.

4 The conservator general, in discussion with the museums about
 these plans, suggested involving diploma students from the building
 theory and design department at the Technische Universität Dresden.
 See draft letter by Seiler, the SMB's site manager, dated 15 March 1965,
 VA 3660, ibid.

5 Cf. VA 1148, Akten des Generaldirektors 1974–1979, VA 6479, Invest-
 vorhaben Museumsinsel, ibid.

6 In July 1976 Erich Honecker, as chairman of the GDR State Council,
 accompanied Indian Prime Minister Indira Gandhi on her visit to the
 Pergamon Museum.

7 In: Denkmalpflegerische Aufgabenstellung zum Wiederaufbau des
 Neuen Museums, submitted by P. Goralczyk, chief conservator at the
 Institut für Denkmalpflege, Berlin office, January 1976

8 W. Müller, Allgemeine Aufgabenstellung zum Wiederaufbau des Neuen
 Museums. As of 12 May 1978. In: Akten der Generaldirektion, SMB
 central archive

9 In: A. Erman, Mein Werden und Wirken – Erinnerungen eines alten
 Berliner Gelehrten, Leipzig 1929, p. 129 ff.

10 E. Bartke / P. Gohlke, Neue Eingangslösung für das Pergamonmuseum in
 Berlin. In: Architektur der DDR, vol. XXXII, April 1983

11 VA 1148, Akten der Generaldirektion 1974–1979, SMB central archive

12 E. Bartke / E. Hühns / W. Müller, Ergänzungen zur denkmalpflegerischen
 Zielstellung des Neuen Museums, January 1982. In: Akten der General-
 direktion, ibid.

13 In: Bestandsanalyse 1982/IV, Mappe I, p. 11, VA 5261, ibid.

14 Draft paper on the general reconstruction of the Berlin Museum Island,
 May 1984. SMB/ZA, Akten der Generaldirektion, ibid.

15 The corresponding resolution by the GDR Council of Ministers followed,
 in the same month, the resolution by the SED politburo for the general
 reconstruction of the Museum Island and rebuilding the Neues Museum
 drawn up in December 1985.

16 Cf. confirmation certificate to the "Maßnahmen zur generellen In-
 standsetzung und Restaurierung des Komplexes Museumsinsel Berlin
 einschließlich des Wiederaufbaus des Neuen Museums". Akten der
 Generaldirektion, ibid.

17 Consultation paper 51/1986 for the minister on 28 April 1986 on "Anwei-
 sung über die Bildung und Arbeitsweise der Aufbauleitung bei den
 Staatlichen Museen". Akten der Generaldirektion, ibid.

"Core Form and Artistic Form" – The Art of Construction in Prussia under the Influence of Industrialization

WERNER LORENZ

The construction of Stüler's museum began a mere seventeen years after that of Schinkel's museum – reason enough simply to name the former the "New Museum". However, regarding the methods used to erect the two, more than seventeen years appear to have elapsed between both construction periods. Whilst Schinkel relied on the classical fund of solid and timber construction for his

structures and thus stood in the engineering tradition of the 18th century, Stüler extended this structural repertoire with new, industrial construction techniques that are now inseparably associated with the 19th century. In the amazingly short time from 1843–45 and in the course of the first great wave of Prussia's industrialization, he erected a building with a novel type of structure that soon became an *incunabulum* of innovative Prussian architecture and engineering, which used the new materials available in the early days of industrialization. The new understanding of the term "construction" included all its levels of meaning – the process, the product and the architectural and artistic interpretation.

Construction as a process

Let us first address construction in the sense of constructing, i.e. designing, dimensioning and building: How was this monumental building with dimensions larger than any other earlier building in Berlin actually constructed? How was it designed on paper, detailed in the foundry and anchored in the marshy soil of the island in the river Spree?

The novelty of the construction started with the way the site was prepared. For the first time in the Berlin area, a train on iron rails was built for transporting the construction materials from the Kupfergraben and distributing them on the site. Later, a 120-feet wooden hoist tower was built at the site of the not-yet erected main staircase. The hoist lifted the materials in purpose-built wagons to the gradually rising construction levels where again they were distributed on rails. This made reloading of the materials unnecessary.

The hoist was powered by a Borsig 5-h.p. steam engine, which beat the pulse of the entire construction site. It also powered the pumps for draining the foundation pit and later the large mortar mixer. Its main advantage was, however, that in driving the 2,344 (!) foundation piles into the soil, it replaced manual power by steam-engine power. This was an extremely important innovation, as

1 Details of the railway on the construction site of the Neues Museum: rail profiles, turntables and tip wagons. Illustration of an article by site manager Carl Wilhelm Hoffmann, 1842. *From: Notiz-Blatt des Architekten-Vereins zu Berlin, 1842*

the unstable ground in Berlin's central urban area often left no other option open than pile foundations, and driving them down manually with traditional bell-rope hands was really hard work.

Other remarkable and significant changes in the construction process included the extensive use of iron structural elements, which became typical of the late 19th century and shifted considerable parts of production from the building site to the factory. On-site building was increasingly reduced to assembling kits of parts that had been prefabricated in the Berlin factory of August Borsig, the "king of locomotives". How unusual this still was at the time is underlined by the fact that Stüler and his site managers altered the initial dimensions of a number of structural members later on in the planning process, unifying them – an indication that they must have only realized the potential of prefabrication at the detailing stage. Thus, instead of changing the dimensions of the bowstring girders for different levels, depending on the loads the girders would have to support (as originally planned), they opted for serially produced standardized girders. These had obvious advantages: the required number of girders was cast in identical moulds based on a single model, and joining pieces and fasteners were produced to standard designs. Standardizing structural parts took into account the fact that industrialization was changing production processes – a development which at that time was already fully implemented in Borsig's mass production of entire locomotives.

Stüler's comprehensive "innovation package" considerably speeded up the construction process. Whilst the building shell of the Altes Museum had taken almost two

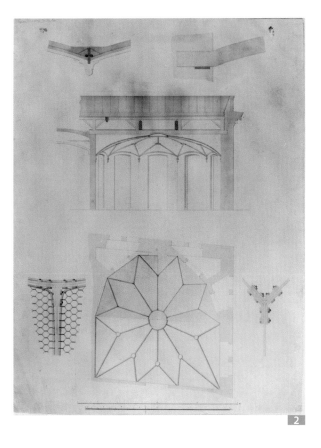

years to complete from the foundations upwards, that of the Neues Museum was built in less than a year. However, there are a number of "desperate letters" in the project files about Borsig's temporary delivery difficulties, which show how absolutely dependent the progress of construction was on industrial prefabrication of the iron parts. The successful logistic organization of the construction process and the effective use of new construction methods there-

2 Iron framework of the wire lathing and plaster vault in the Sternensaal, with details. Final drawing, pen and ink, water-colours, around 1843. *Source of photos 2–5: Zentralarchiv der Staatlichen Museen zu Berlin*

3 Iron framework of the glazed roof above the Ägyptischer Hof, with details. Final drawing, pen and ink, watercolours, around 1845

4

5

produced by Borsig and essential for the stability of the bowstring girders was tested at the plant in a hydraulic press for its load-bearing capacity before it was delivered. This is indicative of the strictly organized quality control system applied here, an innovation which is generally regarded as having constituted a characteristic novelty of the later, 1851, London Crystal Palace.

Although the bearing structure as the product of construction has not been described in detail thus far, it will already have become clear that, due to the new techniques used to develop and erect the building, the Neues Museum became an early example – unique in Berlin – of a new understanding of construction processes closely linked to industrialization.

Construction as a product

Despite its appearance, the building had hardly anything in common with a conventional solid construction, as it contained the most diverse cast or wrought iron structural components throughout. In terms of construction typology, many of these were new in and around Berlin, some even in Europe. After World War II a number of these technical novelties had to be counted as irretrievably lost.

The losses included, for example, the extremely lightweight star vault of the Sternensaal, or Gotischer Saal (Star/Gothic Hall). Simple flat irons were bolt-jointed using L-irons (later a typical solution in steel construction) to form a filigree web of ribs. Here the gothic vault caps consisted of plastered wire-mesh – at the time a technical novelty in Prussia, which Leo von Klenze had already used in 1840 in a coarser form for the coffered ceilings of the Walhalla near Regensburg, Bavaria. The war losses also included the filigree glass-and-iron roof, for which Borsig had supplied the iron members and which spanned the 380-square-metre column-free area of the Egyptian Courtyard. This weather-protected, yet light-flooded atrium, later a typical feature of department stores, was the first of its kind in Berlin. The tightly staggered, purlin-free suspension trusses with their unusual details were inspired by roofs of British railway stations and factories. This means Stüler covered the Egyptian Courtyard with a modern "factory roof".

Looking at the surviving iron structures, one is at first surprised about the use – apparently as a matter of course – of cast-iron beams not only for capped vaults, but also for coffered ceilings. This seems to suggest that by 1840 these had already been in use locally for some time. However, the contrary is true: cast-iron beams in connection with masonry caps were a British invention that had rarely been seen in Prussia before that time. Known as "Prussian capped ceilings" they became widely used only

fore represent some of Stüler's and his site managers' greatest achievements in erecting this huge building.

Apart from the construction process proper, the 19th-century planning process also differed substantially from earlier conventions. In this context, it suffices to mention the hesitant introduction of scientifically founded new dimensioning methods – an early form of structural analysis – or the higher degree of precision required in drafting the final construction plans. Another highly unusual novelty is worth mentioning here: the "manufacturing ritual" in which every single wrought-iron tie rod

4 Iron framework for the domed ceilings with spherical segments in the Majolikasaal. Final drawing, pen and ink, watercolours, around 1843

5 "Bowstring girders" for the Mythologischer Saal (Mythological Hall), with details. Unimplemented construction design, pen and ink, watercolours, around 1842

later for the roofs of factories and warehouses in Berlin. The material of the caps was also unparalleled in Berlin at the time. In order to reduce their weight and thrust, Stüler used hollow clay cylinders instead of the traditional bricks, and thus introduced a construction method that in the early 19th century had first been used in Parisian residential buildings and then in English factory construction. Yet Stüler's main source of inspiration was probably the reconstruction (started in 1838) of the Winter Palace in Saint Petersburg, where for the impressive ceilings this type of hollow clay cylinders had been used extensively.

In parts some structures of another type survived the war, i.e. the cast-iron structural framework of slender columns, beams and/or arched girders. These "frames" were installed throughout the two Kunstkammer galleries and the Majolikasaal (Majolica Hall) on the top floor of the south wing. Here again, the caps of the vaulted ceilings were built of hollow clay cylinders. This structural system created a group of seemingly floating spaces without parallel in the city of Berlin and beyond. Just a few years later, Henri Labrouste chose the same column-and-beam framing, only larger, in his two legendary library buildings in Paris, the Bibliothèque Sainte-Geneviève (1838–50), which contains barrel-vaults like the ones in Stüler's Kunstkammer galleries, and the Bibliothèque Nationale (1858–68) with its orthogonal web of transverse arches and sail vaults as in Stüler's Majolica Hall.

Of all the surviving load-bearing members, the wide-span girders in almost every gallery of the northeast wing are probably the most impressive. They are found in the Niobidensaal, the Roter and the Mythologischer Saal (Niobides, Red, Mythological Halls). In the latter, however, Stüler hid them from view by enclosing them with masonry (in the form of architraves). Each one of these "bowstring girders" actually consists of one cast-iron and two wrought-iron tie rods, which made it possible to span building depths of a good 10 metres column-free without horizontal shear acting on the outer walls. If we are to believe Stüler's de luxe Neues Museum monograph of 1862, each of the tie rods, or "strings" – which absorb shear forces and are thus essential for the building's stability – was forged at the Borsig factory of seven English top-quality round iron rods, then rolled out until it had a diameter of 2 1/3 inches and finally put through the above-mentioned stability test.

The bowstring girders are an impressive example of the high technical standards achieved throughout the Neues Museum, right down to every structural detail. The intricate compound structure of cast and wrought iron with every component dimensioned to withstand the respective stress or tension, may justly be regarded as

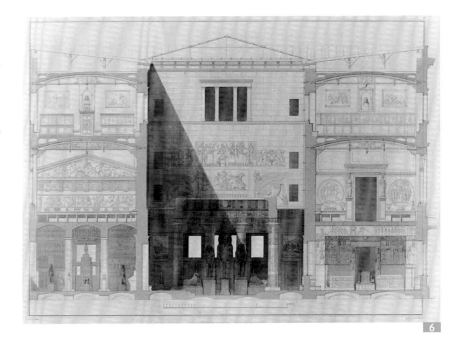

high-tech, even compared with international examples. The Bibliothèque Sainte-Geneviève, built at the same time, may here again serve as a comparison to illustrate the high standard of Stüler's building. For its iron roof structure, Labrouste still used simple inserted joints secured by tenons and wedges – following traditional timber construction. In Berlin, however, huge iron tightening screws like the ones used in mechanical engineering facilitated the precision-tensioning of the "strings". This is why the bowstring girders of the Neues Museum are outstanding examples of an "art of construction" in a period of transition that already knew how to build very complex structures, using cast and wrought iron parts even before standardized profiles and details finally paved the way for 20th-century steel structures.

The significance of the new overall structural quality of the museum building beyond individual aspects becomes clear if one looks at the existing site conditions and the main functional programme of this huge building, i.e.:
- minimum structural self weights in view of the difficult subsoil conditions;
- light-weight walls which in view of the different degrees of ground subsidence had to be interconnected tension-proof and, due to the small number of transversal steel girders, needed to be joggled with the ceilings;
- ceilings with wide spans, as light as possible, fire-proof, free of horizontal shear, and of low structural heights in order to accommodate three adequate gallery storeys in a building not higher than the neighbouring Altes Museum;
- and finally, the shortest possible construction period for the structural shell.

6 Cross section of north wing around the Ägyptischer Hof, 1853/1862, plate 6, "cross section of the neues Museum Berlin, 1862". *From: Friedrich August Stüler, Das neue Museum in Berlin, 1862*

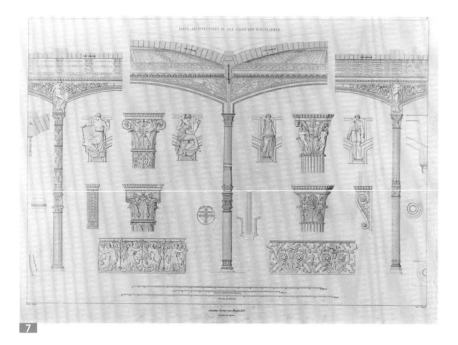

Carl W B Boetticher and refers observers to neoclassical traditions influenced by Johann Joachim Winckelmann and Karl Friedrich Schinkel.

In analyzing the results of his systematic study of classical architecture, Winckelmann – the pillar of 18th century German classicism – distinguished clearly between "the essential" (das Wesentliche) and "delicateness" (Zierlichkeit) in architecture. With the category of "the essential", he introduced structure as the determining parameter into architectural theory, whilst with his "delicateness" he defined the theoretical foundations for cladding structural elements. In doing so, he also formulated two paradigms for Stüler's design, i.e. the dependence of architecture on structural design, and the clear division between structural core and decorative cladding.

Yet the architectural language Stüler developed with iron as a construction material is not really rooted in Winckelmann's theory, but in Schinkel's, who introduced two new aspects into this debate. First, he specified the category of "the essential" more precisely, stating that the specific qualities of the materials formed the basis for every type of construction. Yet in thus relating architectural design to the nature of the materials used, Schinkel raised the basic question about the nature of all future iron architectures: "requires new forms ...," he noted (somewhat at a loss) in the drafts for the architectural textbook he planned to publish. Second, Schinkel named the central problem arising from the inevitable confrontation between neo-classical formal ideas and the potential "delicateness" of iron structures, i.e. the problem of mass, or rather the lack of it. "For all their stability, the metal constructions are too light ...," wrote Schinkel, thus also defining the limits of their functionality, which he himself had propagated through his treatment of iron.

The fear of losing mass (Julius Posener) was to become one of the main causes of friction in 19th-century architecture. Stüler's position in this debate becomes clear when we compare his attitude once again with Henri Labrouste's. In 1830, Labrouste had stated that stability depended more on the way materials were joined together and less on their respective mass, that it was necessary to achieve beauty through the structure itself, and that this had to be both rational and expressive. Having thus practically declared mass as irrelevant, Labrouste was able to design exposed iron structures for his two library buildings, whose delicate balance is maintained by iron supports at the limits of statically allowable slenderness. Labrouste's iron constructions appear as aggressive and dramatic as Stüler's, but also – and above all – immediately identifiable. His iron parts are visible.

Given these difficult general conditions and viewed realistically, it was impossible for Stüler to erect a conventional solid construction. The extensive exploitation of the new potential of cast and wrought iron became the *conditio sine qua non* of his design. Stüler could no longer step back into the 18th century, he could only move on from there. For the first time in Prussia, he erected a pioneering monumental building with a complex fabric of different spatial and structural configurations developed directly from ironwork construction. Similar to a trade-fair display, the building exhibited the potential of this new construction method and proved that Prussia's construction industry had entered the industrial age.

Construction as a problem of architectural adaptation

Two essential characteristics of the way structural iron elements inside the Neues Museum were artistically enhanced have been mentioned above: first, the designer's consistent use of new structural materials and second, the way he made the structural elements "legible" to dramatic effect. However, and this is the third characteristic, he did not show the iron elements openly for everybody to recognize immediately. One saw the structures, but never the iron itself. The iron members were all hidden behind cast or embossed zinc or brass claddings. Stüler thus did not show the iron structure itself, but only an "illustration" of it, so to speak.

Stüler's architecture based on iron structures is aggressive, dramatic and yet somehow indirect. It becomes comprehensible in the context of the architecture of his time associated with names like Henri Labrouste and

7 "Art form and core form" of the iron structural framework for the Majolikasaal, 1853/1862, plate 12. *From: Friedrich August Stüler, Das neue Museum in Berlin, 1862*

Stüler, on the contrary, pulled a skin over the iron, in line with the theory devised by Carl Boetticher, who was one of Schinkel's students. Like his teacher, Boetticher propagated a further development of neo-classical architecture in keeping with the times and saw iron-based construction as the future of architecture. However, for him the new forms this required always had to keep to the old tectonic rules, and particularly the exterior shape of every single structural member had to express, in strictly tectonic form, its structural function. To define this dialectic, Boetticher – starting out from Winckelmann's categories – introduced the terms 'Kernform' and 'Kunstform' – core form and artistic form.

The Neues Museum and, in particular, Stüler's aggressive, dramatic, but all the same invisible adaptation of iron structures must certainly be read as the first and immediately very consistent manifestation of these theories, which were not only reflected in the tectonic logic of many structural components, but above all in the way they were clad. The zinc and brass claddings represented the 'artistic forms' clearly distinguishable from the 'core forms' of the iron beams, girders, columns, etc. They illustrated the static behaviour in a formal language borrowed from antiquity, for example the bowstring girders' tie rods painted to appear like ropes, or the statically irrelevant, purely decorative brackets in the angles between bowstring girders and walls.

Beyond these subtle theoretical references and his own obvious pathos in building in Boetticher's hand, Stüler realistically adapted his design to the new prefabrication method of structural iron components. The increasingly streamlined mass production processes in the field of construction technology simply demanded that the rough structural cast be distinct from the delicate ornaments, in other words – that core form and artistic form be treated as two separate matters.

Conclusion

Construction as a process, a product and an artistic architectural adaptation. – On all these levels, the Neues Museum expresses a new understanding of construction based on iron (cast or wrought), the new material of the industrial age. On the one hand, the way the building was designed and erected is a reference to the option, newly available at the time, of utilizing industrial prefabrication in architecture, on the other it reveals a new practice of planning – that of the civil engineer. The result was a great monumental building in Prussia, in every last detail consistently developed from the load-bearing potential of iron building frames. The museum's architectural design must be seen as the first manifestation of an originally

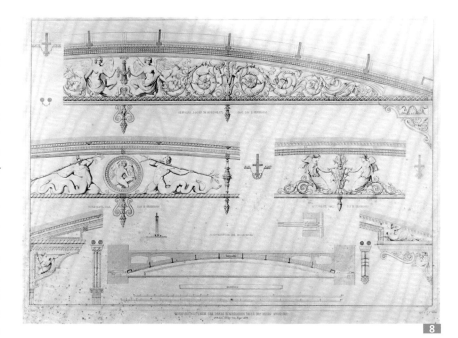

Prussian architectural theory which knew how to combine iron construction technology with neo-classical design in a logical concept.

Further publications by the author:
Stülers Neues Museum. Inkunabel preußischer Konstruktionskunst im Zeichen der Industrialisierung. In: Zentralinstitut für Kunstgeschichte (ed.), Die Museen in Berlin. Munich, 1994, pp. 99–112.
Konstuktion als Kunstwerk. Bauen mit Eisen in Berlin und Potsdam 1797–1850. Berlin, 1995 (includes numerous bibliographical references to the Neues Museum).
Classicism and High Technology. The Berlin Neues Museum. Construction History Journal 15, 2000, pp. 39–55.
Archäologie des Konstruierens. Eremitage, Walhalla, Neues Museum in Berlin. In: Bundesingenieurkammer (ed.), Ingenieurbaukunst in Deutschland, Jahrbuch 2005/06, Hamburg, pp. 172–181.

8 "Art form and core form" of the "bowstring girders" for the north wings, 1853/1862, plate 8. *From: Friedrich August Stüler, Das neue Museum in Berlin, 1862*

The Widow Levy's House as an Obstacle for the Development of the Museum Island

BIRGIT TUCHEN | PETER R. FUCHS

The early history of development

Up until the 17th century, today's Museum Island was *'a low-lying meadowland, cut through by the river Spree in several directions and thus formed into several smaller and larger islands'*.[1] In 1652, the pleasure grounds of the palace were extended to include this area with no other buildings on it but a 'Pomeranzenhaus' (orangery) and a gardener's cottage in the west. The baroque city fortifications (constructed from 1658) included a moated bastion north of what is now Bodestrasse. Another moat – the so-called 'Pomeranzengraben' (fig. 1) – was built between this bastion and the pleasure grounds. The orangery inside the bastion was completed in 1685, and the area beyond the ramparts was developed only from the mid-18th century.

The Levy house

Following the razing of the baroque city fortifications in the 18th century, several residential buildings were erected on what was to become the Museum Island. The first was the house 'hinter dem neuen Packhof 3', which Johann Georg Sulzer (1720–79), professor of mathematics at the Joachimsthaler Gymnasium (1747–63), had erected to plans by Friedrich Wilhelm Dieterichs (1702–82). For a while Dieterichs was *Oberbaudirektor* under Friedrich II (the Great) and later became an independent architect, who designed and built other noble buildings in Berlin, among them the Ephraimpalais. Whilst Nicolai quoted 1749 as the year of completion for Sulzer's house,[2] Fidicin wrote that *'in 1753 the property Neuer Packhof no. 3 was still a wasteland'*.[3] In 1753, by royal privilege granted by Friedrich II, it was registered as a freehold property – freed of all public burdens.[4]

In 1764 Sulzer sold *'his freehold property situated on the high road behind the new bonded warehouse next to the Clement brothers' house, with a yard, a garden, meadows, land and everything appertaining to it, as he owned, used and utilized it, free of all debts and burdens to president von der Horst'*.[5]

Only two years later, the property – *'a residence with stables, a carriage house, gardens and a yard'*[6] – was bought by Georg Wilhelm Schweiger, a banker, who sold it again to his colleague Daniel Itzig in the same year. In his will, Itzig decreed that after his death his son-in-law Samuel Salomon Levy was to come into possession of the property. In June 1800, Itzig's executors therefore sold it to Levy for 31,700 thaler. The property was described as consisting of *'a front yard on the street and behind this a house of two storeys; an outbuilding on the side of the back yard which contains flats, stables and carriage houses; a byre and a poultry house along with a massive manure pit; in addition a byre, wood store and carriage house on the left-hand side of the back yard; furthermore a horse stable and a guard's house with a timber-floored fodder loft; and a back garden stretching up to the highway'*.[7] Levy left the property to his wife Sara, so from 1809 the 'Levy widow' was registered as the owner of the house 'hinter dem neuen Packhof no. 3' (fig. 2).

In the course of plans being developed for the Neues Museum and the transformation of the island into an area dedicated exclusively to art and science, the royal tax office bought the private properties on it one by one, including the Levy house, which in 1843 became part of the royal estate for 180,000 thaler. However, the sales contract[8] concluded on 28 March 1843 by Sara Levy and the director general of Berlin's royal museums, Ignaz von Olfers, included the condition that *'madam, the vendor, during her lifetime [...] retains the usufruct of the entire property along with everything in it'*, and that she was also entitled to *'let it at her discretion for any rent she chooses'*, on condition that she did not *'conclude any tenancy agreements with a duration of more than three years from the signing of the said agreements'*.[9] Only *'that part of the sold property, 50 feet long and at its rear end 7 feet wide, seen from the street as situated beyond the Thorweg, must be immediately handed over to the royal tax office as a freely usable property'*.[10]

The reason for this last contractual provision was that this strip of land was in conflict with the planned

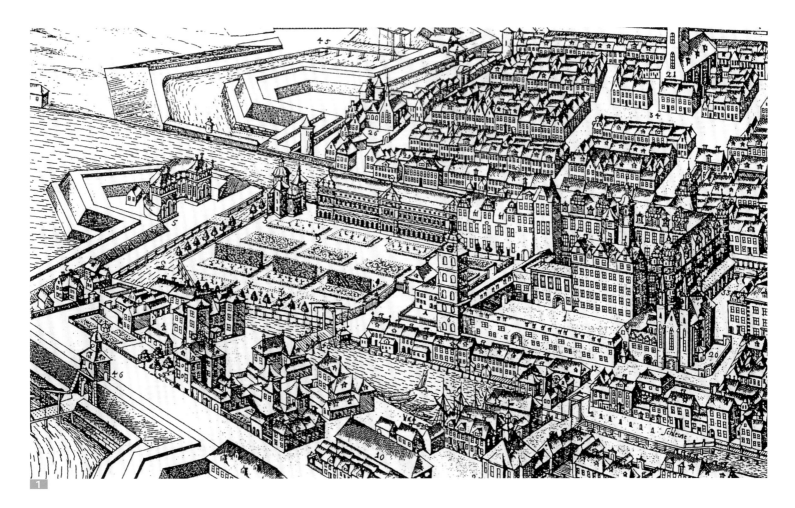

location of the Neues Museum – i.e. with the colonnades in front of the east façade (fig. 3). The initial plans actually envisaged demolishing the Levy house entirely as its orientation did not match that of the Altes Museum, which in turn was meant to serve as a point of reference for the orientation of the Neues Museum. Despite protracted negotiations, Mrs Levy, who by then was a very old lady, was not prepared to leave her property for good. Even Alexander von Humboldt, asked to act as a mediator, failed to persuade her to do so: *'He himself was an old man and knew what familiar rooms mean in old age, so it came to pass that an agreement was reached, according to which Mrs Levy kept her house intact and only ceded a small part of her garden for the building. We therefore saw ourselves compelled to lay out one wing of the museum out of line.'*[11]

An additional sales contract, signed on 15 May 1843, also contained a clause on how to proceed, should the construction of the Neues Museum cause any damage to buildings on this neighbouring property. The tax office agreed, *'1st to firmly restore the solid summer and bathing house on the site border with the new museum and to make it entirely liveable inside and out; […] 2nd to reconstruct the wall between the main house and the summerhouse […] as well as, 3rd, the garden wall north of the […] summerhouse to their*

former appearance and heights; 4th to eliminate the disadvantages any subsidence of the eastern part of the main house occasion; and 5th to eliminate the subsidence of the western part of the garden, where it borders on the new museum, at least sufficiently for the subsidence not to be perceivable or even dangerous'.[12]

Mrs Levy died on 11 May 1854, and the state finally came into full possession of the property, but the new ownership was not entered in the land registry until 1856.[13] By that time, the Neues Museum was almost completed, whilst the construction of the Nationalgalerie (National Gallery) only started ten years later. Thus, at first, everything remained as it was: the tenants continued to live in the Levy house, and its demolition was postponed.

It had been an obstacle in the case of the Neues Museum and was again in the way when the Nationalgalerie was planned, this time because it blocked a vehicular access to the construction site. A letter of 1866 lists the tenants of the house at the time: *'The front rooms on the ground floor of the residential building no. 3 'hinter dem Neuen Packhof' are occupied by the tenant Cohn, and several rooms on the attic floor by the female tenants Alexander and Burgheim. Building supervisor Strann also occupies a few rooms of the bel étage. Finally caretaker Günther of the houses Cantianstrasse nos. 4*

1 Johann Bernhard Schulz, Residentia Electoralis Brandenburgica (detail), 1688

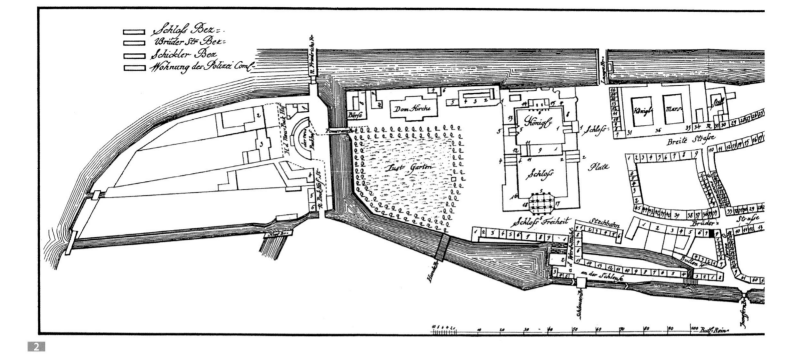

and 5 lives in the attic rooms of this building.'[14] – In order to create a vehicular access to the construction site of the new museum, tenants Cohn, Alexander and Burgheim were to vacate their dwellings in the western part of the house for the demolition of part of the Levy house – a section *'three windows wide'* – on the side facing the museum to proceed *'as soon as possible'*.[15]

Nothing obviously came of this, for in 1870 the director general of Berlin's museums filed a complaint that the Levy house *'by its position in the immediate vicinity of the museum – even touching it with its gable – completely robs the museum's ground floor of air, which is already limited by the colonnades in front of the northeast front [... and] does considerable material damage to the Egyptian collection in the parts concerned'.*[16] He demanded the demolition of the house. In their letter of reply, however, the Prussian Ministry of Religious, Educational and Medicinal Affairs pointed out that the desired demolition of the former Levy house *'cannot, at present, be effectuated as most of its rooms are still used by the building administration of the Nationalgalerie as work spaces, rooms for storing plaster models, as the dwelling of an office attendant, pp., and the procurement of other rooms for these purposes is not possible'.*[17]

Furthermore, the letter referred to the fact that the former director general of Berlin's museums had agreed to preserve the rest of the property until the Nationalgalerie was completed. He only held out the hope that, should it become possible to move the construction management offices to rooms inside the Nationalgalerie, an earlier demolition of the house would be considered. The fact that the Levy house was only sold for demolition in 1875 shows that this hope had not materialized. 3,560 marks were paid for the house described in the sales contract of 4 September 1875 as a two-storey building with a total floor area of 445 m², a basement and a tiled roof. The buyer agreed to demolish it within eight weeks down to the basement floor and was entitled to all the demolition materials, except for *'the red wall-paper found in the back room on the first floor'*, already taken down by the construction administration.[18]

The ground was levelled and laid out as a garden and exhibition area of the Nationalgalerie. It comprised lawns and *'road embankments'* with top layers of 5 cm-thick tamped asphalt and 6 cm-thick poured asphalt on 20 cm beds of concrete. The roads lined pavements of granite slabs.[19] In 1875 the museum had acquired Moritz Schulz's marble sculpture 'Mutterliebe' (Maternal Love).[20] In 1878 this was placed on the northern of the two lawns beside the Neues Museum – *'on the southern side on a polished granite pedestal'* (fig. 4) and was enclosed by a wrought-iron fence anchored in the granite slabs of the surrounding pavement.[21]

When Louis Touaillon's bronze sculpture 'Amazon on Horseback' was acquired in 1896/97, it was decided that this should also be placed in the garden between the Nationalgalerie and the Neues Museum. As the chosen spot was very near the 'Maternal Love' by Moritz Schulz (fig. 5) and as the latter could *'not possibly assert its position'* against the former, it was decided to relocate Schulz's sculpture to the central pavilion of the colonnaded passage

2 Map of Berlin police district no. 5 A, 1812. *From: Salomon Sachs, Allgemeiner Strassen- und Wohnungsanzeiger von Berlin, Berlin 1812*

overlooking the Spree. This seemed a good decision, also in view of the fact that *'there the marble would be removed from the worst effects of the weather'*.[22]

In 1934/35, in preparation for the 1936 Olympic Summer Games in Berlin, the garden between the Nationalgalerie and the Neues Museum was redesigned. The remains of the colonnades that formerly lined the north façade of the Nationalgalerie were regarded as particular eyesores in this open space between the two museums.[23] The colonnades had been largely demolished to make way for the construction of the Pergamon Museum. The few fragments left were now removed completely and a new colonnade was erected a few metres south of the old one. In connection with the construction of this so-called Olympiakolonnade, the arrangement of the sculptures was also altered and the 'Amazon on Horseback', for example, was repositioned 15 metres north of its old place. Today, it can be found on the lawn in front of the colonnades facing the Spree.

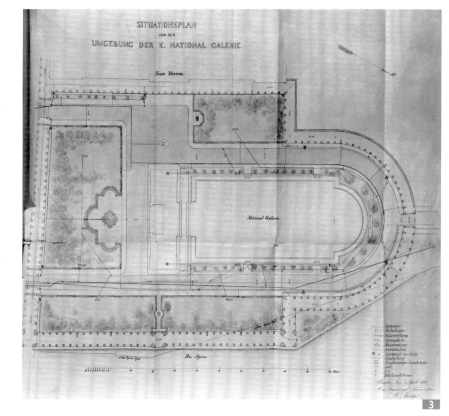

3

1 Fidicin, E: Historisch-diplomatische Beiträge zur Geschichte Berlins, vol. 5: Geschichte der Stadt, Berlin 1842, S. 122.

2 Nicolai, F: Beschreibung der königlichen Residenzstädte Berlin und Potsdam. Berlin, 1786, p. 72.

3 Fidicin, E: op.cit., p. 90.

4 Central Land Registry, ZGA, Alt-Coeln (Berlin), vol. 10, folio 676, folios 5–6.

5 ZGA, Alt-Coeln, vol 10, folio 676, folio 7.

6 ZGA, Alt-Coeln, folio 676.

7 ZGA, Alt-Coeln, folio 676, folio 53.

8 ZGA, Alt-Coeln, folio 676, folios 84–89.

9 ZGA, Alt-Coeln, folio 676, folio 85.

10 ZGA, Alt-Coeln, folio 676, folio 85.

11 Lewald, F, Meine Lebensgeschichte. Reprint of the 1861/62 edition edited by Ulrike Helmer, Frankfurt/M. 1989, p. 87.

12 ZGA, Alt-Coeln, folio 676, folio 88f.

13 ZGA, Alt-Coeln, vol. 10, folio 676, folio 3.

14 Secret State Archive Prussian Cultural Heritage, GStAPK, I. HA, Rep. 137 II K, Nr. 8, folio 4

15 GStAPK, I. HA, Rep. 137 II K, Nr. 8, folio 6.

16 GStAPK, I. HA, Rep. 137, Nr. 29, vol. 10, folio 79v.

17 GStAPK, I. HA, Rep. 137, Nr. 29, vol. 10, folio 80v.

18 GStAPK, I. HA, Rep. 137 II K, Nr. 12, vol. IIa, folios 49f.

19 Central Archive of the State Museums in Berlin – Prussian Cultural Heritage, ZAPK, I/NG 358, folio 120.

20 ZAPK, I/NG 1944.

21 ZAPK, I/NG 358, folios 122f.

22 ZAPK, I/NG 2002, folio 31.

23 ZAPK, I/BV 643, folio 58.

3 Urban layout plan of the Königliche Nationalgalerie's immediate surroundings, 1880. *Source: Zentralarchiv der Staatlichen Museen zu Berlin*

→ Photos pages 48/49: Römischer Saal (space 2.02) in November 2004 and in June 2008. *Photos: Johannes Kramer/BBR*

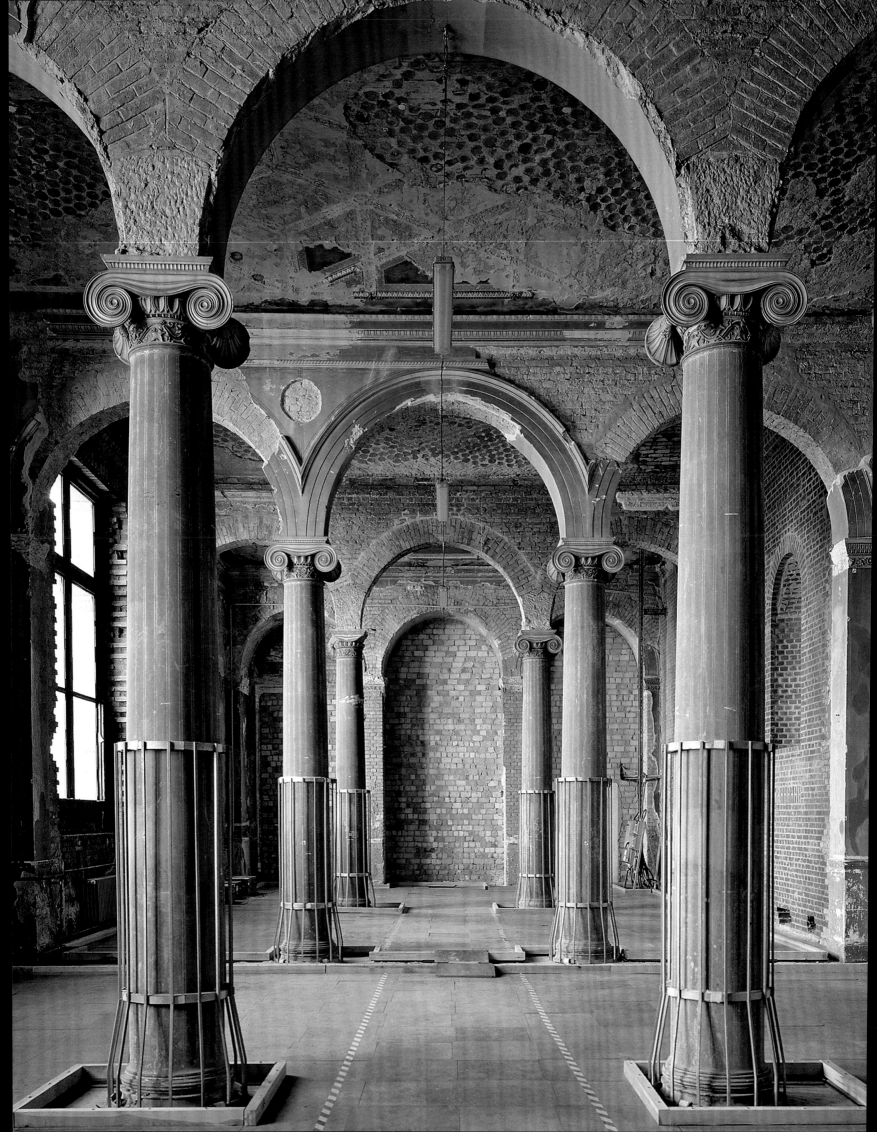

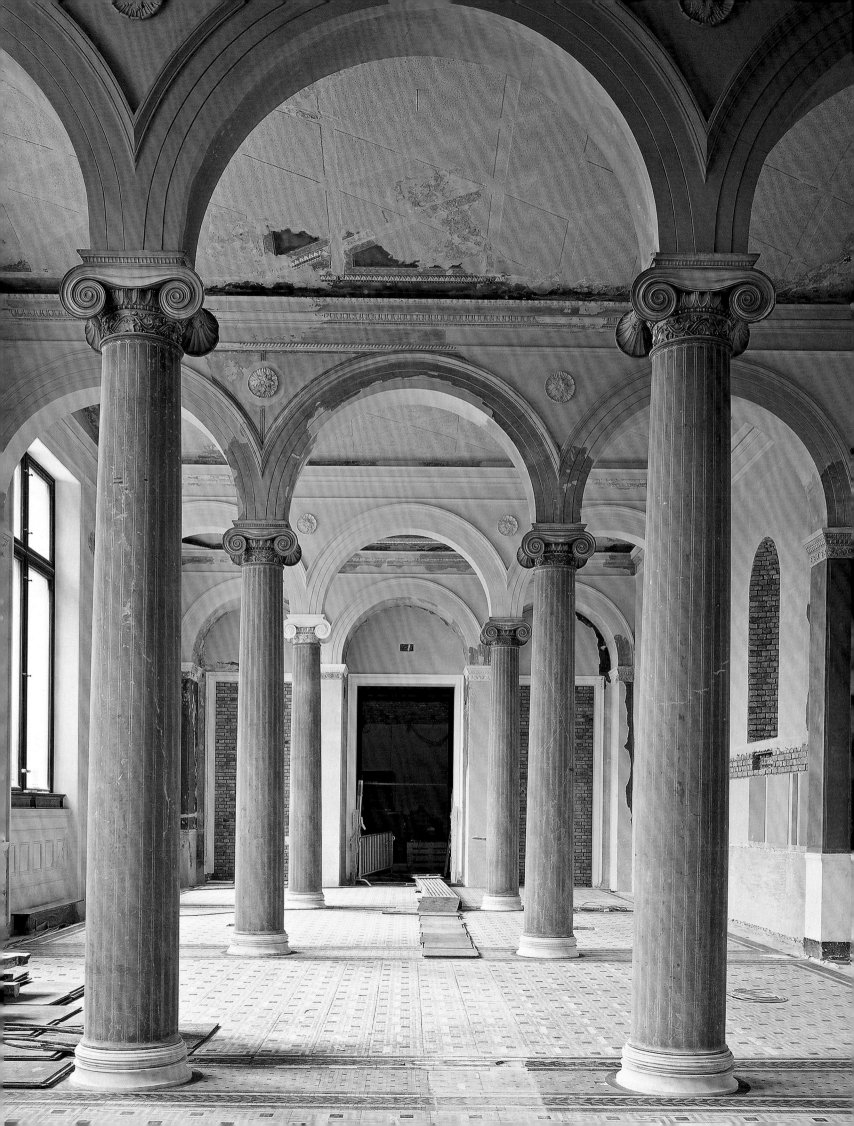

From Invited Competition via Consultation Procedure to "Master Plan Museum Island"

BARBARA GROSSE-RHODE

In 1993, an invited competition was published "for planning the reconstruction of the Neues Museum and for erecting supplementary and connecting buildings with the aim of concentrating the archaeological collections of the Staatliche Museen zu Berlin – Preußischer Kulturbesitz on the Museum Island". The official wording indicates that this was not only a competition for the Neues Museum, but for a far more comprehensive project. The design basis was the concept of the Staatliche Museen of bringing together the archaeological collections in the Altes, the Neues and the Pergamon Museum, and building a new extension between the Neues Museum and the Kupfergraben watercourse. The competition asked for an urban and architectural solution to the problem of how to continue developing the Museum Island in an appropriate way. It also called for "a complementary reconstruction" of the ruined Neues Museum. The aim was not only to use this museum as an exhibition venue, but – also by means of the extension building – to re-equip it in such a way that it would play a central role in improving the access to, and the infrastructure of, the entire Museum Island.

Invited competition 1993/94

Eighteen internationally renowned architects experienced in building museums were invited to submit designs for the competition. Sixteen offices finally submitted proposals. At the end of a three-day session in March 1994, the jury, chaired by Max Bächer, awarded five prizes and three purchases. The winner was Giorgio Grassi (Milan) and the runners-up were David Chipperfield (London), Francesco Venezia (Naples), Frank Gehry (Santa Monica) and Axel Schultes (Berlin), whilst Juan Navarro Baldeweg (Madrid), Schweger und Partner (Hamburg) and Gerhard Spangenberg (Berlin) were awarded purchases for their designs.

The jury report on Giorgio Grassi's design said: "The authors have succeeded in re-evaluating the historical free-standing buildings both spatially and functionally, using only a few elements. The positive restraint and the spatial distance to the Neues Museum has been paid for with a building volume whose architectural design is not entirely convincing and – as the main entrance to the short tour – is also somewhat casual. On the other hand, the idea of converting the *cour d'honneur* of the Pergamon Museum into an introverted garden parterre is a very interesting contribution. The suggestion that the three museums (Pergamon Museum, Nationalgalerie and Neues Museum) should be accessed via the Arkadenhof [arcaded courtyard] in the manner of an open foyer lends the Museum Island new clarity and gives it a focus."

The jury voted unanimously to recommend the winning design for further development, but this did not put an end to the discussion about how to redevelop the Museum Island as an up-to-date ensemble of museums, whilst preserving its value as a historic architectural monument. The Staatliche Museen criticized the lack of functionality in Grassi's design and made no secret of the fact that they preferred Gehry's 4th-prize proposal. Grassi was asked to revise his design to optimize the access, the foyer, the short tour, the presentation of central exhibits and the connection to the Altes Museum. However, after two revisions two things became clear – first, that the alterations destroyed the clarity and consistency that had distinguished the original competition proposal, and second, that the revised designs did not conclusively dispel the qualms of the museum experts.

Expert consultation procedure 1997

The foundation council of the Prussian Cultural Heritage Foundation decided not to commission either Grassi or any of the other prize-winners, but to call in expert consultants to judge the projects of the five runners-up. This procedure was carried out in 1997.

A reduced programme was compiled not least to reduce the risk of potential conflicts and to promote a speedy reconstruction of the Neues Museum. The new brief restricted the project to redesigning the Neues

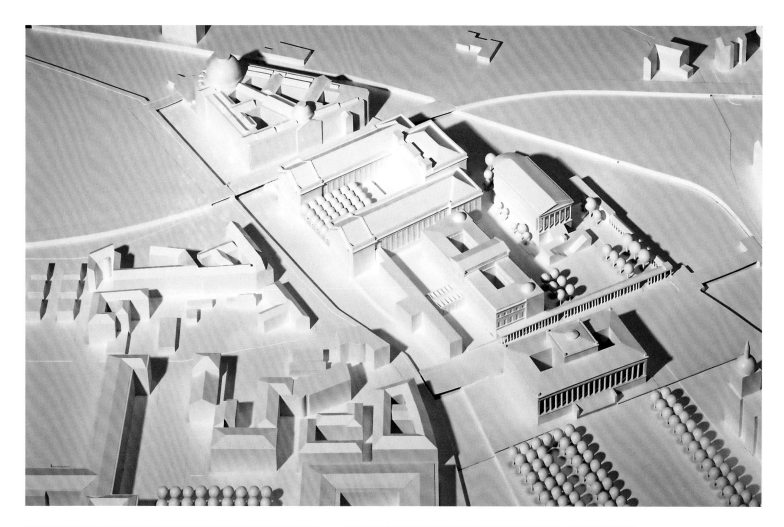

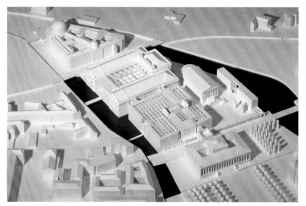

1 Models of the prize-winning designs of the 1993/94 competition.
From the top and from left to right:
1st prize: Giorgio Grassi; 2nd prize: David Chipperfield;
3rd prize: Francesco Venezia; 4th prize: Frank Gehry;
5th prize: Axel Schultes
Photos: Harf Zimmermann & Jens Rötzsch/Ostkreuz. Source: BBR

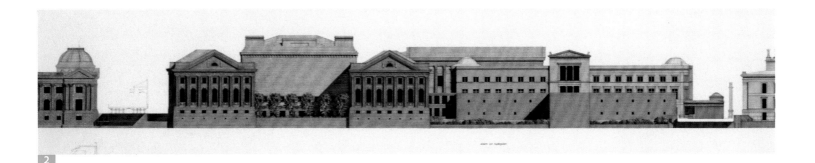

Museum in its original cubic volume to accommodate the Egyptian Museum with the papyrus collection, the Museum of Pre- and Early History as well as central entrance facilities. The option of building up the Kupfergraben embankment area at a later date was to be kept open; and the design was to take the connections to the Altes and the Pergamon Museums into account. Compared to the competition programme with a floor area of 16,535 m², the new brief called for an effective floor area of 6,890 m².

The revision: Chipperfield versus Gehry

Werner Knopp, at that time the President of the Prussian Cultural Heritage Foundation, appointed an advisory board of museum representatives, conservationists and architects, chaired by Florian Mausbach, President of the Federal Office for Building and Regional Planning. In the first session, the five architects presented their designs. The board then decided to ask both David Chipperfield and Frank Gehry to revise and develop their projects in greater detail. To enable the architects to do this, the members of the board explained their doubts and criticism to them. How to do justice in equal measure to the functional demands of a museum and to monument conservation standards, remained the central question of these discussions.

The advisory board judged the revised designs during a final meeting in December 1997. Both designs defined the large central staircase hall as the "heart" of the building. Whilst Frank Gehry wanted to introduce an organically curving sculptural stairway into the hall that had been gutted by incendiary bombs during the war, David Chipperfield took up the historic arrangement of the stair flight. He also quoted Stüler's structure for the complete reconstruction of the north-west quadrant section of the building and recreated the Ägyptischer Hof (Egyptian Courtyard) in a modern architectural language. His design included a new bridge between the Neues and the Altes Museum, where the old one had been, and a connecting wing between the former and the Pergamon Museum with split levels making the transition between the two buildings'

different storey heights as well as offering extra space for exhibitions. Instead of a symmetrically organized building with two interior courtyards, Frank Gehry designed a new structure that took up the entire northwest quadrant and offered spacious, flexibly usable modern museum galleries. Gehry's connecting bridges to the Pergamon and the Altes Museum were formally identical.

Both designs showed that each architect had thoroughly analyzed and deeply reflected on the disparate demands, and both offered solutions which the members of the advisory board considered to be of the highest quality. All the same, the board advised the President of the Prussian Cultural Heritage Foundation to choose David Chipperfield's design for implementation, on the grounds of his subtle use of historic forms and typologies, successfully combined with fundamental functional requirements of a modern museum. The board argued that Chipperfield's design therefore offered the best basis for the further development of the reconstruction project.

David Chipperfield contracted in 1998

The President of the Foundation followed the board's recommendation and early in 1998 the Federal Office for Building and Regional Planning awarded Chipperfield the commission to reconstruct the Neues Museum.

The planning process started with another study of conservation requirements. It became clear that the introduction of central entrance facilities would mean substantial interventions in the building fabric of the Neues Museum. Another very critical point was that Chipperfield's design connected the Neues Museum to the neighbouring museums on the first upper floor level, which meant that great numbers of visitors would be led through the best-preserved and at the same time most sensitive galleries (Niobidensaal, Bacchussaal, Römischer Saal).

"Master plan Museum Island" 1999

Questions from the original competition still had to be answered to facilitate a reconstruction of the Neues Museum in accordance with conservation standards and

2 1993/94 competition: Giorgio Grassi, west elevation towards the Kupfergraben. To the left the Pergamon Museum with new parterre, to the right the Neues Museum, in front the extension building. *Source: BBR*

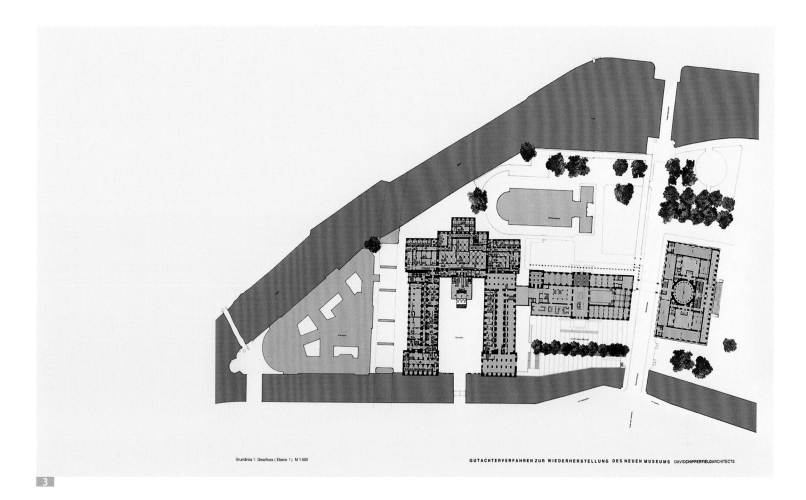

Grundriss 1. Geschoss (Ebene 1) M 1:500

GUTACHTERVERFAHREN ZUR WIEDERHERSTELLUNG DES NEUEN MUSEUMS DAVIDCHIPPERFIELDARCHITECTS

3

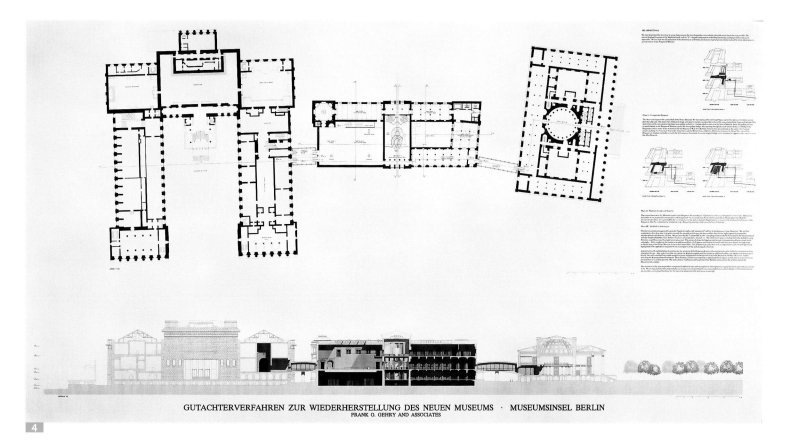

GUTACHTERVERFAHREN ZUR WIEDERHERSTELLUNG DES NEUEN MUSEUMS · MUSEUMSINSEL BERLIN
FRANK O. GEHRY AND ASSOCIATES

4

3 1997 consultant procedure: David Chipperfield, floor plans level 1 (ground floor left). From left to right: Pergamon Museum, Neues Museum and Altes Museum. *Source: BBR*

4 1997 consultant procedure: Frank Gehry, revised design, ground plan first floor; from left to right: Pergamon Museum, Neues Museum, Altes Museum – and longitudinal section of the Neues Museum. *Source: BBR*

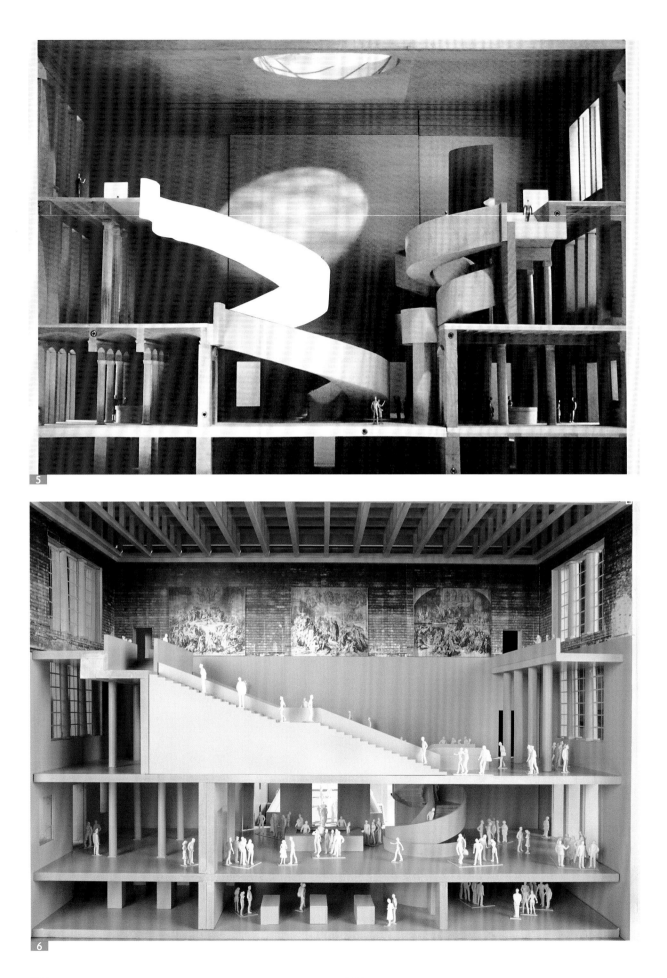

5 1997 consultant procedure: Frank Gehry, revised design, model of the staircase hall. *Photo: Haselau. Source: BBR*

6 1997 consultant procedure: David Chipperfield, revised design, model of staircase hall. *Photo: Haselau. Source: BBR*

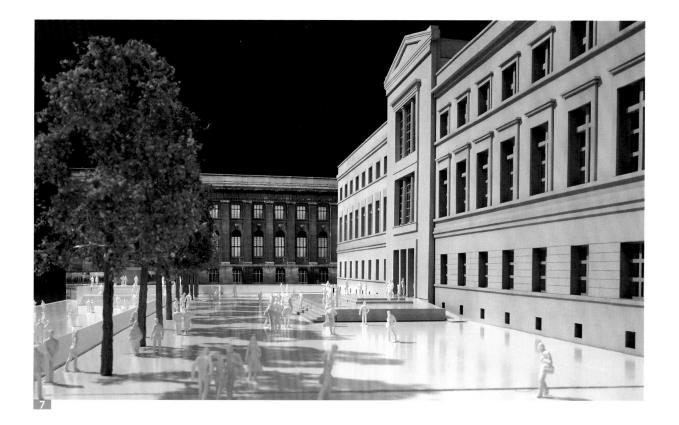

create the right conditions for the further development of this and the other buildings on the Museum Island. In mid-1998 the foundation council commissioned a planning team to develop the "Master plan Museum Island", an overall access and infrastructural concept for this piece of urban area, based on the Foundation's intention to concentrate all its archaeological collections in this location. The "planning team Museum Island" (coordinated by David Chipperfield) cooperated with the Staatliche Museen, the Berlin monument conservation office and the building authorities in developing the master plan. In July 1999 the foundation council adopted this as the basis for further planning. Especially with the new entrance building and an "archaeological promenade", two main elements of the masterplan, the team succeeded in relieving the Neues Museum of functions originally intended to be created inside the existing building, and thus in ensuring its reconstruction and repair true to monument-conservation standards.

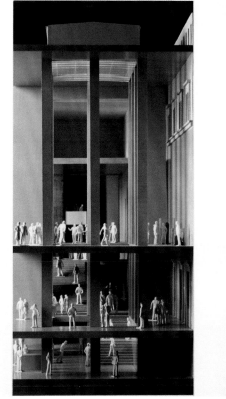

7 1997 consultant procedure: David Chipperfield, revised design, west façade with square in front towards the Kupfergraben. *Photo: Haselau. Source: BBR*

8 1997 consultant procedure: David Chipperfield, revised design, model of the Egyptian Courtyard. *Photo: Haselau. Source: BBR*

The Neues Museum
Architectural Concept

David Chipperfield

Ever since John Ruskin published his moralistic essay[1] attacking the 19th century tendency of historic reconstruction, the argument between those who wish for monuments to be rebuilt to visually simulate their original glory and those who wish to preserve the building fabric as the physical evidence of history has been constantly rehearsed.

Nowhere has this debate been so well and so fiercely articulated as in post-war Germany. The argument, inevitably a complex cocktail of emotion and intellect, draws upon the conflicting desires to remove the 'rubble and the memories' and conversely the desire to put back what was lost.

Like the paradox of the boat of Theseus[2], the debate requires us to consider the method by which we preserve our history and to what degree we destroy or confuse meaning and reality in the process of restoration or preservation.

Despite inheriting the clear guidance of the historian Georg Dehio who argued "conserve not restore"[3] and despite the clear direction of the Venice Charter[4] and despite the freedom from a modernist agenda that sought to make a "tabula rasa" ("Nothing will be achieved if we don't clear away every ruin along with the mental debris"[5]), the prevailing prejudice has continuously tended towards historical restoration.

It is unfortunate that the argument has become so polemic; every situation needs to be considered on its own merits. Reconstruction, conservation, restoration, renovation and repair are all at our disposal; no technique has a moral certitude of its own, only the purpose of its application can invest it with one.

A few specific conflicts best define the ambitions of the battle. We can think of the total but (in my opinion) justified rebuilding of Goethe's birthplace in Frankfurt[6] as a symbol of Germany's growing desire to reclaim cultural dignity from the rubble mountains; Egon Eiermann's articulate collage of ruin and modern intervention for the Kaiser Wilhelm Gedächtniskirche in Berlin; the radical reinterpretation of the Pinakothek in Munich by Hans Döllgast; and finally the much celebrated reconstruction of Dresden's Frauenkirche as a testament to the public will see once again the symbolic silhouette rise from the piles of stones that sat as a haunting presence since the war.

The recent decision by the German Parliament to instruct the Federal Government to rebuild the Berlin Schloss, including three of its baroque facades, elevates the prejudice for historical reconstruction from being the territory of the public and the media to that of the State.

Against this background the restoration of the Neues Museum has been planned and carried out. Desiring neither to imitate nor invalidate the remaining complex of ruined fabric, a Piranesian structure of bricks and architectural fragments, our concern has been motivated by the desire to protect and to repair the remains, to create a comprehensible setting, and to reconnect the parts back into an architectural whole.

The project has required the construction of large missing sections of the building as well as the repair and consolidation of the remaining parts. It has been our ambition to bind these two activities into a single approach, the new and the old reinforcing each other not in a desire for contrast but in a search for continuity.

This intention of continuity and completeness has been carried out within a philosophical and technical

1 Sketch by David Chipperfield. *Source of all illustrations: David Chipperfield Architects*

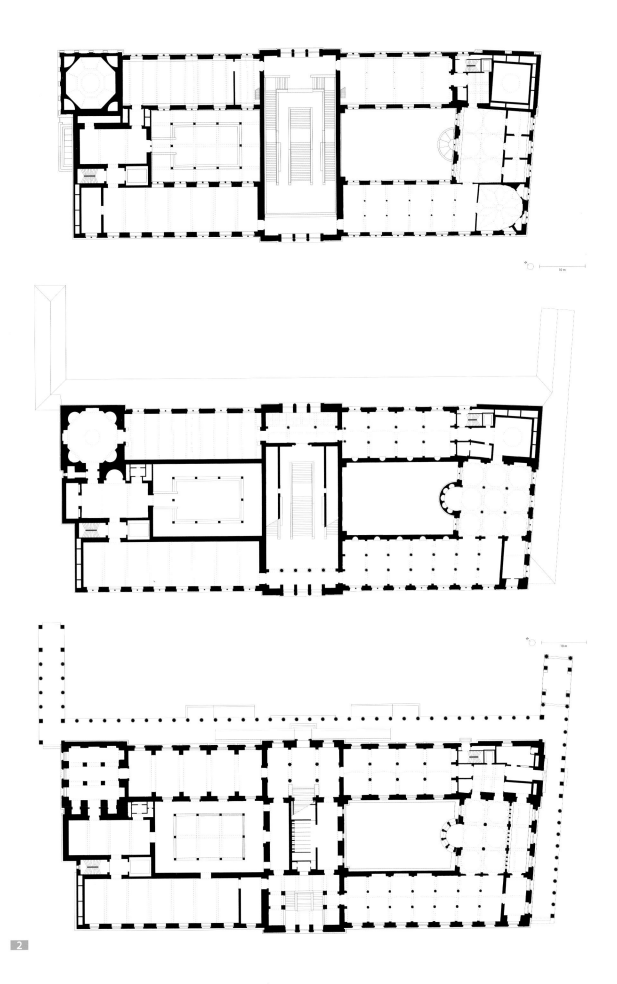

2

2 Ground plans, from top to bottom: level 3 (2nd floor),
level 2 (1st floor), level 1 (ground floor)

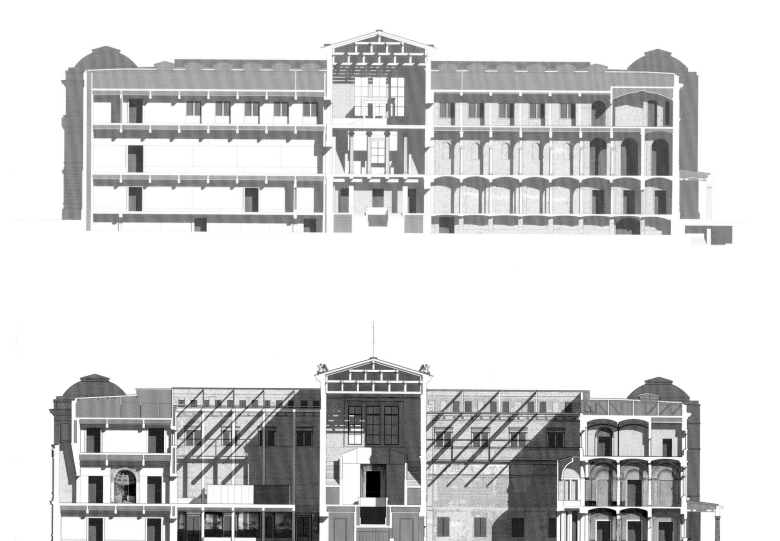

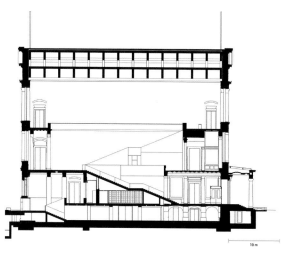
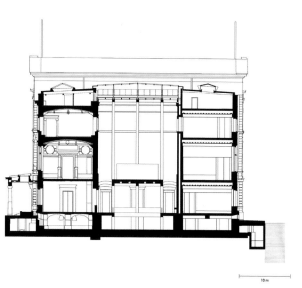

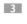
3 Longitudinal sections, from top to bottom: section G-G, from left to right: northern west wing, staircase hall, southern west wing; section H-H, from left to right: north wing, Egyptian Courtyard, staircase hall, Greek Courtyard, south wing; left

section A-A (through the staircase hall, looking north); right: section D-D (looking south), from left to right: east wing, Egyptian Courtyard with platform, northern west wing (new building)

approach that elevated the protection of original fabric to its central credo. This approach inevitably denies the ambition of "making things as they were". Historical reconstruction would require the suppression, if not destruction, of original material in a desire for "the made new again".

The project, while dealing with the philosophical concerns of restoration, has also had to deal with the not inconsiderable technical task of achieving thermal and environmental standards, as well as the organisational requirements of a modern museum and a building that forms (via the new archaeological promenade) part of the Museum Island ensemble of museums and their archaeological and fine art collections.

The meticulous process of repair and restoration carried out under the guidance of Julian Harrap makes explicit the process as a series of informed and careful judgements, balancing the status of the piece with the vision of the whole. This approach pervades the whole project, ensuring that the new and the old, the original, and the repair, the restoration and the intervention are fused together into a singular whole.

At the larger scale the realisation of the concept of continuity and completion has been achieved by the construction of new simple volumes and surfaces in brickwork and pre-cast concrete. These new volumes, while supportive to the concept of completion and avoiding the imitation of historical detail, have a sufficient scale that demands that they must establish their own presence.

If the concept of repair is then to link together surfaces, to bridge between original elements, to bind fragments into a whole, scale is critical. A missing part of a plaster wall sets less challenge than a missing wall or part of a room. This "bridging dimension" requires a different contribution of the repair (or bridge). A small repair needs no quality of its own; a large one, if it is not just to become a lifeless and empty "placeholder", must have a physical and material character of its own.

Herein lies the task – to develop strategies and techniques that deal with repair of different scale yet are consistent to an approach. At the largest scale the repair becomes an intervention and requires its own "story". The Neues Museum contains a series of major interventions (moments where the neutral imitation of the original was judged to be insufficient). These interventions inevitably occur where the damage was greatest: the staircase hall, the northwest cupola, the southwest wing, and the Egyptian courtyard.

The dynamic correspondence between repair, conservation, restoration, and intervention has evolved through continuous dialogue not only between the participants in this process – client, conservationists, planners, and restorers, but also with the potent remains of Stüler's extraordinary building.

1 "The Lamp of Memory" from "The Seven Lamps of Architecture" (1857) by John Ruskin. Ruskin admonishes the practice of historical restoration: "Do not let us talk then of restoration. The thing is a lie from beginning to end."

2 The "paradox of Theseus" stands for the question whether an object of which all the components have been replaced is still the original object or something new.

3 Georg Dehio, art historian, gave a lecture in Strasbourg warning against the excesses of restoration. "Conservation aims to mention the existing – Restoration aims to recreate the non existing (the lost) on the one hand is a reduced, faded reality – but invariably reality on the other is fiction." 'The Protection and Preservation of Monuments in the Nineteenth Century', an address given at the university on 27 January 1905.

4 The Venice Charter (1964 Charter for the Conservation and Restoration of Monuments and Sites) Article 9, "The process of restoration is a highly specialized operation. Its aim is to preserve and reveal the historic value of the monument and is based on respect for original material and authentic documents. It must stop at the point where conjecture begins."

5 "Wir werden nichts erreichen, wenn wir nicht jede Ruine zusammen mit den Trümmern in den Köpfen wegräumen." (Hans Schwippert)

6 The proposed rebuilding of the Goethe house in Frankfurt provoked furious debate. The justification was not from the point of view of the physical but the symbolic.

The Neues Museum
The Restoration Concept

JULIAN HARRAP

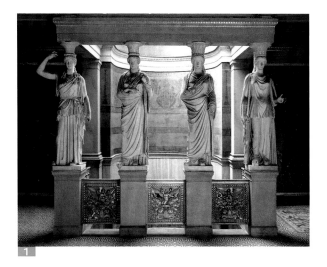

Karl Friedrich Schinkel prepared a directive, subsequently issued by the Prussian Ministry of Culture in 1843, stipulating that "the aim of restoration is not to give a building a new appearance by eliminating minor defects that reveal the traces of centuries past and contribute to a building's character. Restoration should only extend to defects that pose a threat or are likely to do so in the future, and these defects should be eliminated as inconspicuously as possible. The best form of restoration is that which inconspicuously rectifies any damage."[1]

This statement of faith has inspired generations of architects and restorers throughout Greater Berlin. The work at Charlottenburg and Potsdam is a monument to the meticulous re-creation of the edifices of the past to a point where the distinction between new work and old work is almost invisible except to the highly trained eye. This approach to restoration endangers the testament to the past that a building provides because it creates a new, modern reproduced context, which some would say falsifies the cultural significance of the original.

Among the ruins of history

The extraordinarily picturesque ruin of the Neues Museum, devastated during the years of conflict in 1939–45, increasingly became a problem for the GDR regime as its redevelopment programme for East Berlin, based on utilitarian and social ideals, progressed. For a long time it was simply passed over, perhaps because it represented too great a challenge for the state's limited resources. Nevertheless, there was never any question that it should be fully restored in the original classical style.

Many of the surviving works of art had already been removed and conserved in depots elsewhere and thus been spared from war damage. In addition, portions of the stucco and interior decoration had been removed in order to investigate the structural difficulties arising from a heavy museum building having been constructed on timber piles on a sandy island in the middle of a river. The brick walls showed deep cracks, and the shallow vaults of the clay-pot ceilings, which depended on firm abutments, were so severely damaged that it was unlikely they would be able to bear any significant load.

The shell of the building was regarded as being of little or no cultural value. It was therefore secured and repaired without paying any heed to aesthetic considerations. Large gaps in the brickwork were filled with clinker bricks and coarse cement and sand mortar. All external and internal walls were disfigured by these "replacements," but the prevailing view at the time was that it did not matter because they would be concealed by re-plastering, rendering and painting to provide a faithful reproduction of a 19th-century palace museum.

At the same time, this ugly red brickwork served an immensely important function in holding together the fragments of the surviving ruin, enabling further measures to be taken to stabilize the structure. Even then this proved to be an exceptionally difficult task, because it involved installing new piles extending through the elegantly vaulted brick basement with its low ceiling into the stable strata below the sand. This challenge was comparable with the introduction of piling beneath the

1 Roman Baths in the Sanssouci Park in Potsdam – an example of the meticulous, faithful reconstruction of historic buildings. *Photo: David Chipperfield Architects*

Round Tower at Windsor Castle, when the 11th-century motte began to subside.

Since its original completion the museum building had subsided about 500 mm, so the floors in the basement had to be lowered to provide enough headroom. This exposed the stone foundations, laid on the timber piles, which made the room suitable as a gallery but not to house a caretaker's flat, storage areas and a coal cellar to supply the heating and hot-water system. The modern reconstruction of the south-east and north-west sectors of the building included new foundations, while the portion of the building still standing continued to be supported by the foundation slabs put in during the measures carried out to secure the building by the GDR authorities.

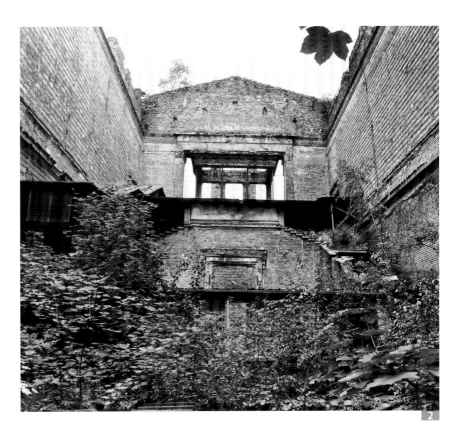

Taking stock – some encouraging finds

Despite the removal of many pieces of the interior decoration, a thorough examination of the building revealed it to have an extraordinary number of historic surfaces and fragments in a remarkably good state of repair. These included wall paintings, painted décor, cornice and door frames, which had survived in a remarkable state of preservation. The Niobidensaal (Niobides Hall) was almost completely preserved while the decoration in the Römischer Saal (Roman Hall) was completely intact at the northern end, but highly fragmented at the southern end. The Bacchussaal (Bacchus Hall) linking the two was intended to form a connection between Stüler's concept of the Treppenhalle (main stair hall) as an internal landscape and the external staircase of the Alte Nationalgalerie (Old National Gallery) to the east, by way of the segmentally arched arcade between the galleries to the north and the south.

The rooms on the upper levels of the museum were in many ways some of the most romantic spaces imaginable, with fragments of decoration that had survived exposure to the weather for decades since the war. On the west side, the missing floor of the Ethnographischer Saal (Ethnographical Hall) provided a truly Piranesian vision of a ruined structure. The challenge was to capture the original character of this decayed fabric using a balanced repair and restoration concept geared towards preservation and at the same time to install the technology required by a modern museum.

The first task was to prevent all the fragile surviving material suffering any further damage while GDR–era securing material was removed and the load paths of the original Stüler construction were re-established.

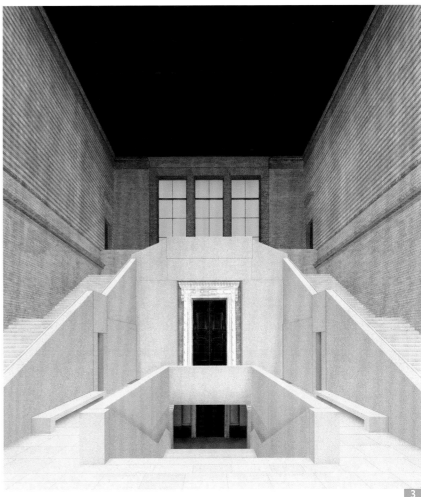

2　The Neues Museum, main stair hall – view of the east wall and ruined caryatid porch in 1985. *Photo: Schreiber. Source: Zentralarchiv der SMB*

3　Stair hall – computer simulation. *Source: DCA*

The angry red brickwork was removed and replaced by carefully selected old bricks set in the original fabric using sand/lime mortar. We found manufacturers who could still produce the hollow terracotta pots for the vaulted ceilings, first in England and later in Görzke, near Berlin. First we built a test vault in order to try out this historic building technology and to test how much load it would bear before breaking. This also helped to inspire the confidence of the construction teams and the future users in the stability of this kind of structure.

We found out where the original utility lines had been in the old building and had these cleared out, extended and broadened in order to use them for the new heating and air conditioning systems that would be required to cater for the numbers of visitors expected to be drawn by internationally significant exhibits such as the Nefertiti bust. New cases were designed to house the vast collection of the Neues Museum, which had lain in storage for half a century. These will insulate the exhibits from the general environment of the galleries with their streams of visitors. The windows of the museum retain the original oak frames, but an extra layer of glass was added to provide thermal protection from the rigours of a Berlin winter.

The masonry shell of the museum was initially stabilized using a light-weight steel roof structure to secure the upper levels of the building. The cornice of the Treppenhalle was reconstructed with 2.5-ton blocks of Silesian sandstone and now forms the connection between the east- and west-facing pediments. Each of the two courtyards, the Greek Courtyard to the south and the Egyptian Courtyard to the north, were capped with new glazed steel roofs to provide shelter from rain and wind and to enable light to percolate down to basement level. Here, the lowered floor level of the museum was extended to the north and the south to link the Neues Museum with the Pergamon Museum and the Altes Museum.

A new form of architectural expression

Within the Treppenhalle a new, gently rising staircase was re-constructed in polished concrete with careful attention to the details of Stüler's original design. The loss of the décor in the interior of this great space required a new form of architectural expression. The surviving masonry was repaired and supplemented using recycled old bricks and specially made new bricks fired to match the surviving material. The new roof designed to provide a shelter from the weather now covers a space that is more like a landscape than a piece of architecture. Some believe that the roof was inspired by the reconstructed Manege roof over the former Moscow Riding School. A debate continues about whether the new roof should be seen in silhouette against the boarding or whether it should form a dark and mysterious capping to the space.

A main component of the structure of the ceilings between the floors of the Neues Museum is the wrought- and cast-iron bowstring trusses, which span the side-lit galleries in the northern half of the building. Curiously, the pig iron for the cast structures was imported from Britain. Some of the original iron structures were damaged during the war by firebombing and by the temperature shock suffered when water was used to extinguish the fires. Much of the cast iron was embedded in masonry, and exploratory non-destructive techniques of assessment were employed. To have removed and replaced this fractured material would have been immensely invasive. As a consequence, radical techniques of strengthening the cast iron were developed with the project engineers, who devised a system applying carbon-fibre tapes to the outside of the tension zone of the beams ensuring their continuing load-bearing function. This technique is widely applied to stabilize failing concrete bridges and occasionally failing timber frames, but it had rarely been applied to cast-iron structures of the size and with the load-bearing capacity of those found in the Neues Museum. For this reason we first built our own prototypes to test the behaviour and the load performance of the composite structure.

After obtaining positive results from the tests on the prototypes we were able to reconstruct the flat-vaulted ceilings between the floors using the historical techniques. For this purpose hollow bricks (clay pots) were laid on the shallowly vaulted timber formwork with brick diapering at high stress points. The Silesian sandstone columns, which had been plastered with marble cement, were found to be in excellent condition and readily able to carry the load of the new ceiling. At the first floor level, by contrast we found columns made of polished French marble and some exhibited diagonal beds, which presented potential slip planes. The load potential of the supports was therefore empirically tested and confirmed. These were pinned with shear pins across the line of potential fracture. Four columns had survived only in cracked fragments. New stone was quarried and, with careful engineering supervision, reconstructed from a series of short lengths. These were arranged in a perfectly vertical manner to ensure that the load path avoided any eccentricity.

On the second floor of the museum, we discovered that some of the cast-iron supports, once clad with zinc casings, had survived, but were incapable of carrying loads. Accordingly, a new ceiling of reinforced concrete was installed immediately above, which enabled the main technical service centre to be placed on the top floor.

The restoration of the interior

Once the careful restoration of the load-bearing structure had been completed, the cleaning and restoration of the painted surfaces in the galleries could commence. The first task was to determine the artistic and cultural significance of each stage in the paint chronology. While the shell of the museum building was completed in 1843, it took until 1865 to finish the interior. It was therefore highly probable that a number of experimental coats of paint were put on the walls. It was decided that, in choosing the colours for the walls, the wall paintings should always take priority, and that the colours of the architectural embellishment should play a secondary role. This sometimes involved removing the various layers of paint applied in the mid-20th century by hand. The Vaterländischer Saal (National Hall), for example, which was painted olive green, was revealed to have originally been painted cobalt blue. A further period in the evolution of the museum's decor began in 1919, when it acquired the Amarna collection. This collection was displayed in rooms that in the mid-19th and early 20th century were not only decorated differently but in completely contrasting colour schemes. The repertoire of techniques available to the team managing the design and presentation of the conserved interiors was, however, able to provide a solution to these apparent contradictions.

The basis for re-creating the interiors was carefully researched using a series of Photoshop drawings providing individual room concepts. These addressed the question of how much it was possible or desirable to take into account the chaos caused by war damage and decay in the systematic planning concept for the restoration. The first consideration for each gallery was always the floor. Some of the upper floors had been laid out with parquet, others with terrazzo on a bed of gypsum-lime mortar. Other halls contained mosaic alternating with ornamental marble-cement slabs.

The restoration of the shell

Each of the side-lit galleries in the southern half of the building is punctuated by cross arcades of columns, which rise to support the ceiling above and naturally divide the gallery into a series of smaller chambers. This enabled restorers to sub-divide the damaged surfaces into painted "tapestries," which they carefully "re-stitched," stabilized and, most importantly, furnished with a new architrave or frieze. In this way it was possible to re-create the mouldings and architraves in keeping with the spirit of the architectural design of the interior. If it were too rigidly adhered to in all the rooms this kind of restora-

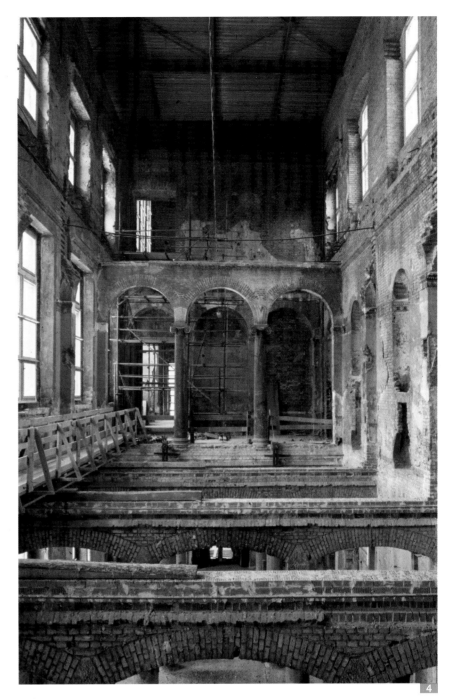

tion would appear over-systematic, yet it is surprising how the eye can reconstruct the complete geometry of a room on the basis of just a few surviving hints of how the walls and ceilings originally looked.

Many of the lines of architectural decoration were re-created in stucco or lime mortar in order to restore the architectural framework and to provide a fitting context for the wall paintings, almost like framing a work of art. If one looks at photographs of the ruins before work started, one may ask anxiously whether more restoration has been undertaken than was strictly necessary (or was envisaged in the original concept and planning).

4 Piranesi-type ruin – the Moderner Saal with through-views to the Ethnographischer Saal (below) and the Westlicher Kunstkammersaal (above), 1990. *Photo: Wolfgang Wolters*

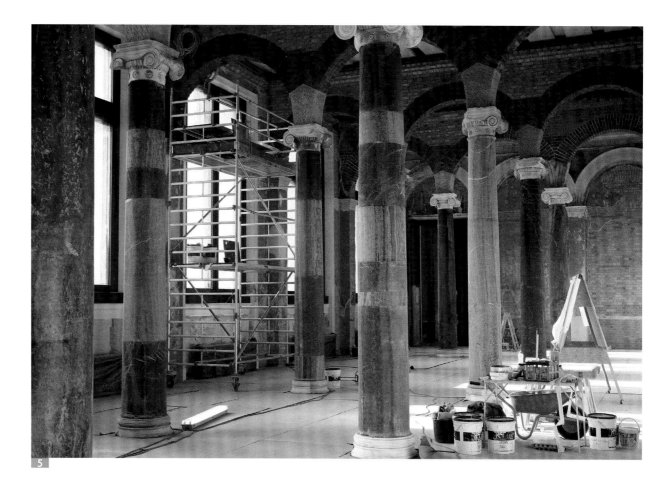

If this is indeed the case, then it is partly attributable to the fact that different teams of restorers were responsible for each gallery or room of this unique building, all of them striving to do their best. Cleaning of the wall surface revealed that far more original paint had survived than was initially evident. By re-incorporating the fragments salvaged before the structural stabilization of the shell the interior decoration has been further enriched.

Until all the original painting in a gallery had been uncovered it proved difficult to judge what would constitute the right harmonious balance between the different layers of paint preserved and the nuances of decay and to plan accordingly. Our approach was similar to that of a restorer of old violins, who, after completing his work, must first tune the strings before he can make the violin sound again.

1 See Norbert Huse (ed.), Denkmalpflege. Deutsche Texte aus drei Jahr-
 hunderten, München, 1984, p 67. Footnote 15 refers to J. Reimer's, Hand-
 buch für die Denkmalpflege, 4th ed., Hannover, 1912, p 442.

5 Column drums in the Moderner Saal. *Photo: Ute Zscharnt*

The Neues Museum
The Museological Concept

In terms of purpose and architectural design, the Neues Museum is an organic part of the complex organism called the Museumsinsel (Museum Island). Decades after its destruction in World War II, it is reopening its doors to visitors from around the world not as an individual museum, but as a part of an ensemble of museums. Showing both its historical splendour and its scars, it now forms a precious setting for a 21st-century museum.

After the fall of the Berlin Wall, little discussion was needed to decide on the Neues Museum on the Museumsinsel as the new home of Berlin's archaeological collections, which had been split in two during and just after the war, part of them being kept in West Berlin. The plan to house the collections of the Ägyptisches Museum (Egyptian Museum) and the Museum für Vor- und Frühgeschichte (Museum of Pre- and Early History) in the Neues Museum represented not a nostalgic return to the former's beginnings in this location, but a quite natural result of the thematic concept underlying the Neues Museum and the Museumsinsel. The geographical range, historical depth and exceptional variety and quality of Berlin's archaeological collections permitted the history of the ancient world to be traced from the Middle East to the Atlantic Ocean, from North Africa to Scandinavia, and through the millennia from the Palaeolithic age to the early Middle Ages. An interdisciplinary approach and a presentation that promoted comparisons between the different civilizations were the natural guidelines for planning the museum displays.

The archaeological promenade

The idea of an Archaeological Promenade, articulated in the "Master Plan Museum Island", formed the basis of the architectural and programmatic planning of the museum displays. The lowest floors of the museums – from the Altes Museum by the Lustgarten and the Pergamon Museum to the Bode Museum on the northern tip of the island – contain exhibition galleries which form not only "walk-in" architectural links between the buildings, but also a thematic axis which, gallery by gallery, addresses the

same issues from a variety of cultural angles. The section of the Archaeological Promenade included in the Neues Museum, comprising four subject areas, is an example of this overall concept. "Gott und Götter" ("God and Gods") unites six different representations of the divine from four continents against the background of an ancient Egyptian cult idol shrine: a Dogon ancestral figure; an Aztec mask; a Hindu lingam; a hanging lamp from a mosque; a Polish folk-art carving of Christ and a Roman marble statue of Dionysus. The ancient "world order" in the Griechischer Hof (Greek Courtyard) is represented by a cycle of reliefs from Pharaoh Sahure's mortuary pyramid temple; the colossal statue of the supreme Greek god, Zeus, from Magnesia; an Assyrian temple relief from Nimrūd; four figurative Kuman stelae; and the Berlin Circle by contemporary artist Richard Long – a perfectly geometric circle of fieldstones laid out on the floor. Above these manifestations of divine, political and artistic orders, chaos returns in the form of Hermann Schievelbein's frieze on the four walls of the Griechischer Hof, a relief showing the destruction of Pompeii that belong to the building's original decoration. The gallery "Zeit und Geschichte" ("Time and History") leads to the Ägyptischer Hof (Egyptian Courtyard), which presents "Jenseits und Ewigkeit" ("The Hereafter and Eternity") in the form of ancient Egyptian, Roman and early Christian carved stone sarcophagi.

In the Ägyptischer Hof, the presentation and David Chipperfield's architecture form an ideal combination. "The Hereafter and Eternity" is presented not as a tenebrous netherworld, but as a realm brightened by a "wreath" of indirect daylight. There could scarcely be a more appropriate way of suggesting a vision of the beyond leading to eternal light – a vision that recurs in the illuminated papyri depictions of the afterlife which cover forty metres of the courtyard's longer walls.

The principle of intercultural, comparative displays adheres to traditional practice on the Museumsinsel, as manifested in the ensemble formed by the processional street and the Ishtar Gate from Babylonia; the market gate

Concept
64|65

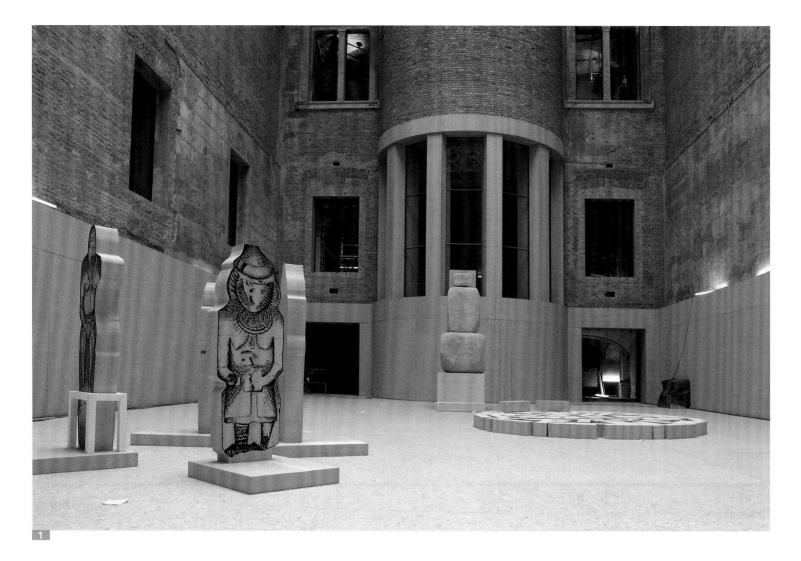

from Milet; the Pergamon Altar; and the palace façade from Mshattä. The ensemble will continue with the Qalabsha Gate and the columned courtyard from Pharaoh Sahure's mortuary pyramid temple in the new fourth wing of the Pergamon Museum, closing the horseshoe-shape of the museum building and completing a traversal of Middle Eastern, ancient Egyptian and classical cultures. Thus the Museumsinsel offers a two-fold path along which visitors may experience the culture of antiquity as unity in diversity, and may also draw analogies to other times and places.

Successful test run

While the Archaeological Promenade and the fourth wing of the Pergamon Museum met with lively public interest, little attention was accorded the development of the exhibition concept for the Neues Museum, although – or perhaps because – the planning took place in the presence and with the participation of visitors. Over a test run of almost four years, for example, many original objects from the Egyptian collection destined for permanent display in the Neues Museum were shown on the top floor of the Altes Museum.

Every aspect of their presentation was critically examined (while visitors came to look at them) and repeatedly modified.

This practical form of planning proved extraordinarily efficient, in particular for exhibition designer Michele de Lucchi from Milan, but also for everyone else involved – the architect, the lighting designer, the building authorities and the museum curators. Over the test-run years, the "comparative" museological concept, which breaks with the ubiquitous chronological arrangement of museum exhibits, not only met with widespread approval from millions of visitors, but was also received favourably among experts around the world. The exhibition design did without digital media and without long, detailed explanations of the various galleries and individual objects. As the designers had hoped, this was not perceived as a deficit, but helped to intensify people's visual and emotional responses to the original works of art.

Like the other museums, the Neues Museum will continue to use audio-guides as the most important means of establishing a dialogue with its visitors. Experience showed that displaying too many objects did not make for

1 Griechischer Hof. Proportional models used to test the arrangement of the Kuman stelae, Richard Long's Berlin Circle and the statue of Zeus from Magnesia. *Photo: Ute Zscharnt. Source: DCA*

clarity. The designers therefore felt encouraged to adopt a policy of "less is more" and to increase the number of exhibits only marginally, despite the fact that the museum now contains three times as much gallery floor space as the original building. This restraint also embodied a response to the large numbers of visitors anticipated and their social structure. With visitors estimated at 3,000 a day, the majority of them tourist groups bound to strict schedules, it seemed natural to design a single main tour through the museum that established certain thematic priorities, emphasized aesthetic aspects and generated lasting impressions through a harmony of objects and spaces.

Interaction between architecture and displays

Many of the historical spaces in the Neues Museum embody clear "directives" for arranging exhibits. The scenes from heroic legends painted on the walls of the Vaterländischer Saal, for example, are themselves exhibits, but also form a backdrop for other items in the gallery. The few vedute from imperial Rome that survived in the Römischer Saal now create a framework for exhibits from the Roman provinces, while the golden helmet with its band of astronomical ornaments has found an appropriate place in the Sternensaal.

The museological concept interacts with the architecture of the building. Chief thematic focuses occupy the ground-floor and first-floor galleries, which are also the most noteworthy because they preserve features of the original architecture and decoration. Further themed galleries are found on either side of the Archaeological Promenade on the lowest level and on the second floor. They contain a wider range of objects from the ancient Egyptian and the early and prehistorical collections respectively.

"Ägyptomanie – Ägytologie" ("Egyptomania – Egyptology"), housed in the Mythologischer Saal (Mythological Hall), introduces the Egyptian collection. Most of the original Egyptian-style decoration of this gallery has survived. It thus forms an appropriate setting for a display relating to the reawakening of interest in ancient Egypt in modern times. This "mood-setting" section is followed by the "Pharaoh" gallery, which provides a first encounter with masterpieces of Egyptian art, and by the "Geschichte Ägyptens" ("History of Egypt"), which comprises a set of twenty-five portraits from three millennia, with dates projected onto the walls. The middle of the Historischer Saal (Historical Hall) is taken up by three accessible tomb chambers from the third millennium BC, their elaborate stone reliefs preserving an image of life in this world for all eternity. The adjoining Ägyptischer Hof gallery, from which visitors can look down into the space housing the "Hereafter and Eternity" display, contains a brightly toplit series of temple reliefs to represent the presence of the divine on earth. On the first floor, the

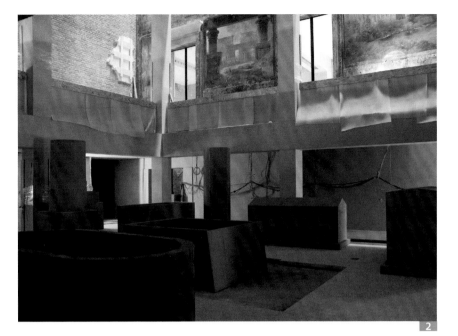

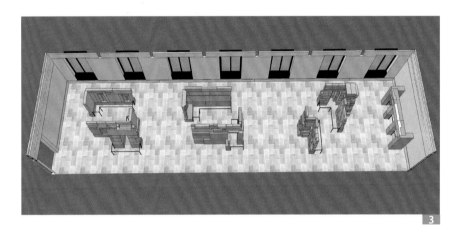

Griechischer Saal (Greek Hall) presents works of sculpture in the typological arrangement successfully tested in the Altes Museum, which used the same combination of natural and artificial light and the same glass cases and "cages" surrounding each sculpture. The Apollo Saal (Apollo Hall) forms a kind of prelude to the space containing the head of Nefertiti, which is the main attraction for most visitors. Teje (Tiye) and Amenophis III (Amenhotep III), both of whom paved the way for the Amarna period, guide visitors to a platform on which are gathered portraits of the royal family of Akhenaten, lit brightly from the glass ceiling. Their arrangement is the outcome of several adjustments made during the test run in the Altes Museum. Not without reason, David Chipperfield calls this gallery "The Sanctuary".

Nefertiti receives visitors in majestic solitude in the Nordkuppelsaal (Northern Domed Hall), at the intersection of extensive sightlines. Those who have advanced this far will have received at least a passing glimpse of the

2 Ägyptischer Hof. Trial arrangement using models of items from the "street of tombs". *Photo: Andrea Kroth. Source: DCA*

3 Historischer Saal. 3D computer simulation showing the position of the three Old Kingdom tomb chambers. *Source: DCA*

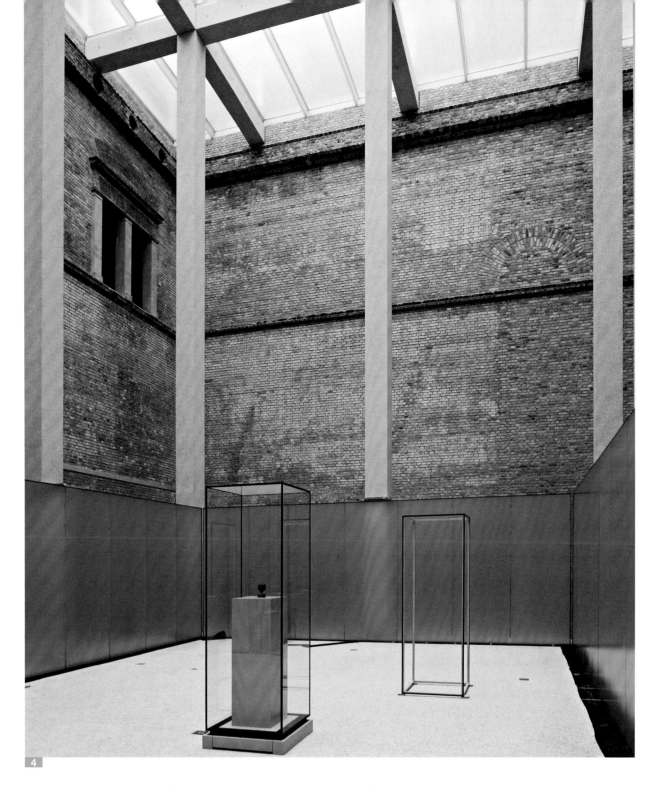

4

fascinating world of ancient Egyptian art. On leaving the royal presence to return to the staircase, they encounter the best-preserved gallery of the Neues Museum, the Niobidensaal (Niobides Hall). The dominance of its architecture and decoration prompted a restrained exhibition design. Long showcase tables flank the central axis. They contain, laid out on sliding boards, papyri and other text-bearing objects from four millennia, which form a "Library of Antiquity" encompassing Egypt, Asia Minor, ancient Greece and Rome, the Old and the New Testament, and items from the Arabian world.

The displays on either side of the Archaeological Promenade, on the lowest level, provide background information on the religion and culture of ancient Egypt and feature a unique presentation on ancient Sudan. This includes, on permanent loan from Sudan, temple reliefs excavated in recent years by a team from the Ägyptisches Museum and assembled to form entire temple walls.

Seventy years after its closure, the Neues Museum is taking up the threads of its illustrious past. Yet it is also breaking new ground, conceptually, in terms of its exhibiting style and with regard to some of its contents.

4 Platform of the Egyptian Courtyard (space 2.12), Amarna hall. *Photo: Johannes Kramer/BBR*

The Museum Island's Pathway to the World Heritage List

Norbert Heuler

UNESCO, the United Nations' organization responsible for education, science and culture, was founded by 37 states over sixty years ago. The 1972 "Convention Concerning the Protection of the World Cultural and Natural Heritage"[1] is one of the most successful initiatives in cultural understanding between the peoples.

The guiding idea of the World Heritage Convention is the "consideration that parts of the cultural or natural heritage are of extraordinary importance, and must therefore be preserved as part of all mankind's world heritage" (from the Preamble to the World Heritage Convention). Germany has been a contracting state since 1976.

The World Heritage List now includes 878 World Heritage sites from 145 contracting states.[2] In most cases these are cultural heritage sites (679), then a gradually increasing number of natural heritage sites (174) and finally some mixed cultural and natural sites. Article 1 of the Convention states that monuments, ensembles and sites of outstanding universal value are considered part of the "cultural heritage".

The World Heritage Convention is the first agreement aiming at a mutually agreed international protection status for cultural and natural assets. The World Heritage emblem illustrates the interplay between culture and nature: the central square is intended to symbolize a form created by man, while the open circle stands for the nature embracing the culture.

The 187 signatory states make up the general assembly, which meets every two years in Paris as part of UNESCO's general conference. It chooses the interstate World Heritage Committee from its midst. This decides once a year about World Heritage applications that are currently on the table on the basis of the World Heritage Convention and the "Guidelines for Implementing the Convention Concerning the Protection of the World Cultural and Natural Heritage", devised by the World Heritage Committee and constantly brought up to date.[3] The guidelines lay down the criteria for inclusion in the World Heritage List, but also those for putting inscribed World Heritage sites on the List of World Heritage in Danger, and for deleting them completely. The permanent World Heritage Committee administrative office is the World Heritage Centre in Paris, established in 1992.

A World Heritage site must meet at least one of the ten criteria listed under points 77 and 78 in the guidelines, and "to be deemed of outstanding universal value, a property must also meet the conditions of integrity and/or authenticity and must have an adequate protection and management system to ensure its safeguarding".

Applications to the World Heritage Centre for inclusion in the World Heritage List can be submitted only by the contracting states themselves. Before the application is made, the contracting state must submit a tentative list, on which the proposed sites are listed for a period of five to ten years. The World Heritage Committee decides about which of the proposed sites are to be included in the World Heritage List. It is supported in this by three specialist advisory bodies, the International Council on Monuments and Sites (ICOMOS), the International Centre for the Study of the Preservation and Restoration of Cultural Property (ICCROM) and the International Union for Conservation of Nature (IUCN). After the applications for cultural heritage sites have been submitted, ICOMOS experts undertake a detailed evaluation on behalf of the World Heritage Centre. As a matter of principle, the independent experts do not come from the contracting states involved. Finally, the advisory bodies' recommendations form the basis for the World Heritage Committee's decision about acceptance.

ICOMOS[4] is a non-governmental organization with its headquarters in Paris. The role of this council, established in 1965, is to promote the application of theories, methods and scientific processes to conserving the architectural and archaeological heritage. Its work is based on definitive papers, such as the International Charter for the Conservation and Restoration of Monuments and Sites (Charter of Venice)[5] of 1964, the Washington

Welterbe Museumsinsel Berlin

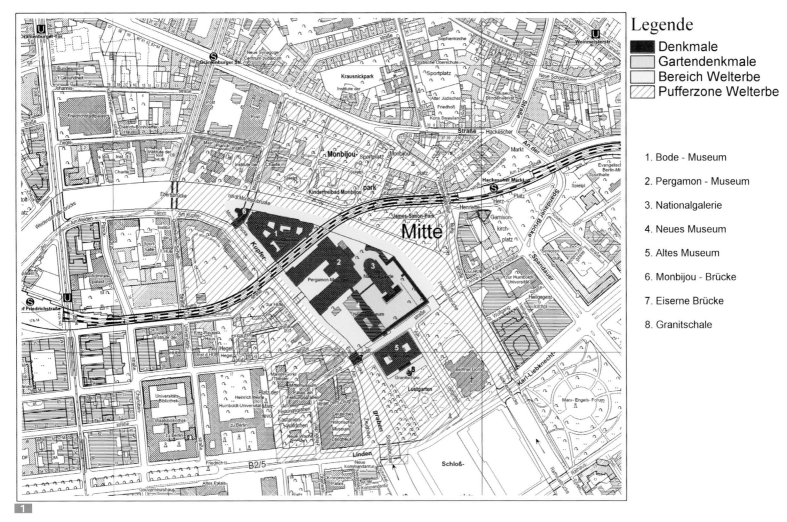

Legende
- ■ Denkmale
- ▢ Gartendenkmale
- □ Bereich Welterbe
- ▨ Pufferzone Welterbe

1. Bode - Museum
2. Pergamon - Museum
3. Nationalgalerie
4. Neues Museum
5. Altes Museum
6. Monbijou - Brücke
7. Eiserne Brücke
8. Granitschale

Charter on the Conservation of Historic Towns and Urban Areas[6] of 1987, the Lausanne Charter for the Protection and Management of the Archaeological Heritage[7] of 1990, the Nara Document on Authenticity[8] of 1994, and other agreements.

The international principles laid down in these documents agree that the authenticity of monuments and historical ensembles and that of their surroundings is to be preserved, that conservation enjoys the highest priority, that strict limits should be set on restoration aimed at preserving aesthetic and historical values, that hypothetical reconstructions are to be avoided, that all measures should be prepared and documented scientifically and across disciplines, and that they must be carried out expertly and have to be reversible. Among ICOMOS's special duties in the context of the Convention is to assess sites applying for inclusion in the World Heritage List, to monitor the state of preservation of cultural assets that are part of the World Cultural Heritage, to examine applications by contracting states for international support, and to offer advice and practical support for measures aiming at increasing capacities.

Application procedure in Germany

In the Federal Republic of Germany, culture and thus also the protection and care of monuments are a matter for the individual Länder (states), so nomination rights fall to them. At the same time, they are responsible for the financial obligations arising from a site's inclusion in the World Heritage List.

First of all, applications from the intended World Heritage site are processed in co-operation with the department responsible for monuments in the state concerned, and submitted by the appropriate state ministry to the office of the cultural ministers' conference. The permanent conference of the state culture ministers is responsible for all matters and for implementing the UNESCO Convention Concerning the Protection of the World Cultural and Natural Heritage. It puts all the proposals from the states together in a uniform German

1 Apart from the buildings, gardens and underground monuments of the Museum Island World Heritage site, a formal buffer zone was designated to protect the surrounding area. This was a first for a World Heritage site in Germany. *Source: Landesdenkmalamt Berlin*

tentative list, appoints delegates from Germany to the UNESCO World Heritage Committee and is responsible for reporting to the World Heritage Committee. The German quota of sites for nomination for World Heritage status chosen by the cultural ministers' conference is passed on to the World Heritage Centre in Paris by the state authorities via the office of the cultural ministers' conference, by the Foreign Office, which is responsible for Germany's co-operation with UNESCO, and by Germany's permanent representation to UNESCO.

The first German building to acquire World Heritage status was the Kaiserdom in Aachen, in 1978. As this happened at the World Heritage Committee's first meeting, it is one of the first twelve World Heritage sites world-wide. The most recent inscription was six Berlin Modernist housing estates in 2008.

The application process for the Berlin Museum Island

When the Berlin Wall fell in 1989/90 there were only eight World Heritage sites in the whole of Germany. The GDR did not join the World Heritage Convention until December 1988. It had prepared some applications, though five of them were not submitted until after the fall of the Wall. In 1990, the year of reunification, all the Berlin and Potsdam palaces and gardens in the (now former) GDR and in West Berlin were jointly entered on the World Heritage List.

An ad hoc working party of the cultural ministers' conference drew up the first tentative list of possible World Heritage sites for a united Germany. The working party consisted of four representatives of West and East German ministries, and a state monument conservation officer. The list included 13 potential World Heritage sites, including the Berlin Museum Island, and was confirmed and placed on the Federal German priorities list at the 261st plenary session of the cultural ministers' conference in Bonn in late 1992.

In December 1995 the World Heritage Committee held its 19th ordinary session in Berlin. The then urban development senator, Dr. Volker Hassemer, promoted the inclusion of the Museum Island on the World Heritage List in the course of a city tour.

The application to include the Museum Island[9] was made in 1998. Criteria II, IV and VI of the World Heritage guidelines were cited as a basis for application, with the following justification: "The Berlin Museumsinsel is a complex of buildings composed of individual museums of outstanding historical and artistic importance located in the heart of the city, and as such meets the World Heritage Convention's criteria for a cultural property.

The individual museum buildings erected in the course of the 19th century by the most renowned German architects form a unique complex that serves purely museological purpose and constitutes a town planning highlight in the fabric of the city in the shape of a kind of city crown. The Museumsinsel meets the following criteria in the Operational Guidelines for the Implementation of the World Heritage Convention in particular:

II. The Museumsinsel visibly documents the changing human values mentioned in the Operational Guidelines because it bears outstanding architectural testimony to the new institution of the art museum that began to emerge in Europe following the French Revolution as an important institution of middle-class self-perception. The Museumsinsel illustrates in addition – as seen from the chronological order of its individual museums – the change that the institution of art museum underwent from beginning of the 19th century up to the 20th, being first the central place of middle-class educational aspirations, then becoming a place of national identity and ultimately allying itself with the gesture of imperial power.

IV. At the same time the Museumsinsel is an outstanding architectural example of a type of building that testifies to an important stage in the development of human history. The different designs of the Museumsinsel's individual museum buildings illustrate in a confined space the typological development of the European art museum from a middle-class temple of education (Altes Museum) to a place of historical art studies and interpretation of history (Neues Museum, Nationalgalerie) and from there to the exhibit building of plain design which gives pride of place to the work of art exhibited (interior of the Pergamon Museum). Furthermore, the individual museum buildings harmonise so well with each other in design terms that the Museumsinsel presents the art museum as a building type in a unique architectural and urban design manner.

VI. Last but not least, the Museumsinel with its collections of works of art of world renown and its prominent buildings is a place of outstanding artistic significance."

The state of planning at the time for the individual buildings and the ensemble as a whole was explained and extensively documented in the appendices. An independent comparative report by Prof. Dr. Helmut Börsch-Supan was appended to the application, emphasizing the Museum Island's outstanding position in the German and European museum landscape.

Unlike earlier applications from the Federal Republic, a formal buffer zone to protect the surroundings was identified for the first time in the Museum Island applica-

UNITED NATIONS EDUCATIONAL,
SCIENTIFIC AND
CULTURAL ORGANIZATION

CONVENTION CONCERNING
THE PROTECTION OF THE WORLD
CULTURAL AND NATURAL
HERITAGE

*The World Heritage Committee
has inscribed*

Museumsinsel (Museum Island)

on the World Heritage List

*Inscription on this List confirms the exceptional
and universal value of a cultural or
natural site which requires protection for the benefit
of all humanity*

DATE OF INSCRIPTION
4 December 1999

DIRECTOR-GENERAL
OF UNESCO

2

the Stadtbahn viaduct, which runs across the island. Other eminent testimonies to Prussian history such as the Lustgarten, the Berliner Dom, the Zeughaus and the Magnushaus are in the area to the south and in front of the museum group, or on the banks opposite the Museum Island. As part of the buffer zone, they are subject to special requirements relating to areas surrounding World Heritage sites.

The World Heritage application was evaluated by ICOMOS in February 1999 by ICOMOS delegate Prof. Dr. Todor Krestev (president of ICOMOS Bulgaria). The boundaries of the buffer zone were changed as a result of the evaluation, and the application supplemented. The changed buffer zone was confirmed by senate resolution no. 2111/99 dated 20 April 1999. In his 1999 expert report,[10] Prof Krestev recommended that the Museum Island be placed on the World Heritage List on the basis of criteria II and IV:

"II: The Berlin Museumsinsel is a unique ensemble of museum buildings which illustrates the evolution of modern museum design over more than a century.

IV: The art museum is a social phenomenon that owes its origins to the Age of Enlightenment and its extension to all people to the French Revolution. The Museumsinsel is the most outstanding example of this concept given material form and a symbolic central urban setting."

The Museum Island is inscribed on the World Heritage List

The Museum Island was accepted at a meeting of the World Heritage Committee in Marrakech in December 1999. As well as the text explaining how criteria II and IV were met, taken from the evaluation document, the following recommendation by the Polish representative is recorded in the minutes of the meeting.[11] It addresses criterion VI again which had been dropped from the resolution version: "The observer of Poland emphasized that in this type of properties it was essential to maintain not only the values of the monumental buildings, but also to maintain the integrity of the museum collections."

The certificate for the Museum Island's inscription on the World Heritage List was handed over to the then governing mayor, Eberhard Diepgen, on 10 March 2000 by Dr. Koichiro Matsuura, the director general of UNESCO, in the rotunda of the Altes Museum.

The continuing monitoring of the condition of the listed World Heritage sites is one of the World Heritage Convention's most important tools. This is done by means of preventive monitoring, reactive monitoring and periodic reporting. The procedures for these are set out in the guidelines.

tion. This buffer zone, the surrounding urban space, which affects the Museum Island's appearance, was intended to ensure the visual effect made by the World Heritage site according to the guidelines.

The World Heritage site itself includes the five museum buildings, the Altes Museum, the Neues Museum, the Alte Nationalgalerie, the Bode-Museum and the Pergamon Museum, and also the colonnades and the Kolonnadengarten as a garden monument, the granite bowl, then also the Monbijou Bridge, the Iron Bridge and

2 World Heritage declaration by UNESCO. *Source: bpk/ SMB/Dietmar Katz*

Preventive monitoring for World Heritage sites in Germany is carried out once a year by the monitoring group of the German national committee of ICOMOS. It is intended to contribute to the avoidance and minimization of conflicts by early involvement and hints.

Reactive monitoring comprises all the procedures that concern intended measures which could affect the World Heritage site's universal value, no matter whether they are recommended by the site's own obligatory reports or result from information submitted by third parties. For an evaluation of such cases the World Heritage Centre itself or, on behalf of the World Heritage Committee, can ask the advisory bodies/ICOMOS to comment. Then, as a rule, foreign experts will be brought in.

The periodic reporting introduced in 1997 is carried out every six years. It includes an extensive questionnaire about the implementation of the World Heritage Convention in general, and about the individual German World Heritage sites. The first periodic report was made in 2006 for the older German entries. It will not be applied to the Museum Island until 2012.

1 Convention concerning the protection of the World Cultural and Natural Heritage, announcement in the Bundesgesetzblatt 1977, Bonn, 26 February, p. 213 (see also http://www.unesco.de/welterbekonvention.html)

2 World Heritage List: see http://whc.unesco.org/en/list

3 Guidelines for implementing the Convention Concerning the Protection of the World Cultural and Natural Heritage: www.unesco.de/welterbekonvention.html

4 ICOMOS International: see www.icomos.org; ICOMOS Germany: see www.icomos.de

5 Charter for the Conservation and Restoration of Monuments and Sites (Charter of Venice) of 1964, in: Denkmalschutz. Texte zum Denkmalschutz und zur Denkmalpflege, Schriftenreihe des Deutschen Nationalkomitees für Denkmalschutz, volume 52, Bonn 2007, pp. 43–45

6 Washington Charter on the Conservation of Historic Towns and Urban Areas of 1987, in: loc. cit., pp. 163–164

7 Lausanne Charter for the Protection and Management of the Archaeological Heritage of 1990, in: loc. cit., pp. 175–178

8 Nara Document on Authenticity of 1994, in: loc. cit., pp. 233–235

9 Text of the Museum Island application to be listed as a World Heritage site, published under Nomination file: http://whc.unesco.org/en/list/896/documents/

10 Text of Todor Krestev's evaluation, "Advisory Body Evaluation", published under http://whc.unesco.org/en/list/896/documents/

11 Minutes of the World Heritage Committee meeting in Marrakech in 1999, Decision, Report of the 23rd Session of the Committee, published under http://whc.unesco.org/en/list/896/documents/

Further information about the Museum Island in Berlin can be found on the German UNESCO Commission website: www.unesco.de/315.html?&L=0

⇒ Photos pages 74/75:
Eastern Kunstkammersaal (space 3.02) in November 2004 and in January 2009. *Photos: Johannes Kramer/BBR*

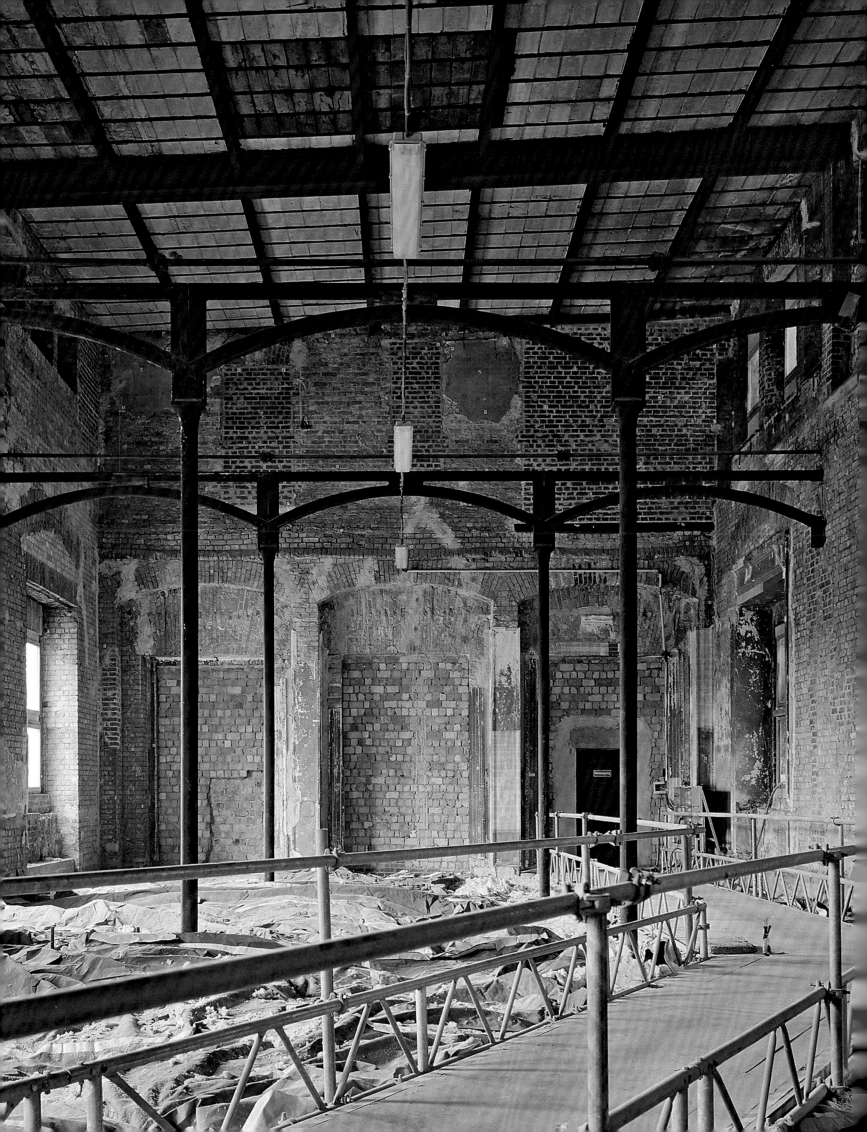

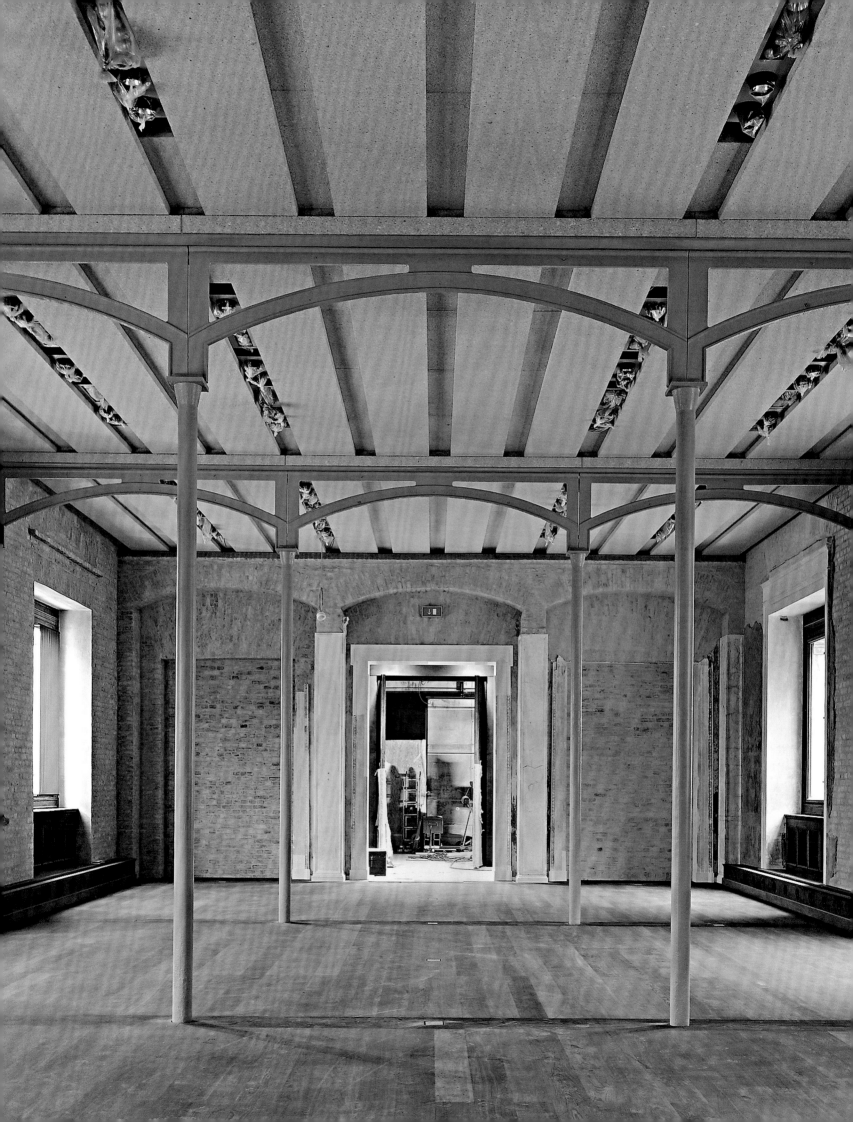

Organization – Co-operation – Process

EVA MARIA NIEMANN

discussion surrounding the treatment of the historical fabric of the Neues Museum that demanded, right from the start, a degree of co-operation going beyond institutional spheres of competence and being oriented towards factual and technical issues. Furthermore, the impressive ruins of the Neues Museum, even though in places reduced to a brickwork shell, still testified to the vision shared by Friedrich Wilhelm IV and his like-minded architect Friedrich August Stüler and director general Ignaz von Olfers. Their common goal was to build an ideal museum on the basis of a royal master plan and the latest advances in structural techniques and materials. Despite the most adverse circumstances – from an unstable foundation soil to the March Revolution of 1848 and the intransigence of Widow Levy – their vision was realized between 1841 and 1859. The royal building commission secured the input of Prussia's most innovative and creative minds, including the architectural theoretician Carl Boettcher, the mechanical engineer and designer August Borsig and site manager Carl Wilhelm Hoffmann. Any planning and construction process organized to meet contemporary needs must uphold this same tradition.

The planning process was structured and moderated by the Federal Office for Building and Regional Planning and steered with the assistance of a project controller. Tried-and-tested instruments tailored to the particular

The organizational procedures and terms of reference for building measures implemented by the Stiftung Preußischer Kulturbesitz (Prussian Cultural Heritage Foundation) are comprehensively regulated. The Federal Office for Building and Regional Planning assumes the role of principal on behalf of the Foundation and is thereby able to draw upon its many years of experience in bringing construction projects to fruition within budget, on time and to the required standard of quality. The decision-makers and decision-making bodies are determined and the involvement of the future user, in this case the Staatliche Museen zu Berlin, and the relevant authorities in the planning process is ensured.

The necessary work and co-ordination levels have to be more closely defined from measure to measure – in particular in the case of the Museum Island master plan, which embraces five museums and the James Simon Gallery as the sixth building. Lasting several years, the process must be tailored to the respective demands placed upon planning. Alongside the unique nature of the rebuilding project itself, it was undoubtedly the controversial

TOPIC III

1 User workshop in the Vestibül in front of the staircase hall, May 2008. *Photo: Johannes Kramer/BBR*

2 Jour fixe no. 54 in the Griechischer Saal, September 2006. *Photo: Johannes Bennke/DCA*

nature of each project were employed to control costs, deadlines and quality standards. In the case of construction measures supervised by the Federal Office on the Museum Island, the involvement of the Berlin State Conservation Office is obligatory. The flow of information was guaranteed by monthly steering and information meetings at the work level, and results were presented at regular workshops and *jours fixes*. Over the course of the project, the planning team came together in altogether 160 steering meetings and the same number of information meetings. The decision-makers were involved in a large number of on-site briefings and in approximately 80 presentations.

Guided tours of the construction site, symposia and lectures ensured exchanges extending beyond the bounds of the project. Not least, the general public was offered regular opportunities to follow the progress of building on Open Heritage Days and Open Days, as well as at the official start of construction in summer 2003 and at the topping-out ceremony in September 2007.

The planning process was accompanied by pronounced public interest and sometimes by massive criticism, ranging from petitions to highly publicized protest actions right up to calls for a referendum. However, the reconstruction project received the energetic support of the "Friends of the Neues Museum", who dedicated their efforts in particular to the restoration of the original artistic décor and thereby added unexpected highlights to the reconstruction process. Thanks to their commitment, it was possible amongst other things to secure the original model of the Schievelbein frieze and to install the two colossal statues in the south cupola and an informative virtual presentation of the reconstruction in the Lapidarium.

"Plea for a complementary reconstruction" – Guidelines

In 1990 fundamental differences of opinion regarding the evaluation of the surviving historical building fabric and regarding the building's future use made it necessary to convene a commission of experts. With the aid of this commission, the decision-makers were able to steer focus away from broader controversy over issues of heritage conservation and back to the specific nature of the task in hand. The commission faced the difficult task of drawing up, within a short space of time, the principles of conservation to be applied to the reconstruction of the Neues Museum. After two years, in 1992 the commission summarized its conclusions in the *Plädoyer zur ergänzenden Wiederherstellung* ("Plea for a complementary reconstruction"). By clarifying levels of importance, it was possible to formulate central conservation aims which were to serve as the foundation for the subsequent treat-

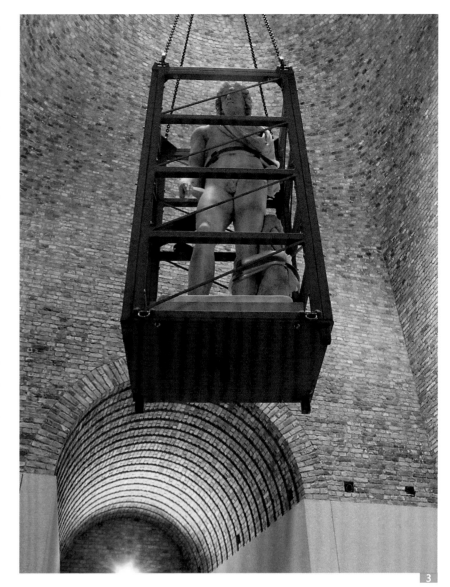

ment of the surviving fabric of the historical monument, under due consideration of the irreparable losses it had already suffered. These principles were incorporated into the process of selecting the architect and into the forward planning for the locations of the state museums in East and West Berlint. The *Plädoyer* thus contributed towards bringing together the archaeological collections on the Museum Island and to the design of a sustainable usage concept.

With the appointment of the architect David Chipperfield, working in close collaboration with the restoration architect Julian Harrap on issues of conservation and restoration, the principles laid down in the Plädoyer could be carried a stage further. As a first step, Julian Harrap drew up guidelines based on the Venice and Burra Charters. Concrete conservation aims were formulated with a view to the complementary rebuilding of the Neues Museum in the context of the four other existing buildings

3　Helios "floating in" through the south dome, September 2007. *Photo: Torsten Weiß*

on the Museum Island. The glossary of terms relating to conservation theory and restoration techniques, included here in the Appendix, proved to be particularly helpful. Over the further course of the project, the vocabulary thus made available facilitated agreement over the measures planned. The conservation guidelines were presented to the decision-makers in February 1999 and approved in March 1999.

Assessment of the historical building fabric – Restoration strategies

Archival research, assessment of the extent of historical building fabric and its state of conservation, technical investigations and not uncommonly pure research stand at the start of any proposed restoration project. In consultation with the Federal Office, which until 2001 was in charge of construction and stabilization measures, the Berlin State Conservation Office – on issues of monument conservation – and the Staatliche Museen as future user, strategies were developed to preserve Stüler's original design together with the layers superimposed upon it. Bearing in mind the outstanding heritage value of the Neues Museum within the overall ensemble of the Museum Island, the surrounding space, the façades and the decorative features and state of preservation of each individual room were examined with regard to the building's future use as a museum. In September 1999 Julian Harrap combined the results into so-called restoration strategies.

The next step saw the prudent assessment and careful analysis of the damage to the building fabric resulting from decades of neglect. With the transfer of responsibility for the building to David Chipperfield Architects, the stabilization measures already initiated were driven forward. This was accompanied by investigation campaigns devoted above all to structural issues of statics and technical questions of restoration. Preliminary assumptions were confirmed by tests relating to the restoration of the surviving building fabric, the revival of old craft techniques and the development of contemporary methods. To support the planning team, the services of materials experts, surveyors and scientists were engaged amongst other things to research the provenance of materials and aggregates and to calculate the load-bearing capacity of the clay-pot ceilings.

Spatial function and aesthetic design – Aims of the restoration concept

All measures were clearly illustrated by means of plans and models of the main rooms and sections of the Neues Museum. Together with the detailed mapping of the

surviving historical building fabric and its areas of damage, the results of the investigation campaigns and tests were delivered in a continuous flow. Using digital technology, the layouts of the walls, the ceilings as seen from below and the floors, and later wall paintings and architectural decoration, were "virtually" conserved and restored. Brought to life in the same manner were those areas of new construction designed to restore the building to its original volume, as well as the planned interventions in those sections surviving in a damaged state, such as the central stair hall and the two courts.

On the basis of surveying images and a comparison of the building in its existing state with plans for its future, a concept was elaborated, setting out the goals of restoration from the point of view of spatial function and aesthetic design. By progressively narrowing down appropriate conservation and restoration methods, it was possible to name the further investigations and decisions required. All findings were brought together in the restoration concept in August 2000 and approved by the decision-makers in May 2001.

Building upon this, detailed descriptions of the planned aesthetic impact and of all construction and restoration measures were drawn up and agreed with the

4 Successful interaction between existing and new construction in the Ägyptischer Hof. *Photo: Johannes Kramer/ BBR*

5 Handmade bricks from the original building period were used for lost parts of the building and façades. *Photo: ARGE Rohbau Neues Museum Berlin, Dywidag Bau GmbH/Dreßler Bau GmbH*

Federal Office, the State Conservation Office and the user. Small working groups discussed questions of principle and explored individual issues in greater depth. Numerous sets of samples were prepared and inspected on the building site. Briefings on site and joint excursions devoted to particular topics were particularly helpful for understanding how the concept would be implemented. In summer 2002, for example, the issues of façade design and the restoration of the architectural silhouette were spotlighted in a combined tour of Berlin and Potsdam, which visited built examples of a technically "correct" restoration of polychrome plasterwork and an abstracted imitation in the language of our own day. The material properties of traditional lime slurries, as used for the Belvedere on Pfingstberg hill in Potsdam, offered a particularly convincing means of blending the new areas of façade with the original plasterwork façades still in situ. Handmade bricks were confirmed as an appropriate material with which to fill in and replace missing parts of the building and façades. The choice thereby fell upon bricks reclaimed from other destroyed buildings of the same epoch, with "Rathenow red" and "Birkenwerder yellow" being selected for their shape and colour.

The exploration of the bounds and possibilities of retouching and adding to historical works of architecture began in spring 2003 with a joint visit to the Pompejanum built by Friedrich von Gärtner between 1839 and 1850 in Aschaffenburg. Lastly, an impressive picture of David Chipperfield's typical language of materials and forms was conveyed by a visit to the Museum of Modern Literature in Marbach in spring 2006.

Realization – Planning of restoration measures, coded plans and webpage

The conference on developments and trends in restoration aesthetics, held by the German national committee of ICOMOS in Munich in May 2003, played not a minor role in enabling the proposed measures to be set out in greater detail. Under the moderation of Prof. Wolfgang Wolters, an expert with in-depth knowledge of the Neues Museum, individual topics were aired, unresolved points presented, contradictions identified and concrete solutions approved. Using Photoshop presentations, the degree of conservation, consolidation and completion and the use of retouching were simulated as accurately as possible. The results were incorporated into the restoration programme and translated into the planning of restoration measures. A catalogue of specialist cleaning and working techniques was correspondingly drawn up and provided the basis for the specification.

A useful tool was provided by coded plans, drawn up in this detail for the first time, which linked the catalogue of work techniques with the measures to be carried out and localized these within the site. Work proceeded with and upon the basis of these plans from tendering to final accounting. Their updating to include the input of the restorers means that they provide comparable documentation of all the measures carried out on the historical building fabric. Due to their authenticity and clarity of expression, these plans were featured in an exhibition on the Neues Museum in Sir John Soane's Museum in London in summer 2008.

Particular mention should also be made of the selection of suitable restorers, who are the true guarantors of the successful execution of the planned measures. In order to convey the wealth and complexity of the work that lay ahead, a webpage was specially created in order to offer potential suppliers an insight into the type and scope of the restoration tasks to be carried out. It presented the services required from the various professional trades within each storey, section of the building and group of rooms. At the same time, the overall concept was presented and restorers were encouraged to form associations.

Restoration services are not generally governed by standardized guidelines such as technical rules and industrial norms. There are no universally valid recipes for preserving the substance in historical buildings. A case in point is the continuing potential threat of damage posed by the salt load in the masonry work and by the clay-pot ceiling, for example. A colloquium organized in summer 2004 to address this problem, however, contributed towards weighing up the acceptable risks in favour of preserving the existing building fabric.

6 Existing and new parts of the building are perfectly matched – a view of the south façade with new corner projection. *Photo: Johannes Kramer/BBR*

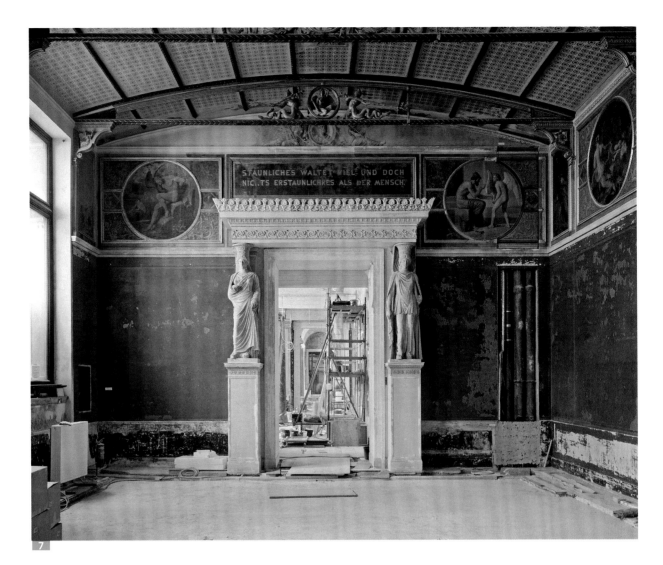

7 The Niobidensaal: South wall during restoration in March 2008. *Source: DCA*

8 The Niobidensaal: DCA_ProD plan of measures for the south wall ("Fähnchenplan"). *Photo: Johannes Kramer/BBR*

Identifying a suitable method of restoring and putting back in place the badly damaged ceiling paper in the Mythologischer Saal posed a similar problem. A strategy was only worked out in spring 2006, after several series of tests, during a colloquium of restorers convened especially to examine the restoration of the wallpaper.

Stipulation for handling the historic monument – User manual

In the discussion rounds, the on-site meetings and colloquia on individual issues, the Staatliche Museen had an early opportunity to bring their own expertise to the project. Experience from the Neues Museum rebuilding and restoration project shows that, knowing the problems and risks, the archaeological collections in particular are ready to accept modifications to their use. The decisions taken in favour of the conservation of the historical building fabric thus reflect the museums' understanding of their role as the guardians of cultural assets. For greater convenience, a user manual was presented that describes how to make responsible use of the heritage site. In addition to monitoring, regular maintenance and the observation of care instructions, maximum limits with regard to loads and lighting must be borne in mind in the day-to-day running of the museum.

In conclusion, it remains to be stated that, despite massive public hostility, those involved in the planning were always ready to keep faith with David Chipperfield's and Julian Harrap's concept. The fact that this was achieved is due first and foremost to the working methods of David Chipperfield and his team, characterized by analysis, in-depth expertise and a discursive approach.

At the instigation of the ICOMOS monitoring group, in June 2008 a resolution was passed by all German regional archaeologists and monument conservationists that expressly supports the rebuilding and restoration concept. 15 years after the publication of the "Plea for a complementary reconstruction", the completion of the Neues Museum demonstrates the resolute implementation of these principles of conservation. Even those who were unable to participate in the planning process will be delighted with the end result.

9 Group photograph of user workshop, June 2008. *Photo: Johannes Kramer/BBR*

Historical Building Fabric and Contemporary Usage

GERHARD EISELE | JOSEF SEILER |
KLAUS STEFFENS

Means and implementation of verification management for listed monuments

Historical building materials and supporting structures in most cases fall outside the scope of current methods of verification, which – calibrated to modern construction methods – are not directly transferrable. Architectural elements with "history" bear marks of time that need to be monitored and interpreted, and which reveal causes of damage and consequently a starting point for the planning of restoration measures. When compared with computational predictions of their load-bearing capacity, which can only be approximative, masonry vaults and related structures in particular often have exceptional load-bearing reserves that as a rule can be mobilized with the aid of experiment-based investigations. A further fundamental consideration when building within historical structures are the interim states of construction, which in the Neues Museum in particular often had a decisive influence upon the forms of construction chosen.

Latest iron technology and antique lightweight construction

Although the Neues Museum resembles a solid construction from the outside, in its interior the latest iron technology of the day was sympathetically combined with an antique lightweight construction. The extremely well-organized and systematized erection of the structural shell could also serve as an example to many a modern building site. Respect for this unique testimony to industrialized construction demanded that every effort was made to conserve the historical elements and, if possible, indeed to reinstate them within their original role.

First indications of subsidence damage appeared only shortly after the museum was opened. Settlement activity would ultimately reach 40 cm at its worst point! In the course of the Second World War, the central stair hall was destroyed in 1943 and the northwest wing, the Ägyptischer Hof (Egyptian Courtyard) and the southeast projection in 1945. Parts of the building were subsequent-ly exposed to the elements for over 40 years. Not until the middle of the 1980s was the decision taken to rebuild the museum, but first of all a large-scale removal of damaged sections of the building was undertaken.

Work was begun on stabilizing the foundations and the surviving construction even before German reunification. The installation of c. 50,000 continuous metres of piles and afterwards the execution of the new foundations were carried out, with interruptions, from 1988 to 1994. By 1996 the building, greatly damaged by weathering and subsidence, had been made safe. The planning of the reconstruction began in 1998 and the first building measures were implemented five years later. What follows here is a discussion of selected aspects of the work carried out by the structural engineers on the historical building fabric during the planning of the reconstruction. The use of ground freezing for groundwater control and soil support is the subject of a separate article.

In the case of the Neues Museum, those planning the supporting structure set themselves the challenge of retaining, with as few changes as possible, the unique, listed construction while at the same time meeting the requirements of the user. Tasks of this kind can no longer be carried out by a single engineer or indeed even by one engineering company. Instead, it is necessary to secure the input of a series of specialists in various fields of expertise. Some of the historical construction systems defy formal evaluation solely on the basis of existing methods of calculation or books of regulations. For this reason it was necessary to consider from an early stage the use of experimental methods to back up computational evaluation of the safe load-bearing capacity of the historical elements. The verification methodology was set down during the planning stage and, with regard to the experimental part, was subsequently implemented by the structural engineering company Ingenieurgruppe Bauen in collaboration with Prof. Steffens Ingenieurgesellschaft mbH (PSI) and with the participation of the Institut für Experimentelle Statik at the Hochschule Bremen. Due to the complexity of the

relationships between the individual construction stages, the planning of the excavations and of the intermediary states of construction was drawn up not by the construction companies as is normally the case, but by Ingenieurgruppe Bauen. The specialist engineering firm of Dr. Orth was brought in to plan and supervise the temporary freezing of the underpinning, as described in greater detail in the next chapter.

It became apparent even during the pre-planning phase that, in the case of a number of parts of the building, reliable results could not be yielded by computational analyses alone. For this reason, investigation programmes were developed at a very early stage for the additional experiment-based evaluation of load-bearing capacity in the case of the clay-pot ceilings, limestone columns and historical cast-iron girders, with the aim of establishing the performance parameters of the surviving construction and of avoiding static reinforcement measures if possible. In the event that the requirements of individual areas would prove impossible to meet, it was agreed with the extremely knowledgeable and cooperative user that in isolated cases the planning of the display could be adapted to the particular situation. With a modern facility management system, this should be perfectly possible.

Problems affecting the foundations and remediation measures

In accordance with its location in the Berlin-Warsaw glacial valley, the foundation soil in the region of the island in the river Spree is characterized by unstable Holocene inclusions in the load-bearing Pleistocene layer. Of all the buildings on the Museum Island, the Neues Museum is particularly affected by such inhomogeneity. From its southeast to the northwest corner, the stable subsoil falls away to a depth of some 25 m below the lower edge of the foundations (fig. 1).

The museum's original builders were already aware of this fact and sought to counter the problem by founding

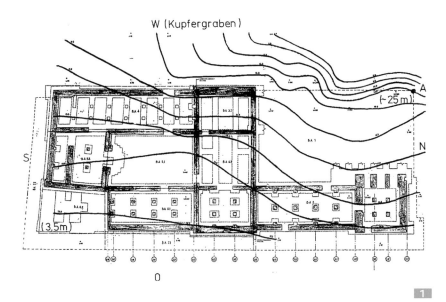

the structure on wooden piles. As these wooden piles were only of limited length (no more than 20 m), the northwest area of the site rested on "floating" pile foundations (fig. 2). The resulting uneven rates of settlement meant that damage started to appear only shortly after the opening of the museum and required remediation measures.

This was compounded by the lowering of the ground-water level on several occasions over protracted periods of time during the construction of neighbouring buildings (the Pergamon Museum in around 1910, the Palace of the Republic in the 1970s). As a consequence, the wooden pile foundations and the pile foundation grill above it were invaded by parasites, triggering an irreversible process of rot in the grill and the pile tops.

Remediation of the foundations

By 1990 a foundation slab resting on piles in the area of the former northwest wing had already been built and the foundations of the adjoining walls replaced. After German reunification, the task of continuing these remedial measures was entrusted to the Ingenieurgruppe Bauen.

The first task was to assess the existing structural method of load transfer from masonry to the new piles. During the GDR era, a "high-tech" system of steel block dowels and pre-stressed steel tension rods was installed. This caused high peak stresses in the historical masonry, however (fig. 3). The Ingenieurgruppe Bauen suggested instead a "robust" construction that in total demanded less drilling into the historical building fabric, could be carried out using normal structural steel and creates lower stresses in the historical masonry (fig. 4).

After weighing up constructional and economic points of view, the newly proposed robust construction was adopted for the remaining walls. The piles used are

2 "Floating pile foundation": crack formation on the walls due to uneven setting. *Drawing: Ingenieurgruppe Bauen*

1 Contour lines indicating the depth of the stable subsoil, which lies between approx. 3.5 and 25 m below the foundations. *Drawing: Ingenieurgruppe Bauen*

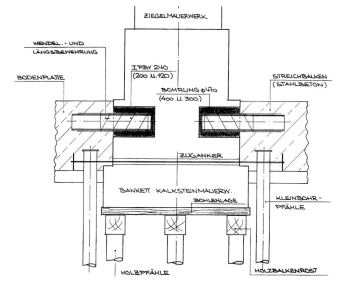

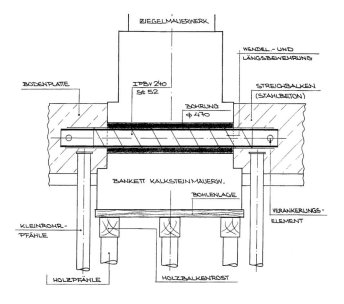

building fabric. These measurements continue to be made today with an appropriately modified measuring programme. By comparing measurements at significant points against the process of construction, the following findings were obtained:

- Settlement activity was temporarily and unavoidably increased during drilling.
- These instances of settlement activity were ones that would have occurred "uncontrolled" over the course of time.
- The movement mechanisms of individual parts of the building, resulting from damage already present in the edifice due to the inhomogeneous nature of the foundation soil, were revealed in the course of drilling work. They served as the basis for the formulation of measures to stabilize the building fabric.
- After the construction of the foundation slab, identical settlements were measured on the foundation slab and the walls, which proves that the load-transfer system is effective.
- Further instances of settlement occurring after the hardening of the foundation slab are small. Differential settlements anticipated between neighbouring points are acceptable and can be absorbed by the building above.
- It must be ensured throughout the rebuilding project that the balance of settlements and deformations currently achieved is preserved.
- The possibility of minor local damage owing to differential settlement cannot be excluded.

Stabilizing the building fabric

The measures to stabilize the construction of the museum were designed and executed at a point in time when no overall plan for the reconstruction of the entire building had yet been conceived. For this reason the planning and implementation was carried out on the principle that the historical building fabric should be made safe in its current state without thereby placing limitations upon a reconstruction. As far as possible all new measures had to be reversible or compatible with a reconstruction.

The most urgent step was to stabilize structurally significant cracks that threatened the overall stability. After settlement activity had abated, the cracks at the joins that had appeared between individual shear walls and parts of buildings as a result of subsidence were bridged, reinforcing walls that had come away were incorporated into the overall structure and, where structurally necessary (for protection against weathering), smaller, statically less significant cracks were repaired. Finally, the ability of the surviving ceilings to support human traffic had to be investigated and guaranteed for the interim period.

small-bore piles as composite piles (steel tubes and reinforced concrete), which were manufactured as a special construction in East German times and after the reunification as tubular piles with building inspectorate authorization. Between 1990 and 1994 a total of 2568 piles with lengths of 9 to 32 metres were put in place, altogether adding up to some 50,000 continuous metres.

Settlement measuring and structural stabilization

Parallel to the work being carried out on the foundations, extensive measurements were taken in order to monitor the movement of the building during the works and if necessary to be able to stabilize, should more significant movement – caused by drilling – be detected. After German reunification these measurements were systematically evaluated with regard to making safe the surviving

3 Load-transfer construction "high-tech".
Drawing: Ingenieurgruppe Bauen

4 Load-transfer construction "robust".
Drawing: Ingenieurgruppe Bauen

Aspects of support structure planning during rebuilding

In the wake of the Industrial Revolution in Great Britain, the use of iron formed a characteristic feature both of the construction and the architectural design of the Neues Museum, one of the first prestigious buildings in Berlin to use this construction material. As one was aware of the problematic subsoil, efforts were made to minimize the building's self-weight. To this end, masonry ceilings of so-called clay pots were used.

The large majority of the surviving ceilings were in astonishingly good structural condition considering the history of the building. Highly problematical were several sections of ceilings where the exposure to the weather had led to damage to the building fabric or where the removal of lateral structural supports had caused considerable deflection in the centre.

It was the user's wish that all ceilings should fulfil modern-day requirements and be able to support traffic loads of $p = 5\,kN/m^2$ in line with DIN ($=$ German industrial norm) 1055. Rough calculations and references found in documents of the day imply that service loads of $200\,kg/m^2$ ($2\,kN/m^2$) were considered adequate at that time.

The goal was to preserve the historical structural elements as a monument to past building techniques and to restore them as faithfully as possible to their original function, while at the same time fulfilling the wishes of the user. Since the preservation of the historical construction was granted priority, in some cases it would have been possible to adapt the exhibition concept to the particular situation.

It was possible to evaluate the components of the supporting structure, in particular large parts of the iron framework, with current verification concepts. The results showed that, from a modern-day perspective, in places they have considerable residual load-bearing capacity vis-à-vis the loads originally envisaged.

Evaluation of the load-bearing capacity of the clay-pot ceilings

The original ceilings were vaulted using a technique borrowed from antiquity and employing cylindrical, hollow bodies of clay, sealed at both ends, referred to in the language of the project as "clay pots", which are laid in gypsum mortar. It was thereby possible to achieve extreme light area weights with astonishing load-transfer capacities. The clay pots, manufactured with side walls and lids only approx. 7–10 mm thick, were employed with a connecting matrix of gypsum mortar as "bricks" for various purposes. This type of construction was used for instance for flattened cupola vaults, in which flattened

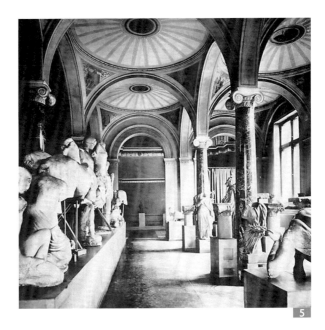

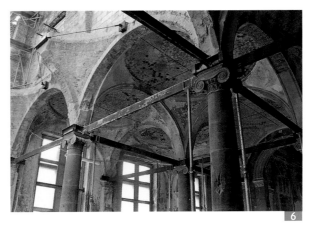

domes of c. 4.5 m diameter (figs. 5, 6) rise between transverse arches and spandrels of masonry, for barrel vaults with spans of 5–6 m, and flattened barrel vaults between steel girders.

Statics analysis

First of all, the stresses in the existing ceiling systems built with clay pots (flattened cupola vaults, barrel vaults and flattened barrel vaults) were estimated on the basis of preliminary calculations. For this it was necessary to make suppositions with regard to material characteristics, such as the modulus of elasticity, loading capacity and systemic rigidity. All the sources found in the literature were consulted for this purpose: the findings from a historical loading test on a single-span vault and partially surviving test reports by the direction of works on test bodies of original pots and various mortars were compared with the results of a calculation based on the three-dimensional model following a calculation method with so-called finite elements (FE model) (fig. 7). On the basis of parameter studies on partial systems

5 Flattened-cupola vault of clay pots in the Flachkuppelsaal, historical photograph. *Source: Ingenieurgruppe Bauen*

6 Flachkuppelsaal, its condition prior to restoration. *Photo: Ingenieurgruppe Bauen*

with clearly observable static stresses, the suppositions thus extra-polated for the material characteristics were varied and the results of these calculations evaluated.

The following fundamental statements were possible:

- The greatest stresses on the clay-pot ceiling systems are found in the barrel vaults. The stresses in the flattened-cupola and flattened-barrel ceilings are substantially lower.
- Due to the relatively low self-weight of the ceilings, effects of stress from service loads can be observed from span to span, in particular in the case of the multi-span systems of the barrel vaults transferring primarily along a single axis. The limits of possible service loads are given not by the high strength of a rigidly supported single vault as theoretically calculated and also as confirmed in the historical test, but by the deformation behaviour of the system as a whole.
- The load-bearing behaviour of the clay pot/mortar matrix is interpreted as the combined action of two load-bearing effects: the membrane load-bearing effect of the relatively hard upper and lower ceiling layers of pot lids in conjunction with mortar, and the more yielding "honeycomb" structure found in the ceiling interior and formed by the tubular pot walls and the mortar matrix surrounding them. Even with pot lids missing, it is possible for the honeycomb system alone to carry the load with more pronounced deformations.
- Without experimental investigations, the calculation of service-load potential would have had to be based on only conservative suppositions, which in turn would have permitted only limited utilization of the museum.

Experimental investigations

Based on the findings of the statics analysis, a programme was developed to estimate the load-bearing capacity of the clay-pot ceilings:

- Tentative experiment on an existing four-span barrel vault in situ for the purpose of system identification;
- Basic investigation conducted on small test bodies followed by more detailed computational analysis ;

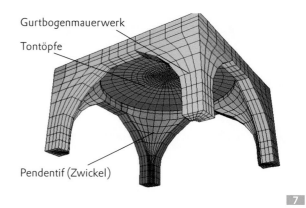

Gurtbogenmauerwerk

Tontöpfe

Pendentif (Zwickel)

- Loading test on a newly-built test vault
- Development of a suitable calculation model; static evaluation of all clay-pot systems;
- Confirmation of the calculation model and thereby of the load-bearing capacity through stress tests at selected points;
- Inclusion of the plaster screed present on the original ceilings within the investigation of load-bearing capacity and of its contribution to this latter in the ceiling areas to be newly built.

Tentative experiment on an existing four-span barrel vault

A four-span barrel vault with span widths of approx. 6 m was chosen for the tentative experiment. Through reciprocal loading of two spans, it was possible to check the parameters of stiffness of the overall system, deformation behaviour, modulus of elasticity of the clay pot/mortar matrix, torsion of the transverse arches, effect of continuity and two-axis loading (fig. 8).

Mobile loading frames with load-distributing apparatus were used to produce experimental loads from span to span. On-line measurement software and an accompanying sound emission analysis (SEA) guaranteed that the experiment was conducted without causing any damage. From the measurements of deformation and inclination, it was possible to abstract the system for a back-analysis with finite elements.

Basic investigation conducted on small test bodies

Alongside the conservation and repair of the surviving ceilings, it was planned to augment the two surviving spans of a barrel-vault system originally extending through seven spans by five new clay-pot spans built in the original manner (fig. 9). For this it was necessary to select both clay pots and gypsum mortar recipes of a kind that largely correspond with the historical original both in their mechanical properties and in their finished appearance. To this end, some 30 small test bodies of different "pots" and mortars were examined

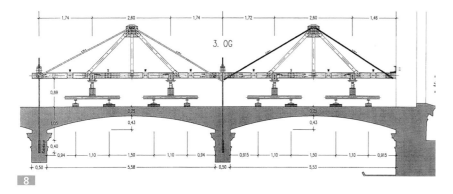

8 Loading experiment on historical barrel vault, schematic. *Drawing: Ingenieurgruppe Bauen/PSI*

7 FE model of the flattened-cupola vault: basic system with transverse arch and pendentive from below. *Image: Ingenieurgruppe Bauen*

under laboratory conditions in various combinations and under various types of load. For calibration purposes, SEA was also conducted on the small test bodies at this early stage. The materials eventually employed were chosen on the basis of the findings obtained.

Through these experiments and their accompanying computation on the refined model with the law of elastic-plastic material, it could be shown that a redundant load-bearing system is present. After the failure of the rigid external disc (i.e. the pot lid falls off), the load is diverted – with a corresponding increase in deformation – to the honey-comb structure of pot walls and mortar in the interior cross-section (fig. 5).

Test vault

Since no historical vault was available for testing up to critical load, a new, full-scale two-span test vault was built in-house for the purposes of trials. It was thereby also possible to test construction methods and work sequences etc. The test vault was investigated first without and then with an additional, jointly load-bearing screed. In the course of the second measurement campaign in-corpo-rating the static effect of a screed, load-bearing tests were continued until collapse. The results served to complement the calculated values for the existing vault spans and those to be planned, and lastly made it possible to demonstrate sufficient load-bearing capacities for museum use. After inclusion of the existing historical undercoats in the computations, loading in the region of the live load of $p = 5.0\,kN/m^2$ desired by the user is possible. The reinforcement or strengthening of those historical ceilings that had survived without their original floor structure, namely by the application of a bonded screed, was adopted as a constructional concept into subsequent planning.

Building a barrel vault of clay pots on lagging. *Photo: Ingenieurgruppe Bauen*

Evaluation of the load-bearing capacity of limestone columns

Columns of different types of natural stone (sandstone, limestone, marble) were employed in the central axes of the individual exhibition rooms. In addition to their self-weight, the columns receive substantial service loads from the operation of the museum and in places heightened loading as a consequence of the building of an additional storey below the roof, housing the technical systems. Of importance in this regard was the condition of the individual column components which, being made of materials not necessarily suitable for external use, had suffered the effects of weathering due to their prolonged exposure as an unprotected ruin. Thus the columns with capitals and bases of Carrara marble and shafts of lime-stone, such as those found in the Bacchus Saal and the Moderner Saal, had to be examined in closer detail. Eight columns still stand in their original position (figs. 10, 11). Two undamaged and four broken columns had been stored in pieces in the depot. By way of example, we shall describe the examination of the column shafts.

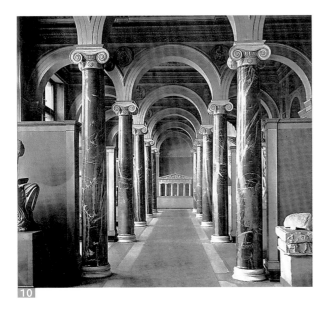

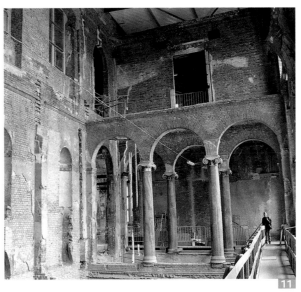

10 Moderner Saal, historical column arrangement with barrel vault. *Source: Ingenieurgruppe Bauen*

11 Moderner Saal, condition prior to reinstallation. *Photo: Ingenieurgruppe Bauen*

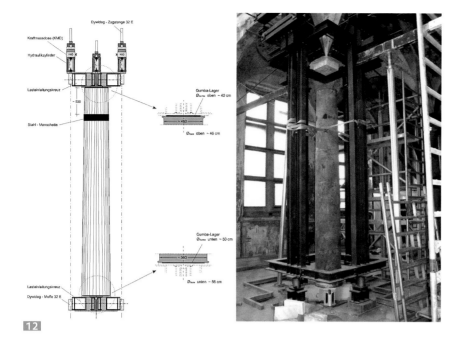

The shafts are made of a type of limestone known as Pyrenean marble or *marbre Campan mélangé*. The material is not homogeneous and the surface exhibits veins of various colours running in different directions. Areas of damage both on the shafts and in the bases and capitals were clearly visible. It was known from the literature that, even before the columns were first installed, damage they had suffered during transportation had to be repaired.

Preliminary investigations using ultrasound and geo-radar measurements delivered reference values that allowed the existing work pieces to be categorized. Here, too, however, mathematical calculations alone were insufficient, since it was not possible adequately to re-present internal load-bearing behaviour, even idealized. In this case, too, it was necessary to combine mathematical and experimental forms of verification.

To arrive at a more precise estimation of the load-bearing potential, both non-destructive and collapse load tests were carried out on drums cut from column fragments dismantled in the 1980s, under centric and eccentric load. SEA was also employed at this early stage for calibration purposes. Next, using mobile test apparatus and again monitored by SEA, working loads increased by the safety-margin correction value were applied centrically and eccentrically to the two column shafts in a prone position.

The load-bearing capacity proved sufficient in the case of centric loading, but in the case of even minor eccentricities, the permissible loading had to be reduced as a consequence of the inhomogeneity of the limestone. For construction, this meant by implication that if eccentricities at the point of load introduction can be kept low, the stresses occurring are acceptable. Following on from this,

other column shafts identified as particularly critical by preliminary investigations were successfully tested standing in situ with correspondingly modified loading apparatus (fig. 12). On the basis of the established reduction of load-bearing capacities as a consequence of eccentricities, the geometric inhomogeneities actually present in the columns on site were measured and fed directly into the computational analysis. Through comparison with the mean values for individual load scenarios obtained in the test, it was then possible adequately to estimate the permissible load-bearing capacity by computational methods.

The stated constructional marginal conditions in conjunction with the results of the loading tests for all columns allowed the required load-bearing capacity of all historical columns to be demonstrated also by computational means. Planning revisions as a consequence of insufficient load-bearing capacity were not necessary. The sensitivity of the columns to eccentric load arrival was taken into account by ensuring heightened precision when installing the columns that had been stored off-site and by corresponding constructional measures.

The majority of the column fragments were re-installed: the fragments were cut into cylindrical single drums and installed as composite columns complemented with drums made of a different stone. These columns could be designed according to masonry building regulations. After being cut to size, the individual drums first underwent loading tests with centric and eccentric loads at the test stand.

Reinforcement of historical cast-iron girders with CFRP plates

Many cast-iron components were used in the original construction of the museum. This poses no problems where these components are predominantly in compression. However, cast-iron cross sections were also employed as "ceiling joists" with gaps between them, which it was then easy to brick in as flattened vaults. These loaded joists demonstrate a pronounced zone of bending stress and their load-bearing capacity therefore had to be analysed in terms of the service loads required from a modern point of view. The tensile strength of historical cast iron represents only 30 to 40% of its compressive strength. Inhomogeneities resulting from the manufacturing process (blowholes) further weaken the areas of tensile stress and result in a dangerous tendency towards brittle fracture (sudden fracture without preliminary signs).

Assuming components that had not suffered previous damage – a rather optimistic starting-point considering the history of the building –, approximative calculations

12 Test set-up of column shaft, schematic and in situ with emergency support. Base, capital and ornamental ring have been dismantled. *Source: Ingenieurgruppe Bauen*

using measurement methods from the literature yielded computationally reliable service loads of 1.0 to 2.0 kN/m². This was not sufficient for the use as a museum, however.

Historical cast iron cannot be welded; screw-mounted steel plates were ruled out on grounds of their geometrical proportions as well as on architectural and conservation demands. The reinforcement of the areas of tensile stress with carbon fibre reinforced polymer (CFRP) plates offered a solution (fig. 13). This process is already familiar from the sphere of concrete construction and fulfils the requirements of heritage compatibility in an ideal manner, since no mechanical interventions are required in the component to be strengthened and the measure is also reversible.

No experiences with reinforcement measures using this combination of materials had previously been gathered. For this reason, in collaboration with the Institut für Massivbau und Brandschutz at the Technical University of Braunschweig, a verification concept was developed based upon the process for non-reinforced girders according to Frey/Käpplein. It was necessary first of all to establish principles for the behaviour of cast-iron girders. For this purpose, new model girders were cast on a reduced scale – a challenge in itself, since in our high-tech age it was by no means easy to obtain a grey cast iron of the equivalent "poor" quality. Some of these girders were further damaged prior to testing by sawing a small notch, c. 4 mm deep, into the underside of the girder. The girders were then tested in a reinforced and non-reinforced state with regard to their load-bearing capacity.

On the basis of these experiments, a measuring procedure suitable for practical application was developed, capable of determining adequate safety levels after reinforcement even in the case of girders with existing damage. The reinforcement plates and their dimensions were chosen on this basis (fig. 11).

For the purposes of verification, certification tests were carried out in some test areas on site after the reinforcements had been put in place. The effectiveness of the measure was thereby impressively demonstrated. The required service loads of 5 kN/m² could thus be certified for all the historical ceilings.

Conclusion

Civil engineers are confronted ever more frequently with challenges falling within the field of tension between historical construction and the demands of modern usage. While they are generally able to rise to these challenges from a technical point of view, with almost everything being possible, an understanding of historical buildings and conservation objectives are less widespread. Such an understanding is fundamental, however, for an appropriate approach to buildings of great heritage value.

In the case of the Neues Museum, the most important task facing the engineers was to recognize early on that purely theoretical starting-points were inadequate and that it was necessary to include all parties involved – the principal, the user, the architects and the necessary specialists – in the discussion and also to moderate this discussion. The development of concepts of verification, an interdisciplinary planning of the tests required and co-ordination with the building inspectorate were all essential aspects of the services to be provided.

Further reading
G. Eisele/J. Seiler: "The Berlin 'Neues Museum' – structural analysis, stabilisation and structural design for restoration." In: Structural Studies, Repairs and Maintenance of Historical Buildings VI, C. A. Brebbia and W. Jager (eds.), Ashurst, Southampton 1999, pp. 767–778

C. W. Hoffmann: "Die feuerfesten Decken des Neues Museum hierselbst", Notizblatt des Architektenvereins Berlin, February 1846

K. Steffens: Experimentelle Tragsicherheitsbewertung von Bauwerken, Grundlagen und Anwendungsbeispiele, Berlin 2002

G. Eisele / M. Gutermann / J. Seiler / K. Steffens: "Wiederaufbau des Neues Museum in Berlin. Tragwerksplanung pro Baudenkmalpflege". In: Bautechnik 81, vol. 6, 2004

G. Eisele: "Tragfähigkeitsbewertung an Natursteinsäulen am Neuen Museum in Berlin". In: Natursteinsanierung Stuttgart 2006. Neue Natursteinrestaurierungsergebnisse und messtechnische Erfassungen, Stuttgart 2006, pp. 19–28

A. Frey/ R. Käpplein: "Beitrag zum rechnerischen Nachweis der Tragfähigkeit alter Biegeträger aus Gusseisen", Stahlbau 62, vol. 8, 1993

13 Ceiling above the Vestibül: coffered ceiling of clay pots between historical cast-iron girders after reinforcement by CFRP plates in areas of tensile stress, in part re-clad. *Photo: Ingenieur-gruppe Bauen*

Ground Freezing for Soil Support

WOLFGANG ORTH | GERHARD EISELE |
JOSEF SEILER

In the course of reconstructing the Neues Museum in Berlin, the pile end plates from the secondary foundations on the south façade had to be removed and reinstalled at a greater depth as part of the new foundation slab below the water table. During the construction period 2005–06, the structure loads were absorbed by a frost body that rested in turn upon the existing piles and also compressed the excavations. Under its protection, the new foundation plate was manufactured in such a way that the existing piles could stay in use.

The task

Declared a World Heritage site by UNESCO, the buildings on the Museumsinsel (Museum Island) in Berlin stand on top of a deep channel draining the Warsaw–Berlin glacial valley. This channel was carved out to a depth of 40 m below ground level by meltwater following the Weichsel (or Vistula) glaciation; as a result of increasing sedimentation, it filled with varying layers of peat and sapropel, as well as loose sand. In the case of the Neues Museum, these fill strata extend to approximately 19 m below ground level.[1]

These subsoil conditions led to the museum being built on foundations of wooden piles. Not all these piles extended as far down as the stable substratum, however, so first signs of subsidence had already appeared by about 1850. Large-scale drainage schemes for the Pergamon Museum (c. 1910), the Palace of the Republic (in the 1970s) and other sites caused the piles to be laid dry in places. Further settlement, brought about by partial rotting of the wooden piles, subsequently necessitated the construction of secondary foundations on injection piles, which were linked with the foundations by plug sections via a 1-m-thick concrete slab.[2]

In the course of reconstruction planning, the pile cap on the south façade had to be removed completely and rebuilt as part of the foundation slab at a greater depth below the water table. This entailed ensuring that the surviving piles could be shortened and then reused for load transfer as before. The interim underpinning had to be introduced with as little deformation as possible, since the building, with its flattened vaults, was very fragile and under great strain owing to the effects of World War II bombing and the subsidence that had already occurred. In the south-east corner of the building, it was also necessary to excavate an elevator shaft that descended below the water table, which reached up to the historical foundation slab.

The mixed conditions in the subsoil, and the many obstacles below ground in the form of the old wooden piles and the new injection piles, made underpinning and sealing the excavations seem too unsafe. After an intensive study of the various options, it was therefore decided to use the technique of ground freezing. Ground freezing was also chosen for supporting and sealing the excavations for the elevator shaft.

Ground freezing and frost body – Underpinning

Below the foundations of most of the façade lie sand deposits up to approximately 4 m in depth, and beneath these a soft layer of peat and mud up to about 3 m thick.[3] The thickness of the unstable strata increases from east to west (fig. 1).

Transferring the loads from the underside of the foundation to the stable subsoil via a frozen underpinning body initially seemed the most obvious solution, but this was ultimately rejected on grounds of cost and, first and foremost, because of the difficulty of predicting the lift behaviour of the peat/mud layer. The potential risk to a building highly sensitive to deformation was too great. In view of the fact that the injection piles had been load-bearing until very recently (not having been disconnected from the building until demolition of the pile cap during construction work), and since they were still present in the lower subsoil and available to carry load, it was decided to transfer load from the underside of the foundation via a frost body into the piles (fig. 2).

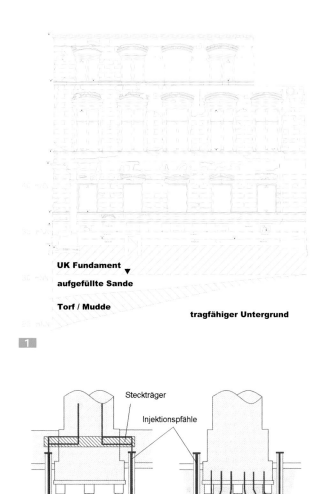

UK Fundament ▼

aufgefüllte Sande

Torf / Mudde

tragfähiger Untergrund

Steckträger

Injektionspfähle

Alte Holzpfähle (defekt)

Frostkörper

Account also had to be taken of the fact that two sorts of pile were present, each designed for different pile loads and inevitably possessing different stiffnesses. The latter resulted, on the one hand, from the different cross-section of the reinforcement pipe and, on the other, from the different depths to which the piles extended into the load-bearing subsoil. Postulating a free middle pile length from pile end plate to the middle of the compression body proved to be an inadequate simplification, since the greater insertion depth, and consequently greater free length, of the stronger piles yielded a lower stiffness. To obtain a realistic picture, it was therefore necessary to analyse precisely the strain lines of the two types of pile. This was also required for the different insertion lengths in view of the changing depth of the load-bearing subsoil.

In essence, the force transmission from frozen ground to embedded load-bearing elements via friction was planned and measured on the basis of the findings of two studies[4,5] funded by the German Research Foundation. It was necessary to take account of the heat conveyed by the steel members to the frost body, which would influence the surface temperature of the piles inside the frost body and would therefore affect stability.

It was also necessary to ensure force transmission from the cement sheath to the piles' reinforcement pipe; essentially the same conditions apply here as in the area of load transfer by the piles in the lower subsoil. Nevertheless, account had to be taken of the much lower temperatures of the piles inside the frost body, which led to differing degrees of thermal expansion by the reinforcement pipe and the cement sheath.

The structure loads did not change, so the piles were carrying approximately the same load as before at the point where they entered the solid substratum. A vital measurement criterion was therefore the load transmission from the frost body to the piles and within the piles. Since the pile end plates, previously built into the pile cap, had to be removed and, after the shortening of the piles, welded back on at a lower depth, the force transmission from the frost body to the piles could take place only via skin friction across the pile shafts. This gives rise locally to relatively high shear stresses, which experience has shown trigger creep deformations in frozen ground. In addition, one group of piles was to be selected from the many piles beneath each structural pier in such a way that the resultant of all pile forces coincided with the load resultant and the deformation of the piles did not cause them to become slanted.

■ 1 Subsoil in the underpinning zone. *All illustrations courtesy of Dr.-Ing. Orth GmbH, Ingenieurbüro für Bodenmechanik und Grundbau*

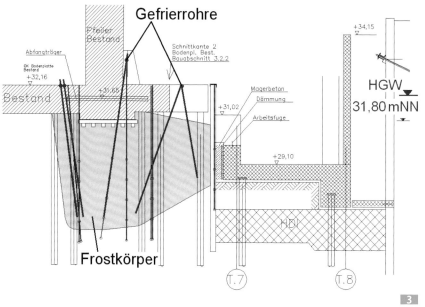

Gefrierrohre

Pfeiler
Bestand

Abfangträger

OK Bodenplatte
Bestand
+32,16

Bestand

+31,68

Schnittkante 2
Bodenpl. Best.
Bauabschnitt 3.2.2

+34,15

HGW
31,80 mNN

Magerbeton
Dämmung

+31,02

Arbeitsfuge

+29,10

HDI

Frostkörper

T.7 T.8

■ 2 Load transfer prior to and during ground freezing

■ 3 Cross-section of the frost body beneath the façade

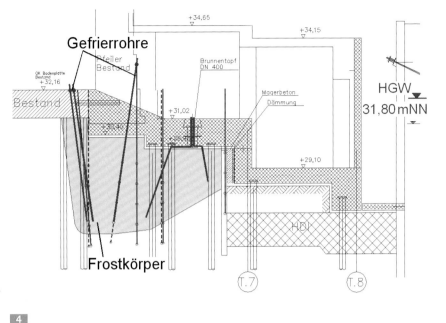

4

and-a-half months, brine refrigeration would normally be more economic than refrigeration with liquid nitrogen. However, liquid nitrogen was chosen, for the following reasons:

- The bore holes for the refrigeration pipes are narrower, which would entail less damage to the historical building fabric, especially when drilling through the façade.
- The narrower bore holes would be easier to guide past the many obstacles, including H-girders, wooden piles and injection piles, that were known only from earlier site plans.
- The lower refrigeration temperatures achieved with liquid nitrogen refrigeration would enable considerably larger temperature gradients to be achieved in the subsoil, which would not only mean shorter refrigeration times, but would also makes it easier to respond to eventual flaws in the frost body or other unforeseen situations.

Managing the groundwater

Since the water table lay close to the upper edge of the historical foundation slab, it was originally planned to lower it in the future construction area through gravitational drainage; ground freezing was to serve exclusively for load transmission. Calculation of groundwater flows soon revealed, however, that these reached very high speeds, in particular in the narrow gap between the upper edge of the peat layer (which was not very permeable) and the lower edge of the planned frost body. These speeds far exceeded those at which it would be possible to enclose the frost body between the refrigeration pipes. Furthermore, as a consequence of this permanent groundwater flow, the frost body would have absorbed greater heat, which in turn would have entailed an increased use of liquid nitrogen (fig. 6).

Following a suggestion by the geotechnical expert, the frost body was consequently extended by a further row of refrigeration pipes to reach the sheet pile wall to the south (figs. 3, 4), creating a watertight trough that offered

The load-bearing frost body beneath the façade was eventually created with three rows of refrigeration pipes, one laid inside the building and two outside, within and in front of the façade (fig. 3). As described in the section on movements on the building (see below), a fourth row of refrigeration pipes (on the right in fig. 3) served exclusively for the sealing part of the frost body. Following the demolition of the original foundation plate, the supply pipes for the front row of refrigeration pipes had to be re-routed underneath the future foundation plate, so that they could be bundled within a small number of ducts with well pots that were concreted in and could later be reliably sealed (fig. 4).

Excavation of the elevator shaft

In view of the confined space, excavations for the elevator shaft at the eastern end of the façade were also supported and sealed with a frost body. The floor of the excavations, here located largely in sand, was sealed by means of oblique frost plates in the manner of an inverted roof (fig. 5). Buoyancy safety was ensured first by the earth volume contained underneath and second by the vertical loads in the underpinning body at the adjacent corner pier. On the south side, the ground freezing extended right up to the sheet pile wall running along the excavations and was frozen to it for sealing purposes.

Creation of the frost body – Freezing process

For creating a frost body with a planned total cubic volume of around 630 m³ for a planned duration of around three-

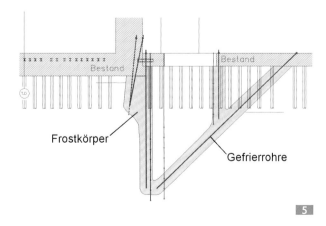

5

4 Refrigeration pipe supply after re-routing beneath the new foundation slab

5 Frost body beneath the elevator excavations

protection during construction of the new foundation slab below. Since the connections for this set of refrigeration pipes also lay underneath the future foundation slab, their accompanying supply pipes had to be fed in bundles through the well pots later to be sealed within the new foundation slab. The thermal sensors built into the refrigeration pipes for control purposes could no longer be reached after re-routing, so they remained in the ground after work was completed.

Implementation – Ground freezing

The frost bodies for underpinning the façade and the elevator shaft excavations were cooled by a total of 123 refrigeration pipes (fig. 7). These were supplied from a central tank via several distribution pipes. The waste gas was collected and released from five chimneys at a height well above the excavations, in order to exclude the possibility of nitrogen concentration in the excavation pit or on the ground floor of the building. Independently of this, the ground floor was, of course, constantly monitored for concentrations of nitrogen, by oxygen sensors and by personal oxygen detectors when the basement was entered.

The expansion and thermal distribution of the frost body were monitored by 29 temperature-gauge tubes with a total of some 130 temperature sensors. These were accompanied by one waste-gas temperature sensor in each refrigeration pipe. All thermal values were recorded in individual measuring stations on the building site and transmitted to a central storage and evaluation centre via a bus system. This was equipped with an automatic limit-value monitoring facility for each thermal value, which triggered an alarm in the event of a temperature exceeding or falling below the limit values and spread the alarm via mobile radio and other channels.

Delays in demolishing the original structure extended ground freezing to around six months. During this time, the existing foundation slab was broken up, the H-girders drilled out (fig. 8) and the injection piles shortened and given new end plates. Although the location of the H-girders and the piles was known only from site plans, no notable damage was caused during demolition, so that all the structural components uncovered could continue to be used. Lastly, the new slab was concreted.

Exterior temperatures were sometimes very high during construction work, generating large temperature fluctuations in the relatively flat frost body and, occasionally, a marked increase in nitrogen consumption. Each construction phase – demolition/excavation, laying the granular sub-base, concreting – was clearly reflected in the

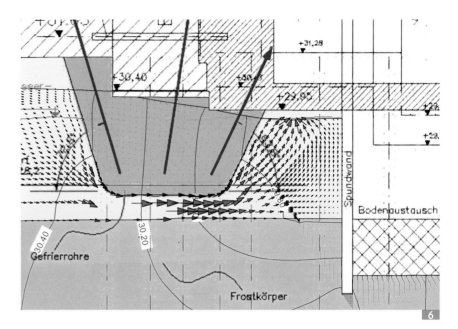

temperature graph. Constant fine-tuning of the refrigeration was therefore necessary to keep the frost body at the desired size and temperature.

Movements of the building

Vertical deformations were measured at eleven places on the façade from the start of ground freezing to the time when the refrigeration system had been switched off. A number of sensors thereby registered lifts of up to approximately 1.5 mm; at these points the frost body evidently still extended into layers susceptible to lift. Further cooling of the frost body after freezing brought

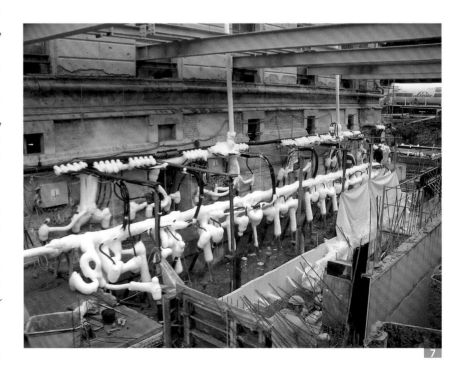

6 Groundwater flow beneath the frost body as a result of drainage

7 Façade with refrigeration pipes

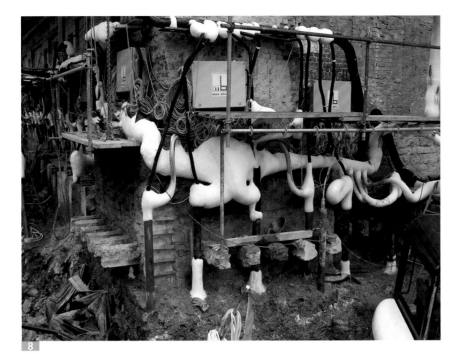

Conclusion

Despite irregular and locally disturbed subsoil conditions, underpinning by means of ground freezing in order to exchange the pile cap on the south façade of the Neues Museum in Berlin was successfully implemented, with very few instances of deformation appearing in the building. Although the construction period had to be extended for operational reasons, the load transfer from the frost body to the piles solely via friction was effected without problem, but it did it require continuous adaptation of the refrigeration system to each stage of construction and to the occasionally extreme exterior temperatures. On the whole, the ground-freezing technique proved effective in mastering the very irregular subsoil conditions.

1 J. Prager and P. Pflaume, Ingenieurbüro Prof. Müller-Kirchenbauer und Partner, 'Baugrundgutachten Neues Museum auf der Museumsinsel', Berlin-Mitte, July 2002 (unpublished).
2 G. Eisele, M. Gutermann, J. Seiler and K. Steffens, 'Wiederaufbau des Neuen Museums in Berlin: Tragwerksplanung pro Baudenkmalpflege', Bautechnik 81, vol. 6, 2004.
3 J. Prager and P. Pflaume (see note 1).
4 G. Gudehus and A. Tamborek, 'Zur Kraftübertragung Frostkörper-Stütz-elemente', Bautechnik 73, vol. 9, 1996.
5 W. Orth, Gefrorener Sand als Werkstoff, Veröffentlichungen des Instituts für Bodenmechanik und Felsmechanik der Universität (TH) Karlsruhe, vol. 100, 1986.

about settlements of up to approximately 3.5 mm, notably in the area of the deep-reaching frost body at pier 5 (fig. 9). During the maintenance phase of the frost body, the temperature field became increasingly homogeneous and the frost body warmer, leading to expansion and a consequent reduction in settlement activity. Overall, movements of the building did not exceed approximately c. 3.8 mm, a figure that includes instances of heat expansion by the façade, since for operational reasons the measurement points lay around 4–5 m above the foundation slab. These influences were also accurately recorded, to the tenth of a millimetre.

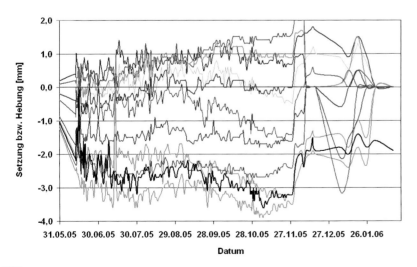

 Exposed H-girders

9 Vertical deformations on the façade during ground freezing

Special Developments in Construction – Restoring the Extant Windows and Doors

ANNE HENGST

The diversity of Stüler's room designs extends to the shapes of the finely made windows and doors. Different window and door types were designed and built for each room and level. They differ in size, method of construction and treatment of materials and surfaces.

Level 2 (the first floor) is the grandest in the Neues Museum. At 5.4 metres high, the door of the Bacchussaal (Bacchus Hall) merits particular attention. It is made of coniferous wood with a rosewood veneer and is handsomely decorated with brass and silver nickel inserts.

The Bacchussaal's windows reach the enormous height of 5.6 m. Despite this, and in spite of the fact that the main casement and the transom casement can be opened, the overall breadth of their wooden muntins is slight. This was achieved using a sophisticated alternating construction of outer and casement frames and top-hung and side-hung casements.

History and inventory

Windows

Some of the Neues Museum's windows were destroyed in World War II, but many survived. These were left unprotected in the façade for decades, exposed to precipitation and other forms of weathering. The lower parts of the outer frames and casements, in particular, were ruined. Some rebates were weathered beyond recognition. The surfaces of most elements were washed away. When the inventory was taken, almost all level 3's base supports, together with the cast-iron metal elements, were missing. They had probably been looted.

Most outer and casement frames are made of oak. The windows' wooden cladding – integral benches, and parapet and embrasure cladding – is either oak or pine. Surface treatment of individual elements varies according to the design. The surfaces of the windows on levels 1 and 4 are fully painted. Severe weathering had removed all trace of surface treatment from the windows on levels 2 and 3. Given their dark wood, they had probably been treated originally with a pigmented linseed oil varnish.

The windows were modified extensively several times while the building was in use as a museum. With the exception of level 1's windows, it can be assumed that the traces of painting are old, but not original.

The French casement windows on level 1 were originally fastened with bascule locks, while the windows of levels 2 and 3 had mortise fasteners. All windows were secured to the outer frames by butt hinges.

Doors

The main wood of all doors is pine, with oak frames. Most doors had sawn walnut veneer, with oak for the doors on level 3 and rosewood for the Vestibül frontages and the door of the Bacchussaal. The wood used reflects the relative importance of their location. There is also brass and silver nickel marquetry on many of the doors. Remains of a high-polish resin lacquer were found on the walnut

1 Detail showing the fastening of an extant level 2 window before restoration and modification. *Source: Holzdokumentation Gernot Mahler*

2 Modified level 2 extant window, a transom, during installation. *Photo: Johannes Bennke/DCA*

3

and rosewood doors. The oak veneer on level 3 had remains of a resin lacquer flat varnish.

Several doors were partly or entirely destroyed by bombing during World War II. Bomb fragments made holes in the wood, and some elements were evidently looted. The leather upholstery from the Vestibül porch, all the handles, some hinges and the floor swivels were missing.

As the building had been left unroofed for decades, the surviving doors exhibited severe damage from damp and weathering. The veneers were warping and coming loose, the oak veneer had darkened and the resin lacquer had acquired white spots and was cracking. Joints in the main wood, secured with water-soluble gelatine glue, had loosened. The iron edge bolts, hinges and floor mounts were heavily corroded. Traces of previous use also had to be removed during restoration. The sockets of the locks were worn, and some of the springs were broken.

Despite this extensive damage, the doors had survived remarkably well. This can be put down to exceptionally fine craftsmanship and the careful selection of materials.

To preserve what remained, the doors and frames had been removed and put in storage in the 1980s. An

extensive record was made of all wooden components. Their state of preservation was documented in the form of photographs and short texts. Detailed drawings provide information on the construction of the various types of door. Damage and losses incurred by every piece were described and each phase of the restoration mapped.

Restoration and reconstruction methods

Restoration measures were undertaken in accordance with conservationist principle of stabilising the original elements in their aged state and reintegrating them into the building. Preserving original features was the top priority. These were to be affected as little as possible by adaptations to new requirements regarding security, fire safety and structural aspects of the building.

Gaps were filled in to make the original construction elements functional again. Wood cracked, broken or destroyed by vermin had to be replaced using new wood.

Windows
First, all the outer and casement frames were detached from the building and dismantled into component parts. Badly damaged parts were replaced with new wood.

The butt hinges of doors that were only slightly warped could be adjusted if necessary. Badly warped elements were replaced, using door leaves that had been stored as a source of replacement parts because they would not be returning to their original place.

As exterior components, the windows were treated with wood protection chemicals to prevent insect and fungal damage. To prevent dry rot, boric salt cartridges were placed in the corners of the end grain areas of the mounting frames.

The hinges were detached. After rust had been removed, they were conserved using a dark linseed oil varnish. Missing hinges were reconstructed, with their surfaces treated to match the originals.

Original iron corner angles were installed only on the inner sides of the windows. They were freed from rust, cleaned and given a dark linseed oil patina. The outer window faces were given new stainless steel corner angles with a surface treatment approximating to that of the original angles.

The original catches were fitted only to the level 4 windows and the courtyard windows on level 1. All the other windows were given sliding edges with telescopic rails, allowing them to be opened with a single turning handle so as to release smoke in case of fire.

Inner weatherboards were made from cast zinc, like their predecessors. The weatherboards for the windows' outer faces were cast in dark oxidized bronze to avoid the

3 Detail of Bacchussaal door before restoration and modification. *Source: Holzdokumentation Gernot Mahler*

T2.01-01
Tür : H0051

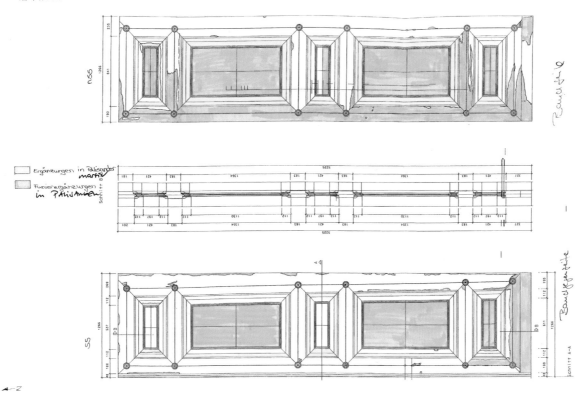

rainwater-induced electrolysis decomposition that would occur with zinc.

The surface treatment of the windows on level 1 was matched to the restored wood cladding of the extant originals. The badly weathered surfaces of the windows on levels 2 and 3 were removed and replaced by a pigmented balsamic oil varnish. New elements were matched to the surviving wood by applying several coats of this varnish. The exterior components were given a coat of lacquer designed for outdoor use and with a colour matching that of the interior components.

Missing windows, cladding and components (such as casements or outer frames) were reconstructed using the original techniques and on the basis of the extant historical items.

Doors

First, a thorough inventory was made of missing timber, the state of veneers and joints that had loosened. Loose joints in the main wood were then bonded using gelatine glue, i.e. fish or animal glue, and missing pieces of wood were replaced. Correct choice of materials was particularly important in order to match the quality of the

4 Bacchussaal door before restoration and modification.
Source: Holzdokumentation Gernot Mahler

5 Bacchussaal door, mapping of implemented measures.
Source: DCA

and greyed and weathered areas were lightened using oxalic acid. Repairs to the walnut veneer were smoothed over and polished. The older surfaces were cleaned and in some cases finely polished. All the repairs were colour-matched using an undercoat of coloured resin lacquer (shellac). This kind of match is possible only if the replacement material is very similar to the original veneer. Resin lacquer was then applied several times using brushes, intermediate sanding and pads. A different process was used for matching colour on the Bacchussaal door. The door's rosewood veneer was acquired from residual stock. With no material similar to the original available, colour-matching was achieved with wood stain. Level 3's oak doors were coated only with hard wax.

Missing doors and door components (such as frames and single leaves), along with their fittings, were recreated using the original techniques and on the basis of the extant historical items.

The raising of the ceiling level by approximately 15 cm on level 3 meant that all door elements had to be shortened. To preserve the overall proportions, all the veneers were detached from the main wood before the doors were shortened panel by panel. The veneer, also shortened, was then put back in place over the joints, using a mitre cut.

Modernization and other improvements

Since the Neues Museum was once again to be used as a museum, its original windows and doors had to be adapted to meet current security demands, fire regulations, physical requirements and structural stipulations. The extant windows and doors were sensitively modified in accordance with the conservation principle of retaining as much original fabric as possible.

Windows

The physical properties of the exterior windows were improved by converting the original one-layer windows into coupled windows. Several hinges were used to mount frameless compound safety glass (CSG) onto each original window's blind frame from the outside. A groove was cut into three sides of the frame to form a rebate for the outer casement. The inward-facing side of the glass has a hard coating thermal insulation layer. In conjunction with the buffering air between the panes and the inner pane, this significantly reduces heat loss through the window.

A continuous 2 mm-thick joint between the CSG and the outer frame provides back ventilation for the space between the panes. Care had to be taken to make sure that driving rain did not pass through this joint into the intermediate space and thence into the building's

original doors. The moisture content and quality of the aged wood used for the replacements matched those of the originals.

Veneers that had loosened were then re-glued and missing sections replaced. The replacement sawn veneers were chosen so as to match the material, thickness, texture and pattern of the originals. Repairs were let into the gaps like marquetry, rather than inserted with the help of straight cuts.

Missing mouldings, cleats and kick rails were reconstructed on the basis of the originals and, like them, veneered in places.

Extant locks were repaired by remounting the sockets and replacing broken springs. Years of water damage had corroded some hinges to such an extent that they had to be replaced. Reconstruction of lost hinges, keyhole covers and locks was based exactly on extant items. The keyhole covers were made from hard-soldered sheet brass, and the sheet-iron hinges were recreated on the basis of historical measurements to ensure maximum accuracy.

How the original floor mounts had been made was deduced from the only perfectly preserved element of this kind, that of the main entrance to the Vestibül. The floor mounts were non-moveable. First, they were cemented into the floor; then the door was put in place and the marble cement on the embrasure worked up to the edge of the door. This method could not be used in the reconstruction of the Neues Museum. Floor mounts were therefore devised that could be moved in three directions, permitting the doors to be adjusted at any time.

The surfaces of all restored doors were freshly treated. Remnants of previous coverings were filled out,

6 Window fastenings, extant items and replacements. *Photo: Johannes Bennke/DCA*

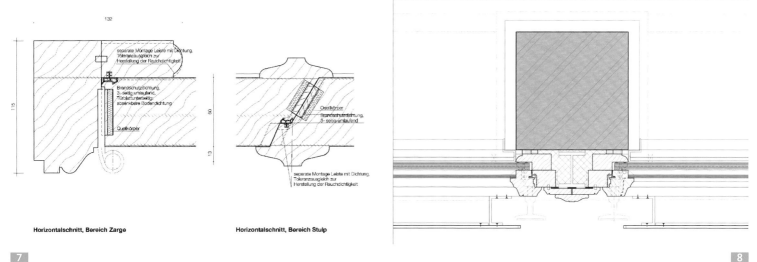

Horizontalschnitt, Bereich Zarge Horizontalschnitt, Bereich Stulp

7 **8**

interior. Seals were placed at the side like ribs between the CSG and the outer frame and positioned to direct flow outwards. This both ensures that rainwater does not get between the panes and allows air to flow in. In addition, small drainage channels beneath the weatherboard channel moisture in the intermediate space outward. The rebate in the old casement frame has two seals to prevent steam entering from the climate-controlled interior. On the inside, anti-dazzle curtains are secured to specially designed cast bronze brackets attached to the casement frame.

The construction of the outer casement's CSG, and its anchoring in the groove on three sides of the outer frame, provide safety from break-ins. The windows' opening and closing are monitored by magnet and bolt contacts. An alarm loop in the CSG monitors the outer layer of the window for break-ins. The passage of the cable between the frameless CSG and the original outer frame was a particularly tough challenge. It had to be very small, but also had to permit the CSG pane to move freely. A cable duct leading from the contacts to the next transfer point was integrated into the outer frame construction.

The wooden inner casement and the new outer glass casement can be opened manually, facilitating smoke evacuation in case of fire. The three turning handles of the extant windows, one on top of the other and connected to three mortise fasteners, had to be replaced with a fastening technology that allowed the window to be opened with a single handle in case of fire. A sliding edge with three telescopic rails was chosen for this reason. The telescopic rails have different closing tracks. If the turning handle mounted at the bottom of the casement frame is turned repeatedly to close the casement, the casement frame is gradually drawn telescopically across the outer frame.

The windows' installation had to be adapted to comply with current structural and physical requirements. The embrasures were insulated all round and connected to the building via vapour barriers and waterproofing layers. Installing the insulation involved dismantling the embrasure and the parapet and lintel areas in accordance with careful structural assessments. A specially designed sub-construction using steel mouldings was secured to the building's structural shell to take the windows' dead load and wind load.

Even before the contract was awarded, the planning process entailed building a specimen window to test the structural and physical properties of the modified construction. This prototype was tested at the IFT Rosenheim for joint permeability, driving rain-proof construction, wind load and heat transition in accordance with DIN (German industrial norm) 18055. The tests helped to confirm planning estimates and optimize weak points. The firm that eventually received the contract constructed another specimen window, which was also tested at Rosenheim. This way of proceeding established that the firm was capable of meeting the highly complex technical and skill-related demands of building such windows and also served to indicate possible improvements.

Blower door tests were used on the building site to spot-check the vapour-impermeability of the installed windows and their connections with the building. Additional rain tests ensured that the windows were rainproof once installed.

Improvements had to be made to the fire safety technology of the courtyard windows on level 3. The wood of the original windows' frames was sufficiently thick, so G30 glass was set in the casement frames to reduce the passage of radiation.

7 Modified extant level 1 door, horizontal section. *Source: DCA*

8 Modified extant level 2 window, horizontal section. *Source: DCA*

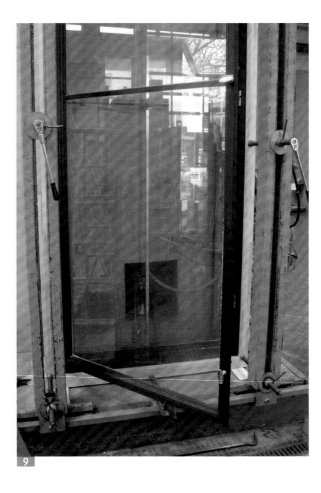

The windows were installed in the building using wooden mounting frames. The cavities between the windows and the building were filled completely with mineral wool.

Doors
Some original doors were subject to fire safety requirements under DIN 4102 and DIN 18096. There were no approved systems that could upgrade their fire safety while retaining their construction. Once modified, the doors and their installation were approved by the fire safety expert.

The wood of the historical doors was thick enough to withstand fire for the required 30 minutes. Drawing on approved systems, a continuous swelling band was mounted on three sides of each door at the front. In case of fire the door would become wedged in its frame, sealing the site of the fire. The door rebate was given a double rubber seal to meet smoke-proofing requirements.

Historical fastenings had to be exchanged for modern replacements on doors enclosing security zones, which also had to be fitted with such modern security technology as opening and closing monitors. After careful removal of the top layer, small switch contacts were inserted into the wood of the doors and frames, together with wiring and covered cable access points. The top layer was then recreated with the veneer.

Since the doors stand open when the museum is in use, they were fitted with a floor door closer containing an integrated closing sequence controller and electro-mechanical locking. The door unlocks if the fire alarm system is triggered.

9 Specimen window during testing. *Photo: DCA*

Issues of Construction Physics in the Reconstruction of the Neues Museum

Axel C. Rahn | Matthias Friedrich |
Thomas Riemenschneider

Building within existing structures – Challenges and opportunities

In the case of all building work carried out upon and within existing structures, from ordinary 19th-century residential buildings to the Neues Museum on Berlin's Museum Island, it is true to say that the measures to be implemented are both a challenge and an opportunity for every planner.

The challenge lies in doing justice to the existing building, in this case the Neues Museum, now a World Heritage site, by finding solutions that respect the original character of the historic monument while solving the many problems it presents from the point of view of construction physics. The opportunity lies in uncovering, through analysis of the existing building, how it performed, why it performed even though it perhaps "shouldn't" have done, and consequently to forecast how it will behave in the context of new marginal conditions of use, and what measures are needed to ensure that these new conditions of use do not lead to damage. All in all an exciting task for everyone involved in the planning. What follows is a brief overview of some of the construction-physics issues investigated during the reconstruction of the Neues Museum and of the solutions designed to address them.

Construction-physics analysis as a compulsory prerequisite for creative solutions

A comprehensive construction-physics analysis is today a compulsory prerequisite for construction measures within historical structures, in order to identify the technical limits of the individual structural components and their interplay and consequently to evolve creative solutions designed to optimize their performance. In the case of the Neues Museum, the construction-physics analysis focused upon three main areas:

- complex moisture analysis of the foundation structure;
- thermal insulation analysis;
- acoustics analysis.

Complex moisture analysis is in principle a subject in itself and in this context the reader is referred to the article in the footnotes[1]. It must nevertheless be stated that – independent of the significance of a historic monument – a complex moisture analysis is always necessary in the case of older buildings displaying signs of damp and salt efflorescence in areas in contact with the ground. Only in this way it is possible to calculate with sufficient confidence the remedial measures required and the residual risk of salt-induced damage appearing after remediation. The purpose of complex moisture analysis is to establish, for selected parts of a building, profiles of damp penetration and salt efflorescence both across the height of the wall and through its cross-section. Knowing the moisture and salt loads present not only in the surface area of the wall but in particular in its cross-section, it is possible to plan the necessary repair measures and if necessary any changes thereby necessitated to the rebuilding schedule.

Within the framework of a thermal insulation analysis, the composition of all structural components must be investigated and evaluated in terms of their insulating performance. The building's outer casing must be examined for thermal bridges and any thermal bridges discovered must be calculated with regard to temperature and heat-flow behaviour. From the thermal insulation behaviour of the structural components and thermal bridges, it is then necessary to deduce reliable relative humidity values, so that condensation and the formation of mould may be avoided.

The thermal insulation analysis served as a basis for designing a "building-compatible" climate-control system. To ensure that the building could be utilized without damage to the historical fabric, the measures necessary to improve thermal insulation were to be kept within justifiable limits. In acknowledgement of the requirements of restoration and heritage conservation, a relative humidity of $\phi = 40\%$ was therefore specified for winter – a critical time of year from the point of view of protection against damp.

In order to be able to estimate the acoustical behaviour of the rooms, an acoustics analysis was also conducted. This formed the basis for an optimization of the acoustics of the surviving parts of the building and for the acoustic design of the areas of new construction.

What follows is a description of the construction-physics analysis conducted in two particular areas, the findings thereby yielded and the solutions developed. Firstly we shall examine the windows and their connection to the surrounding jambs, an important factor from the point of view of construction physics, and secondly room acoustics and their effect and significance.

The window constructions and their connections to the jambs

For the task of designing window systems appropriate to the heritage character of the building, and of taking their peculiarities into account during reconstruction, an analysis of the climatic requirements of the Neues Museum was necessary. The various viewpoints of restoration and conservation professionals had to be taken into account during the planning phase.

Restorers and conservationists find themselves in conflict when it comes to using a listed historical building as a museum, since this involves giving buildings that originally had no air-conditioning – as in the case of the Neues Museum – a full climate-control system as part of the overall renovation or rebuilding. To protect the collections, the fluctuation in relative humidity must be kept within permanent limits both over the course of the day and throughout the seasons of the year. From the perspective of the user, and here first and foremost the restorers, an almost constant relative humidity is most desirable for the protection of the museum collections. Alongside Hilbert's corrector curve[2], the guidelines of the Mechanical and Electrical Engineering Working Party of National, Regional and Local Authorities (AMEV)[3] are often a basis for defining desired limit values. However, these limits may of course differ depending on the cultural assets that are to be protected.

With regard to the historical building fabric, from the conservation point of view the relative humidity should be kept at low as possible and/or necessary during the winter months. The reason for this lies in the fact that as a rule historic monuments – the Neues Museum amongst them – only have a low standard of thermal insulation; the technical limits are consequently very narrow, while the considerations of monument conservation rarely permit thermal improvement measures. High relative humidity can quickly produce capillary condensation in parts of the building with a poor standard of thermal insulation, leading

to the formation of mould and/or condensation. A particular conflict can surface, however, when it comes to protecting special wall decorations or wood panelling, which must also not be exposed to excessively large fluctuations in relative humidity. Problems can also appear when the building is contaminated with aggressive salts. Remedial steps to be taken in such cases may include special measures for an interior climate control.

The problems that had to be solved in the Neues Museum can be illustrated by the windows and their jamb connections. The original window constructions essentially consisted of single-glazed timber windows. It was agreed during the planning phase that the renovation of these windows should include their thermal im-provement, in order to avoid the formation of condensation on the window panes and of mould on the jambs as a result of the planned climate-control measures.

Even though the windows of the Neues Museum appear to differ only in terms of size when seen from the outside, they must nevertheless be considered individually from the point of view of construction physics due to the importance of the jambs and their differences. The necessity of improving thermal insulation and the solutions subsequently developed are discussed here in the example of one window construction and its adjacent jamb, illustrated in fig. 1.

1 Selected example of an original window construction.
Source of all illustrations: Ingenieurbüro Axel C. Rahn GmbH
Die Bauphysiker

As a complement to fig. 1, fig. 2 presents the results of the two-dimensional thermal bridge calculation, which are also stated numerically. It can be deduced from these results that, assuming an exterior air temperature of -15 °C, condensation on the inside of the original window pane may be expected as from a relative humidity of $\phi = 16\%$ and the formation of mould in the area of the interior window jamb as from a relative humidity of 39 %, on the basis of an interior temperature of 20 °C. These results prove, therefore, that the thermal insulation characteristics of the window construction and the jamb needed urgent improvement in order to avoid the damaging consequences of condensation and mould.

In utilizing today's highly sophisticated computer programmes, which make assessing thermal-bridge problems of this kind so much easier, it should nevertheless be borne in mind that the results they yield, seemingly so exact, are all based on approximate values when it comes to marginal conditions as room temperature stratification and heat transfer,. Hence the results of calculations of this kind must always be evaluated taking into account the engineer's professional experience.

Even without going so far as to replace the window, an extremely wide variety of options are available to improve the thermal insulation of window constructions. Decisive factors when choosing possible measures are the climatic conditions to be expected and the energy savings aimed for. As a general principle, from the point of view of thermal insulation the window represents the "weakest link" of all the components of a building capable of transferring heat, meaning that the window can act as a "natural indicator" of "unacceptable" indoor climate

conditions. In other words, before capillary condensation or sorption leads to damage in non-transparent parts of the building, for example in the form of mould growth, the user is alerted – through the appearance of condensation on the inside of windowpanes – that the room climate has assumed values that are having an adverse effect upon the building fabric and hence are unacceptable.

In the case of the Neues Museum, the solutions adopted included, firstly, the modification of the original windows to become double-glazed casements, and secondly the design of new box windows for the south and west façades.

The original windows were modified by doubling the frame and cutting a rebate around the exterior to receive an additional pane of glass. The single glazing facing the interior was also replaced by a pane of hard-coated glass. Particular attention was paid during the creation of the double-glazed casements to ensuring an air-tight join between window frame and wall and to sealing the area around the window on the room-facing side. In order to optimize the thermal performance of the jambs, various measures to prevent heat loss were implemented at the point at which the window connected to the jamb, depending upon the wall decorations and possibilities of the interior. In the present case, the jamb was given thermal insulation 3 cm in depth.

Fig. 3 presents the computational results of the thermal-bridge calculation for the window in its optimized state after thermal improvement. As can be deduced from the numerical expression of the results, the improvement measures described allow the interior climate value of $\phi i = 40\%$ for the whole building to be observed.

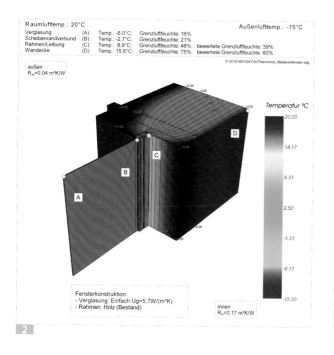

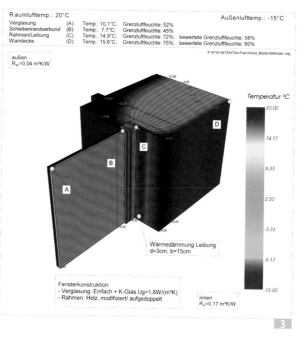

2 Computational model and computational results for the tested window jamb in its original state

3 Computational model and computational results for the tested window jamb in its thermally-improved state

The box windows developed for the south and west façades were constructed in such a way that an air-tight plane that included the connection to the wall was created inside. The inward-facing casements were also double-glazed. The outer plane was single-glazed and manufactured with ventilation openings.

Alongside measures to improve their thermal insulation, when repairing old windows of this kind it is also necessary to ensure that they present an adequate seal against air and driving rain. It must be borne in mind that, in line with the standards valid at the time of their construction, the windows have profiles with comparatively narrow cross-sectional dimensions and rise to heights of up to 6.4 m. In order to minimize condensation, in particular on the inside of the outer panes of the box windows, the connecting joint between the interior casement and the window frame and the join between the window frame and the wall must meet the highest requirements in terms of air- and water-tightness. In addition, corresponding zones of stress relief had to be incorporated between the outer casement and the window frame. Against this backdrop, it was necessary to conduct tests at the Institut für Fenstertechnik (ift) in Rosenheim in order to establish the effectiveness of the planned renovation measures in principle. The renovation measures were subsequently fine-tuned on the basis of the results of these laboratory tests. Quality of construction was monitored on random samples with the aid of blower-door testing. For this purpose, the level of air-tightness was checked with the aid of low and high-pressure simulation and possible leakage sites were identified. Rain tests were also conducted on all the windows following installation. The results of the blower-door tests and rain tests led to further improvements in the construction of the windows (fig. 4).

Effect and significance of room acoustics

The acoustics of rooms operate at a very subtle level and are generally registered unconsciously by people, whose attention in a museum, for example, is directed at the objects on display. Only in the rarest cases does focus fall primarily upon the acoustics of an interior. Acoustics nevertheless have an enduring effect upon people.

Sounds and noise affect us in many ways and are differently evaluated depending on the personal situation of the listener. The crying of a child puts parents on the alert for a possible accident. A lively fairground and the noises that go with it convey hilarity and pleasure, but are strenuous on account of the many impressions that clamour to be processed and individually identified by our sense organs. In a typical railway-station atmosphere with

loudspeaker announcements booming overhead, we even find ourselves wishing after a while that we could simply switch off the constant, intrusive level of background noise.

The acoustics of our surroundings exert a profound influence upon our well-being. But while the acoustical role to be played by theatre auditoriums, conference rooms and rooms for meetings can be clearly defined, this is not the case with museums, whose acoustical function first has to be established during the planning process from a number of very different viewpoints. In the case of a room where the focus is to fall solely upon the exhibits the acoustical requirements will be other than in cases where the museum building itself is of importance and the collection within it "merely" one element of the display. Where an interior is to convey an impression both of its architectural significance per se and its historical evolution from ruin to reconstruction, planning requirements may dictate that the room's visual effect is also reflected in its acoustical effect. This was the task in the case of the Neues Museum.

A fundamental characteristic of the acoustical effect of a room is the reverberation time. This describes how long a sound – or more accurately, the sound energy – remains in the room and is thus a measure of noise development in the exhibition rooms.

In September 1999 measurements of reverberation times were conducted within the framework of a preliminary acoustical planning study. When judged against the requirement profiles normally applicable to new buildings, the reverberation times emerged as very long (fig. 5).

It is possible to reduce reverberation times by introducing sound-absorbing components and surfaces into the interior. In the case of buildings such as the Neues Museum, however, the installation of sound-absorbing structural components or the creation of sound-absorbing surfaces means a disturbance of the historical building

4 Thermally-improved window construction after rain test

fabric and the visual appearance of the room. The concerns of monument conservation consequently ruled out any such sound-absorbing measures either in the floors or on the walls. Only in the areas of new building, where it was planned to use suspended ceilings, was it possible to install special Helmholtz resonators as absorbers in the ceiling cavity.

These types of absorbers work exclusively in the low-frequency range, i.e. they cut out the "boom". However, their effectiveness is dependent to a large degree upon the sound waves produced in the exhibition rooms by people talking, moving about etc. actually reaching the resonators. In this case, acoustics had to take second place to the planned appearance of the interiors: owing to the ceilings being built in as sealed a manner as possible, the direct pathways to the Helmholtz resonators were blocked. Sound waves could only reach the resonators indirectly, namely via vibration of the ceiling construction, which greatly reduced the amount of "boom" cut out. This was intentional, however, in the context of the many reverberant surfaces presented by the building and the planned architectural effect, which can lead some visitors to experience the interior as having an unfamiliar "coolness". The room acoustics in the Neues Museum, while of course also determined by issues of conservation and technical possibilities, thus underline the architectural concept.

Conclusion

The present article offers only a rough overview and insight into selected construction-physics issues tackled during the reconstruction of the Neues Museum. Within the framework of the present volume, it aims to convey the complex inter-relationships that must be taken into account when planning construction measures of such a

sophisticated kind within existing structures, and the fact that construction physics plays a not insignificant role in this context. It also aims to make clear that, in the case of projects of this nature where the demands of conservation and architectural concept must be respected, it is necessary to evolve individual solutions that neither have nor may claim universal validity. Here, the interests of all parties must be weighed up case by case in order to arrive at an appropriate solution.

Further reading
A. C. Rahn/M. Müller, "Wärmebrücken und Wärmebrückenberechnungen – Ziele, Möglichkeiten und Grenzen." In: H. Venzmer (ed.), Aktuelle Entwicklungen der Bauwerkstrockenlegung. 14. Hanseatische Sanierungstage 2003, pp. 41–52, Berlin 2003
A. C. Rahn/M. Müller, "Die Verglasung als natürlicher Indikator für unzulässige Raumklimaverhältnisse". In: H. Venzmer (ed.), Aktuelle Entwicklungen der Bauwerkstrockenlegung. 14. Hanseatische Sanierungstage 2003, pp. 165–175, Berlin 2003
M. Müller/P. von der Weide, "Alte Fenster und neues Klima." In: architektur + bauphysik, vol. 3/May 2004
M. Müller/P. von der Weide, "Den Dampfer wieder flottgemacht – Zeitgemäßes Raumklima in einem historischen Museumsbau." In: architektur + bauphysik, vol. 6/November 2005

1 A. C. Rahn/M. Müller, Mauerwerksdiagnostik – Was ist zu beachten? In: H. Venzmer (ed.), Europäischer Sanierungskalender 2006, Berlin 2006, pp. 124-134
2 G. S. Hilbert, Sammlungsgut in Sicherheit, Teil 2: Lichtschutz, Klimatisierung, Berlin 1987
3 Hinweise zur Planung und Ausführung von raumlufttechnischen Anlagen für öffentliche Gebäude, edited by the Arbeitskreis Maschinen- und Elektrotechnik staatlicher und kommunaler Verwaltungen – AMEV, RLT-Anlagenbau 2004, Berlin 2004

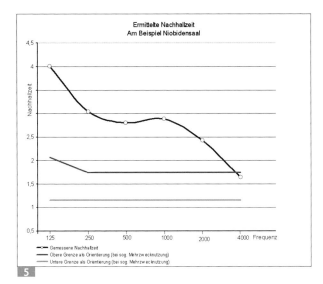

5 Reverberation times measured in the Niobidensaal

Technical Services

HANS-PETER THIELE

Starting points

Installing the necessary technical facilities in the Neues Museum represented a big challenge – both at the time of construction and during the present reconstruction. Over the past fifty years, the standards of technical facilities for museum buildings have developed at breakneck speed. This is why, prior to the actual reconstruction, the technical planning team was faced with the question, "How much technology is indispensable?"

There was no simple or general answer to this question. What was needed had to be defined afresh for every part of the project, and a balance had to be struck between the needs of visitors on the one hand, and the technology required to protect the works of art on the other. What is more, the technical installations had to comply with regulations for the conservation of monuments, with the aesthetic quality desired by the architect and with fire regulations and structural requirements, while also solving the problems of damp-proofing, thermal and acoustic insulation etc.

A further aspect is that even a listed museum building is expected to contain the communications and control technologies of the 21st century as a matter of course. This involves findings spaces to lay cables and in which to put central engineering rooms. Of course, having a computer in a historic museum building is not a major problem, but it represents an example of the technical systems today's museums are expected to house.

These modern systems had to be integrated as inconspicuously as possible into the historic museum building without damaging its structural or other surviving components. In order to grasp the complexity of the task, it is useful to ask what were the standard technical requirements for a museum in the mid-19th century. Basically, these performed the functions of regulating the temperature and humidity in the building and letting enough light in (light bulbs were first shown at the International Exhibition in Sydney in 1879) but also included mechanical safety devices like locks and grilles.

We owe it to Hermann Friedrich Waesemann (1813–1879) that the Neues Museum was fitted with a hot-water heating system, at that time still a rare technical novelty. Friedrich August Stüler, who was receptive to all new technical developments, took Waesemann's concept further and, together with Carl Wilhelm Hoffmann, had a system installed that combined hot-water heating with conventional hot-air heating.[1] Grid-pipe radiators were installed in window recesses, in under-floor ducts and behind wall claddings of a variety of materials. The hot-water heating system went into operation in 1848 and heated the building over a period of seventy years. It marked the start of the rapid propagation of this system all over Germany, not least because it was safer than a steam heating system. It was designed to produce interior temperatures of about 16 °C in the winter.

1 Flue pipes of the 1848 heating system in the Niobidensaal (space 2.11). *Photo: Johannes Kramer/BBR*

In 1915, the service life of the heating system came to an end, so it had to be replaced. In an assessment, the contractor R O Meyer described the various deficiencies of this heating system, listing in particular costly repairs of the many leaks (most of which were difficult to access), the necessary permanent supervision of all the radiators while the heating was on, the impossibility of cleaning the inaccessible radiators, the dust whirling up from the radiators inside the floor ducts, the partial impairment of exhibits, etc.[2]

Following this survey, the firm R O Meyer installed a new hot-water heating system between 1915 and 1919. A number of its radiators remained in use in some halls (Roter Saal [Red Hall], Vaterländischer Saal [National Hall]) until 1995 as part of the building's heating system. Flue pipes of the original system of 1848 have survived to this day in a wall recess in the Niobidensaal (Niobides Hall, fig. 1). Interestingly enough, the heat from the flue pipes was always utilized, and contributed to heating this gallery.

Few traces were left of the first electrification of the Neues Museum. The first electrical streetlights were installed in Berlin in 1882. It is assumed that a number of interior spaces in the Neues Museum were fitted with electric lighting between 1915 and 1919, when the new heating system was installed. Until then the galleries had no electric light and thus formed a real "daylight museum" until well into the 20th century. In the Mythologischer Saal (Mythological Hall) and the Gräbersaal (Sepulchral Hall) one can still see the old built-in conduit boxes (fig. 2).

The following technical systems are now standard requirements for a museum building:

- air-conditioning
- mechanical smoke extraction

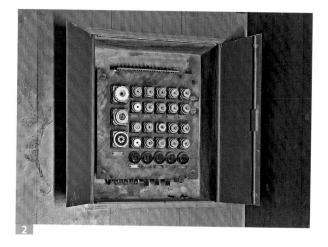

- cooling
- heating
- water recycling
- lifts (goods and passenger lifts)
- lighting (general, exhibition, safety lighting)
- sun blinds
- fire alarms
- burglar alarms
- video monitoring
- electro-acoustic system (including for emergency announcements),
- measuring, controlling and regulation of the building's main technical systems
- telecommunication and IT networks
- fire protection

In addition, a museum needs a number of functional spaces (cloakroom, shop, café, toilets, staff and locker rooms for attendants, etc.). All these systems and spaces had to be installed in a building not originally designed to contain them.

Planning

Installing technology for controlling the quality of the air is always the main priority and also the main problem in listed buildings. The following systems had to be accommodated in the Neues Museum:

air-conditioning	102,900 m³/h
air-conditioning units for individual parts of the building	6,000 m³/h
ventilation systems	11,200 m³/h
extractors	15,500 m³/h
mechanical smoke extractors	151,550 m³/h

The service facilities providing the power for these systems had the following nominal output capacities:

heating	1,200 kW
cooling	670 kW
electric systems	2x 1,250 kVA transformer capacity.

In addition, safety technology control rooms (fire protection, alarm systems) as well as IT server rooms had to be accommodated.

The planners started by compiling a list of user requirements and looking at the conditions for installing and optimizing the different systems and deciding what dimensions they should have. The procedures to assess the building's physical and climatic conditions

2 Historic electricity distribution in the Mythologischer Saal (space 1.11). *Photo: Johannes Kramer/BBR*

and to decide on the layout of the air-conditioning and ventilation systems were highly unusual for a planning process of this kind. Heating and air-conditioning systems are usually laid out and dimensioned according to DIN[3] norms. Here, however, the approach was based on the statics of the building, since it was not possible to say anything about local temperature and moisture patterns or to take into account variations in temperature distribution in high halls. There are, however, dynamic calculation methods (simulations of thermal dynamics and air flow) that enable planners to identify and utilize potential energy savings. In view of the complexity of the Neues Museum building, planning its technical service systems was geared towards achieving planning reliability as early as possible and keeping technical installations to a minimum.

Air-conditioning systems

Until the building was destroyed in the Second World War, the only climatic requirement that could be adhered to was to keep temperatures at 16–20 °C during the winter. In the summer, there was no way of cooling the building, so inside temperatures may have reached 28–30 °C. As relative humidity depends directly on temperature levels, it is possible that humidity in the museum varied between as much as 20 % and 70 %. Nowadays we know that works of art are extremely sensitive to strong climatic variations, so every effort is made to keep the inside temperature and humidity of a museum constant.

In his book *Sammlungsgut in Sicherheit*,[4] G Hilbert describes how the inherent seasonal variations in inside

temperature and humidity can potentially be used to operate air-conditioning systems in museum buildings in an economic manner. Whereas the gradual changes in temperature and humidity that occur with the changing seasons can be permitted, in the course of a day, only slight tolerances caused by the regulation technology are admissible. This complies with the conservationist's requirement for a constant interior climate. As temperatures rise in the summer air-conditioning capacity can be reduced, while in winter the low relative humidity inside the museum prevents the formation of dripping water and mould on window panes and jambs.

During the preliminary planning process, thermal simulations were carried out for selected galleries (Niobidensaal, Mythologischer Saal) to determine the basic conditions. These simulations had to take into account the impact of factors like the exterior climate, number of visitors, artificial lighting and sun protection on the climate inside the building (fig. 3).

At the same time, the planners also looked at what size of technical installation the building would house and what could be achieved with these, and they addressed the recurring question of whether air-conditioning systems were necessary at all. The air-conditioning feasibility study[5] reported that the permissible interior temperatures would be exceeded through natural ventilation due to windows that did not fit tightly and/or exfiltration through exterior walls for more than 2,000 hours per year. The relative humidity levels would be higher than permissible for almost the whole year, and short temporary fluctuations in temperature and humidity would be marked, even producing extreme fluctuations in humidity of between 15 % and 65 % and temperature ranges of between 20 and 31 °C. From the point of view of conservation such conditions would, however, be completely unacceptable. While mechanical ventilation units would improve the

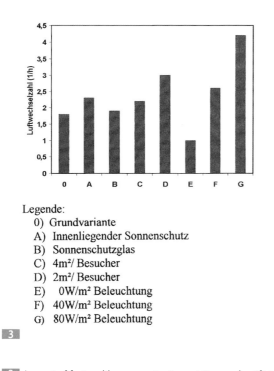

Legende:
0) Grundvariante
A) Innenliegender Sonnenschutz
B) Sonnenschutzglas
C) 4m²/ Besucher
D) 2m²/ Besucher
E) 0W/m² Beleuchtung
F) 40W/m² Beleuchtung
G) 80W/m² Beleuchtung

3

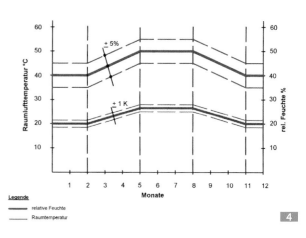

Legende
 ——— relative Feuchte
 ——— Raumtemperatur

4

3 Impact of factors like sun protection, visitors and artificial lighting on the dimensioning of the air-conditioning in the Niobidensaal in relation to a defined basic version (sun-protective layer between the inner and the outer glass panes, 10 m²/visitor, 20 W/m² lighting). *Source: Arup GmbH*

4 Distribution of annual temperature and humidity levels in the galleries of the Neues Museum. *Source: Hans-Peter Thiele/ BBR*

supply of fresh air required to meet standards of hygiene, they would not keep the interior climate constant.

The achievable interior climatic parameters were defined and fixed in collaboration with the Staatliche Museen, taking into account the results of the preliminary study as well as the geometric and physical conditions in the building. It was agreed that the temperature threshold in winter should be 20 +/– 1 °C and relative humidity 40 % +/– 5 %, while in summer the temperature threshold should be 26 +/– 1 °C and relative humidity 50 % +/– 5 %. Slight fluctuations were declared acceptable in the event of extreme weather conditions not exceeding a total of 150 hours per annum (fig. 4).

In analyzing the basic parameters for laying out the air-conditioning system, the planners realized that the artificial lighting would emit considerable heat and that this therefore represented a decisive factor in dimensioning the system and its components. It was agreed with the museum's curators that the heat output of the artificial lighting should be limited to 20W/m². In the final plans this value was achieved for most galleries without having to depart from the required standards of lighting. Where these values could not be achieved, it was agreed that some of the lighting would be automatically switched off in periods of very hot weather.

The detailed planning work began once the basic parameters had been identified and fixed. The priority was to install a "minimized" version of indispensable modern ventilation technology into the historic structure of the building.

The arrangement of the ventilation outlets represented another major challenge, as these had to be installed in exactly the right places for them to perform their function, and the difficulty of linking them to the service shafts made it necessary to carry out additional detailed thermal and flow simulation tests.[6] These showed that the required interior temperature and humidity levels would be maintained and that air flows through the spaces under review (mainly the Niobidensaal, the central staircase hall and the "courtyards") would be constant.

Fig. 5 shows how careful placement of the installations (floor cooling, decentralized air-conditioning units and inlets/outlets of the central plants) made it possible to achieve constant temperatures in the areas frequented by visitors and the potential exhibition areas of the staircase hall by utilizing the potential of the different temperature strata.

The Ägyptischer Hof presented particularly difficult problems because it contained very few suitable surfaces

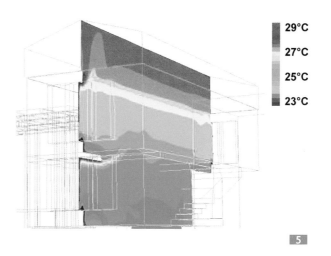

for installing outlets and ventilation ducts. The best way of solving this problem proved to be optimizing the distribution of the air over the three levels. A high-resolution CFD (computational fluid dynamics) simulation carried out for the Niobidensaal showed that the historic windows would remain free of dripping water. The positioning of the envisaged air supply inlets/outlets and the distance between the static sun blinds and the windows were of particular relevance in this respect.

Without these modern planning tools, it would not have been possible to predict in advance how the envisaged technical systems would function and hence to optimize them early on in the planning process. The advantage of this procedure over conventional dimensioning methods was that it allowed planners to precisely identify the building's structural thermal storage capacities and thus to keep the dimensions of technical installations to a minimum.

5 Summer temperature strata in the central staircase hall.
Source: Müller-BBM

6 Experiment to simulate aircurrents in the Niobidensaal (see also fig. 7). *Source: LTG AG*

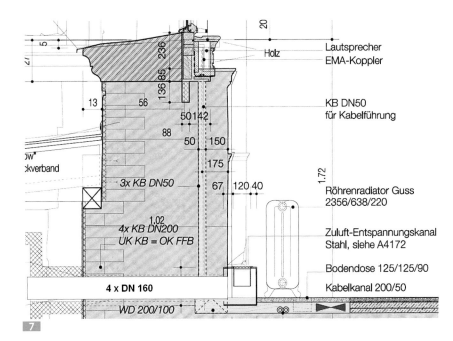

Lautsprecher
EMA-Koppler

KB DN50
für Kabelführung

Röhrenradiator Guss
2356/638/220

Zuluft-Entspannungskanal
Stahl, siehe A4172

Bodendose 125/125/90

Kabelkanal 200/50

7 Installation of historic radiators and air outlet in the Niobidensaal, detail (space 2.11). *Source: LTG AG*

The CFD simulations, in particular, made it possible to plan the damp-proofing, thermal and acoustic insulation as well as the mechanical services in an integrated way. One example of this were the simulations carried out to determine whether condensation would form on the exterior glazings of the double-glazed roofs over the various courtyards. By changing the dimensions of the outlets and changing the construction of the roof joins, air-conditioning and ventilation systems in these halls could be reduced considerably.

Following the results of these simulations laboratory tests had to be carried out by the manufacturers of the modified air inlets and outlets, taking into account of where they were to be installed.[7,8] This was necessary

in order to determine the acoustic requirements and to ensure that interior climates of these galleries were comfortable for visitors (fig. 6).

Of course, the installation parameters for the museum did not correspond with the standard data sheets for installation of these items. In the surviving historic halls (Niobidensaal, Römischer Saal, etc.), the special combination of radiators and air outlets/inlets had to be evaluated (fig. 7), and in the case of the new ceilings, the positioning of the slot diffusers close to the walls had to be checked for function. For the Moderner Saal (Modern Hall) it was possible to show that the air-flow requirements would be fulfilled taking into account the historic wall projection. The findings made it necessary to develop a new type of air outlet/inlet, as the originally planned arrangement of the slot diffusers would not have produced the desired results[9] (fig. 8).

The schematic drawings of the ventilation system (fig. 9) clearly show the difficulties of the planning task, as almost every hall required its own "tailor-made" solution.

In some halls, parts of the service systems were installed in the wall recesses designed for radiators (fig. 10), in other halls inside the historic wainscots.

Horizontal and vertical service ducts were mostly built into the floors and walls of the new sections of the building (fig. 11).

The cavities of the colonnade roof had to be used to connect the historic halls on level 2 (fig. 12)

Every conceivable opportunity was utilized to align cable ducts and channels. Altogether the planning work was enormously complex and time-consuming, as was the actual installation work. Even in 1915, the surveyor of

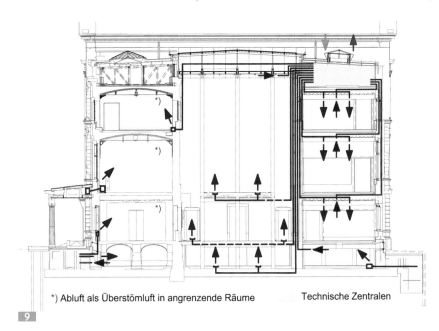

*) Abluft als Überströmluft in angrenzende Räume Technische Zentralen

9 Cross section (from the left) of the east wing, the Griechischer Hof and the west wing: installation of ventilation and air-conditioning systems. *Source: Hans-Peter Thiele/BBR*

8 Ceiling opening for fresh-air inlets, general lighting and spotlights. *Photo: Johannes Kramer/BBR*

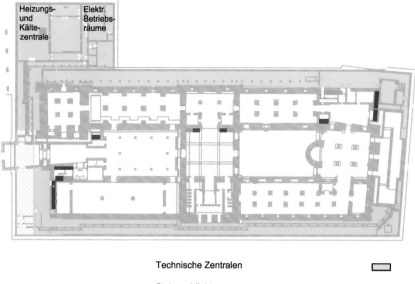

Technische Zentralen

Steigeschächte
Heizung / Sanitär / Kälte

Raumlufttechnik

Elektrotechnik

11

the firm R O Meyer stated that the maintenance and repair of the heating system involved "difficult access,"[10] and this applies even more so to today's installations. The installation conditions, especially in the attic engineering rooms and the installation ducts of level 0, may justly be described as "very demanding" (figs. 14–17).

Heating

The new heating system largely followed the historic layout of 1915. On level 0, the main distribution lines were installed in the newly constructed service lines (fig. 16). This made it possible to use the historic spaces on this level for exhibitions.

The central heating and cooling plant, with the recooling plant belonging to it, and the electrical service rooms were housed in a new underground extension on the east side of the museum (fig. 17).

The new cast radiators installed in the historic spaces on level 2 were specially designed to approximate the shape of the radiators installed in 1915 (fig. 18).

On level 3, the radiators were integrated in the reconstructed historic panels in the outside walls (fig. 19). In all the other spaces the heating was concealed behind new casing designed by David Chipperfield Architects.

Electrical installations

The electrical control rooms are located in the underground service extension and include a transformer station, a central battery unit for the safety lights and a medium-voltage and a low-voltage switchboard (fig. 20).

Like the ducts for the heating and cooling systems, electricity is distributed horizontally to level 0 via the underground service pipes. Laying all the necessary cables inside the historic galleries presented a problem as the relatively thin floor structures did not accommodate cable ducts higher than 50 mm. As these had contain not only

the usual cables for luminaries and sockets, but also a great number of safety cables, the problem of space was aggravated by the problem of potentially overloading the floors. The width of the cable ducts had to be restricted and point loads of 500 kg/cm² had to be ensured.

In addition, in a great number of spaces, under-floor sockets were installed to allow flexible use of the exhibition spaces. Here additional connections to the electricity and data networks and to the security technol-

11 Floor plan of level 0: Horizontal and vertical distribution of the service technology with circulation of pipes. *Source: Hans-Peter Thiele/BBR*

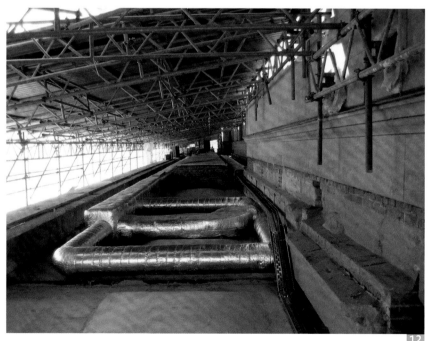

10 Air outlet and radiator behind radiator guard in the Vaterländischer Saal (space 1.02). *Photo: Johannes Kramer/BBR*

12 Laying of cables in the colonnade ceiling. *Photo: Hans-Peter Thiele/BBR*

13 Roof-top air intake and discharge for the air-conditioning and ventilation centre (RLT) in space 4.08

14 RLT centre south (space 4.08)

15 Technical centre (space 4.08) with installations

16 Service pipes, east (space 0.1.1)

17 Central heating and cooling plant (space 0.18)

All photos on pp 112–115: JohannesKramer/BBR

13

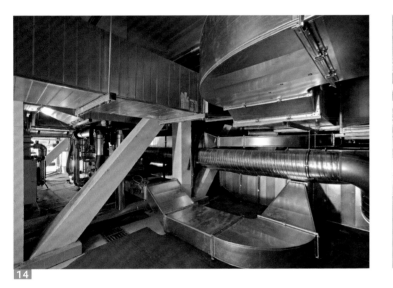
14

15

16

17

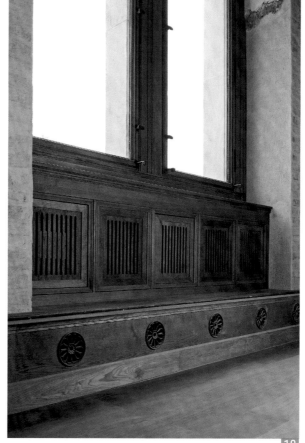

ogy are possible. Additional sockets were installed in the monitoring/control panels operated by the museum attendants in built-in cupboards placed in individual spaces or suites depending on functional requirements. The control panels include emergency buttons (fire brigade, police), touch panels for operating the lighting and the sun blinds, the interface for programming the light controls, telephones, sockets and fire extinguishers.

Artificial and natural lighting

The lighting in a museum has to fulfil a large variety of different functions. It must not only illuminate the exhibits but also provide general lighting (safety and emergency lights, lighting for hours of cleaning and for night-watch rounds).

The lighting of the exhibits must be in keeping with modern museum design. In the case of the Neues Museum, the principle was to light the exhibits, even those displayed in showcases, with ambient light. Again it became clear early on in the planning process that conservation considerations and architectural design forbade standard solutions for lighting the exhibits.

Various planning approaches were tested, confirmed, rejected, revised or newly developed in a number of test

18 Radiators and wainscot air outlets in the Niobidensaal (space 2.11)

20 Main low-voltage distribution in the switchboard (space 0.20.3)

lighting scenarios. As a result, the principle of ambient lighting had to be abandoned for the galleries on level 0 because these were not high enough to achieve sufficient light intensity and satisfactory aesthetic lighting scenarios. These galleries therefore now contain the most diverse combinations of diffuse ambient lighting, spotlighting of exhibits and illuminated showcases.

True to its historic origins, the reconstructed Neues Museum was to continue to use daylight. Following the simulation of the path of sunlight on the façades, it was decided that the galleries behind the east façade would be fitted only with static, translucent blinds for diffuse distribution of daylight, while the galleries behind the west and south façades would be fitted with automatically operable, combined. The interior spaces shaded by the exterior colonnaded passage have no blinds at all. The materials for the different anti-dazzle and anti-sun screens had to comply with the required lighting and thermal standards for a museum. Here patterns that took account of measurements of daylight either confirmed or led to revisions of the choice of material (figs. 21–23).

Detector and Alarm Systems

Fire regulations demanded fire-warning devices in every interior space of the museum. For conservation reasons, most of the galleries were equipped with smoke detectors. The smoke extractors with a diameter of 6 mm are almost invisible, as the restorers cleverly fitted them into the ceiling decorations of the historic halls. The suction pipes were installed in the floor structures of the rooms above, while in the newly constructed sections of the building they were installed in between structural floors and suspended ceilings. The necessary evaluation units were installed in the different technical distribution substations.

Where it was not possible to open the floors of the rooms above (level 0), wireless smoke detectors (spot detectors) had to be installed. Owing to their large dimensions and in some cases great height, the staircase hall, the "courtyards" and the roof spaces had to be fitted with line detectors.

The main purpose of the museum's burglar alarm system is to detect any break-in at the earliest possible moment. The system therefore constantly monitors all the

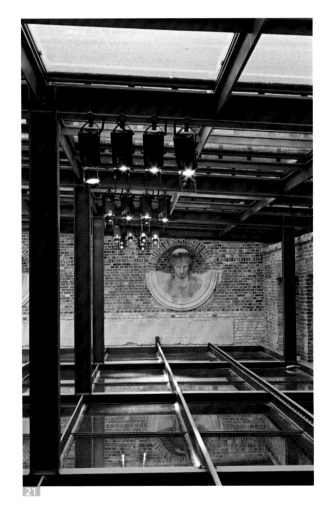

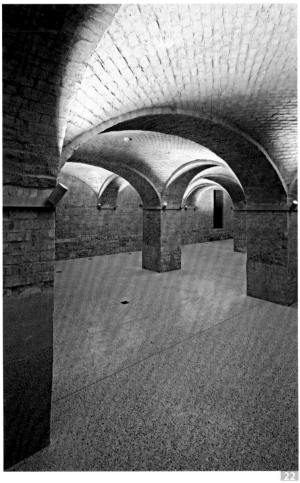

21 Illumination of the Griechischer Hof: space between roofs

22 Testing the lighting in the south-west wing (space 0.06, exhibition room)

windows and exterior doors for breakages, opening or closing. In addition, infrared motion sensors were installed inside the galleries. The alarm system is supplemented by a video surveillance camera, and selected objects are protected by additional, individual alarms. The historic casement windows had to be strengthened with additional outer panes as the old slender wooden frames and single panes did not comply with modern standards of insulation and safety.

The fire-protection concept called for acoustic, spoken warnings broadcast over loudspeakers in every room, which are automatically set off by the fire alarm system when this is activated. This required constant acoustic levels and good audibility, as the system was also designed to be used for other loudspeaker announcements. Early on in the planning process, audio tests were therefore carried out on site to choose suitable loudspeakers, which would transmit spoken messages audibly and understandably. The loudspeakers were placed either behind radiator guards and window parapet screens or – in the newly built halls – behind the suspended ceilings. In spaces with difficult acoustic conditions (long reverberating times) like the staircase hall, the Nordkuppelsaal (Northern Domed Hall) and the Südlicher Kuppelsaal (Southern Domed Hall), additional tests were first carried out to determine the best arrangement of loud-speakers.

1 A Fritzsch, Die historische Heizungsanlage im Neuen Museum in Berlin – Ein innovatives Ausbaukonzept für den bedeutendsten preußischen Monumentalbau der 40er Jahre des 19. Jahrhunderts, 10 August 1995. This degree thesis deals in detail with the problems of dimensioning and installing this innovative heating system.
2 Quoted in Fritzsch, op.cit.
3 DIN = Deutsches Institut für Normung, or German Institute for Standardization.
4 G Hilbert, Sammlungsgut in Sicherheit (Keeping Museum Collections Safe), Berlin, 2006.
5 Carried out by Arup GmbH, 1999.
6 Müller-BBM, Diverse Thermische Simulationen und CFD-Strömungs-simulationen für das Neue Museum, 2002–2005.
7 LTG AG, Optimierung von Akustik und Raumströmung eines 'Sockel-durchlasses' Typ LDB 25/5, February, 2007.
8 Kiefer, Test report Raumströmungsversuch, 20 December 2006.
9 Ibid.
10 A Fritzsch, op.cit.

23 Illumination of the platform of the Ägyptischer Hof (space 2.12)

➡ Photos pages 116 | 117:
Majolikasaal (space 3.04) in November 2004 and in January 2009. Photos: Johannes Kramer/BBR

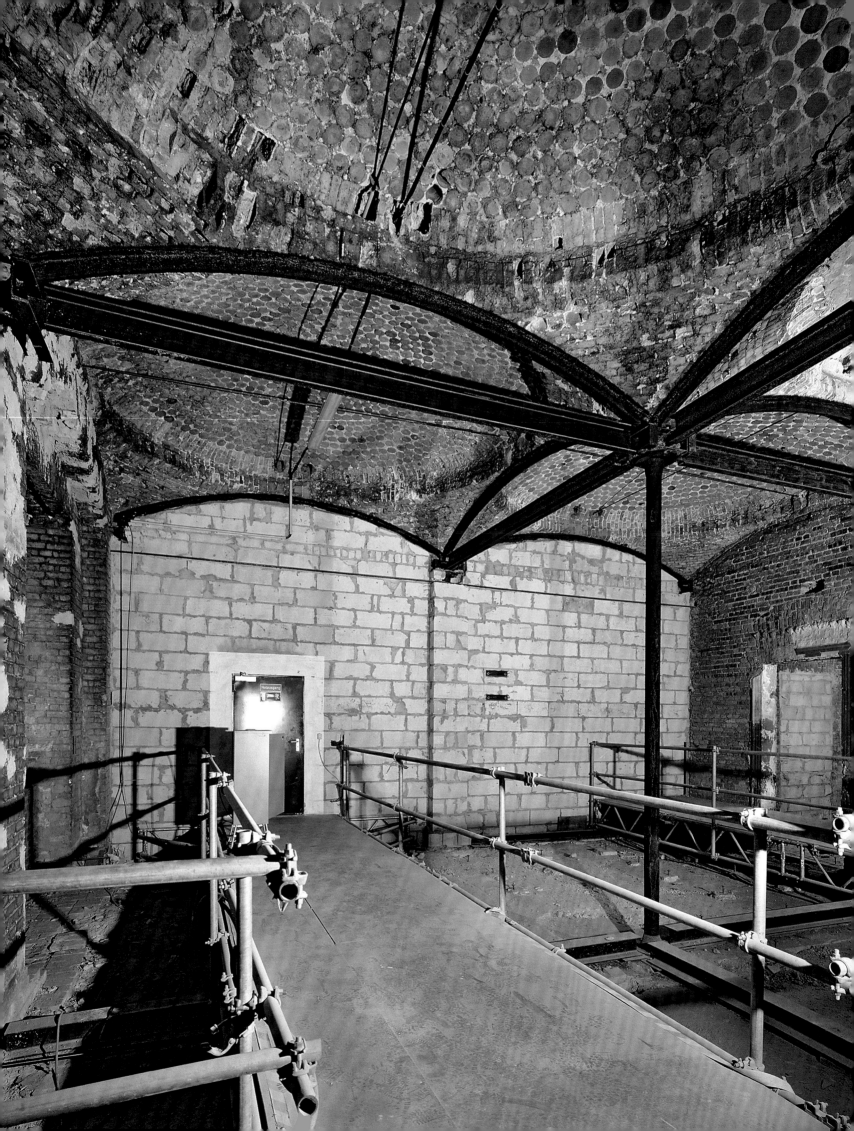

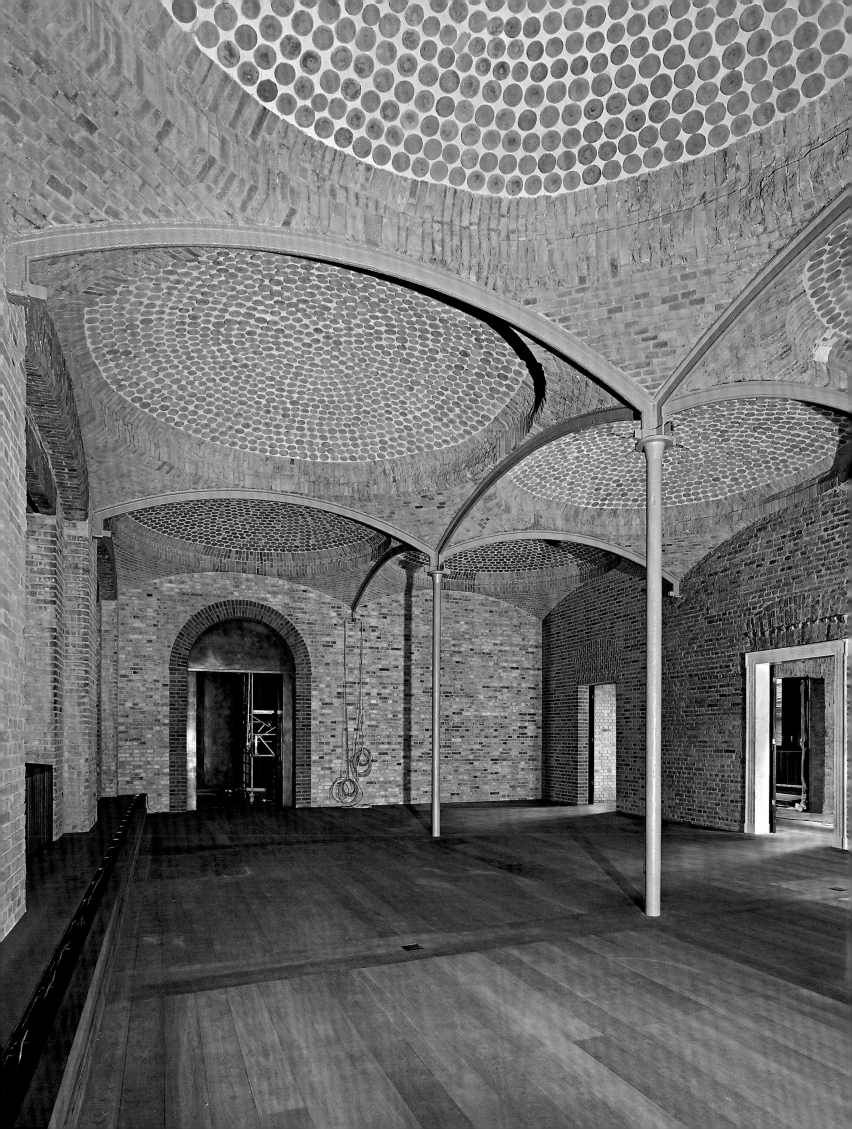

A Survey of the Historic Finishing Materials and Methods Used in the Neues Museum

Claudia Vollmann | Ayten Güleryüz |
Stefan Schiefl | Larissa Sabottka |
Peter Besch | Martin Pomm

At the beginning of the planning process, very little was known about some of the techniques applied in building and decorating the Neues Museum. Planning the restoration work therefore started with comprehensive research into the techniques and materials used by craftsmen in the mid-19ᵗʰ century. Prior to earlier conservation and support work on the ruin, materials had been tested and archival research carried out. The results of this were used by the restoration company ProDenkmal to put together a catalogue of necessary interventions. Open questions were answered through additional examinations, including chemical and physical tests relating to methods of restoration and historic materials. At this preparatory stage – from 2000 to 2001 – the parts of the building and the pieces of plaster finishes that had been taken down and stored were sorted, examined and assessed. The findings were entered into a CAD map of surviving and damaged parts and finishes for detailed assessment. This stocktaking and identification of cases of damage and deficiency were indispensable preparation for the actual planning of the restoration measures, based on extensive sampling and testing of finishing materials and finishes. The most important techniques and results of these preparatory investigations will be presented below.

Rendering Techniques

Claudia Vollmann

Originally, the interior walls and ceilings of the building were all plastered, not only with the usual felt-treated or smoothed selenitic lime mortars of the time, but also with the more sophisticated *stucco lustro* and *marmorino*.

The plaster coats, which generally consisted of three layers, were finished with a thin smoothing layer of lime, containing an extra fine aggregate, in some galleries also

an admixture of gypsum. As exceptions to this rule, a few slightly coarser, sand-floated finishes were also found (e.g. the water-glass coating of the upper wall sections in the Niobidensaal [Niobides Hall] and in the Vaterländischer Saal [National Hall]). All other plaster finishes had smoothed surfaces and, owing to the largely ultra-fine aggregates in the smoothing layer, compact mortar matrices.

Lime and selenitic-lime mortars with round-grained pit-sand aggregates were used for plaster undercoats, up to 3 cm thick, topped by filler courses (1 cm) and final smooth coats (approximately 1 mm thick). No lime spatters – always indicators of unhydrated burnt lime – were found. No brick dust or other hydraulically bound materials were found to have been added to the mortar mixtures. Neither the archival research nor the material analyses showed that these were mixed according to a single fixed recipe for the entire museum building. However, the findings did prove that in all the spaces investigated, the under-coat mortars and finishing plasters used for the ceilings generally contained 10–45 M% gypsum, while pure lime or selenitic-lime plasters were used for the walls. The most luxurious finishes were *marmorino* and *stucco lustro*. Both finishing techniques used slaked lime as a binder while the smoothing plaster was mixed with marble powder and, in a few exceptional cases, with ultra-fine quartz sand. *Stucco lustro* finishes are generally highly compacted by smoothing them with a trowel until they have a low lustre. *Marmorino* is a top-coat imitation marble, but in the Neues Museum, the term *marmorino* was used to designate the unpigmented, smoothed plaster undercoat for subsequent painting.

Marmorino

The *marmorino* finishes in the Neues Museum consist of lime plasters with a highly compacted surface. The crystalline, marble-like appearance of this unpigmented finish is due to its marble powder aggregate, which determines the mostly very pale colouring of the finish. Contrary to their usual use, the *marmorino* surfaces in the

Neues Museum were not exposed, but served as the media for colour paint skins. However, in terms of surface smoothness, there were major differences between the different rooms. The walls of the Niobidensaal, for example, had very smooth surfaces, almost as smooth as glass, and therefore formed a very inappropriate medium for a paint skin, as the patches of flaked-off paint showed. Despite the lack of documentary proof, this suggests that the interior decoration concept for this hall was changed at the time of construction. It is conceivable that, at the time, walls marbled in white were considered the wrong backdrop for displaying the gypsoplasts in this hall, and the colour scheme was therefore changed based on a dark red ground. Another possible explanation is that soon after completion the *marmorino* finish showed first hairline cracks, which necessitated covering the walls with coats of paint.

Stucco lustro

Unlike *marmorino*, *stucco lustro* is a float coat that imitates quarry stone and is coloured with different pigments. Once the top layer has been applied, it is scumbled or veined *a fresco or a secco* depending on the type of stone it is to imitate. Finally, the surface is waxed and polished.

Of all the spaces in the Neues Museum decorated using the *stucco lustro* technique, the Vestibül (Vestibule) and the Nordkuppelsaal (Northern Domed Hall) had survived with the original finishes almost intact. The Vestibül's panelling was finished in red, and the middle wall sections in ochre *stucco lustro*. The scumbling and veining designed to imitate limestone were applied to the hardened mortar medium in oil-resin-wax tempera.

The middle wall sections of the Nordkuppelsaal had green *stucco lustro* finishes (pigmented with chrome green). Once the *stucco lustro* had set, it was spattered with red, grey and white oil-bound pigments and finally waxed. The panelling in this gallery was finished in red *stucco lustro* boldly patterned with coloured veining.

An interesting find in the Römischer Saal (Roman Hall) led to the assumption that there was a change in techniques while construction was already under-way. The investigation revealed green skim coats on the west-wall pillars and parts of the east wall. These seemed to indicate that the original interior design had envisaged finishing them with *stucco lustro*, as the other wall sections only had white *marmorino* as a medium. The original decorators also seem to have experimented with subsequent paint colourings, as the first ultramarine paint layer was not found on all the walls, only on the east and north walls. The bottom layers of paint possibly represent a series of sample finishes to determine and harmonize the colour

schemes in the different halls of the north-south gallery enfilade. This assumption was supported by large patches of colour paint found underneath the original decorative finish on the south wall of the Niobidensaal, as well as by the bottom ultramarine coat of paint in the Bacchussaal (Bacchus Hall) which, according to contemporary museum guides and Stüler's statements, was never visible as the final paint coat in the completed hall.

The assumption that the interior design was changed from *stucco lustro* to unpigmented *marmorino* cannot be substantiated on the basis of the historic sources available. However, it presented a problem for the restoration work, as the extremely smooth *marmorino* in the galleries of the main storey of the museum did not form a good keying surface for the paint coats, as seen by the large patches of flaked-off paint.

Marble Cement

AYTEN GÜLERYÜZ

Marble cement is an imitation marble of gypsum, which resembles stucco marble *(Stuckmarmor)*. Probably for the very first time in Germany, "English marble cement" was used for door and window borders, mouldings, panelling, columns, pilasters and flooring components. In the 19th century this material was also called alunite gypsum or Keene's marble cement. It is characterized by extreme surface hardness, a particularly pure white and an alabaster-like translucent quality. On account of these qualities, the material became a visually perfect and affordable replacement for real marble, which in the 19th century was prohibitively expensive, owing to high transport costs.

Marble cement is produced from a particularly pure type of gypsum. This is calcined twice and becomes extremely hard through a process of alunization in between the two calcinations. In the processing phase, the material is pigmented, then highly compacted and polished to produce a very hard, smooth, shining surface. The term "cement" is actually misleading, as in the 19th century every strong mortar or plastering material was called "cement." As regards its chemical composition, marble cement has nothing to do with the material known today as cement.

Historic documents mention different qualities of marble cement, all of which had to be identified in the ruined Neues Museum. Top-quality marble cement was made of chemically extra-pure raw gypsum with a very high degree of whiteness, often with just a slight touch

of eggshell. This was used for window and door borders, pilaster shafts and floor tiles. The next best quality marble cement was produced from relatively impure raw gypsum and often had a reddish tinge as the iron particles it contained were converted into iron oxide under high calcination temperatures. In the Neues Museum, this type was found mainly in the form of levelling courses and media for top-quality marble cement finishes. Both types of marble cement were produced in England and supplied by the Hamburg-based import merchant C Hagenest.[1] A third, coarser and less diaphanous type of marble cement was produced by Ernst Mach's Tonwarenfabrik (clay-ware factory) in Berlin and used for the fluted columns. The archival documents contain many references to the difficulties of working the material, which indicates that it was not sufficiently known at the time. Stüler repeatedly asked the manufacturer for processing guidelines.

The state of conservation of the building's marble cement courses and finishes ranged from simple soiling and loss of sheen to yellowing and mellowing; some parts even had to be considered total losses. When the restoration planning process began, relatively little was known about the composition of, and the methods for processing, marble cement. The aim was to reproduce and process the material as faithfully as possible to the historic parameters and technological conditions. Chemical tests were carried out, and samples produced, to identify the constituent materials of the different types of marble cement in order to be able to reproduce them.

As the historic production processes were largely unknown, finding a gypsum mill in possession of a shaft kiln that would produce the required calcination temperatures of about 900 °C presented a huge challenge.

1 Roter Saal, pilaster shaft of marble cement before (above) and after the restoration of the destroyed flutings. *Photo: ProD*

In addition, the mill had to be able to guarantee the alunization of the material between the two calcinations and to produce larger quantities of marble cement of equal quality, which also matched the historic quality. ProDenkmal co-operated closely with a supplier who was finally found in Hundisburg (the Hundisburger Baustoffmanufaktur) to reproduce series of marble cement samples (fig. 1).

Paint Finishing Systems and Mural Techniques

Stefan Schiefl

Paint finishing systems

The lavish decorative coloration of the walls was a main factor in the interior design of the Neues Museum. Stüler and his team attributed great importance not only to the plastering work, but also to using a variety of traditional and novel painting techniques to match the stylistic principles implemented in each space. Despite the fact that a number of important main galleries were lost, the surviving and the reconstructed interiors now offer a representative overview of the variety of historic coating techniques applied in this building. The multi-layered paint coats were largely finished with structuring decorative bands or stencil patterns, while *trompe-l'œil* techniques were used to imitate wood, marble or mosaic surfaces.

In almost every surviving interior space, the walls showed an obvious change of paint extenders from the surfaces below the capitals and the lower edges of the main vault arches respectively to the zones above these – for example, in the Niobidensaal and the Vaterländischer Saal. In contrast to the panelling generally finished with shining oil-based paints or long-oil distempers (some of them with a waxed finish), the capitals, main arches and vaulted ceilings had strikingly lustreless surfaces coated mainly with paints containing lean casein or calcimine extenders. An example of this is the Mittelalterlicher Saal (Medieval Hall). Here the pilasters and main vault arches were originally painted in off-white, the former with white lead and iron oxide mixed with an oil-resin-wax matrix, and the latter with a distemper of white chalk and casein. Today the stripped pilasters can once again be seen in their

original bright colour coats. The top off-white distempered surfaces of the arches that supported the vaulted ceiling had become grey with age, owing to a high degree of gypsum formation and dust infiltration. On level 2, renovation work had repeatedly changed the original colours and patterns, and these were preserved in the first half of the 20th century. The interiors on level 1, however, were adapted to different exhibition concepts in the first decades of the 20th century. In accordance with the tastes of that time, ceilings were lowered, pilasters clad, colour-paint coats removed and the respective surfaces repainted in monochrome neutral shades, often in grey. Thus the ceiling of the Vaterländischer Saal was stripped of the calcimine stencil ornamentation and repainted with a light-grey distemper. In the 1930s, the more durable original paint coats of casein-based tempera were stripped only in part and recoated with an alkyd-resin paint, a modern material of the time.

Prior to actual restoration work, the remains of the paint systems were surveyed in all the interior spaces, but even during the ongoing restoration work a number of further analyses had to be carried out. To mention just one example of the original multiple coating technique with oil-resin-based paints and wax: in the Mittelalterlicher Saal, the smoothed top layer of plaster was originally first oiled and then covered with a thin light-blue primer, slightly pigmented to "prepare the ground" for subsequent colouring. This layer provided an evenly absorbent base, which levelled the plaster surface further. The monochrome paint coat proper – in a colour quoted as "celadon green" in the historic literature[2] – was applied to it in two thicker layers. The cool shade of blue was produced with a pigment mixture of synthetic ultramarine, white lead and green earth, while oil, mastic and a little wax were used for the matrix emulsion. In the files of the Royal Building Commission this emulsion is called "wax paint."[3] The paint-coated walls were finally decorated with dark blue lined ribbon frames, using the same type of "wax paint" (fig. 2).

Metal-sheet ornaments were used sparingly in the Neues Museum to accentuate walls and ceilings. Level 1 only contains a few isolated examples, e.g. the lettering on a number of door pediments, and the ceiling beams clad with gilded brass and zinc sheeting in the Vestibül (Vestibule). On level 2, the frames of the wall paintings in the Niobidensaal survived almost intact and formed stronger decorative accents. In the restored Mittelalterlicher Saal, the pendentives (reaffixed in their original positions) now convey a fragmentary impression of the gilded picture backgrounds. In the Sternensaal (Star Hall), the replaced fragments of the vault ribs are decorated with

stencil patterns on gilt grounds. The initial survey showed that the surviving fragments had almost always been gilded by brushing gold leaf onto surfaces pre-coated with pigmented oil-based primers and then thinly covered with a slightly brownish gold size.

The gilded pendentives in the Mittelalterlicher Saal have a rusty tinge which, however, is not due to oxidation as only pure gold leaf was used. Cleaning tests with ethanol revealed a much brighter shade of gold and this suggested that the darker tone must have been produced with a very thin resin-based coating. In the Roter Saal (Red Hall), the metal beams were pre-oiled and then insulated with a bituminous layer whose surface was smoothed with a light-coloured half-chalk ground.[4] This was sealed with shellac, then brushed with gold size before the gold leaf (stained with cinnabar) was applied. Gum arabic was used to fix the stencil patterns to the different sheet-metal parts. In 1847, the Royal Building Commission for the Neues Museum questioned the initial plan to gild columns in several galleries on level 3, and favoured bronzing them instead. However, King Friedrich Wilhelm IV himself decided to have the gilding carried out as planned.[5] The bowstring girders of the antechamber (servants' room) to the Roter Saal were the only ones with a bronze finish instead of a gold-leaf one. This may have been due to Stüler's intention of emphasizing the basic load-bearing structure of this room.

The wall painting techniques

A number of the main galleries were decorated with wall paintings of which some have survived almost intact and others in parts. Painted figures were also found on pendentives and ceilings in other rooms. Most of these were executed with water-soluble paints such as casein distemper, for example on the ceilings of the Flachkuppelsaal (Flat-domed Hall) and the Niobidensaal. Wall paintings in oil were found in other spaces, among them the murals in the Ägyptischer Hof (Egyptian Courtyard)

2 Mittelalterlicher Saal, transverse section of the wall coating system. First version, consisting of a primer coat, two layers of a bluish grey paint and a blue lined band framing. *Photo: Ekkehardt Fischer*

and the Römischer Saal. These were painted on surfaces primed with oil paint, occasionally also with casein-based paint either with thinly applied glazes or as thick impastations. Drying oils with mastic, colophony and beeswax additives were used as matrices.

The picture cycles executed using a stereometric technique represent a technical particularity of art-historical significance. The most important murals painted in this way – the ones in the main staircase hall – were destroyed during the war, but the two other cycles in the Vaterländischer Saal and the Niobidensaal survived without any substantial damage. This is all the more important as only a few examples of this early form of water-glass painting have been preserved to this day, and also because this technique was used extensively for the first time in the Neues Museum. The technical paint-coat system is very similar in both these halls, while the style of painting (executed by two groups of artists) is very different. The undercoats and the picture ground (the plaster stuff) were produced using similar lean lime mortars (with a matrix percentage of about 16%) which, after drying, were saturated with 1:1 dilutions of soda glass or double-water-glass. The paints were pigmented with watery pastes of lye-proof pigments. Finally, the paintings were fixed with double-water-glass, sprayed on as a fine mist with a piston atomizer invented by Josef Schlotthauer.

Later revisions were carried out with paints based on watery extenders (fig 3).

Prior to the actual restoration work in 2004 and parallel to studying the work techniques, the team of restorers surveyed the state of conservation of the interior decorations in order to detect any potential hazards and to decide what measures needed to be taken. As work on the foundations of the adjoining Ägyptischer Hof was expected to cause some structural disturbance, the wall paintings in the Niobidensaal were checked for blister-ing, and the plaster underneath was gauged for its strength properties. The gauging tests only registered relatively low, constant compression strengths of between 1 and $1.5 \, N/mm^2$ that are typical of lime plasters. The slightly higher compression strength of the top layer ($2-2.5 \, N/mm^2$) is due to the final fixing film on the paint surface. Cavities with considerably weakened underlayers of plaster – a frequent and feared damage to water-glass-saturated lime-plaster finishes – were fortunately not found. In the Vaterländischer Saal an earlier acrylic-resin saturation of the lime plasters had produced a weakened strength profile. Here compression strengths of over $5 \, N/mm^2$ were registered for the layers near the surface (at depths of up to 3 mm). At the time of the investigation, no major damage could be traced as having been caused by the formation of these cavities. In order to avoid damage through structural disturbances at the beginning of the construction period, the plasters were monitored and partly back-filled prior to actual restoration.

Painted Wallpapers

STEFAN SCHIEFL

Stüler's interior design also envisaged using wallpapers painted with figured representations as an alternative to plastered and painted wall surfaces. However, only a few badly damaged fragments were salvaged from the Gräbersaal (Sepulchral Hall) and the servants' room, while larger patches were found in the Roter Saal, and almost complete decorations of this type in the Mythologischer Saal (Mythological Hall). The ceiling papers in the latter gallery showed copies of paintings from Egyptian burial chambers and temples, which were executed by applying several polychrome layers of distemper. The servants' room, which Stüler designed

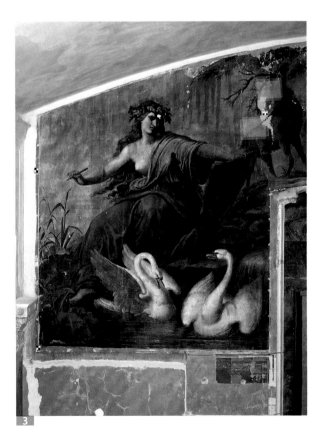

3 Vaterländischer Saal, mural no. 3, "Nornen" (Norns), stereometry, detail. State of conservation before restoration. *Photo: Karl-Heinz Petzold*

to demonstrate the building's load-bearing structure, has a ceiling of "clay pots" (hollow clay cylinders), "reproduced" in the form of two-fold stencil patterns on an orange-red ground on the wallpaper that covered the physical "clay-pot" ceiling structure.

One decorating technique is worth explaining here, using the wallpaper on all four walls of the Roter Saal as an example. First, the walls were papered with lining paper (in this case pages from old books). In a second step lengths of plain wallpaper were pasted, slightly overlapping, onto the lining paper. Analyses revealed that the wallpaper contained resinous-size-bound flax fibres. The bright red distemper, which gave the gallery its name, consists of pure cinnabar with small amounts of an extender (chalk). The bone glue used for pasting was mixed with a little oil, which did not, however, impair its water solubility. Only a few paint surfaces have been preserved where walls were covered with showcases. When the gallery was renovated earlier, the walls were repainted with an oil-based iron oxide paint.

Flooring

Larissa Sabottka

The floors – important interior design elements – brought out the colours of the walls and ceilings and consisted of different materials from floor level to floor level. On the first upper floor, pure gypsum-based terrazzo flooring was laid, while richly patterned mosaic tiling or terrazzo floors with inlaid mosaic tiles and pieces of stone dominated the second upper floor galleries.

The terrazzo floors

Stüler himself called these floors "Venetian screed," "lastrico floors" or "terrazzo" – depending on their designs. These terms designated gypsum floors, or plaster screeds with stone chippings of different colours and sizes added to them. These granular materials were either scattered in the freshly surfaced screed, or hammered into it when almost dry. This technique, already used in ancient Rome, was abandoned north of the Alps early in the Middle Ages, but experienced a revival in Venetia from the 14th century onwards. In Germany, terrazzo was rediscovered in Baroque times, yet was not widely used until the 19th century. Laying this type of gypsum or plaster screed floors is now an almost forgotten technique, although this flooring is very durable and becomes even harder with age.

The terrazzo floors in the Neues Museum are distinguished by a rich variety of designs: perfectly plain floor areas alternate with plain areas offset with strips in a different colour aligned along the axes of the column positions. The terrazzi on the second upper level were enriched with stone chippings and mosaic tiles.

Restoring these floors true to the originals necessitated, of course, analyzing their multi-layered structure. This was done by investigating a number of fractured edges. Depending on the configuration of the different spaces, the irregular surfaces of the brick floors on top of the ceiling vaults were levelled by means of filler courses of gypsum-based mortar containing coarse aggregates. The terrazzo floor structures in the Neues Museum did not include the usual sand cushions, spread 1–2 cm thick on such levelling courses to check screed expansion during the setting process and to stop structural movements from disturbing the screed. The investigation revealed that in many places there was no bond between levelling layers and base courses, perhaps because the former had often had a longer "operating life" as a working area. The filler courses were topped with underlays (ca. 5 cm thick) of gypsum burnt at very high temperatures, which formed the basis for the wearing courses. These in turn consisted of 2.5 cm underlays and overlays coloured with either pigments or rock meal. Gypsum, colouring agents and small stone chippings were first mixed together dry and then stirred into a thick paste with water. This was spread in setting templates adjusted to the required sizes. These floor sections, also called "Tagwerke" ("days' work" or man-days), are recognizable by their different colours, depending on the type of filler material, and by their different textures, depending on the type of aggregate.

Once the screed had been spread, levelled and smoothed, the stone chippings (limestones and marbles of various origins) were added to it by scattering and driving them in. Once hardened, the terrazzo floors were buffed. In the 19th century, this was done by dragging sandstone blocks in special holders across the floor. After each buffing, the small pores and holes produced in the process were refilled with gypsum paste. A treatment with alum water (potassium-aluminium-sulphate dissolved in water) served to strengthen the gypsum, and a final oiling and waxing gave the floors their characteristic sheen.

War bombing and subsequent decades of exposure to the weather had done considerable damage to the terrazzo floors. Total loss of original parts, separation of layers, disaggregation, soiling, cracks, blistering and subsidence were the types of damage for which a restoration plan had

to be drawn up. The survey (i.e. the optical analyses of coarse and thin sections as well as mineralogical solid-phase analyses) of the surviving original structures and components showed that, unlike the Venetian terrazzo floors, the ones in the Neues Museum were not based on lime but gypsum. According to the historic documents, this came from Halberstadt. The gypsum stones were calcined at about 600–1000 °C to produce a mixture of anhydrite, semihydrate and dihydrate. This mixture of half mature, mature and killed matter is characterized by its good, but relatively slow setting behaviour. Gypsum-based terrazzo floors are not only strong, but also hard-wearing. Laboratory tests showed that they are comparable to ZE 30-quality cement screeds as regards their flexural tensile strength and resistance to abrasion.

In co-operation with the Hundisburger Baustoff-manufaktur, gypsum calcined at high temperatures was reproduced for the Neues Museum. A series of specimens containing different aggregates was produced and tested to study their reduction and expansion behaviour as well as the setting time for this type of gypsum.

The preliminary survey revealed the very different states of conservation of both the surface and the layered structure of the terrazzo floors. The floors were tested by lightly knocking on them. Hollow knocking sounds suggested that the layers had separated in the respective spots. Endoscopic examinations and radar screening provided information about all the floors' structural systems and states of bonding. These findings made it possible to determine conservation measures to consolidate hollow patches and unbonded sections. As large terrazzo floor sections had been completely lost, the original types of stone chippings used as granular aggregates had to be identified macroscopically to procure identical or similar replacement material. Scientific tests were carried out on the existing structures to identify their flexural tensile strength and wear resistance. The historic techniques were redeveloped and repair techniques practised in a number of sampling and test series.

The mosaic floors

The interior spaces that would be subject to the most wear and tear, i.e. the galleries on the main level and the passages, were not laid with terrazzo, but with mosaic tiles of "clay stones which, dry-pressed from powder and fired in Mr March's factory, have been given great hardness."[6]

The unglazed stoneware mosaic tiles were supplied by Mr March's Berlin clayware factory in different colours (white, grey, green, blue, black, red and yellow) and in three basic geometric shapes (square, triangular, rhomboid). According to the project files, most of them were industrially prefabricated, as the aim was to obtain large numbers of pieces of uniform quality and colour, produced in the most rationalized manner. However, the colour variations and different sizes of the tiles found in the ruined building clearly show that this aim was achieved only to a limited extent. In the mid-19th-century years of 1844 to 1849, the time of construction of the museum, it was simply not yet possible to produce items of "standard" quality. The colour of the slightly humid unfired material was apt to change considerably in the kiln, depending on firing temperatures and mix-ratios.

The construction files also contain information about the types of clay and pigments used for the mosaic tiles. They consist of clays (stuff), sands (aggregate) and pigments (colour). The mass was dry-pressed and then fired immediately. In order to lay the tiles with the utmost efficiency, they were first put together in the form of larger plates. For these, the tiles were first laid upside down – and as jointless as possible – in moulds and then covered with casting mortar (additives: lime and fine sand) to form plates 3 cm thick. One or several mould formats were used for the different mosaic floor designs destined for different interiors. The tiles were then bedded in fresh mortar and levelled up to form perfectly even overall floor surfaces, once the plates were laid. In a final step, the narrow joints were filled in with a watery mortar.

The attempt to implement a form of industrial prefabrication was only successful up to a point. The project files document that large sections of the mosaic floors had to be removed after their completion. The state of the ones that remained in situ also indicated that the mid-19th-century manufacturers had not entirely mastered the technology involved. Thus there is documentary of the fact that in the Niobidensaal different types of bedding mortar were tried out, which is possibly the root cause of large unstable floor areas resulting from the lack of bonding between bedding mortars and mosaic plates as well as between bedding mortars and mosaic tiles.

4 Floor of the Mittelalterlicher Saal before restoration.
Souce: ProD

grilles were not gilded but paint-coated in the colour of the respective interior, or to the desired imitation effect. In the Vaterländischer Saal, for example, they were painted with bronze-green oil paint, while the wall grille was painted in the shade of red of the panelling in the Nordkuppelsaal.

Quarry Stone

PETER BESCH

In the tradition of antiquity, quarry stone was used for structural elements such as stone columns or in the form of flagstones in much-frequented interiors such as the entrance foyer and the staircase hall.

In the Neues Museum, some of these elements had been directly hit by bombs and were therefore either badly damaged or totally destroyed, while others were only soiled or had suffered structural disturbance. In some galleries, all these types of damage were found. Samples were used and methods tested for cleaning and strengthening the stone surfaces. The test results were relatively satisfactory and complied with the aesthetic and functional requirements of the museum. The stability of the load-bearing stone constructions and the load-bearing capacity of the flagstone floors had to be safeguarded, and this complicated the task of restoration. Conserving the historic stone elements was the top priority. In the Moderner Saal (Modern Hall) and the adjoining stair-case hall (passage to the Griechischer Saal, or Greek Hall) the degree of residual load capacity of the damaged but not destroyed stone columns had to be ascertained. A similar problem, i.e. the question whether they could be reused or not, arose with regard to the drums of the fallen columns.

The Material Testing Institute (MPA) in Braunschweig carried out extensive tests to identify the different stone materials built into the Neues Museum. Supported by historical sources, most varieties and their origins were identified. Yet the MPA expertise was unfortunately only of limited use, as some of the historic quarries no longer existed or the strata worked in other quarries at the time of construction were markedly different from the ones quarried there today. The expert's report listed stone-dressing companies able to supply various old cut stones in Germany and beyond, and these specimens were

Appropriate restoration techniques were chosen after extensive sampling and test series had been carried out (trial cleaning; tests for stabilizing and rebonding mortar courses; test laying of mosaic tiles according to the historic technique). The missing mosaic tiles were reproduced based on the results of X-ray diffractometric and fluorescence analyses of the original materials.

Metal Furnishings

CLAUDIA VOLLMANN

The structural elements of cast and wrought iron were clad and decorated with plastic elements of cast zinc and with moulded zinc sheeting, in line with the overall design of the Neues Museum. These parts included the bowstring girders used for the column-free spanning of the galleries in the northern half of the building, and the cast-iron post-and-beam structures of the Kunstkammersaal on level 3.

Zinc was used because it was relatively easy to work with and to mould with precision. The surfaces of these cast and moulded claddings were gilded and in some cases also embellished with additional stencil ornaments or satin finishes. The claddings of the cast-iron ceiling joists in the Vestibül included moulded zinc-sheeting cornices, but also stamped brass-sheeting claddings of reed blades and pearl mouldings. Cast zinc was also used in the form of open-work shaft grilles, banisters (as in the main staircase hall) and some architectural ornaments such as corbels, or open-work decorative grilles to cover heating ducts. Unlike other decorative zinc elements, these

5 Layered structure of the terrazzo floor in the Moderner Saal. *Photo: Thomas Schubert*

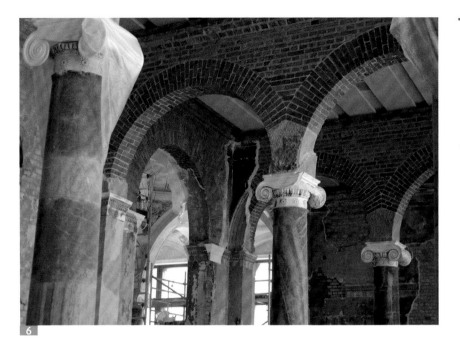

The Historic Façade of the Neues Museum

Martin Pomm

The extent of the damage to the original rendered surfaces (which was in some places extreme) as well as the reinvention of the original work techniques presented the biggest challenges both in planning and in actually executing the restoration of the facades.

Prior to, as well as during, the planning stage, various tests were carried out, many of them on specially produced specimens. The results formed the basis for developing adapted conservation and restoration techniques, for formulating a detailed catalogue of necessary interventions and for planning the actual schemes management.

The Neues Museum is a rendered masonry structure of hand-made bricks of different colours and physical qualities supplied by different brickfields. The façades are subdivided into two zones. The ground floor was faced with a rendered imitation *opus rustica*, while the first- and second-floor façades were rendered with a scored imitation ashlar bond. The details included a limited number of architectural sculptures, ornaments and structuring elements such as projections, cambers and unusually formed roofs. The original ashlar and rusticated surfaces consisted of several layers, mostly polychrome pigmented lime mortars with partly carbonate and partly hydraulic setting behaviours. These were used at the time to imitate the subdued colouring of real sandstone façades.

The survey of the surviving façades revealed not only original patches of rendering, but also repaired sections. All of them were put on the agenda of conservation measures. The preliminary investigations were geared towards identifying the very diverse materials and colours of the surviving rendered surfaces. From 1860, the façades – originally designed as unpainted poly-chrome rendered surfaces – had been repaired and patched up in several maintenance stages with mortars of varying quality (mixed to different recipes), some of them monochrome. Friedrich August Stüler had planned a rendered façade, but soon after completion, in 1860, it became necessary to resurface some of the pigmented rendered sections, probably due to lack of both material and technical quality. The preliminary tests also revealed the various casein and oil-based paint coats applied be-tween 1860 and 1936. The latest complete renovation (repainting) of the façades with a greenish brown, oil-modified alkyd-resin-based paint was carried out just

assessed during the planning stage. The flagstone floors of the Vestibül, and large sections of very dark grey, reddish grey and light grey limestone flags on the plat-form of the former Korenhalle (Caryatid Hall) had survived. Some of these were badly cracked and fissured, mainly caused by the roof of the staircase hall falling in. The task of restoring the flagstones that were preserved in situ was complicated by the fact that the original substructure had been of poor quality in the first place. This had necessitated extensive renovations even before the war. In preparation for the 1936 Berlin Olympic Summer Games, for example, several flagstones in the Vestibül had to be replaced.

The columns of Povonazzeto marble in the Vestibül were remarkably well preserved, which made extensive restoration unnecessary. The situation in the Moderner Saal was quite the reverse. A bomb hit had destroyed both the ceiling and the stone floor, and of a total of six pairs of columns of dark red nodular limestone only the three outer pairs remained standing. In the Ethnografi-scher Saal (Ethnographic Hall) directly below, the limestone columns were still standing, but had lost almost all their fluted marble cement finishes (unlike the ones in the Vaterländischer Saal, which were well preserved).

After the building had been ruined, all the remaining stone columns were stabilized in situ. Those in the Römischer Saal even retained fragments of the original gold-leaf flutings.

6 Interior view of the Moderner Saal after restoration.
Photo: Peter Besch

before the 1936 Olympic Games. Large parts of this paint coat had survived up until the present reconstruction.

During the restoration process, the alkyd-resin-based paint was removed and revealed the fragments of the earlier painted surfaces that had already been identified by the preliminary survey, and included the joint fillings in the rendered window jambs of the ground floor façades which were designed to imitate carved sandstone jambs. Important findings like these, documented during the preparatory survey, were again examined, documented and preserved based on later knowledge gained once the 1936 coating had been removed.

Examining the façades also entailed examining the plastic structuring ornaments and architectural sculptures. Different façade materials such as terracotta, sandstone from quarries at Posta and Cotta, plaster of Paris and cast zinc were identified. In analogy to the imitation of sandstone with pigmented plastering mortars, the cast zinc, plaster of Paris, terracotta and other sandstone elements had also repeatedly been recovered with *trompe-l'œil* paint coats. These were also examined and the results documented. The design decision to look for a modern coating system that would emulate the aesthetic aura of the historic one meant that samples had to be produced and tests carried out prior to, and during, the restoration process to ascertain that the planned measures would utilize compatible materials and, not least, comply with important conservation standards.

1 Order to Hagenest of 19 July 1847 (see the files of the Royal Building Commission for the Neues Museum, 'Acta der Königlichen Baukommission für das Neue Museum', GSA PK I. Rep. 137 II. H, no. 15).
2 F Adler, 'Das Neue Museum in Berlin', Zeitschrift für Bauwesen, 1853 (3), p. 580.
3 'Acta der Königlichen Baukommission für das Neue Museum', GSA PK I. Rep. 137 II. H, no. 40, vol. 1, p. 164. Here the change in matrices in the vaults has not been taken into account.
4 The paint coating of the metal girders in the Niobidensaal did not have an interlayer of half-chalk ground.
5 N Vösgen, Zink am Neuen Museum II, p. 21.
6 F A Stüler, Das Neue Museum zu Berlin, Berlin, 1862, p. 1.

Samples and Specimens for Restoration

WULFGANG HENZE

In the construction industry and, in particular, in the restoration of historic surfaces, it is not unusual to test sample surfaces first, which can be as large as entire spatial axes or even rooms, etc. This was also done prior to the reconstruction of the Neues Museum. Many samples were produced to answer technical questions and to be able to judge future aesthetic effects with a measure of certainty. The more complex the original condition of a historic surface or interior decorative scheme, the more difficult it is to imagine what the room will look like after restoration. Due to decades of neglect, the condition of the different surfaces inside the ruined Neues Museum varied considerably and required a corresponding number of samples, which will be described below.

The Neues Museum was one of the most important building projects in Prussia in the mid-19th century – at a time of great technical change. For Friedrich August Stüler and his team as well as his contractors (in particular engineer Carl Wilhelm Hoffmann; constructing engineer and factory owner August Borsig, who supplied the iron structural members and construction machinery, and architectural theoretician Carl Boetticher), the building marked the beginning of a new construction method based on technical and aesthetic reasons, and it was their answer to Heinrich Hübsch's question, 'In which style should we build?' Due to the protagonists' will to innovate, the construction site of the Neues Museum became the testing ground for a constructional revolution. Consequently, even during the erection of the museum samples of the new materials were made and construction techniques were tested. It also meant (undocumented) uncertainties as to their application and, inevitably, mistakes in the execution. In addition, some of the innovations built into the Neues Museum were subsequently either changed substantially or abandoned, which is why they are now largely forgotten and scarcely retraceable from historic archival documents. All this meant that the exclusive application of modern tried and tested restoration techniques was insufficient for reconstructing the Neues Museum. Prior as well as parallel to actual planning and reconstruction, multiple tests were carried out. Though these helped essentially to identify the chemical and material composition of the different surfaces, they did not provide absolute clarity about the related historic craft techniques. This necessitated the production of several sets of samples to develop restoration techniques which could reinvent, revise and supplement mid-19th-century craft techniques.

Sampling prior to final planning

A catalogue of the required restoration techniques was compiled in preparation for the tendering procedure, and samples of twenty-four techniques were ordered. One of the sets of samples exclusively dedicated to studying technical problems was for the restoration of mosaic floors.

The mosaic floors in the Neues Museum consist of little ceramic mosaic tiles produced of dry compressed clay in Ernst March's clayware factory in Charlottenburg. Dry-compression of granulated clay was a technical innovation March had developed by following British patent documents. As early as in 1830 Samuel Wright had been granted a patent for his method of producing multicoloured tiles from dry-compressed clay. However, this new technology only became a commercial success after 1840, when Birmingham engineer Richard Prosser invented a pressing machine powerful enough to compress a mixture of clay and feldspar to a quarter of its original volume. The technique was first used to produce buttons. Ernst March's and – after his death in 1847 – his wife Sophie's difficulties in producing the little mosaic tiles for the Neues Museum are on record. This is not surprising as the building served as the testing ground for this new construction material in Prussia.

As tiles of dry-compressed clay are still being produced today, it was not difficult to procure replacement tiles. However, only two tenderers complied with the conditions specified in the Europe-wide call for tenders

by not only sending in their bids, but also samples. The number of tiles required (after all, more than 400,000 pieces) was probably not attractive enough for most tile manufacturers.

Cleaning and sorting the roughly 500,000 mosaic pieces that had been removed and stored prior to the stabilization work carried out in the ruin, presented another, more difficult problem. Stored for years in more than sixty crates, they were dirty and splashed with mortar. Different cleaning agents and acids were tested as to easy application and effectiveness. Heating the dirty mosaic pieces to about 900° Celsius and then cleaning them first with a dry brush and afterwards with water proved the most cost-effective method that was finally used successfully.

Another series of specimens in connection with the restoration of mosaics was used to test methods to conserve historic mortar layers. The original mosaic laying technique was as follows: the mosaic pieces were bulk-delivered, laid in frames in the workshop and joined to form tiled floor slabs by applying a layer of gypsum-lime mortar (bedding mortar) up to 3 cm thick on the back. These slabs were then laid in roughly 3 cm of gypsum-lime mortar. The reconstruction of flooring using this craft technique was done without any prior testing of samples, as it was not difficult to carry out. However, when the mosaic tiles had been removed for storing, large patches of the old mortar beds (e.g. in the Römischer Saal/Roman Hall) had remained in situ. Mortar samples were therefore tested as to their suitability for thin-bed laying in order to preserve as much as possible of the original beds, but the necessary laying techniques proved too time-consuming or required the use of modern types of mortar containing synthetic modifying agents, which was undesirable for large floor areas in connection with the original historic constructions. Every one of these techniques would also have necessitated removing at least a thin layer of the original bedding mortar. The final conclusion of these tests was to abandon the entire remains of the original mortar bed and to replace it by a new one using traditional materials and techniques. In places where just a few tesserae were missing or underfloor TGA ducts had to be covered, mosaic floor slabs were laid in thin-bed fixing technique.

In one instance, the organizers of the tendering procedure received a complaint about the fact that the supplier of a number of test specimens was not excluded from bidding. The argument was that this firm had acquired a competitive edge over others. The complaint was successfully dismissed, as the results of testing had been stated in the tendering documents and every tenderer had had access to the complete documentation.

Sampling as part of tendering and contracting

In some cases, specimens sent in together with tenders for the Neues Museum were tested for their quality as an additional criterion for awarding the contract. These cases concerned unusual construction materials or techniques, for instance the production of hollow clay cylinders for the vaults.

Travelling together in 1829/30, Stüler and Carl Heinrich Eduard Knoblauch heard of the so-called 'Parisian grilles' widely used in France. These were wrought-iron main constructions the individual areas of which were vaulted with hollow clay cylinders. Stüler had designed thin structural walls and therefore needed extremely lightweight materials for the vaulted ceilings and, in particular, for the extremely low-rise vault caps in the three galleries of the south wing. The shear force of the vault caps acting on the outer walls had to be as weak as possible. (For the northern wings he had achieved this with wide-span bowstring girders and tie rods, which supported the ceiling construction vaulted with the same type of hollow clay cylinders without any horizontal shear on the outer walls.) Stüler opted for a hollow clay cylinder (based on the Paris model) that was made on a potter's wheel, had a wall thickness of between 6 and 9 mm and was closed at both ends. Masonry work done with these 'clay pots' had not previously been tried in Prussia, and Knoblauch had been the only one who, in 1834, had topped the Epsteins' family mausoleum at the cemetery of the Dreifaltigkeitskirche (Holy Trinity church) in Berlin with a calotte vault of open clay cylinders, spanning about 4.4 m. However, this form of lightweight construction had no future, as mechanic extruders were already in use and finally won through in 1854 with the extruder produced by Carl Schlickeysen in his Berlin factory. Soon afterwards, extruders were already being used effectively to form perforated bricks. This meant there were no instructions and experience to draw on for producing this type of hollow unit that had only been used in very few buildings and for a very short time. Archival material did not offer sufficient information, either.

Approximately 40,000 new 'clay pots' were needed to reconstruct lost vaulted ceiling sections true to the original structural design. This item was contracted without prior tendering following negotiations with potential contractors, in compliance with German regulations for contracts and the execution of construction works (VOL/A). The preliminary agreement (prior to the actual awarding of the contract) stipulated the delivery of sample units for two testing stages. The intention was to obtain clay cylinders that would match the original hollow clay cylinders as perfectly as possible in terms of their geometric

and physical qualities (dimensions, weight, porosity, tensile bending strength) as well as their surface quality and colour.

To ensure this, every bidder was provided with one whole original unit and some potsherds. As part of the first stage the bidders were asked to provide five sample cylinders of every type, which were then assessed. As none of the specimens they submitted matched the required standards, the first sampling stage had to be repeated. Only then two bidders achieved the desired results and were asked to produce 700 units each for the second sampling stage. Individual units and smallish masonry specimens of hollow clay cylinders from these batches were then submitted to a series of different physical tests. A number of these tests had to be repeated, some even several times, before it was finally possible to award the contract to the manufacturer who had submitted the samples that matched every requirement. In fact, thirty-six months passed from the day tenders were called for until the contract was awarded, as at every sampling stage the bidders needed four to eight weeks to produce new hollow clay cylinders, and testing these also took up considerable lengths of time. However, as the calls for tender were published early enough, this protracted procedure did not cause any delays in the construction schedule.

Reference samples

Reference samples serve to enable quality controls to be carried out as objectively as possible. In calling for tenders for the various contract items, the best samples identified in the course of the preparatory sampling procedure described above, were always quoted as references for the respective type of restoration or reconstruction work, and calls for tenders always stated that the restored finishes had to match these samples in terms of both quality and aesthetic appearance. Of course, it was not possible to identify every problem in advance and to produce samples of every piece of interior work that needed restoration, as historic architectural monuments invariably have surprises in store. Besides, aesthetic quality is difficult to put in words or to illustrate and this meant that, as restoration was progressing, in a number of rooms the contracted restorers had to produce further samples for the most important finishes (and the related techniques). As these sample surfaces had been included in the contract specifications, no extra fees had to be paid for them. Following the assessment and the acceptance of work on the part of those responsible for the project, these samples were then declared the reference specimens for all further work.

Sampling during ongoing construction

As indicated above, deciding how to specify the required appearance of the restored finishes beforehand was difficult. In addition to samples and working models, the decision-makers also transferred historic photographs into three-dimensional computer simulations of the future state of an interior. In some cases these, of course, did not match the appearance of the items in their spatial context. A number of surface specimens were therefore designed, produced and assessed by representatives of the museum and the Berlin monument conservation office during regular inspections after restoration work had already begun. Often enough, the architects and other project contributors were sent into another 'round of sampling' with requests for revisions.

Making the right decisions for the Römischer Saal was a particularly difficult and lengthy process. On the one hand, this was due to the fact that this gallery offered the entire gamut of possible states of preservation – from areas of new masonry of modern bricks or unrendered historic masonry stained by salt efflorescence, to plain rendered surfaces and almost intact paint finishes on the walls and the ceiling. On the other hand, Stüler had deliberately overloaded this hall with decorations in strong colours in order to illustrate its 'ancient Roman' character. It had a powerfully structured ceiling with coffers (largely blue) modelled on ancient examples, emerald-green walls and pillars decorated with golden lines. War bombing and subsequent years of rainwater seepage into the hall through ruined walls and ceilings had damaged and distorted the original appearance of this room, now dominated by the jagged edges of the remaining green wall areas and a few isolated fragments of the ceiling decoration. The original plan was to slightly equalize the patches of exposed masonry and the coloured surfaces by applying a final glaze as part of an archaeological restoration of this space. This would not have substantially improved the appearance of the hall and the plan was rejected by the future user of the building. The restorers therefore produced a number of samples, one as large as half the size of one wall axis, to find out how to 'calm' the visual effect of the walls without having to reconstruct the entire wall finish. The team finally opted for plasters with a special surface texture and an inherent colour from coloured aggregates. A lightly pigmented glaze was applied as a finish.

Restoration Work – Devising an Approach

GERTRUD MATTHES

The lost parts of the Neues Museum needed to be rebuilt, and other construction and technical work was required, as for any building. Also, the surviving parts of the museum needed a great deal of restoration. Unlike the building work, which from a particular level of scope upwards is awarded after a Europe-wide competition, following the German construction contract procedures (VOB), the allocation of restoration work is not clearly defined. As it was not possible to describe this work precisely, current practice was to award the contracts on the basis of previously assessed hourly quotas.

New selection methods had to be used because of the scale of the work and, linked with this, the large number of restorers needed for different surfaces and craft techniques. Given the number of questions to be resolved, the choice of the correct award strategy was an important topic.

One possibility considered was setting up a "masons' lodge", in which the best restorers would work together on the massive task. This idea was focused on the best possible result for the building in terms of quality, but it foundered, and not only because the necessary business structures were not available. Who would set up this company, and be the contact both for the restorers under their single umbrella and also for the architects and the building administration? It was not possible to resolve this with the forms of business organization at the project's disposal, without ending up with something like a prime contract company for the restorers, which in its turn ran counter to the whole idea. Lastly, this approach would not meet the requirements of the building administrators, namely that work should be put out to tender not just on a basis of quality, but also taking economic factors into account.

Thematic specimen and test procedures

In order to ensure financial as well as quality competition, the balancing act had to be achieved of describing the restoration work needed, which actually could not be described completely precisely and thus not properly estimated, to the extent that calculations could be made and a price competition held. The relatively long planning period helped in this respect. And additionally, the Neues Museum, which had survived for decades as a ruin, was one of the most thoroughly investigated buildings there were, even at the beginning of the rebuilding process. The aim was now to explore the right way of handling the existing stock using so-called thematic specimen and test procedures. These procedures were intended to establish aesthetic criteria, and also criteria applied to materials and techniques.

Of course this work had to be put out to tender on the basis of charging by the hour as, dependent on the result achieved with the originally intended test area, various modifications or entirely new approaches had to be devised to resolve any questions that might arise. This could succeed only by working with the restorers on the job, and in certain cases by bringing in experts on materials, material combinations and manufacturing techniques that are not in regular use today. It this way it became possible, by investing a considerable amount of time, to draw up the requirements for devising service descriptions and making comparative calculations based on various restorers. As well as the aesthetic aims to be met when the work was done, the precise description of the work needed became the central content of the service descriptions, using insights acquired from the specimen and test procedures.

Awarding of restoration work using the regulations for free-lance contracts

At the same time, the restoration planners who had been employed charted the extent of the damage and the existing stock. This information now made it possible to quantify. This meant that the requirements of considering both quality and economic factors when putting restoration

work out to tender had now been met, and the awarding could be effected following the regulations for free-lance contracts (VOF).

A further difficulty was raised in separating off the building work that could be carried out by craft firms or craft restorers. This work was subject to the construction contract procedures (VOB). Of course a ruin like the Neues Museum with such lavish decoration in varying states of preservation cannot be neatly divided into categories that can be handled by builders and those that demand specialist restorers.

Despite the relatively good condition of the sequences of rooms in the eastern part of the building, it was still necessary to secure the structure under the surviving coloured paintwork. And the plaster under the paintwork needed to be secured as well. The western part of the building was much more dilapidated because of the missing roofs, but despite all the damage there were still remnants of paintwork that could be retained and needed a restorer's hand. Demineralization measures – a classic restorer's task – were needed in all spheres.

The guarantee question had to be considered when drawing up these distinctions as well. How would it be possible to establish at a later stage who was responsible for a defect if for example the area of plaster to complement a fragment of wall paintwork had been produced by a construction firm and the marble plaster layer on top added by a restorer, especially given that both the plaster and the marble plaster were connected with the original surfaces?

Bundling work for a tender

Ultimately the overall planning for each room served as the basis for fixing the awards. All the work on the structural shell was summed up in one tender unit. In order to produce well prepared service packages, room sequences with similar coloured paintwork were established for the subsequent work. All the work in these rooms (plaster and decoration) was bundled in a single tender. The aim

was to achieve uniform appearance by making one firm or individual employed responsible for coordination. Sharp divisions were to be avoided as much as possible and transitions between different states of preservation and materials were to be worked on as a whole.

Whether the work required was put out to tender on construction or free-lance contracts was decided on the basis of a monetary assessment. If there was more craft work, the tender went out on a construction contract, if there was more restoration work, the tender was on a freelance basis. This meant that the majority of the bundled room sequences were put out to free-lance tender. Only the badly damaged rooms on the west side of the building, including the two courts, and the rooms on the new o exhibition level went out to construction tender.

The same approach was also applied to the work not included in the "room work groups". These were, for example, the floors that ran through a whole storey in the same material, but also the natural stone work that extended throughout the building both inside and outside. They were brought together in terms of material techniques, leading to tender packages for terrazzo, mosaic, natural stone for interiors, natural stone for the colonnade, dry rot treatment by restorers or outer façade restoration etc.

To sum up, it can be said that thorough planning and experiments in the specimen and test series it became possible to draw up service descriptions for restorers as covered for other work at various fee levels etc tendered according to free-lance regulations. However, these would not work for other building projects, as they apply to particular found states, materials and working techniques needed specifically for the Neues Museum. But the approach to drawing up the tender descriptions is definitely worth imitating.

1 Level 2: Room work groups. The figures in the plan define the relevant tender units. *Source: David Chipperfield Architects*

Restoration Work – Legal Grounding and the Tendering Process

WULFGANG HENZE

One view taken by many people putting public work out to tender is that restoration work is a construction service, it changes a building and so it goes out to tender on a construction contract. This is advantageous to the employer in that almost everything is fixed in detail, from tender types to the technical contract conditions.

One inconspicuous factor is hidden away in § 8, no. 2, para. 1 of VOB/A (the German construction contract procedures): "*For public invitation to tender, the documents are to be given to all applicants who provide professional services of the type described.*" Lawyers interpret this to mean the following: bidders and/or those inviting to tender for public commissions must offer the service in question as professional traders. This requirement is compulsory for all tender procedures using the VOB/A regulations.

The requirements for carrying out a profession or trade are laid down in the trading and craft regulations. These state that only those contractors who meet the trade law requirements may work on construction. According to this, if craft services are being provided, they must be listed in the qualified craftsmen's register (§1 HwO (craft regulations)).[1]

Interpreting §25, no. 2, para. 1 VOB/A produces a similar result. The text of the regulation states: "*For public invitation to tender, the bidder's suitability must be examined first. Here the supporting information submitted should be used to select the tenders made by those bidders whose suitability offers the necessary certainty of fulfilling the contractual obligations.*"

In a judgement dated 27 December 2001, the Celle superior district court interpreted the clause thus: the necessary certainty "*is lacking if the services tendered may not be provided by a bidder because they involve a craft for which the bidder is not entered in the craft register. In this case, the bidder cannot guarantee to provide the service, as there is a risk that he will be claimed against for neglect by competitors or that the responsible authority will forbid him to continue trading.*"[2]

To sum up: construction contract services offered by free-lance workers are seen as illicit work. §1, para. 2, no. 5 should also be consulted: "*A service is deemed to be illicit work if a person provides service or carries out work, or causes them to be carried out, while ... as a provider of service or work practises a trade requiring registration without being listed in the qualified craftsmen's register (§1 of the qualified craftsmen's register).*"

One conceivable way out would be listing in the qualified craftsmen's register, which in principle is possible according to the law regulating crafts for the restoration diploma (§ 7, para 2 HwO): "*Furthermore, engineers, technical college graduates and of state or state-recognized specialist schools of technology and design may be listed in the qualified craftsmen's register corresponding with the school or college specialization of their examination.*" But as a rule, this is not in the interest of restorers. The difference between a restorer and a craftsman is defined in the co-operation agreement between the Union of German Restoration Associations and the Central Association of German Craft in 1996: "*In theory and practice [the restorer's activities] are characterized by a scientific and academic methodology. A restorer registered as a craftsman is and remains a craftsman and member of his trade.*"

Mecklenburg-Vorpommern is the first and hitherto only German state to have passed a law about using the word "restorer" to designate a profession (Restorers Act RG M-V dated 9 November 1999). In §1 of this the restorer's professional duties are defined as follows: "*The restorer's activities lie in the material preservation of cultural and artistic assets in public, private and ecclesiastical ownership by examination, listing, conserving, restoring, maintaining, advising and research and providing the appropriate documentation. In exceptional cases, the restorer will also participate in scientifically/academically sound reconstruction of cultural and artistic assets. A restorer does not practise a trade.*"

Summary: restorers see themselves as a free-lance profession. "*The distinction between craft and free-lance*

services is based on the categorization of free-lance activities laid down in §18, para. 1, no. 1 EstG ... and the case history developed from the judgment on 'similar professions' ... According to this, the activities of scientists/academics and artists are generally categorized as free-lance. As a rule, these activities require higher education verified by a college or specialist college qualification and are not directed at profit in the first place, but have higher interests (of the employer or the general public) in view."[3]

The above applies to restoration: restoration work is aimed essentially at the preservation and improved perception of the existing stock; restorers do not create new values. Restorers' work is academic/scientific to a great extent and frequently also artistically driven. Restorers' work cannot be defined with complete precision, it involves intellectual and creative elements that cannot be determined in advance. Restorers recognize interests that are higher than their profit, for example as formulated in the Code of Honour for Restorers.

For all these reasons, restoration work can/may not be put out to tender on a construction contract, so when preparing the invitation to tender for restoration work at the Neues Museum, the following statement was made: *"It is crucial in the awarding of restoration services to establish who can provide these services. If the work can be done by craft restorers, i.e. craftsmen with additional training, then such work should definitely be put out to construction contract tender. ... If the work is so complex that it can be done only by restorers with diplomas, these should be invited to tender as free-lance workers."*

Inviting to tender for restoration work on a free-lance basis

In §2, para. 1 VOF (free-lance contract regulations) the fields to which these regulations can be applied are defined: *"The VOF provisions are to be applied to invitations to tender in the spirit of §1, as mentioned in Appendix I A and Appendix I B. Only §8, paras. 2 to 7 and §17 apply to the awarding of services mentioned in Appendix I B."*

Work was classified as appropriate to Appendix I A or I B on the basis of the CPV or CPC reference numbers (see http://simap.europa.eu) appropriate to the services to be provided. The CPC nomenclature was published in the European Community Commission's ruling on a common vocabulary for public contracts dated 5 November 2002 and is to be applied since 16 December 2003. *Measures for the preservation of historic buildings* can be found under code 925 22 200-8. The CPC code describes the United Nations' system for classifying goods, services and assets. Here *Preservation of historical sites and buildings* can be found under code 96322.

Both classifications correspond with category 26 "Recreation, culture and sport" from VOF Appendix I B, i.e. only §8, paras. 2 to 7 and §17 apply (see above). §8, paras. 2 to 7 deal with job description in terms of formulating technical requirements and environmental qualities such as the use of brand and type designations. §17 deals with publishing the awarded commissions.

In other words, classifying the restoration work under VOF Appendix I B means that the employer is free to decide whether and how he manages a competition. However, he still has to devise appropriate rules for this.

Tendering under negotiation procedure according to public announcement of invitation to tender based on §5, para. 1 VOF

The Federal Office for Building and Regional Planning decided that the Europe-wide tender announcement procedure prescribed according to §5, para. 1 VOF for tender invitations should also be used for the tenders for restoration work at the Neues Museum, as this would make it possible to reach the greatest possible number of applicants. Interestingly, neither the awards chamber nor the awards senate may be asked to commission an inspection procedure, even though the invitation went out Europe-wide, voluntarily. The Stuttgart superior district court ruled on this head on 12 August 2002: *"A public employer can commit himself to more rigorous tender regulations voluntarily when inviting to tender ... But it cannot be deemed by voluntary self-commitment of this kind that this opens an inspection procedure by the awards chamber and the awards senate."*[4]

A website was set up for applicants' information. This not only provided a short description of the anticipated restoration work, but also contained information about the pending awards, and application documents to be downloaded.

The most suitable applicants were selected from those who came forward, and they were asked to submit a tender. The main thrust of the assessment procedure was to examine how well the personnel to be used were qualified, with regard to the professional careers and several reference projects of a prescribed number of employees who were to be identified by name.

The offers had also to be accompanied by explanations, which were used to assess the quality of the team, the organization of the work and the level of the fees (award criteria). To make uniform assessment easier, questions were devised for the bidders to answer.

Here are the texts informing bidders in the "invitation to tender" about how the documents submitted would be assessed:

On the quality of the team: *"The quality of the team will be assessed on the basis of two reference projects. The leading restorer, already named in the application, and one of the other colleagues are to describe their experience in the field of restoring interior plaster and architectural paintwork, based on work they have carried out personally in each case. Here the questions listed below about a representative individual area or a corresponding individual service for a reference project are to be answered as succinctly as possible (even in note form).*

One of the pieces of work presented should involve revealing a piece of decoration or contain one, the second should correspond as closely as possible in technical terms to one of the key items under tender. The concept for the restoration work presented should be as close as possible to pure conservation. Restoration interventions such as completing coloured paintwork or plaster, retouching etc should be limited to essentials and should match the surviving original fragments.

The documents should be accompanied by photographs of condition before the work, stages of the work and the condition after restoration. (...) If necessary, short explanations of the pictures may be provided. The photographs should show the quality of the craft/technical execution of the work.

Assessing the documents submitted:
- *Quality of the documents submitted max. 2 points (The assessment will be based on precision, the completeness and comprehensibility of the written presentation, the quality of the photographs, the eloquence of the photographs in terms of the craft/technical quality of the work.)*
- *The work presented by the bidder corresponds with one/several of the work(s) put out to tender in terms of craft technique max. 5 points*
- *The restoration concept for the work presented corresponds with the aim of applying predominantly conservation and careful restoration measures max. 5 points*
- *Implementation quality for the restoration concept of the work presented max. 5 points*
- *Craft/technical quality of the work presented max. 5 points*
- *The overall assessment of the team's quality will be based on the sum of evaluations of the two presented works."*

The organization of the work: *"Organizational schemes, techniques or instruments for completing the commission should be presented in response to the questions below. Project organization will be assessed with a view to appropriate structuring of the responsibilities, their efficiency and their effectiveness in reducing risk.*
Assessing the documents submitted:
- *Organization of the expert and technical work max. 6 points*
- *Quality control max. 8 points*

- *Organizing documentation and charting work max. 6 points"*

The fee tender: *"The basis for assessing the fee tender is the average value of all tenders submitted within the award unit. Fee demands under 75% and over 115% of the average tender value are awarded 0 points. The maximum point score will be awarded to a tender at 85% of the average tender value. Between 85% and 75% 2 points will be knocked off for each percentage point under 85%, between 85% and 115% 2/3 points will be knocked off for each percentage point above 85%.*

Assessing the fee tender:
- *Level of the fee bid in relation to the average value of all tenders max. 20 points"*

This award procedure ensured that only really well-qualified teams were short-listed and that the bidder who was most suitable for the work to be done with appropriate fee requirements was awarded the contract.

1 Quoted from a letter from the Federal Ministry of Transport, Building and Housing dated 15 August 2002 about an award decision for the manufacture of a specimen window for the Neues Museum by a free-lance diploma restorer that was withdrawn on the grounds of a complaint from a carpentry firm
2 Quoted from Vergaberechtsreport 10/2002
3 Quoted from the above letter from the Ministry of Transport, Building and Housing
4 Quoted from Vergaberechtsreport 10/2002

Pre-existing Structural Shell, Rebuilt Structural Shell, Façades and Colonnades

MICHAEL FREYTAG

The Neues Museum's construction plays a special role among 19th-century museum building projects. The unsuitable subsoil and the king's desire for the museum to have three full storeys while not exceeding the height of the Altes Museum forced Friedrich August Stüler to reduce the weight of the building and the height of the roof construction. He used iron constructions (bowstring girders) that were developed in the Industrial Revolution as well as a lightweight construction method with clay cylinders and lightweight bricks. This made the Neues Museum the first Prussian monumental building to deviate from the previous solid construction method and use modern, lightweight techniques that took advantage of mass production. However, the appearance of the building remained largely neo-classical. Due to their cladding, structural elements like iron girders, clay cylinders and stone supports appear only indirectly and pictorially; they are not on display. There is a clear distinction between core form and artistic form.

Today, after destruction during the war and sixty years as a ruin, parts of the museum's structural shell are not merely visible but the main feature of its rooms and constituent parts. This makes the shell central to the rebuilding concept, which is based more on the aura of the original – on what exists prior to rebuilding, together with its traces of aging – than on the quality of the art and images that were once there and have now been lost (see chapter "Raumgruppen"). In modern times – at least since the rebuilding of the Munich Pinakothek by Hans Döllgast (1952–57) and the increasing conversion of historic industrial buildings into museums – visible construction and visible structural shell surfaces are not seen as incompatible with high-profile museum architecture. The structural work for the Neues Museum includes small-scale repairs to the existing structural shell, repairing and making usable the original constructions (cast-iron girders, clay cylinder ceilings and natural stone columns), and recreating the building volume envisaged by Stüler by erecting new structures to replace the missing parts.

Taking the brick, in this case the second-hand brick, as the basic modular unit allowed a continuous transition from small-scale repair to repairing larger volumes of the building.

Existing structure

Repairing the existing structural shell – healing wounds to the Neues Museum from destruction and decay as well as from necessary measures to secure the structure – involved small and large-scale replacement and additional bricks. Any missing bricks of special types were recreated based on the existing bricks. Repairs to the bare masonry of walls in the central Treppenhalle (staircase hall) are particularly striking. Destroyed during the war – burned down to the flooring slabs and "robbed" of all its layers of décor and visual art (Kaulbach frescoes) – the Treppenhalle today is a repaired space of bare masonry.

In areas where parts of the original constructions (barrel vaults, shallow domes, load-bearing stone columns) still remained, they were repaired and completed. This involved reactivating many original craftwork techniques. Iron girders, clay cylinders, lightweight and special bricks were recreated, and special gypsum mortar was manufactured based on the original. As these were load-

1 Mittelalterlicher Saal (room 2.04), detail of the apse with prefabricated concrete parts. *Photo: DCA*

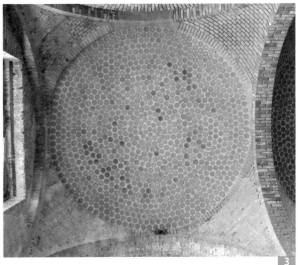

bearing components, many physical parameters had to be kept in mind alongside the conservation and aesthetic aspects. Extensive investigations and load tests and special concepts for reinforcing cast-iron girders with CFRP ribs and rehabilitating the natural stone column drums, meant that original constructions could often be modified in close coordination with the structural engineer and retained as load-bearing components.

Rebuilt structure

The recreation of the building's volume by filling the gaps with new structures (the northwest wing, the southeast protruding section and the main staircase) is closely based in its structure and arrangement on Stüler's plan. Pre-produced large-format cut stone slabs with finished polished or sandblasted surfaces, stacked with great precision room by room, create the exhibition room volumes and the "sculptural staircase" in the staircase hall.

The large-format cut stone slabs, in part but not always load-bearing and divided into zones closely based on the broad zones of the plasterwork in the original rooms, are core form and artistic form in one. Obviously additions rather than original, the new exhibition rooms fit into the existing rooms' sequence, completing the building and making it a whole again.

From inside, the newly built additions are revealed by the cut stone slabs, but from the outside their defining feature is brickwork. Bricks, used for the structural shell elsewhere, are an unplastered exposed surface here. Yellowish sandstone-coloured brick was chosen. The colour harmonised the brickwork with the existing façade. The same second-hand bricks were used as for the repairs to the existing masonry. As an irregular building product, they had to be specially checked for suitability as a load-bearing component as well as for façade brickwork.

Façades and colonnades

Like the room décor, existing facades were differently restored depending on their state of preservation. On levels 1 and 2, the conserved plaster was filled in flush with the surface. On level 3, the larger gaps in the plaster were matched to the other levels' colour tones by applying a slurry to the bricks. This slurry more or less covers the brickwork of the structural shell, making the latter invisible to a casual glance.

Structuring architectural elements made from stone or terracotta (pedestal zone, cornices and window jambs) were repaired where still present. Those that had been entirely lost were reconstructed. The pedestal zone and the window jambs were reproduced in the two newly built additions, toned down in form and using materials in correspondence with the new structures. Stone colonnade components were returned to their original sites on the east and south sides. Missing elements and the lost ceiling construction were reconstructed. Apart from a thin coat of slurry to harmonise the colours, the brickwork of the ceiling construction was left visible.

2 Mittelalterlicher Saal, apse, vault. *Photo: DCA*

3 Mittelalterlicher Saal, vault with new shallow-domed ceiling made from clay cylinders. *Photo: DCA*

Existing Structural Shell/ Colonnades/New Structure

TOBIAS MANN

Contract for pre-cast parts production

In the spring of 2005, with the awarding of the aggregate contract for the structural shell of the parts of the building to be rebuilt to ARGE Rohbau Neues Museum, Dywidag/ Dreßler, the pre-cast components factory of Dreßler Bau GmbH in Aschaffenburg was awarded the contract to manufacture architectural concrete pre-cast components. The final parts were installed in August 2008.

The totally destroyed north-west wing with the Ägyptischer Hof and the southeast projection were newly erected. The stairs of the main staircase hall and the interior spaces of both wings were executed using modern architectural concrete pre-cast parts. Where no building fabric remained, architectural concrete with a polished or sandblasted surface was generally chosen as the material for ceilings, walls and flooring (fig. 1).

The architects could only meet the extreme practical challenge by previously measuring the existing fabric and unitising it down to the smallest detail. This ambitious project was only possible through collaboration between the architects, our onsite construction management, the technical engineering firm and the pre-cast component factory's concrete laboratory, which implemented the specifications for component thickness, bracing, details of joins and concrete technology. Planning and production within this collaboration both required great effort.

The new concrete parts had to have absolutely clear-cut edges. Their surfaces' colour, roughness and structure had to be as uniform as possible, and they had to fit together to the millimetre, with each other as well as with the existing construction. One particular example of this were the horizontal and vertical joints measuring 5 mm specified in the contract. Joint tolerances were set at +/- 1 mm.

Obviously such a specification could not be kept by using normal pre-cast component techniques. Specially calibrated measuring tapes and rulers were needed for production and installation. To enforce specifications for pre-cast production, particularly with regard to appearance and tolerances, we instituted quality checks for all the contracted firms. For each individual component, suitable tools were developed to ensure high quality – from mould construction to the pouring process to storage and transport.

The principal's demand for pre-delivery, pre-installation evidence for adherence to tolerances in individual components was satisfied by a quality control passport for each pre-cast element. Only suitable parts were certified for transport to the site. This prevented any interruptions to installation work. In all, 8,200 pre-cast parts were installed. Due to differences in geometry, most of them were unique. The heaviest pre-cast part weighed 21 tons.

Marble cement and its processing

During production, 1,950 m³ of marble cement were processed, 5,300 m² of concrete surface were polished and 11,250 m² were sandblasted. High-value construction material was created using Erzgebirge marble quarried from underground. After extensive tests, a very harsh concrete was developed.

High strength was an important factor in creating the desired uniform concrete surface. The concrete was made from marble aggregate, white cement, sand, water and plasticizers. 1 m³ of concrete contains 1,300 kg of marble with an aggregate grain size of 2 to 35 mm. Ceiling joists and slabs, door jambs, supports, floor covering, steps and wall slabs with individual element sizes of up to 8 m x 3 m were polished (fig. 2) and sandblasted. 50/50 supports of up to 15 m in length were blasted on all four sides and the stair banisters were ground to a round shape using a diamond-formed milling cutter.

Transport and installation

To prevent avoidable accumulation of dirt during transport from Aschaffenburg to Berlin, enclosed transport vehicles were generally used. The valuable individual concrete parts had to be painstakingly secured. A high lift crane was generally used for installation. This meant opening the

1 In areas where building fabric no longer existed, architectural concrete pre-cast parts were used, for instance so-called "carrot supports". *Photo: Andrea Kroth*

adjustable canopy over the site above the existing building areas for every crane lift.

The effort-intensive inner-building transport of precast components to their installation sites took place on the sub level. As the rough concrete surfaces were to be left as the final surfaces, these had to be extensively protected. This involved measures such as back-ventilated wooden cladding and galvanised starter bars.

Rolling ceilings

The ceilings for the building's wings were missing entirely due to war damage. This meant more freedom in designing for the inner-building systems needed in a modern museum and their wiring ducts. The aim was to construct a sandblasted lower ceiling with an in-between space for inner-building systems and the load-bearing in-situ concrete ceiling above it. The "rolling ceiling" was the solution.

First, in the lower, visible area, the load-bearing, sandblasted downstand beams were mounted. The self-supporting lower ceiling elements made from sand-blasted marble cement were then mounted at intervals on the supports on top of the downstand beams. These ceiling slabs were fitted with runners where they rested on the beams, allowing them to slide easily. The third step was to mount filigree slabs on the downstand beams and apply the load-bearing ceiling concrete (figs. 3, 4).

The inner-building systems were installed by sliding the lower ceiling elements together. They were spaced out again after the installation. The space left between the ceiling slabs was used for the light fittings or closed with 2 cm-thick sandblasted concrete slabs.

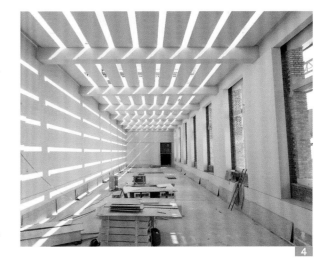

Courtyards

Aside from individual rooms and the Griechischer Hof (Greek Courtyard), the Ägyptischer Hof (Egyptian Courtyard) and the main staircase were surely the highlights of the architectural concrete work. In contrast to its structure before the destruction, the Ägyptischer Hof was given three storeys of new exhibition rooms. A system of columns supports these rooms and ultimately the glass roof.

The design involved 50/50 supports, 15 m in height and sandblasted on all sides. The pre-cast construction junctions were built so that a viewer would not see the individual elements, and would think the junction was solid. All visible concrete surfaces were sandblasted.

The 15 m supports were manufactured horizontally with a 55/50 cross-section. After the first setting process, 5 cm were removed from the pouring side, giving a final cross-section of 50 cm x 50 cm. The high strength of the concrete was very important for this unusual procedure, which ensured that all sides of the support looked similar once they had been sandblasted (fig. 5).

2 Marble cement: grinding the slabs. *Photo: Dreßler*

4 Rolling ceiling: lower ceiling. *Photo: Andrea Kroth*

5 Ägyptischer Hof:
Columns of the
grating which supports
the glass roof. *Photo:
Dreßler*

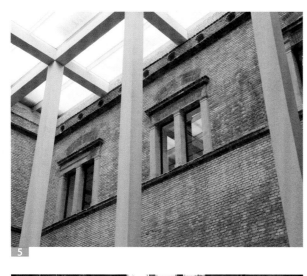

5

6

7

The Griechischer Hof was very well-preserved apart from the destroyed apse. Marble cement, the new material, was used to construct a continuous sandblasted wall in front of the lower wall area. The apse was recreated in the upper area using second-hand bricks.

Haupttreppenhalle (main staircase hall)

Until 1986, the main staircase hall's 22 m high masonry walls had no protecting roof. The architectonic concept for rebuilding the Neues Museum left the walls in this hall as they were, marked by war and by the division of Germany. It only kept the function of the main staircase. All that remains of the once richly decorated walls is the brickwork. The original dimensions of the space were retained. The new stairs were made entirely from marble cement pre-cast parts with a polished and sandblasted surface (figs. 6, 7).

Restoring External Façade Plaster

KLAUS RICKEN

The original plaster's state of preservation is different on all four façade sides. After the numerous overpaintings were removed, it became clear that even well-preserved areas of the variously coloured mock-ashlar plaster are shot through with fine shrinkage cracks. The west side had been exposed to weathering since the loss of the painted layers. A restoration concept to conserve the coloured plaster developed from extensive scientific examinations and sample work. The plaster was to be filled in only within its continuous surfaces, while the brickwork of the structural shell surfaces was covered with a slurry. The two-layered plaster structure was reproduced as a slightly hydraulic lime mortar, based on the grading curves and using the indicated aggregate, and investigated using a sample section on the east side.

As well as the usual plaster securing and backfilling, conserving the plaster involved completely infilling the network of cracks with material adapted to the colour of the individual ashlars and bosses. A mortar formula colour palette had to be created that could be used for crack infilling and for plaster repair.

State of plaster

Over almost 170 years, a variety of external influences, from war damage to air pollution, structural settling and natural weathering on the façades have caused wide variations in the original exterior plaster's state of preservation. In some places the bonding agents have been lost. Prior to the restoration, the largest concentration of

6 Staircase hall: The new stairs were made entirely from marble cement pre-cast parts. *Photo: Dreßler*

7 Staircase hall: polished banister with sandblasted inner stringboard. *Photo: Andrea Kroth*

damage was found on the west side. The situation is best on the east side and the surviving east part of the north façade.

After removing numerous overpaintings, the differences were even clearer. Despite heavy surface encrustation (gypsification), original plaster with smooth surfaces and contrasting, differently coloured ashlars still exists, even on the central projection – the most damaged area – of the west side (the side most exposed to the weather).

The layers of surface paint that remained on the other façades were more quickly worn away here. Almost intact plaster ashlars have been preserved on the east façade, particularly on both projections, although they are permeated by shrinkage cracks that appeared in the surface plaster layers at an early stage. This was one reason for the 19th-century renovations when the facades were painted a uniform grey.

The original plastering techniques

Fired red Rathenow bricks were used for the external facades. For the bossages on the ground floor, the joints were worked into the masonry.

The plaster mainly has a two-layered structure. The coarse-grained lime mortar of the base plaster is preliminary rough-cast and a framing profiling coat mortar for the broad angular bossage joints. The plaster ashlar joints had already been drawn in the coarsely rubbed-down base plaster.

The coloured top plasters end at the joints. They are applied beyond the joints and smoothed over. According to the joint formation, they are cut away from areas outside the joints while still fresh. The next, differently-coloured ashlar is then placed in position adjacent to the preceding joint.

The fine-grained lime plaster's composition is determined mainly by the coloured components. As well as red earth pigments, red ashlars contain an exceptionally high level of crushed brick, while grey ashlars have slate powder as a colouring aggregate. These aggregates' hydraulic (plaster-hardening) function was presumably an undesired side-effect. The excessive bonding it caused produced especially severe pattern cracks.

Previous repairs

Several phases of repairs including mortar replacement, mainly with mortar containing cement, took place during the course of the four redecorations between the end of the 19th century and the first half of the 20th century. The earliest plaster repairs involved damaged areas, presumably with serious cracks, being renewed ashlar by ashlar with plaster

solidly coloured with ochre. The polychrome façade survived until the redecoration at the end of the 19th century. Later additions to the plaster were mainly performed with sometimes very hard mortar containing cement. This created new cracks in the surfaces.

Restoration concept

The final restoration concept was confirmed in 2006. It was based on a sample section between the 2nd and 3rd window axis of the left part of the east side façade. The idea was to only fill in the plaster within continuous surfaces, and to give the frost-sensitive brickwork on the shell structure surfaces a slurry coat. Battering protects the broken plaster edges.

The planned conservation measures were based on the results of long-term scientific studies of all the façades. The plaster additions were to be closely based on the – usually original – existing surfaces and somewhat lighter than the immediate surroundings. The surfaces of these expanses of plaster were to be differentiated from the existing plaster by rubbing them down somewhat coarser. Success in exactly matching the colour tone for the additions depended on a number of outside factors, such as atmospheric humidity, temperature and absorbency of the undercoat. It proved particularly difficult on the existing historical surfaces, with their varying degrees of patina.

1 East façade, level 2: state after backfilling, with areas marked for needling and colour determination. *All photos: Klaus Ricken*

Conservation and restoration measures

After removing still adhering remains of oil paint, spots of brown discoloration from a first coat of varnish (linseed oil), presumably applied during the first redecoration, were left in place for the time being. Over the course of three to six weeks, some lightening in these spots was observed. Fine cleaning of the existing surfaces was done mechanically and without liquids with scalpels, spatulas and small scrapers to clean the joints. Foreign materials such as dowels, small corroded pieces of iron and remains of gypsum and cement mortar were also mechanically removed.

Old repairs to the plaster were also removed if their greater hardness (in the case of Portland cement) was damaging the softer construction material or if they contained damaging salts. Hollow places, usually created by the base plaster coming loose from the brickwork rather than the upper fine plaster layer coming loose, were found in areas with and without settling cracks. The loosened plaster layers were usually reconnected by backfilling the hollow spaces.

In areas that could not be infilled using mortar injections, the plaster surfaces had to be needled with glass fibre-polyester needles. They were stuck into the plaster using epoxy resin. Hairline cracks and plaster cracks less than 1 mm wide were closed using pigmented mineral mortar (Ledan D1).

The colour tones for the mortar repairs were decided, with the tone of the crack-filler material based on the existing surfaces. This made it necessary to develop a comparable pigmentation formula system for crack closure, specifying the pigment aggregate for the plaster additions. The pigment for the crack-filler material was largely matched to the existing surfaces.

Some surviving bullet holes were exempted from the plaster repairs. Holes of 3-6 cm in diameter were closed if the edges had been blurred by subsequent weathering and the breakage caused by it. Smaller holes remained open. Gaps of more than 6 cm in diameter were closed. Repairs to the joint pattern on the ashlars and bossages as well as the plaster edges were intended to visually reinforce the different construction members' geometry.

After filling-in of places where very poor mortar had been removed, the preliminary rough-cast coat of air-hardening lime and Teschendorf sand mixed to a ratio of 1:3 was applied. After initial hardening, it was cut away down to 0.5-0.7 cm below the surface.

The coating mortar, flush with the surface, was coloured to match the existing plaster. The objective was a cooler and lighter toned surface that was also somewhat rougher than the existing surface. In the lower half of the surface, the bullet holes were battered, a measure intended to allow runoff of rainwater. Those plaster repairs that were left and stood out too much from their surroundings visually were colour-matched using pigmented lime casein glazes.

2 East façade, level 1: colour tests on a gap in the rustication plaster

3 West façade, level 1: ashlar plaster with its network of cracks sealed and with plaster repairs

Together with the intended stabilisation of sanding surfaces, the final consolidation of the existing surfaces using silicic acid ester caused a reduction in capillarity leading to a minor change in coloration which the project team knew would vanish within a few weeks, leaving a visually and physically balanced surface that still spoke of the discontinuities of history.

Stone Façades

MAX-FLORIAN BURKHARDT

The biggest challenge was guaranteeing the quality needed for the restoration concept, with its unique design, without compromising static requirements and within the agreed time frame. Despite sometimes extremely difficult working conditions, the demands of the existing building were met without compromise. The archaeological reinstatement work was focused on the cornice (on the west, south and east sides), on the Apollo projection, on the Reko axis and of course on the south portal. Here, whole parts of the building were recreated as if they had never been dismantled.

Archaeological reinstatement of the Apollo projection

The first step was a painstaking inventory and remediation of the badly damaged removals and original pieces. After the selection and cleaning of the original stones earmarked for the reassembly, their measurements, profile, surface and level of damage had to be individually recorded. This was done in the grounds of Hohenschönhausen. To trace fragments shattered in many pieces, the existing cornice fragments were sometimes laid out beforehand like a jigsaw puzzle. Finally, the whole Apollo projection was reconstructed on paper, with planners filling in its gaps with the necessary new parts.

The tympanum and pediment were particularly demanding. Their geometry was recreated from the available surviving pieces and combined with a fine-tuned support structure. Now the pieces to be reinstated could be prepared for their reinstallation. Replacement parts were painstakingly made from material taken from the site. Cracks were needled or braced, and broken cornice pieces were joined together and anchored so as to

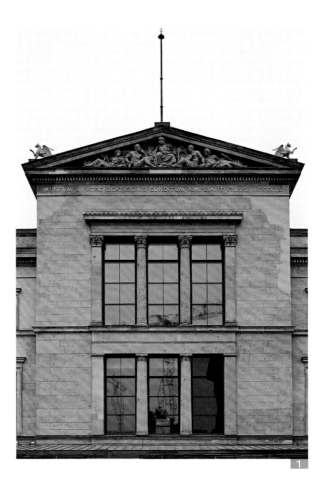

transportable or braced using horizontal elastomere bearings. Due to the variety of measurements, profiles and damage histories, each stone needed an individual concept. Adapting the cut stones' formats to varying new physical and static requirements was another exacting part of the preparation.

After preparations at the storage location, logistically determined consignments of materials were transported to the building site together with any equipment needed to lift them. Each piece had to be transported to its original position through openings in the roof and scaffolding. Planning and stonemasonry preparation came together to precisely fit the pieces horizontally and vertically into the rows of recreated masonry for a faithful recreation. To match the building's original masonry technique, all of the stones were aligned on lead bearings and anchored to the building. The very precise joints were tamped using hemp-jute rope and filled by pouring or grouting using casting channels.

Archaeological reinstatement for the south portal

The whole south portal, together with its corner pilasters, was reconstructed in the same way. The particularly large individual segments and the severe damage in this exposed location were however exceptionally challenging. All

1 East façade of the central staircase hall with new sandstone surrounds of the three-light windows and new sandstones inserted into the plain moulding with a crowning cornice. *Photo: Johannes Kramer/BBR*

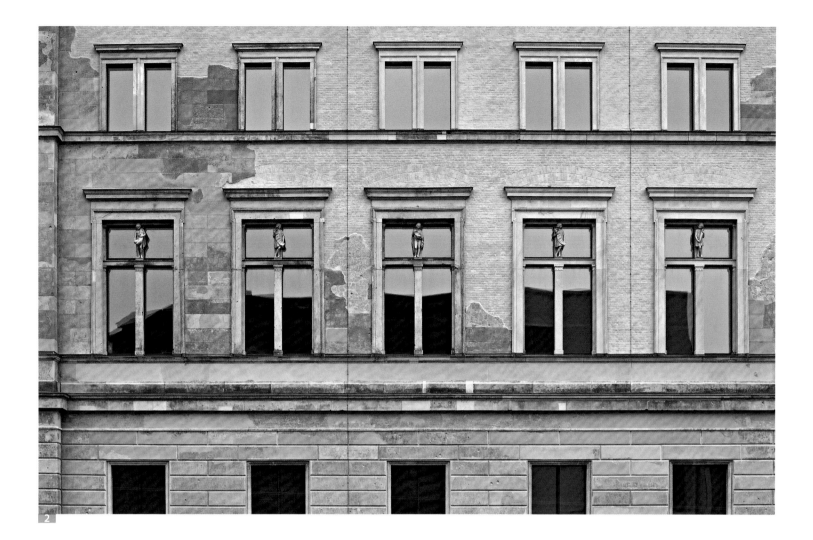

additions to the stonework within the exposed surfaces shorter than 3 m were created with the same level of damage, almost entirely preventing any loss of existing material. This design concept did however have to be reconciled with the static requirements. Vertical and horizontal blocks had to be added to the backing wall to ensure sufficient load-bearing capacity.

Initially, the pilasters and architraves of up to 6 m in length were laid out in the workshop so that every trace of damage could be recorded. Recesses were then created on the rear sides. Complex stepped formats had to be created to absorb all shear forces. Only now the actual new replacement parts could be refined based on all the observed incidental conditions. Every individual addition was shaped by a combination of missing volumes of angled stones with a complex rear configuration. In exposed areas, they echoed the same degree of damage. They were anchored to each other as well as to the reinstated parts.

Triple windows 2.01 and 3.07

The damage to the sandstone of the solid pilaster surrounds of the triple windows in the two central projections had to be corrected in a complex series of working phases. In order to remove the damaged parts, the whole stone and brickwork load-bearing structure had to be improved and temporarily relieved of its load, an exacting process. Steel supports were bored into it and grouted, while all cracks in the subsoil were injected. The original loadbearing state could then be recreated only by a progression of minimal-disturbance removal and partial subsoil renewal. While this was taking place, huge blocks of sandstone were measured in the quarry, cut in the factory and positioned against the elaborate corner constructions as cladding. Then it was carefully integrated to form the new pilasters.

Creating new large-format workpieces

In recreating solid cornices and window jambs from scratch, the focus was on the surmounting geison along

2 West façade: level 1 and 2. *Photo: Johannes Kramer/BBR*

the length of the staircase hall, the continuous pedestal and the window jambs on the west and south sides. The shape of window jambs with 25 individual elements weighing 12 t in total could be recreated exactly. This required the exact joining together of existing parts and any new parts in each component. Each stone was up to 5 m in length and weighed up to 4 t.

First, the junctions with the existing structure and the removed parts were recorded. The different formats and profiles were measured in the Hohenschönhausen grounds and combined with the planning guides for all the subcontracted work to produce a complex reconstruction on paper. At the same time, all the necessary raw materials were selected based on qualitative properties. As well as meeting physical requirements, they had to be matched with the positioning, texture, structure and colour tone of their planned site. Selection based on these criteria, giving each rough stone a designation, was also carried out during the process of cutting into the required series of slices using a frame saw. Now the actual cut stones could be formatted using a bridge saw. Finally, they were delivered to the stonemason to be worked. With the help of the individual work dockets and the specially produced templates, the most delicate part of the masonry work then began, involving individual profiles and decoration patterns. After the completed new parts were transported to the building site, laying work took place as previously described until every stone had been placed as intended.

The sensitive selection and great precision used for every individual replacement part deserve particular recognition. These elements are now once more a natural part of the building's appearance.

This symbiosis of reinstatement and new parts can be found in all parts of the façades and in many variations.

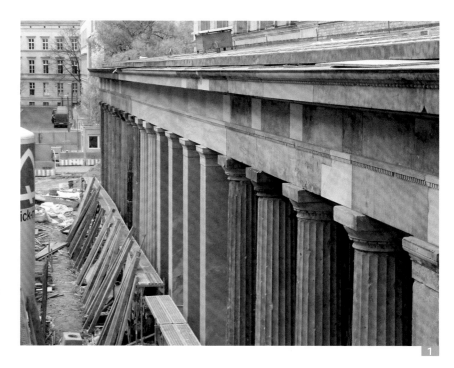

Stone in the Colonnades

HERMANN GRASER JR. | VOLKMAR HILLIG

The object of the contract was the reconstruction and rebuilding of the historic colonnades, consisting of the transverse colonnade, the east colonnade – including a ramp for accessibility and a stair at the main entrance – as well as the south colonnade with its passage and connection to the existing colonnade of the Kolonnadenhof in front of the Alte Nationalgalerie. This included restoration work, static improvement, transporting and placing the original work-pieces initially stored at Hohenschönhausen and manu-facturing, delivering and placing new workpieces with attention to the neighbouring original parts. Manufacturing, delivering and placing the casting channels and their mountings was also part of the contract.

Put simply, the task was to put together a colossal three-dimensional puzzle out of separated parts weighing tons, half of which no longer existed and the other half of which were partly damaged and not stored in proper order. They all had to be inspected, sorted, cleaned, restored and transferred to new locations several times before they could be brought together with the additional new "puzzle" stones at the right time and made available exactly where they had to be installed.

1 View of the entire completed south colonnade. *Photos: Bamberger Natursteinwerk Hermann Graser GmbH & Co. KG*

2

3

4

A logistical challenge

More than 520 individual reusable stones (weighing about 1,070 t in total) from parts of the building dismantled in the 1950s, including stones weighing up to 8 t each, were in outside storage. Additionally, over 600 individual components weighing up to 16 t were manufactured. These parts weighing tons but being very fragile due to delicate patterns including indented friezes, beading and cannelures had to be moved several times and installed with great precision to recreate the colonnades. In particular, a specially developed technology was needed to transport and put in place monolithic columns and pillars more than 5 m in height and about 80 cm in breadth.

Producing the new materials

The planned finished measures for the stones used, particularly for the accessibility aids (the ramps) and the large architraves, pillars, columns and cornices, required rough stones in measurements not generally available from the selected granite and sandstone quarries, for geological reasons.

It was also important to choose sandstone blocks that not only had the right dimensions, but also matched the colour and structure of their future installation site. Transporting these large and heavy stone blocks out of the quarry and then to the workshop for further processing involved specially efficient technology.

Particular challenges for restoration

The preservation model largely involved using the original materials in their original locations. Pre-existing damage to these stones that posed no risk to stability was to be left visible as witness to the building's chequered history. For this reason, components with multiple scars were stabilised with additional stainless steel anchors.

3 Detail showing installed new elements of the sandstone entablature (cornice with bead and reel, frieze metopes/frieze heads, and architrave with indentations)

4 Existing and new components: granite floors, stairs and ramps for the disabled

Stone in the Interior Spaces: Columns in Spaces 2.06 and 2.07

PETER BESCH

The demands on restoring the interior's stones were very complex due to their many different varieties, designs and states of repair. Key areas for this work were the columns, capitals, bases and flooring in the first, second and third storeys. This article deals in detail with the rows of columns in the passage connecting with the Haupttreppenhalle (main staircase hall) to the west and the rows of supports in the Moderner Saal.

Row of supports in the Moderner Saal (space 2.06)

In the Moderner Saal, the main task was to erect the fallen and broken columns in a load-bearing state. The existing components' structure and surfaces had been damaged, sometimes severely, by the effects of war and decades of weathering. Due to the structural damage, all elements had to be load-tested. This test was carried out on the intact columns in situ (space 2.04) and carried out on the surviving column drums' by the MPA-Bremen (Bremen Institute for Materials Testing) in Saalburg. Replacements for the missing drums were also manufactured in Saalburg from "Violett Vogelsberg" stone. Acquiring suitable materials for replacements proved difficult, as the original quarries are now closed and the original material (Campan Melange) is no longer quarried. A suitable substitute material was obtained from the Fa. Saalburger Marmorwerke, who made their remaining stocks available, as the "Vogelsburger Steinbruch" (quarry) is also no longer worked.

After the ceiling over level 1 was recreated, the individual column drums were placed on the restored historic bases via the still-open roof of level 2, using the original craft techniques. The statics involved had to be very precise, as the calculated load-bearing capacity allowed barely any margin of error. For safety purposes, the joints were grouted by high pressure injection after the drums had been put in place.

With one exception, the capitals, badly damaged but still capable of taking a load, could be reused. One missing capital and a complete base were shaped in plaster based on historical models and reconstructed in Carrara marble using the pointing process.

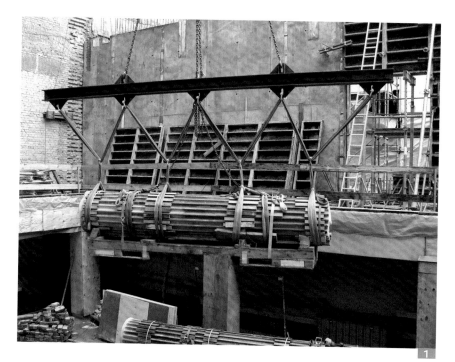

Row of supports in space 2.07

In the Treppenhalle area, the four Ionic columns beneath the westward connection of the third level were erected once again.

The 6 m-high monolithic Carrara marble columns suffered severe fire damage during the building's destruction. The column surfaces showed several kinds of damage: gaps, cracks, sugaring of the marble, peeling, mechanical damage, deformation and blackening. After being salvaged, the columns were kept uncovered in the Griechischer Hof for many years.

1 Salvaging the column shafts of the main staircase hall from the Griechischer Hof. *Photo: ARGE Weiß, Späthe, Haug*

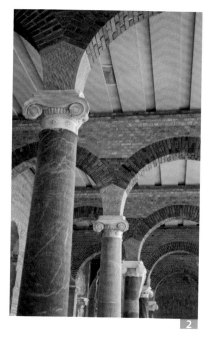

2 Moderner Saal (space 2.06), restored and conserved capitals. *Photo: ProD*

3 Main staicase hall, preparation of putting the columns back in place. *Photo: Katrin Haug*

Weathering washed away parts of the black crust. With the columns back in place, the resulting horizontal streaks were to be preserved as a "patina". The column restoration was limited to measures necessary for conservation – i. e. basic surface cleaning and strengthening.

The fallen columns had to be transported from the building to the restoration workshop to be restored. Due to the site's layout, transferring the 6 m-long columns proved very complex and effort-intensive.

As with the columns in the Moderner Saal, the historic material's load-bearing capacity was tested. The Treppenhalle columns were assessed using ultrasound and drilling resistance tests. Regardless of the result, no further static load was placed on the columns. They were only required to support their own weight.

1 The columns were made from Pyrenese marble – Campan Melange rouge

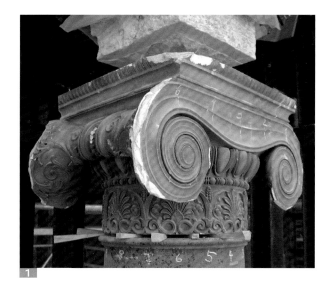

1

Stone in the Interior Spaces: Repair of Column 04 in the Mittelalterlicher Saal

ANDREAS KLEIN

The Mittelalterlicher Saal's (medieval hall's) nine shallow domes are supported by four columns. The columns' shafts are smooth with no cannelures and an entasis. The Ionic-type voluted capitals each have a palmetto-decorated ornamented ring. The column's base is elaborately patterned. The two-part capitals and the bases were worked in Statuario marble from near Carrara. The columns' monolithic shafts are made of an Italian serpentinite breccia. The disintegration of the pillars, capitals and bases presumably began as the direct result of disturbance and heating due to the war's events.

Like the rest of the building, the Mittelalterlicher Saal was heavily damaged at the end of the Second World War. This included the collapse of two of the shallow domes. Their long-term exposure to the elements in the ruined building would also have had a negative impact on the state of preservation of the Carrara marble in particular.

Ultrasound tests carried out in 2002 showed dramatically reduced ultrasound speeds for some column components. The capital and base of column 04 were assessed as particularly critical. Due to these components' presumed insufficient load-bearing capacity, the column was initially secured using a temporary prop.

Before the capital and base could be detached for loadbearing capacity assessment in a testing institute, all the capital areas that were crumbling and breaking away had to be conserved, and crack stabilisation and battering had to be carried out on unstable areas. To detach the capital and base, the ceiling's weight first had to be taken off the column. First the lowering wedges underneath the steel prop were replaced one by one with hydraulic presses. These could be individually activated using a synchronous lifting system, ensuring an even lift to balance out the different loads experienced on each of the four sides. Displacement transducers between the prop and the floor allowed the degree of lift to be checked. When the weight of the ceiling vault transferred from the column to the steel prop, the individual presses registered the increase in pressure. The presses' adjusting rings were used to fix this setting for the duration of construction.

To detach the capital, space first had to be created so it could be lifted off the column. This was achieved by removing a roughly 20 cm-high piece of sandstone from directly above the capital. The joint between the column and the capital, only about 1-2 mm wide, was parted. This was done manually using hacksaws with narrow blades. Shallow wooden wedges driven into the joint in several places ensured even load distribution and prevented edges from being broken during lifting of the capital.

After being lifted off the capital was transferred to the adjacent scaffolding using Teflon strips and then lowered onto a pallet using a block and tackle.

1 Dismantling the capital of column 04 in the Mittelalterlicher Saal, April 2005. *Photo: Andreas Klein*

To detach the base, the column had to be lifted. Its lower third, at the slight entasis, was bound with lashing straps. These straps were attached to hoisting slings. The column was lifted using two block and tackles hooked to the vertical prop construction. It was temporarily laid on squared timbers. Finally, the base was detached.

The detached components were transported to the Bundesanstalt für Materialprüfung (BAM) in Berlin. The preparation of the tested units, the test setup and the results of the load tests are given in the BAM report "Belastungsversuche an Säulenelementen aus Marmor".

The components were prepared for reinstallation in the contractor's Potsdam workshop. After renewed strengthening of the damaged parts, the ornamented ring and the upper part of the capital were mounted in order to make installing the capital easier. A Wolf was hooked into the hole on the upper bound of the upper part, allowing the piece to be lifted. It could not be attached to lifting apparatus in any other way due to the weakness of the material.

Several 8 cm x 5 cm lead plates were arranged radially atop the upper bound of the ornamented ring, about 3 ⁄ 4 cm from the outer edge. A stainless steel dowel of 15 mm diameter was inserted in the existing dowel hole. Trass/lime mortar was used for mortaring. The upper section was placed on the ornamented ring, with the evenly applied mortar completely filling the joint. The narrow 1 ⁄ 2 mm joint thickness was kept to, in line with the historical model.

Hooked up to the block and tackle and strap lifting construction already described, the column was lifted in the way described above. Loose grime and dust was cleaned off the base's sandstone mount so that it could be laid without mortar using a lead bearing and aligned. For the dowel anchoring, the historic anchorage hole and a stainless steel dowel were used. The precise position required to match the original location could be told from marks left during the removal.

The column was set on the base without mortar, by means of the lead plates and dowels embedded in the joint. The capital was installed in its original place. The impost block above the capital was filled in with a precisely fitting block of Posta sandstone.

The narrow joints were filled without cavities using injection syringes and cannulae. The materials and process for the injectable seal had previously been tested and modified in the workshop using two circular slabs of marble matching the column's cross-section and joint thickness. Lime mortar was used to grout the joints. Fitted pieces of sandstone were also used to interface the base's lower joint to the mounting stone, to adapt the sandstone mounting's cross-section to that of the lower column shaft.

After the mortar had set, the ceiling vault's weight was rested on the column again. A hydraulic hand press was used to slightly raise the presses, freeing up their adjusting rings so they and the whole strut construction could be lowered. The weight of the ceiling vault now rested on the column once more.

Tests on Selected Stonework Materials

Gerda Schirrmeister

In 2001, diagnostic tests were documented by the Gesellschaft für Baudiagnose und Schadensanalyse on flooring slabs in the Vestibül and column elements in the Bacchussaal, Mittelalterlicher Saal und Moderner Saal. The restoration measures involved checking, refining or correcting the data on the types of stone used in these documents in order to find present-day suppliers for the stone.

There was no data at all on the origin of the stone used for the column shafts from space 2.07 being kept in the Neues Museum's storage area for removed parts. This delayed identifying them and proposing current suppliers.

When the project began, the Alpenweiss Rosé stone type given as the aggregate for the concrete cut stones to be used for façade repairs was no longer available. Suitable alternatives had to be found.

The flooring slabs and column elements in the rooms of the Neues Museum or in storage were examined macroscopically. They were also mineralogically analyzed using a magnifying glass. Samples were taken from building materials in storage. Polished cross-sections and thin sections were made to further define the stone type.

Comparative studies were made using the collections of the Deutsches Natursteinarchiv in Wunsiedel, the Bundesanstalt für Geowissenschaften und Rohstoffe in Berlin and the Institut für Angewandte Geowissenschaften at the Technische Universität Berlin. Samples of two flooring slab types from the Vestibül were also sent to the Czech Republic for analysis. After evaluating the test results, the search began for current sources of the types of stone required.

Bohemia, given as the origin for two Vestibül flooring slab types, was corrected based on the test results. The

fossil content in particular allowed the geological age and environment where the stone was deposited to be determined (see figs. 1+2), narrowing down the possible places of origin and helping to suggest suitable substitutes.

Campan Melange from historical sources, given as the material for the column shafts in the Bacchussaal and the Moderner Saal, was confirmed. Three remaining blocks of the original material were found in France, but they did not yield enough suitable material to reconstruct the Moderner Saal columns. After recommended compressive strength tests, searches for similar materials of the same geological age led to *Violett Vogelsberg* and *Saalburg Königsrot* from Thuringia being used.

The space 2.07 column shafts were identified as *Bianco Carrara Ordinario* using results from the thin section samples. Also using results from the thin section samples, the listed place of origin Fosse de Zechino (a historical source) for the bases and capitals in the Bacchussaal, the Mittelalterlicher Saal and the Moderner Saal was assigned the *Statuario* marble type.

Five available aggregate types were profiled and evaluated as substitutes for *Alpenweiss Rosé* dolomite marble. The recommendation was for *Lengefelder Marmor Weiss* dolomite marble from the Erzgebirge, which was ultimately used (see fig. 3).

2 Reddish-grey limestone from the Vestibül with many fragments of corals, crinoid stem sections and Stromatoporoidea. This is a reef detrital limestone. Geological age: Middle Devonian

3 Cast concrete stone with Lengefeld Marmor Weiß aggregates

Groups of Rooms – Plaster and Décor Restoration Work

Anke Fritzsch | Martin Reichert | Eva Schad

Unlike "reconstruction" in the strict sense and "archaeological conservation," the term "restoration" is highly vague, describing the many approaches that lie between these two extremes. Public discussions on this subject tend to be dominated by dogmatic standpoints, with little thought given to the specific type of restoration involved in any given case. The decision is generally left to the restorer concerned, in consultation with the responsible preservation authority or with the principal.

Although those involved in making the decisions may not like to admit it, every restoration – unlike a straightforward conservation or strict reconstruction – involves a number of individual decisions, often with far-reaching consequences. There is no automatic connection between initial conclusions and the restoration's outcome. The large number of individual restoration technique and preservation theory decisions occasioned by cleaning, exposing layers of décor, partial replacement, retouching etc. all have an aesthetic impact on the end result. To put it another way, one cannot be certain that a theoretically sound restoration concept will not produce an aesthetic disaster, because the aesthetic implications of certain decisions have not been duly considered.

For us, these observations carry a twofold message. Any at all complex restoration assignment needs a degree of planning commensurate with the task – and any restoration planning is also (although not only) a design process, a "restoration blueprint."

The starting point and focus of our restoration concept is the existing material, the surviving décor – essentially, what is tangibly there, the material that has been left to us. The starting point is the original plus the signs of ageing accrued over its history. Our idea of a monument's value is influenced more by the aura of the original and its value as a historic object that has aged than by the quality of the art and images that were once there and have now been lost.

Our restoration blueprint, however, is not rigidly dogmatic. The aim is not "pure veracity," but rather a fitting, sensible and of course beautiful solution. Great respect for the surviving material is involved, without this becoming an obsession. The aura of the original should be preserved without it becoming stylized as a relic.

The repertoire developed together with the Landesdenkmalamt Berlin (Berlin State Conservation Office), the collection's directors, Dr Gisela Holan, departmental head for construction for Berlin's Staatliche Museen, and many others is not a fixed set of rules, but rather a catalogue of different procedural models which we use to avoid the implicit tendency towards single-mindedness and a narrow schematism in German concepts in particular. Depending on initial conditions and the room's requirements, the restoration may involve anything from primarily archaeological conservation to partial reconstruction. In each case, the decision depends on the condition, the significance and the value of a room or of individual architectural components and on how they fit into the sequence of rooms and the building as a whole.

The intentions behind the restoration of the Neues Museum

The intention behind the restoration was to make the damage less obvious, rather than being the major overall impression, as it was at the time. The restoration measures have endeavoured to make the rooms ordered and expressive enough for the original design idea to become readable again.

This meant using methods and techniques taken from two disciplines generally (or in Germany, at least) considered largely irrelevant to building preservation. One was the restoration of archaeological exhibits (pure conservation, the aesthetic of the fragment etc), and the other was the restoration of wall painting (in particular retouching techniques). Applied to a modern building, especially one from the mid-19th century, both of these may appear surprising at first. Although the architecture of the late classical school and Historicism has been rehabilitated in the realm of art History in the past three

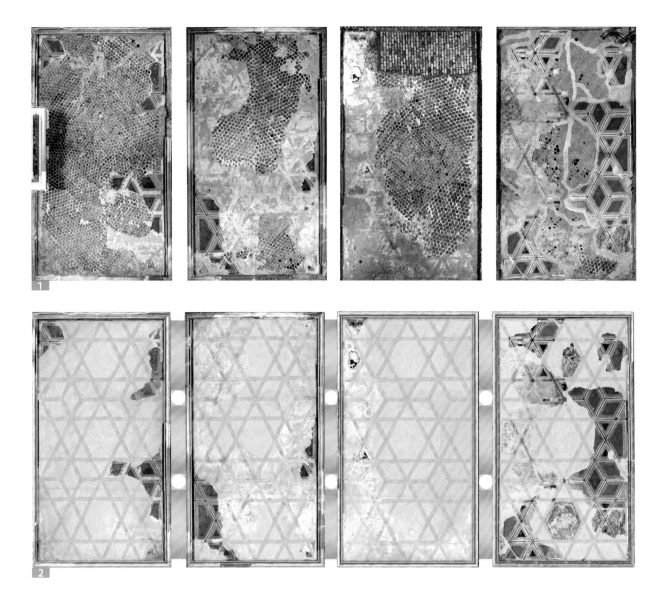

decades, this kind of evaluation seldom has an impact at the material level. Unlike the significant buildings of the Middle Ages, the Renaissance and the Baroque period, architectural surfaces from the 19th century – including layers of décor and the surfaces to which they are applied – are still generally replaced or decorated over without a second thought.

So, if this practice is usual in preservation, why do we not follow it? There are several reasons. To mention the most important:

Firstly: In terms of quality of craftsmanship, technique and the history of building technology, fine art decoration, cultural history, the history of museums, art, architecture and superstructure history in Berlin-Brandenburg and Prussia, the Neues Museum is not only an important but the most important monument from the mid-19th century. Until it was partially destroyed between 1943 and 1945, there was relatively little interference

with the structure. The original exposed surfaces were redecorated, if at all, only in the spirit of the original decoration. Its ruined state made the building a sleeping beauty for almost 60 years. This means that what we have today is a "fresh," i.e. unrestored artefact passed over by the destruction, reshaping and reinterpretation of the post-war decades. The significance and intact state of what remains is unique on Berlin's historical sites map.

Secondly, the destruction and in particular the open-air weathering have created damage phenomena and general conditions similar to archaeological sites – inside the building as well as outside it. The spatial configurations within approximate the original model, albeit unintentionally.

The Römischer Saal (Roman Hall) or the Nordkuppel (North Dome) today seem like original ancient Roman remains. What could be more natural than to treat these spaces like ancient monuments? Given their future

1 Ceiling of the Römischer Saal (space 2.02), state in 2000. *All photos: David Chipperfield Architects*

2 Ceiling of the Römischer Saal, study of restoration

as a display space for archaeological finds from Egyptian, Greek and Roman culture, this would create an unusual resonance between exhibition venue and exhibits. If a non-standard form of restoration is usually met with scepticism by users of the building, the reverse was true here. The methods, solutions and approach taken to dealing with the building were in line with the everyday practice for the archaeological collections, whose directors proved very able partners in the planning process.

Thirdly, our aesthetic reception patterns have been significantly changed in the past few decades by the viewing habits demanded by archaeological objects, and also through new visual experiences with modern art. Looking at fragments, at surfaces that are not uniformly lavish, the fine details of retouching and the palimpsest nature of the layers of décor, the "arte povera" quality of plastered surfaces etc. has an aesthetic dimension. Today this can be perceived and appreciated as a quality in its own right and is, for many people, preferable to a flawless, uninterrupted, pristine surface.

This means that our idea of a monument is holistic, respecting the many-layered nature of monuments. Our appreciation includes invisible features – the historical construction, for instance – as well as unimposing and incidental features. This begins with elements of the historical inner-building systems like the fire dampers and flues, and ends with traces of a room's different uses over its history, such as a map of Egypt dating from 1920 or historical hall names.

Restoration planning aided by an internet-based "archive room book" and visualizations

Given the restoration project's size and complexity, thorough preparation and planning were essential. Only decisions on necessary modifications were made as work was actually being carried out.

For restoration planning, as opposed to construction planning, there are hardly any compulsory standards. We organized the restoration planning in stages based on the planning phases used in architecture and engineering – base estimate, preliminary planning, design documentation and construction documentation. Written documents, conventional line drawings and visualizations were used as planning instruments. The visualizations in particular proved very important to the decision-making process. They allowed us as the planners and everyone else involved in the planning process to have a fairly precise idea of the desired aesthetic appearance.

The vast amount of sources, files, literature, historical photos and drawings etc. involved were collated and filed by room in an internet-based "archive room book." During

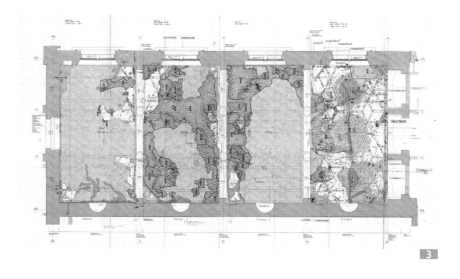

the basic planning stage, assessment of requirements, planning of scientific and restoration surveys, construction and structural engineering surveys, practical construction research etc. took place. In the course of the design documentation, objectives were converted into images using visualizations of specimen components. Using photogrammetry to represent the "status quo," virtual restoration processes were simulated in sequence using "Photoshop" in order to illustrate how the results would look at different stages. Mapping of existing material and damage was accompanied by technical models intended to clarify the feasibility of restoring specific damage phenomena and the effort required.

During construction documentation, we used in-depth and supplemental visualizations to illustrate specific problems. Aesthetic models aided decision-making. Technical construction documentation consisted of restoration measure mapping, involving so-called measure flags and supplemented by an "aesthetic objective."

3 Ceiling of the Römischer Saal, plan for restoration measures ("coded plans")

The Vestibül and the Vaterländischer Saal

WOLFGANG GÄRTNER | GÜNTHER DÜRR |
JULIA FELDTKELLER

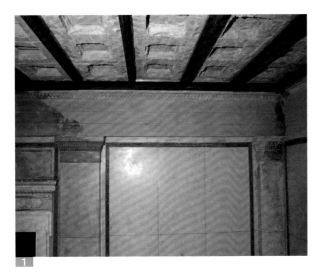

1 The Vestibül (space 1.01): The ceiling and the upper wall area have lost extensive areas of their stucco lustro as well as of their original plaster and décor. *All photos: Karl-Heinz Petzold*

Vestibül (space 1.01)

The restoration concept required a connection to be made between the function of the room and significant aspects of its state of preservation. The latter's main feature is a conspicuous increase in damage moving from east to west – i. e. from the entrance to the passage that leads to the Treppenhalle (the stair hall) The original form of the space was to be made the main focus once more, without destroying the history recorded in the damage. In order to do justice to both, different concepts were developed for handling the walls and the ceiling. The walls, which dominate the viewer's impression of the space, were to approximate the original illusion of marble slab wall cladding, whereas the damaged state of the ceiling was to be left largely unchanged.

This meant that work on the ceiling was primarily limited to conservation. The large areas of crumbling plaster were stabilized to prevent the process of decay from going any further. The clearly visible trail of increasing weathering leading to the devastated Treppenhalle was left largely intact. Only isolated scars that were particularly conspicuous and disruptive were corrected. These included sharp broken edges, deep holes and abrupt transitions between different levels of damage. The exposed brick and clay cylinder structural shell created glaring colour contrasts in places. The ceiling was covered with a glaze that replicated the plaster colour to tone these down. Restoration had the effect of harmonizing the space's overall appearance, enhancing the coffered ceiling as an architectonic form.

For the walls, on the other hand, both the architectonic structure and the imitation stone colour scheme had to be recreated. The *stucco lustro* wall surfaces were extensively restored, although the principle of distinguishing the old from what had been added was maintained here.

The space's appearance was significantly improved by cleaning the wall surfaces. Previous retouching and painting over, which had become discoloured over time and disrupted the walls' appearance, was also removed during this process. Any changes caused by ageing, on the other hand, such as yellowing or craquelures were left visible.

First, however, the large areas of plaster that had come loose from the undercoat had to be secured. To minimize risks of losing more of the existing building's material, the detached plaster slabs were conserved in

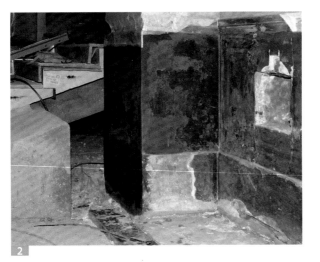

2 The Vestibül: badly damaged panel zone to the side of the ascent leading to the staircase

3 The panel zone after repairs to stucco lustro and coating with wax. In order to keep the additions made during restoration distinct from the older parts, the lines of the framing were not recreated.

situ instead of being removed and replaced later, as per the original plan. The glue involved was injected into the cavities between the separated layers.

The sometimes quite large gaps in the stucco lustro surface were filled in using the original techniques. The guiding principle of the restoration was to approximate the original appearance without actually reconstructing it. For this reason, the veins in the marble and the painted bands and lines were not copied on recreated sections.

The concepts for treating the walls and the ceiling meet at the architrave zone. While its sharp demarcation was recreated as the overall form, small gaps and places where fragments had broken off were intentionally not mended. The colour scheme was restored mainly to homogenize the existing décor – which, as it stood, was irregular – as well as creating a match with the filled-in and new sections. The idea was to unify the whole inventory as it had developed through its history, not to recreate the original colour scheme.

The Vaterländischer Saal (space 1.02)

The damaged Vaterländischer Saal showed a historically disparate collection of plaster, décor and paintings. The space was given a more unified look modelled on the original design, without a thorough-going reconstruction of lost colour schemes. The restoration plan for the ceiling is a good example of this. The vaulted plaster ceilings have a distemper coat dating from 1933. Beneath it, the original decoration pattern can be seen, but only in isolated fragments. They are barely sufficient to show what the original design and its relationship to the architecture was. In fact, they confuse the ceiling's dominant modern-day architectonic form. It therefore seemed unwise to recreate the original painted decoration. Instead, it was decided to keep the light-coloured coat from the 1930s, together with its aged appearance and patina. After cleaning, demineralization and conservation of the existing material, the plaster was recreated as a smooth, uniform surface. The additions to the plaster this involved were then integrated into the older parts by colouring, without matching the colour so completely that old and new could not be told apart.

The walls are patterned with the original design, with a series of wall paintings on the upper half, a uniform middle wall area creating a coloured background surface to the exhibits and a contrasting colour for the pedestal where it meets the floor. The original middle wall décor, clearly completed before wall brackets for displaying exhibits were put in place and consisting of a coat of grey-blue casein emulsion over a more green-coloured undercoat, was exposed to recreate this pattern. Fortunately, the complex of layers between the original décor that needed to be exposed and the later coatings split relatively easily, meaning that the uncovering work could mainly be done mechanically with putty knives and paint scrapers. Firmer-sticking coats could be removed by heating or by softening them with solvents. In places, the paint layer being uncovered had come loose from the undercoat and had to be restuck to it during the uncovering process. This involved inserting mineral and synthetic glues between the two separated layers.

To recreate the room so that it would hang together, it was decided to restore the wall plaster as a structurally and materially uniform surface. Parts of the stucco window recess surrounds had to be repaired. On the west wall, which opens on to the inner courtyard, they had to be reconstructed. The aim was a technically perfect harmony between the plastered surfaces and the stucco mouldings and the original elements.

The grey-blue paint layer, on the other hand, was restored according to the principle of keeping the new distinguishable from the old. The retouching and filling-in was therefore done using slightly more restrained colours than those of the older parts. However, a many-layered structure created a colour with a similar lustre and depth.

Although not definitely part of the original décor, the black-painted pedestal was left in place and retouched and filled in in places for formal reasons. The original marbling could not be reconstructed, but we aimed to apply a coat that resembled it in its irregularity.

4 The Vaterländischer Saal (space 1.02): north wall in damaged state with scars and missing areas and a combination of older and more recent layers of décor

5 North wall with exposed and restored original wall décor. The lighter colour of the retouching reveals the later changes.

Spaces 1.04 to 1.06

DUNJA RÜTT I ANNETTE STURM

The Flachkuppelsaal (space 1.04)

From 1859 onwards, the Flachkuppelsaal (Flat-domed Hall) in the south wing of the museum was one of the three main exhibition rooms for the ethnographical collection. Crossing rows of transverse arches on two pillars and pilasters divide it into two times three sections. In the central section of the north wall is an apse with full-length windows looking onto the Griechischer Hof (Greek Courtyard). In 1883 this space was taken over by the Egyptian collection, and in 1919 it was converted into the Sarkophagsaal (Sarcophagus Hall). In the course of this the apse was removed, light slits were installed in the south wall and a hanging, level wire-and-plaster ceiling was put in. Entrances to the space went through several alterations, and the the way the room was divided up was changed to suit its use.

From an early stage, movement in the edifice caused cracks in the original masonry and ceiling plaster. The wire-and-plaster ceiling was removed during the remedial work. The flat-domed roof was secured using tie rods and steel props, causing severe damage to the surrounding plaster.

The general state of the plaster and décor in the Flachkuppelsaal is comparatively good. The restoration concept involved recreating lost plaster surfaces while allowing signs of the conversion work, part of the history of the space's use, to remain visible. The plaster on the northwest and southeast calottes was heavily salinated and damaged, resulting in a large-scale loss of the original décor. The gaps in the plaster were filled so as to match the older materials, and the moulded frames were reconstructed. Any cracks in the ceiling plaster were worked into the new areas, appearing to follow their natural course. The polychrome wall décor's embrittled paint layer (casein distemper) was secured. The remains of overpainting and desolate pieces of the original plaster were removed during this process.

The stencilled polychrome ceiling décor, with floral elements and grisaille painting in the pendentive inner surfaces, was heavily and irregularly dirtied. The whole ceiling was cleaned moderately, restoring a consistent overall impression without totally removing the traces of age. The wall décor with panels and ribbon surrounds was also cleaned and conserved.

No attempt was made to completely reconstruct the original décor. The existing décor was joined with the

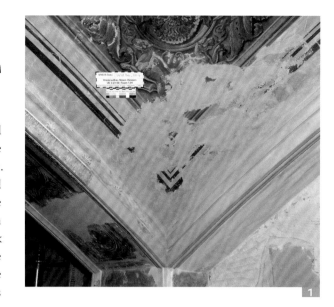

replaced parts using a neutral retouching technique without a division between the panelling and upper wall zones. The domed roof was treated in the same way. Lime paint was used for the first coat, followed by glazes with a cellulose derivative glue base on the ceiling to match the colour to the older neighbouring areas. Gaps within the existing areas were retouched using distempers. The colour and brightness of the retouched spots is less pronounced than that of the existing décor, so that damage and alterations can still be identified.

Café (space 1.04.2)

The design and former function of this small three-section space in the south part of the building were the same as that of the neighbouring Flachkuppelsaal (Space 1.04). For a while (from 1900 onwards), the eastern part was used as a separate space, and its wall décor was given a different design. The installation of the partition wall damaged two pilasters. Only fragments of the original polychrome wall décor (casein distemper), with its zone divisions and ribbon surrounds remain. Like the pilasters and pilaster capitals, these remains were decorated over in monochrome. Large-scale replastering was carried out on the space's north wall during conversion work.

Of the flat, barrel-vault ceiling's three sections, only the central one has any original plaster and casein distemper remaining. The original stencilled ornaments can still be seen on the transverse arch soffits of the rows of supports.

The original design was not recreated, as the intention was for the conversion and damage history to remain visible. Ceilings with exposed masonry were left as they were. Damaged bricks were replaced and mortared in slightly below the level of the rest of the ceiling. The most

1 Flachkuppelsaal (space 1.04): Retouching on pendentive: Places where the décor has been filled in are more subdued in colour and brightness than the existing décor, and remain discernable to the viewer. *All photos: RaO*

recent décor layer, in monochrome, was removed and the original décor was presented like an archaeological restoration. A new redecoration integrated replacements to the missing pilaster capitals into the existing surfaces. All surface repairs were integrated into the existing material using a restrained glaze. Décor remnants were transparently glazed over. Plans to use this space as a café meant particular demands on the existing surfaces. To allow for people coming and going and climatic pressures, a silicon resin-bonded paint system was used.

Kitchen and bar (space 1.05)

This small space in the southwest part of the building was originally used for administration (as the director's office). It has a flat barrel-vault ceiling. There was no trace of the original blue wallpaper beyond a few remnants. The plaster ceiling was badly damaged and coming loose – especially in the northernmost part of the room.

In future, the museum will use this space as a kitchen and bar. The concept for this room was to recreate it using the original design and colour scheme.

Heavily salinated, non-intact original plaster was removed from the ceiling. The remaining ceiling plaster, together with its décor, was secured and repaired. The ceiling cornice, part of what gives the wall its structure, was recreated. As in the neighbouring Space 1.04.2, the repairs were integrated into the existing plasterwork using a restrained silicon resin-bond-based glaze in such a way that they could be distinguished from the aged parts. The walls were to be papered, like the original design. A thin paper was applied to the conserved and smoothed plaster and covered with an easy-maintenance emulsion-based coating. A blue colour was used for the coating, to match the original. The projecting wooden base had been removed before restoration began. The surviving parts were put back in

place. Missing areas were filled in using identical materials and integrated with the retouched existing parts using a brown glaze.

Ethnographical Hall (space 1.06)

This seven-sectioned, elongated hall with a central double row of pillars was the main hall housing the ethnographical collection. The space was adapted to the requirements of each exhibition using temporary partition walls.

The hall was heavily damaged during the war. The ceiling and upper parts of the walls were largely destroyed, and the interior was left exposed to the elements for decades. The almost total loss of the marble cement cannelures left the base layer and the sandstone core of the pillars visible. The marmorino wall plaster was very badly damaged and badly worn away on the upper third of the wall, leaving large areas of the base layer exposed. Large areas of masonry were visible. All in all, the Ethnografischer Saal (Ethnographical Hall) was in a ruinous state.

During basic repairs to the museum, the gaps in the structure were closed. The missing shallow-vaulted barrel ceilings were coped over using copies of the original clay cylinders.

The focus of the restoration plan was to preserve the space's character as a ruin. This meant preserving as much of the original surfaces as possible, including the weathered base plaster layers.

The remains of the wall décor layers with a zoned structure and ribbon surrounds – a greyish-green colour on the upper walls and illusionistic painted panels and panel cornices – were secured and moderately cleaned. Metal and ceramic elements whose historical use has been superseded but which are part of the building's inventory were retained. Gaps within the original marmorino wall plaster were filled in flush with the surface using

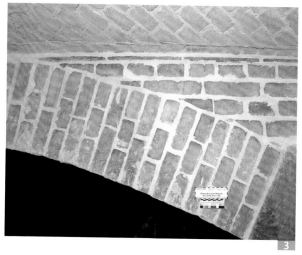

2 Café (space 1.04.2): complemented pilaster capital with new colouring on the basis of neutral retouching

3 Ethnographical Hall (space 1.06): Wall pointing and junction with clay cylinder ceiling: Brickwork left exposed is held together across the surface using a slurry joint.

the original techniques. To recreate the original wall arrangement, the moulded window surrounds were made whole again. The repairs were retouched with casein distemper matching the plaster's colour. Visible parts of the old masonry were repaired using old brick and joined across the surface using slurry joints. The pointing inside the surviving clay cylinder ceilings was completely renewed. Finally, the hall's whole ceiling was covered with lime slurry. The historical architectural peculiarity of the clay cylinder ceiling construction can still be seen.

To preserve the neighbouring base plaster layers, previously unusual securing and repair work was carried out. The repair of, for instance, gaps within the plaster's surface involved adapting the additions structurally and optically to the weathered base plaster. The technique for conserving weathered plaster surfaces where they meet the wall areas with exposed masonry came to be called "splintered break conservation." Usually broken plaster pieces are battered visibly. In this case, the restorers succeeded in securing them "invisibly" to preserve the image of a ruin.

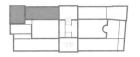

The Gräbersaal and the Mythologischer Saal

ANETTE SCHULZ

The Gräbersaal (space 1.10)

The Gräbersaal (Sepulchral Hall) is on the ground floor of the Neues Museum, at the building's northeast corner. It is the only room with a quadratic floor plan. It is dominated by pillar and architrave architecture, with four massive pillars arranged in a square supporting two architraves. Built between them is a flat brickwork Prussian cap vaulted ceiling with cast-iron supports. This hall was originally an exhibition space for the Ägyptische Abteilung für Objekte des Alten und Mittleren Reiches (Egyptian Department for Objects of the Old and Middle Kingdoms) and housed three built-in Ancient Egyptian sacrificial chambers. The traces of their installation can still be seen on the walls and the floor.

In line with the harmony of décor and exhibits seen throughout the whole museum, the Gräbersaal had Egyptian elements. The most obvious vestige of this design is the portal on the south side leading to the Mythologischer Saal

(Mythological Hall), with its Egyptian form and décor, and the continuous haunch-type cornice with its similar décor.

The hall has a squat appearance owing to the quadratic floor and the massive pillars in the centre. The original wall design, with a black pedestal and polychrome banding, is like that found in Egyptian graves.

Owing to numerous changes of use, the space that survives today is very heterogeneous. When restoration work began, large areas of wall had been stripped down to the structural shell, and the surviving gypsum-lime plaster surfaces showed heavy damage, with loose plaster, cracks and hollow areas. Apart from small remnants of plaster around the edges, only the shell construction of the ceiling was left. This was presumably due to the conversion work done in 1935 and 1936, when a hanging wire-and-plaster ceiling was put in. At this time, the original division of the wall décor into a panelled zone and an upper wall zone was decorated over in monochrome.

The restoration concept primarily involved toning down and harmonizing the hall's generally heterogeneous appearance without removing historical traces of ageing. At the same time, the former polychrome painted décor had to be revealed.

The bare shell character of the ceiling surface was largely left unchanged, except that after treating the joints, the red colour of the bricks was toned down using a light-coloured glaze.

Aside from securing the preserved fragments of plaster, the toning down of the wall and pillar surfaces involved filling in the larger gaps, using the original techniques. Recreating the original room design involved scraping away wall plaster to reveal the fourth design phase, which was faithful to the original décor, dividing the wall surface into panelled and upper wall areas. Exposing the first layer of décor was rejected owing to its comparatively much worse state of preservation. Various models for retouching the wall surfaces culminated in a plan to use glazes to match the new plastered surfaces to the heterogeneous original surfaces but to retain the plastered areas of wall in a fragmentary state of preservation. The surviving haunch-type cornice with its unchanged original décor above the hanging wire-and-plaster ceiling was cleaned and the gaps filled in.

After detailed examination, layers were scraped away step by step from the room-dominating portal in the south wall until the seventh layer of décor was exposed. During this phase, a layer of repairs to the original décor was exposed on the architrave and the tympanum of the portal, while the pilasters were given a monochrome banded coat. The decision to expose this layer of décor was motivated by the above-mentioned intention of preser-

1 Gräbersaal (space 1.10): Revealed portal with Egyptian painting. A winged sun-disk is depicted on the architrave and the coving is in the form of palm fronds. Here, the pilasters, originally painted with papyrus plants, have been covered with simple banding. *All photos: RaO*

pilasters, architraves and coving lead to neighbouring rooms.

In the original room design the ceiling and upper walls were covered with images of Egyptian gods, and the panelled area painted with an imitation of wood terminating in polychrome banding. During the conversions of the 1930s, a hanging ceiling was put in, meaning that the original ceiling design and the wall pictures above the wire-and-plaster ceiling remained largely intact, as did the panelled area. The wall pictures, on the other hand, were completely destroyed by a monochrome redecoration.

The gypsum-lime plaster of the walls and pilasters had plaster and parts of the décor missing, with local separations, and was coming loose. This increased towards the south half of the room. The complete loss of wall pictures on the wall's middle area and the abrupt break in the upper wall's figural frieze left the three-part wall structure obscured. The preserved panel and ceiling design meant an extremely sharp transition for the room's design.

The restoration plan aimed to recreate the frieze, middle wall and panel wall structure. The idea was to link the surviving areas of the room.

The intact upper half of the original frieze directly below the ceiling was cleaned and consolidated. The gaps in the plaster were closed using the original techniques and matched to the original surface using glazes. The figures were not reconstructed, but the frieze area in its original height was marked out with fine grooves to show where they had once been.

The more recent monochrome redecorations were removed from the middle wall area, allowing a pencil preliminary drawing of the original room design on the south wall to be secured and documented. After the surviving plastered surfaces had been secured and the gaps had been closed, the wall surfaces were harmonized

ving the room together with the traces of its conversion phases while revealing its original design. The gaps were filled in using the original techniques and given plaster grooves and glazes in the surrounding background colour tones for integration purposes.

The Mythologischer Saal (space 1.11)

Architraves and pilasters divide the oblong Mythologischer Saal into five sections. It was formerly an exhibition hall of the Ägyptische Abteilung, and sarcophagi, mummies and grave objects were displayed here. Egyptian-style portals in the north and south walls with

2 Mythologischer Saal (space 1.11): The panelled surface after exposure, consolidation and closing of gaps using the original techniques

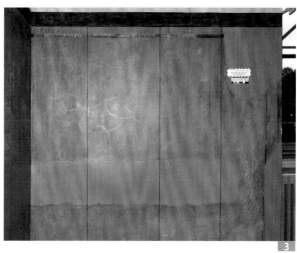

3 Mythologischer Saal: The glazes match the wood grain in colour, but have a strictly graphic structure. The lines between boards and the ribbon surrounds were recreated for better integration.

using glazes, while retaining traces of the space's past use such as room names, labels and a map of Egypt on the west wall.

In the panelled area and on the window soffits, the second layer (repairs to the original) of the imitation wood painting and the banding above it were exposed and consolidated. Gaps in the plaster were closed using the original techniques. Various models for retouching the panel décor showed that, owing to the size of the gaps, a monochrome glaze would not be sufficient to hold the panelled zone together optically. A glaze was therefore applied on top of the ground tone that matched the wood grain in colour, but with the structure kept strictly graphic. From a distance, the panel looks continuous, but a closer examination would tell the additions from the original parts. The lines between boards and the ribbon surrounds were recreated, for better integration.

There was no question of restoring Stühler's design owing to extensive losses on the walls, but the ceiling paper and the restored panelled zone give an impression of the original bold colour scheme. Recreating the zones on the walls shows the original structure but keeps the surviving surfaces in the foreground.

The Haupttreppenhalle

MICHAEL BRUCKSCHLEGEL

A major focus of restoration work on the Haupttreppen-halle (main stair hall) was cleaning the badly weathered brick and mortar (Space 2.00).

The original brick walls were made of different kinds of brick. These were installed according to their varying physical properties (strength, weight, surface density etc.) For instance, in areas under high static stress (rows of windows, entablature, the roof truss zone), red "Rathenow" bricks were laid, whereas in areas with less load (gable walls, lower storeys) yellow "Birkenwerder" bricks were used. The upper wall surfaces, once adorned by Kaulbach's water-glass paintings, had yellow curved shaped bricks as headers and red "Wellenziegel" with a wave pattern cut into the narrow side as stretchers laid in such a way that cavities were created inside the wall surfaces. A light-coloured lime mortar was used to mortar these bricks. In areas subject to heavier static stress, dark grey trass-lime mortar was used.

Almost all of the original plaster and stucco had been lost. The surviving brick wall surfaces had a very inhomogeneousappearance. For instance, many brick areas had been fire-damaged during the war. They were discoloured and partially embrittled by the extreme heat. Others had been defaced with mortar during sub-sequent conversion and securing work. Remains of bi-tumen showed there had been roof flashings within the Treppenhalle. Blackened remains of the destroyed plaster covered the red and yellow brick surfaces, forming isolat-ed patches or clinging along the joints between the bricks and creating a very lively landscape of joints.

The idea behind cleaning the brick surfaces was to reduce the defects mentioned above and reveal the

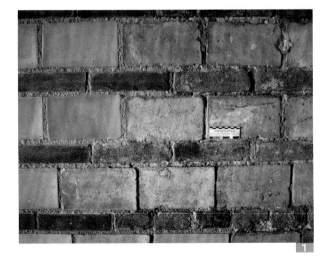

1 Staircase hall, north side, intermediate state after cleaning. Test areas for joint cleaning; left half: complemented bricks and joints; right half: old brick stock with partially repaired joint

uniqueness of the monumental brick surfaces' design. The brick surfaces were cleaned using micro-abrasive blasting. Pressure, blasting material, distance and degree of cleaning were all investigated using several test surfaces and continuously re-evaluated, as every wall surface and brickwork area had specific requirements and defects. Intensive manual preparatory work had to take place before the particle blasting. This involved removing plaster and mortar remnants from the surface stone by stone. After the cleaning work, the discolorations that could not fully be removed were retouched with glaze to approximately match the surrounding parts.

Another major focus of this work was treating the joint areas. While sparing the old surface, plaster, weathered areas and grime had to be removed from the mortar, gaps filled in to match the colour and structure and replacement sections of brick connected and integrated. After the joint areas had been exposed and cleaned manually, mortars were tested for each of the different brick areas. This showed how much influence mortar colour and joint structure can have on a wall area's overall appearance. The lime mortar used was matched to the brick colour using pigments. It was laid to create slightly irregular indentations in the wall.

The Bacchussaal and the Römischer Saal

UWE DE MAIZIÈRE

The Bacchussaal (space 2.01)

The Bacchussaal (Bacchus Hall) and the Römischer Saal are in the southeast wing of the main storey of the Neues Museum. The Bacchussaal is in the middle section of the building. Entered via the Haupttreppenhalle, it connects two large halls, the Niobidensaal (Niobides Hall) and the Römischer Saal, and also connects the Treppenhalle to the outdoor area. The extensive destruction of the southeast corner of the building – the total loss of the Südkuppel (South Dome) contrasted with the good state of preservation of the Niobidensaal – meant that the connecting function of the Bacchussaal/Römischer Saal suite was also relevant to the restoration concept.

The Bacchussaal is divided into two. The west side, closest to the stairwell, has a low vaulted ceiling with

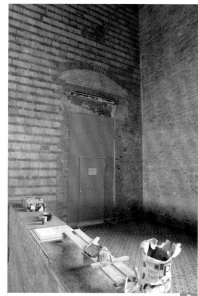

three sections. The light blue paint on the ceiling and upper walls, with trellises and vine leaves, creates the impression of an open-air loggia. From the outside, the three large windows give the room's five-sectioned east side a towering appearance and they create a transition to the outdoor space. The walls are divided into an ochre-coloured panelled area, a dark violet middle-wall area and a grey upper-wall area.

The decades-long absence of a roof caused the almost complete loss of the ceiling and upper-wall plaster. Of the four window pilasters, the southward one was badly damaged by a grenade, and was rebuilt. The surviving paintings were removed first.

Surviving parts of the original hall were secured using preservation techniques. The ceiling and the upper wall in the eastern part of the space were simply pointed. Otherwise, they were left as a bare shell. The plaster and capitals of the four window pilasters were repaired, and the previously removed parts put back in place.

The vaulted ceiling and the upper wall in the western half of the space were given a light-coloured coat of plaster with the pattern of the original painted trellis deeply scratched into it. The ceiling design makes it clear that at one time the whole vaulted ceiling and the tops of the walls immediately beneath it shared this design. The moulding on the architrave, a part of the space's structure, was recreated.

Removing the badly aged and perished redecoration on the middle walls revealed the dark violet layer. The gaps in the décor and the flush-to-the-surface repairs to the plaster were retouched to much the underlying light blue colour. The panel plaster and the base were repaired and integrated into the colour scheme.

2 Staircase hall, north-east corner level 3: initial state (plaster remnants, areas of dirt, repairs)

3 North-east corner level 3: final state of bare structural walls after completion of cleaning, brick and joint treatment and localised retouching. *All photos: Michael Bruckschlegel*

The Römischer Saal (space 2.02)

The Römischer Saal (Roman Hall), which connects with the Bacchussaal on the south side, is divided into four crosswise sections and three lengthwise sections by three pairs of pillars supporting a row of arches. The ceiling, richly decorated with stucco mouldings and boldly coloured, consists of crosswise, flat barrel vaults. To the north, a portal with copies of Pompeii mosaic pillars leads to the Bacchussaal; to the south is a passage leading to the Südkuppel and two one-time doorways, now walled up, leading to a side stairwell and the Mittelalterlicher Saal (Medieval Hall).

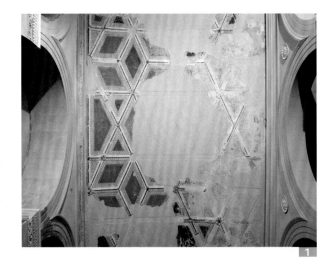

The Römischer Saal's walls are divided into three zones – a violet-grey panelled area, a strong green middle-wall area and an upper-wall area with a continuous cycle of wall paintings. These showed Roman buildings and areas surrounding Rome and Pompeii, reflecting the casts of Roman sculptures that were displayed here.

The southern part of the ceiling in the Römischer Saal has the most historic plaster and décor. The amount of plaster on the walls here, however, is significantly less than in the north half of the space, where the wall paintings are also largely intact.

The ceiling, in particular, contained large amounts of damaging salts, mainly magnesium sulphate. This was the main reason for the severe loss of plaster here. All surviving plaster was preserved by backfilling, securing its structure, needling and salt conversion. The painted layer was secured and cleaned.

Sgraffito-type scratched strips in the plaster of replacement parts of the ceiling echoed the original geometrical ceiling design. Missing stucco mouldings were indicated by recessed bands.

The often extensive loss of plaster on the walls and support placements was the result of a bomb hit in the neighbouring Griechischer Hof and sustained weathering owing to the space above the Römischer Saal having no ceiling. As elsewhere, the plaster and décor were conserved here as necessary.

On the panelled area of the north, south and east sides, the original design – violet-grey imitation stone coffer painting with a stencilled floral ribbon at the upper edge – was revealed by removing two layers of monochrome olive-green redecoration.

The main parts of the space's architectonic structure, such as the ceiling cornice, the rows of supports and the window surrounds were replaced using the appropriate materials. With the exception of the window soffits and sashes, where the materials were visible, the retouching matched the original colour tone.

The type of plaster replacement used for the walls gave them a horizontal structure once more. The structuring effect was produced by features such as the base and the panel cornice, but also the use of different materials, colours and lightness of plaster tone for the panel, middle-wall and picture zones.

No whole layer of paint was applied. Instead it was used in certain areas to tone the plaster so as to minimize contrasts.

1 Römischer Saal (space 2.02), south section of ceiling – state after restoration was finished, November 2008. *Photo: RaO*

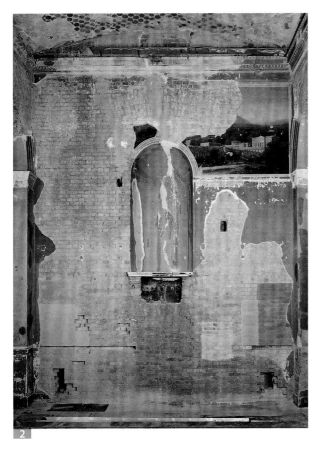

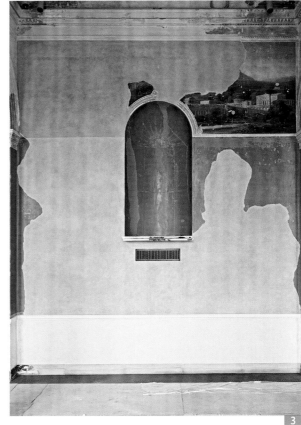

The Mittelalterlicher Saal, the Bernwardzimmer and the Moderner Saal

OLAF SCHWIEGER

The name "New Museum" now seems totally incompatible with the actual state of the Neues Museum, which so clearly shows the ravages of age. The Mittelalterlicher Saal, the Bernwardzimmer (Bernward Room) and the Moderner Saal (Modern Hall), in particular, undeniably show the traces of history.

In the Mittelalterlicher Saal, this is made all too clear. Owing to war damage, parts of the walls, most of the arcades together with the valuable columns and most of the historical ceiling constructions in this room have been irrecoverably lost. Before the recent rebuilding, decades of neglect had produced a dismal state of affairs (fig. 1).

The drastic removal of painting and architecture fragments in the 1980s, which, owing to the attitude to restoration ethics at that time, were only used as reference points for restoring the architectural surfaces, meant that to pursue a more progressive approach these fragments had to be reintegrated. The preservation and return of historic parts of the building was the fundamental principle of the recent restoration work. For the project team Süd-West, it represented an exceptional challenge.

This principle also meant that the salts that crystallize out of the walls cyclically had to be passivated. These had collected owing to the weathering sustained over the years. Innovative solutions for this problem were found. Repairs to the historical cornices and transverse arches of the highly structured dome architecture in the Mittelalterlicher Saal using a specially constructed pair of stucco compasses were also innovative.

The Mittelalterlicher Saal (space 2.04)

The idea was to make the gloomy-looking and heavily depleted space whole again. Both of the southeast domes together with the walls were entirely rebuilt. Almost all the architectural elements were reconstructed and returned to their previous form. As mentioned above, special stucco compasses were needed for the repair of the cornices and transverse arches. Newly developed folding stencils allowed continuous transition between the fragments of the originals (figs. 2+3).

2 Römischer Saal, west wall, section 2 – as it was in June 2006, before restoration began. *Photo: RaO*

3 Römischer Saal, west wall, section 2 – state after restoration was finished, 2008. *Photo: Johannes Kramer/BBR*

exposed. Revealed after being covered over for decades, the colour scheme now stood in stark contrast to the blackened original paint in the ceiling area. To remove the blackening, some of which was in the form of a crust, a special cleaning paste was developed.

The wall pilasters were repaired and reconstructed using solid-coloured mortars mimicking the original mortar colours, thereby avoiding any further applications of paint (fig. 5).

Bare shell surfaces – particularly the rebuilt areas – were left alone, with only a thin coat of mortar which was subsequently scraped away down to the level of the bricks. The calotte surfaces of the dome vault had a similar appearance. Here, the brick surfaces were given a light-coloured glaze.

Classical retouching of the surviving architecture surfaces was avoided as far as possible. Only the colour of conspicuously light or dark areas was corrected.

The partially present damaging salts (mainly magnesium sulphates) were passivated – i. e. reacted with barium hydroxide and converted into not readily soluble and therefore harmless substances.

The Bernwardzimmer (space 2.05)

In concept, the aesthetic goals for the Bernwardzimmer are comparable with those for the Mittelalterlicher Saal. Here, there was the same preference for certain contrasts between different parts of its appearance. The bare shell surfaces remained that way, while the ceiling cornice was entirely repaired and retouched.

The historic wire-and-plaster ceiling, dating from a very early stage, is a particular feature of this space. This had been ravaged over the course of time. Painting fragments were continually dropping away from it, so securing work was already carried out in the 1980s and 1990s. Some painting fragments were also removed during these periods.

A large part of the ceiling's base coat of plaster had to be replaced, using the original techniques. The gypsum-lime mortar was pressed into the coarse wire mesh, which was secured to flat iron bars spanning the room, from below (see the section "Wire-and-plaster ceilings" in the chapter "Special Subjects"). The removed painting fragments were placed in their original locations from below, pressed on and bonded to the wire using gypsum-lime mortar (applied through the wire from above).

Between the newly cast mouldings, the painting fragments on the pendentive surfaces, previously loosened from the wall, were returned to their precise original position (fig. 4).

In contrast to the ceiling, the wall surfaces had already been renovated several times. After basic conservation of the existing surface, the original, blue paint on the recessed parts of the walls and the light paint on the pilasters was

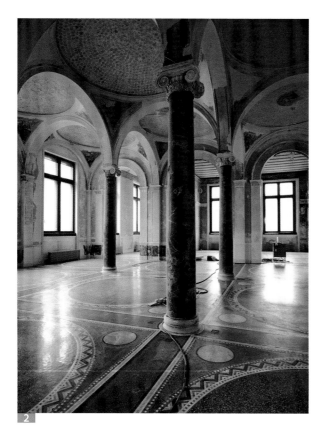

1 Mittelalterlicher Saal (space 2.04) before restoration, July 2008. *Photo: ARGE Süd-West*

2 The Moderner Saal after restoration, view to the west, November 2008. *Photo: Peter Thieme/BBR*

4 Positioning and
fixing of the "removal"
with special clamps.
Photo: ARGE Süd-West

The Moderner Saal (space 2.06)

This extremely depleted hall connects the Treppenhalle
and the Mittelalterlicher Saal. The totally destroyed
ceilings were renewed using modern techniques. This is
obvious to the viewer. In the hall's central area, the rows
of supports and parts of the west wall were rebuilt, with
due attention to historic forms and fragments.

The concept for this space involved almost entirely
avoiding reinstating its shape. Bare shell surfaces were
therefore left that way. In contrast to the Mittelalter-
licher Saal, however, no large-scale treating of brick
surfaces was undertaken. The joints were repaired using a
coarse mortar coloured through with earth pigments.

The idea was to preserve the aged quality of the
surviving original plaster and décor. Layers of grime were
therefore simply thinned and not entirely removed.

Around the north wall, examples of architectural
elements were repaired and reconstructed. For instance,
the ceiling cornice and the archivolts were recast and
integrated into the existing colour scheme.

The only other areas to be reconstructed were the
window sashes and the cornice area. In this last case it was
mainly the pilaster zones that were made complete again,
creating to some extent the impression of capitals.

The wall pilasters were reworked cautiously, and they
were repaired below plaster level. Generally it was only
gaps within their substance that were filled in. The form
and colour of the pit-sand and slaked-lime mortar, with its
earthy tone, proved very favourable for repairs to the
patinated existing plaster.

Some of the painting fragments removed from the
Moderner Saal in the 1980s were returned to their original
position as well. With the exception of the north wall,
however, they were in no way integrated into a surviving or
reconstructed architectural surface. This created certain
problems regarding presentation.

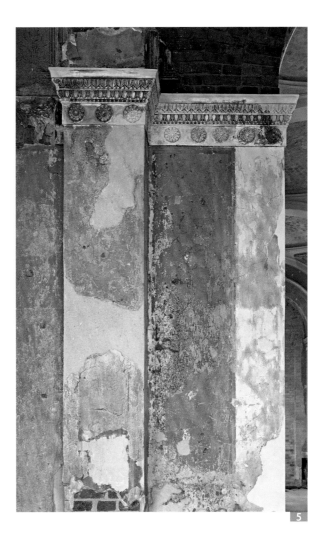

3 Mittelalterlicher Saal: Folding stencil being used for
shaping. *Photo: ARGE Süd-West*

5 The Moderner Saal (space 2.06): wall pilasters with
solid-coloured mortars. *Photo: Johannes Kramer/BBR*

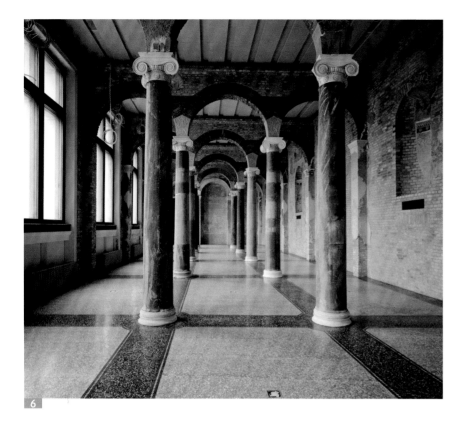

The Nordkuppelsaal

Lars Schellhase | Carsten Hüttich

A striking aspect of the Nordkuppelsaal (space 2.10) is its octagonal floor plan, and the corresponding structure of the dome, which uses classical Roman construction forms. It is lit throughout its two-storey height by a skylight. In 1875, the tambour and the upper edge of the dome were removed and the hall given a larger skylight, to improve the lighting. This space was used for its original purpose of displaying Hellenistic large sculptures until it was closed. Considerable settling in the ground beneath the northwest corner was already creating cracks in the masonry and causing plaster to loosen at the time of building. This continued until static improvements were made during the rebuilding. The walls and dome were severely damaged owing to the destruction of nearby areas during the Second World War and the entrance of rainwater in the post-war years.

Summary / Prospectus

The surviving substance was durably preserved. Restoration work was exceptionally innovative. The restored spaces had an impressive appearance.

The filling-out of the room fragments was neither a straightforward presentation of them nor a simplified reconstruction of the original decoration patterns. The design ethic respected the aged quality of the remains and was courageous enough to include independent, generally subordinate redesigns.

By pooling expertise, this communicative and thoughtful project planning allowed vital insights to be exchanged at an early stage. This principle was also adhered to within the project team Süd-West, and used to good effect. The results we see today were largely created by this teamwork – both in conceptual and in practical terms.

The three main problems for the restoration

The implications and solutions of three problems of restoration technique that became obvious when work began on the Nordkuppelsaal will be briefly described here. Firstly, how could the heavy salination of the plaster and masonry across three quarters of the dome's surface be permanently reduced across such a large area without damaging the stucco? As humidity levels changed during use of the hall, the crystallization pressures of drying-out dissolved salts would cause parts of the material to break away. After some consultation it was decided to use the water sprinkling method, which was easy to use over a large surface, and to apply this in three rounds. Secondly, when removed wall paintings are returned to their original position, air space is usually left behind them, to stop dissolved salts from flowing out of the brickwork. After in-depth discussions with all parties, the architecture firm's preferred method of mounting the paintings directly on the brickwork or plaster surface was used. Thirdly, how could the many large gaps in the stucco lustro be closed so as to be different from the original surfaces without being unpleasantly conspicuous? After several tests, the initial proposal to close the gaps 3 mm under the *stucco lustro* surface and in the bare building structure was rejected. Based on a sequence of suggestions, tests were set up and refined. The final conclusion of this process was to treat the gaps with a technique involving solid-coloured gypsum-based filler. Casein paint was used to approximate

6 The Moderner Saal after restoration, view to the north, November 2008. *Photo: Peter Thieme/BBR*

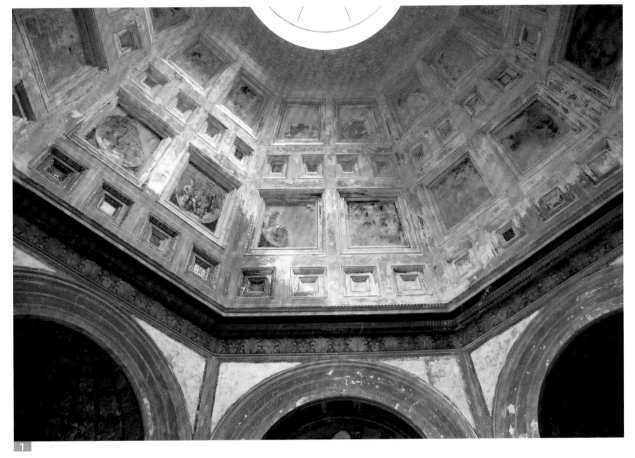

1

them to the surrounding colour scheme and they were polished with wax.

Important steps in the work

The working process involved cleaning the different parts of the Kuppelsaal using brushes and suction before any other work took place. Afterwards, the numerous hollow places in the plaster and stucco lustro surfaces were solidly bonded to the brickwork again using back injection and needling. Any powdery or flaky areas in the paint layer were secured.

The light opening in the centre of the dome, significantly enlarged in 1875, was reconstructed in its original state in brickwork. Dome surface areas with varying degrees of damage were divided into four classes depending on the measures to be used, and treated depending on their different conservation needs. Firstly, those with large areas of exposed brick, such as the reconstructed light opening and the northwest eighth part of the dome were treated with a lime slurry, once the bricks and joints had been repaired. Secondly, the profiling coat of any partially destroyed stucco coffering and all the stucco coffering containing the reapplied wall pictures as well as that of the cornice were repaired or

replaced. They were left with the material exposed. Thirdly, the paint and stucco surfaces which had been preserved mainly in the lower dome area were secured, with the gaps in them retouched to match the surrounding colour. The 14 grotesque and 12 genius paintings that were removed from the recessed parts of the stucco coffering together with the plaster they were painted on at the end of the 1970s were reattached to the brickwork.

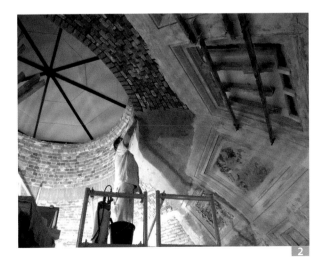

2

1 The Nordkuppelsaal (space 2.10), view into the restored dome. *Photos: Wandwerk GmbH*

2 Condition during restoration

The wall paintings were first altered and prepared for the reattachment in the workshop. The various parts of stucco profiles and decorative surfaces salvaged in the 1980s were also returned to the places they had been removed from and the joins retouched.

Work on the wall surfaces was also divided into four classes according to the measures used. Firstly, as with the dome, the profiling coat of any areas of stucco stripped down to the brickwork was complemented. This involved the archivolts and the archivolt surrounds on the northwest wall. As with the dome, the recessed areas with brickwork exposed were covered with slurry. Secondly, after exposure, the optically disruptive gaps in the upper walls' casein-painted spandrel surfaces were retouched in the original colour. Thirdly, after preserving the paint surfaces on the four wall pictures, the gaps in the plaster were closed using a coloured putty and partially retouched in the surrounding colours. Fourthly, the *stucco lustro* areas on the middle wall and base of the walls, which were damaged to varying degrees, were cleared of salt encrustation and dirty wax. The gaps were plastered, filled and coloured to match the surrounding colour tone. Two partly destroyed wall-structuring architectural elements, the panel cornice and the base, were repaired. The secondary doorway leading to the Pergamon Museum in the north wall was bricked up and integrated into the colour scheme of the *stucco lustro*. Finally, all *stucco lustro* surfaces were waxed and polished.

The Niobidensaal

ALEXANDRA SKEDZUHN

The Niobidensaal (space 2.11), the best-preserved room in the Neues Museum, is on the main exhibition level in the northeast part of the building. Originally, Hellenistic and Roman sculptures from the plaster cast collection were displayed here. The design of the hall matched them; the upper wall frieze shows figures from the Greek narrative tradition. Among the 21 pictures, the only two exceptions are Cheops before Athena and Romulus in the act of ploughing. These could be understood as the transition from Egyptian to Greek art and from Greek to Roman art, respectively.

The bowstring trusses which span the room create an eleven-section hall with nine ceiling sections to each one. The room is lit from one side only, by five windows to the east. The walls are divided into three zones – upper wall, middle wall and panel area.

There are two casts of caryatids to each of the portals situated at the hall's gable ends. They are built-in exhibition pieces. The model for them is taken from the Villa Albani in Rome. The multi-coloured mosaic flooring is divided into three segments per room sector by marble cement tiles with a leafy tendril motif. The edge of the floor is made from red screed.

The design of ceiling and walls, with different materials and decoration techniques, is still intact. As an abstract motif, the cap vaulting echoes the terra cotta clay cylinders it covers. The decoration was created using a variety of stencils.

As well as the roof trusses with cast-zinc figural groups, the surrounds of the wall pictures and the upper wall areas of the stucco pilasters are covered in gold leaf. The middle part of the wall is coloured a monochrome dark red-brown. The division into sections is emphasized by a double, ochre-coloured ribbon surround. A dark blue décor was used for the panelling. The lower area of this is coffered and has a stencilled floral band at the top.

The preservation and restoration concept was based on a separate study both of each individual room and of its relationship with the adjoining halls. For the Niobidensaal, the crucial factor was the exceptional amount of surviving previously existing accoutrements. The restoration here therefore involved almost total integration of repairs to gaps and to the colour scheme of the walls and ceiling. However, the maxim of favouring the original accoutrements and ensuring that any optical completion work could be spotted as such remained fundamental.

Several of the cap vaulting cells had lost plaster and décor owing to water entry and the resulting salt damage. Lime plaster was used to recreate the plaster areas. The surface texture of the plaster was matched to the existing surfaces. The filled-in plaster surfaces were stencilled like the originals, but their lighter and less colour-intensive design and the absence of details like the light and shade on the clay cylinders made them different from the originals. The middle walls were *marmorino*-plastered. Hollow areas were bonded to the undercoat again by means of backfilling. Gaps in the plaster were filled in using *marmorino* plaster identical to the original. This plaster is made from slaked lime and crushed limestone. It is applied in layers and then compacted to produce a smooth, marble-like surface.

Such a smooth surface creates problems for painting. The décor had partly come loose. It was dished and projected from the ground. The paint layer was secured and gaps

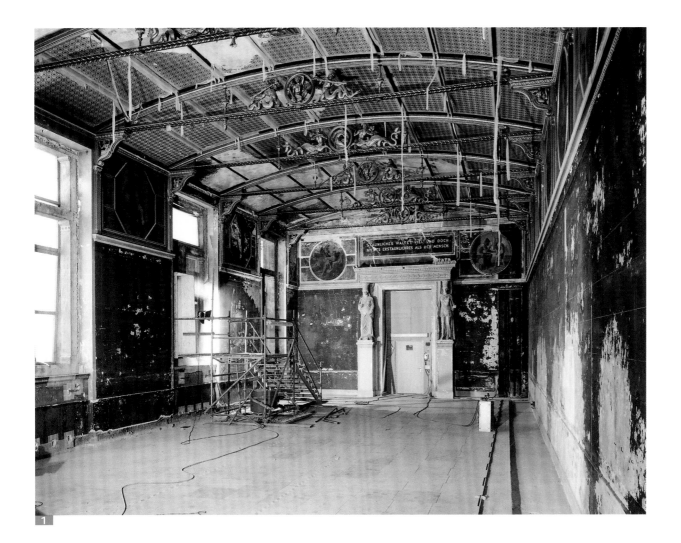

in the décor were retouched to match the surrounding original paint. The colour tone chosen for the retouching was based on the middle wall area's original colour, which was a deeper red-brown than the now visible colour tone, that of the second layer.

In the panelled area, the olive-green exposed layer was removed in order to reveal the dark blue original décor beneath it. Hollow places in the plaster layers were backfilled, and gaps in the plaster were filled in. The socalled *tratteggio* technique was used to retouch the smaller areas. This involves applying a succession of short, horizontal brushstrokes, creating a glaze-like "shimmering" colour effect that fits into the original surface visually and can be recognized as retouching from close to.

For the larger gaps on the gable ends, the décor was filled in using several layers of glaze over a covering base coat. The décor has a visibly horizontal direction.

Owing to the panel bench originally situated in front of the west wall, the dark blue décor was entirely missing from this area, which was redecorated from scratch.

1 Niobidensaal (space 2.11), view to the southeast, state in June 2006. *Photo: RaO*

2 Niobidensaal, view of ceiling, section BC7–9, left: state in June 2006. Right: state after restoration was finished in November 2008. *Photos: RaO*

Several glazes were laid over the first coat, largely negating the horizontal impression.

The choice of different retouching and decorating techniques reflects the different sizes of the gaps and their different treatment.

After restoration was completed, the Niobidensaal once more displayed the former splendour of the building in a largely unimpaired way. The influence of war and post-war damage on the aesthetic effect of the ceiling and wall surfaces had been significantly lessened, without completely destroying the marks left by time.

Further reading:
David Chipperfield Architects: The Neues Museum – Berlin. Restoration, Repair and Intervention, catalogue of exhibition in Sir John Soane's Museum, 2008. Hampton Printing Ltd., Bristol 2008
Neues Museum Berlin, archive databank: http://archivdatenbank-nmu.de

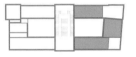

The Eastern and Western Kunstkammersaal, the Majolikasaal and the Three Adjoining Small Galleries

KATHARINE AND WIELAND GEIPEL

The eastern Kunstkammersaal (Art Chamber Hall, space 3.02)

The public Kunstkammer began in 1850, under the directorship of Leopold von Ledebur. The eastern Kunstkammer was used for a collection of architectural models and art furniture as well as model figures from modern Prussian history. There were glass paintings in the windows. After the Kunstkammer was closed in 1876, the vase collection was displayed in this hall. In 1907 it was renovated. From 1909 it was used for the Kupferstichkabinett (collection of prints and drawings).

Cast-iron arcades on cast-iron pillars with gilded ornamentation supported a ceiling of crosswise barrel vaults spanning 6 m and made from clay cylinders. The walls were decorated in monochrome, while the ceiling was given a light ochre colour scheme with a simple stencilled pattern. The floor was inlaid oak parquet.

Large areas of the walls and ceiling were destroyed during the Second World War. The iron structures survived only in part, and the cast-zinc cladding was entirely lost, as was the flooring. Only fragments of the wall plaster with its décor and the window surrounds remained. The gloomy architectural scene was dominated by peeling and dirty décor and bare, mostly damaged surfaces.

The challenge for the restoration was to recreate an ordered architecture while incorporating plaster fragments with painted décor. The structural wall shells had to be prepared using material-appropriate bricks and pointing. A light-coloured plaster slurry unites the bare surfaces.

Plaster fragments were secured by injecting a special mortar. Broken edges were stabilized using silicic acid ester. The fragmentary original decoration was retouched with glazes in reddish and greyish tones.

Gentle wet cleaning lightened the heavily greyed and dirtied window surrounds. Fragments of the surrounds were integrated into the profiling coat of the base plaster repairs.

The Majolikasaal (Majolica Hall, space 3.04) and the three adjoining small galleries

Before it was closed in 1876, majolica and glass objects could be seen in this hall. Afterwards, Indian pieces from the Ethnografische Sammlung (Ethnographical Collection) were displayed here. After renovation and the installation of partition walls in 1905, the hall was used by the Kupferstichkabinett (collection of prints and drawings). The 'Kabinette' (small galleries) were used by directors and museum staff, as well as being used to store materials. Pendentive domes above transverse arcades, brightly coloured ceiling decoration and gilded cast-zinc ornamentation on rows of supports characterized the Majolikasaal. The walls were coloured in monochrome. The space's colour scheme matched the exhibits. The hall had an inlaid oak parquet floor. The design of the Kabinette is not documented. One of these rooms contained some oak parquet flooring.

Apart from a few remains, war damage to the roof and subsequent severe weathering left bare shell walls with multiple damage to the bricks and mortar. They were greyed, grimy, fire-blackened and sintered. The damaged vaulting, reduced to the bare shell, was fire-blackened.

The way this room is built, with yellow and red brick types for different architectural elements and clay cylinders for the vaulting prevents it being perceived as a whole. Localized salt incidence in the south wall and the vaulting in one Kabinett led to darkening and damage. There was extensive damage to or total loss of vaulting in the Kabinette.

The restoration aimed to recreate the construction and look of the structural architecture with its different brick colours (light red brick vaulting, red brick lintels and door arches, yellow and light pastel-coloured walls). The Majolikasaal's south wall and the vaulting of a Kabinett had to be demineralized. The fire-blackening was lightened using gentle powder blasting. Heavier blackening and sintering had to be blasted brick by brick.

The vaulting was recreated or repaired using copied clay cylinders. The joint structure had to be recreated. The walls were cleaned by brushing. The wall masonry had to be repaired, and the original structural shell had to be restored. Retouching using glazes gave the space an ordered look.

The western Kunstkammersaal (space 3.06)

In 1855, small artworks from the Middle Ages and the modern era could be seen here, as well as glass paintings in the windows. After the Kunstkammer was closed in 1876, Indian pieces from the Ethnografische Sammlung were shown here. After the renovation work in 1905, the Kupferstichkabinett took over the space.

The design for this space included cast-iron arcades and supports with gilded zinc ornamentation, crosswise barrel vaults with surface ornaments in subdued colours and monochrome walls. The flooring was parquet.

As a consequence of war damage, the ceiling, the floor and the supports were lost. What remained were the bare shells of walls with remains of plaster and areas of grime and sintering. The restoration aimed to produce an architectural scene structured using yellow, red and pastel-coloured bricks.

The walls were cleaned using powder blasting. The wall structure had to be repaired using the appropriate colours of brick, while a different colour had to be used for the mortar. The plaster fragments were retained. Backfilling and localized repairs to the plaster secured the existing surface. The glazed retouchings, matching the brick colour, improved the look of the structural architecture.

Source: room book (Author: Heiner Sommer)

1 Majolikasaal (space 3.04), intermediate state in June 2008. *All photos: Johannes Kramer/BBR*

2 Majolikasaal, detail of a masonry wall robbed of most of its plaster and decorative finishes due to war damage and decades of exposure to the weather

3 Western Kunstkammersaal (space 3.06), masonry wall after cleaning and with yellow, red and pastel-coloured replacement bricks

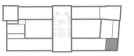

The Sternensaal

The cabinet-like Sternensaal (Star Hall, space 3.05), located in the southwest corner of the second storey, gets its name from its polygonal floor plan and its ceiling, decisive for the space below, a Late Gothic star vault. This figure is echoed by the mahogany intarsia in its oak parquet flooring. This makes the design of the Sternensaal consistent with the Neues Museum's overall concept of giving exhibition space and exhibits a unified form and design.

In 1855, the hall was opened as an exhibition space for Kunstkammer pieces. There were ecclesiastical art objects in the collection, including sacred glass paintings. As with the other rooms in the museum, the appearance of the space changed with the collection on display.

There was severe damage to parts of the interior decoration during the Second World War. The wire-and-plaster ceiling was completely lost. Only a few decorated fragments of ceiling, including parts of the vaulting cells, ribs, a bracket, the edge and central medallions were saved from the wreckage. The subsequent decades of weathering caused further destruction, particularly to the wall surfaces.

When work began, the space had a poured concrete ceiling, placed significantly above where the ceiling had historically been. The plaster on the wall surfaces had

been significantly reduced and damaged. The chapel-like character of the space had to be recreated, while respecting the existing fabric. To do this, the wire-and-plaster ceiling was recreated in its original star vault form. Details of the roof – for instance, the rib and medallion moulding, involving a three-quarters astragal with two connecting sections of coving – were reconstructed from preserved fragments and historical drawings. The stucco medallions and ribs were created using a table or ceiling cast process. The partial reconstruction of the bracket's original form was preceded by intensive study of individual surviving fragments and images. If they could be placed correctly, the decorated vault fragments saved from the wreckage were integrated into the ceiling, flush with the surface, where they would give museum visitors an impression of the original ceiling decoration, which it had been decided not to recreate.

Parallel to the reconstruction of the ceiling, the preservation of the surviving original plaster took place. For the wall surfaces, the aesthetic objective was to recreate, as far as possible, the original wall design. This meant exposing the original upper wall décor, which had been decorated over several times and which originally had a

1 Sternensaal (space 3.05): intermediate state in June 2008.
All photos: Johannes Kramer/BBR

2 Sternensaal: ceiling detail, December 2008

light green base tone. This décor had the niches and window openings as well as the places where the wall met the ceiling framed or separated by a broad blue line and a narrow red-brown line. The first thing to do was to carefully preserve the original décor and plaster. As well as consolidating the plaster structure and backfilling hollow places in the plaster, it was necessary to preserve the badly damaged décor.

In line with the design principle for the ceiling, the decoration on the wall surfaces was not reconstructed either. The additions to the plaster were integrated using a coloured glaze based on the colour of the original plaster surface in the area where the gap in the décor was located.

When the work had been completed, the Sternensaal exhibition room once more became a suitable setting for future collection pieces.

The Roter Saal and the Dienerzimmer

<div align="center">Eberhard Taube</div>

The Roter Saal (space 3.11)

The Roter Saal (Red Hall) was designed as a main hall for the copper engraving collection, open to the public. Its name comes from the red colour of the papered walls. This elongated hall in the second storey of the north wing is entered via the Haupttreppenhalle, to the south, and an anteroom – originally marked off by a low wall – which formed the entrance to the hall as well as the gallery assistant's office.

The Roter Saal was originally divided by a barrier into the southward Studiensaal (Study Hall), open to the public, and the northward Studiendepot, closed to the public. There was also an additional north entrance to the Grüner Saal (Green Hall) here. The space was divided mainly by the pattern of the four windows in the long walls and the cast-iron bowstring trusses of the shallow vaulted ceiling. Above the parquet oak floor and the narrow base wall area, the red-papered sections of the wall, which dominated the room, begin with a narrow frieze where they meet the ceiling. Above the four windows in the east and the west walls are wall pictures, portraits of famous copper and steel engravers (see chapter "Art in Building"). The middle of the north wall

is dominated by a semi-circular niche with a bust of Albrecht Dürer. The doorways in the south and west walls are decorated by portals with high-relief and partially coloured decoration.

The smooth plastered ceiling is structured only by oblong vaulting cells along the iron beams lying atop the bowstring truss. In the Roter Saal, the vaulting cells with a light green base tone are decorated only with a filigree ornamental design.

In the southward anteroom, the ceiling surface was papered and bands were painted on the iron beams. The inner surfaces of the vaulting cells have an ornamental design. Their décor, set against a light brick-coloured background, shows imitations of the ceiling's clay cylinders. The walls of the anteroom are simple smooth plaster with a light grey-blue décor.

In 1885, the passage and the Dienerzimmer were merged. This was presumably when a cast-iron spiral staircase leading from the Dienerzimmer to the top floor was removed. A free-standing projecting upper gallery and a doorway to widen the depot space were installed on the west wall. This work damaged plaster, stucco mouldings and paper. This was presumably when the walls were redecorated in red oil paint. The original vermillion distemper décor is only preserved behind wall cabinets on the west wall. War damage devastated the roof in particular, followed by water infiltration and heavy salt contamination. Mainly this led to loss of plaster and décor on the ceiling and the upper wall areas. Today, the almost total loss of the ceiling paper in the Dienerzimmer appears particularly serious.

In the 1980s, conversion into offices involved installing partition walls and a hanging ceiling. The historic floor and the wooden pedestal were removed, and the level of the floor was raised. Large areas of the wall surface were papered over. Today the date when large areas of the covered wallpaper were lost and the partition wall between the Dienerzimmer and the Roter Saal was built is unknown. Before the actual restoration measures began, the structural shell was repaired and emergency securing of plaster and décor, particularly on the wall images, was carried out.

Major objectives of the restoration measures were securing the existing plaster on the heavily salt-contaminated ceiling by developing a special injection process and reconstructing the walls' red colour scheme in an aesthetically appealing way by creating a transparent Japanese tissue wallpaper.

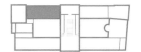

Restoration measures in the Roter Saal

First, efflorescences were reduced using a hot water and suction process, lessening the often serious magnesium sulphate contamination, and the surface was treated with barium hydroxide to convert salts.

Before further work could be done, the loosened décor on the ceiling beams had to be secured and then protected from mechanical damage using cyclododecane. The stable existing décor was cleaned without water. Only the less strongly bonded stencilled ornamentation had to be secured. Areas of plaster that had come loose from the brickwork were permanently consolidated by reducing salt levels using a barium hydroxide solution rinsing process and both localized and wider surface injections of Ledan inserted under low pressure. The plastering was done using the same techniques as for the original plaster, with coarse lime-gypsum plaster and fine lime-gypsum smooth finish plaster and marble powder in the same amounts as the existing plaster.

In line with aesthetic requirements, the retouching and reconstruction of the ceiling décor was done in lightened colour tones. The square yellow frame ornamentation with an aureole and blue central flower ornaments with light green accompanying bands with red scratches was entirely repaired. The lost areas of the ornamented ceiling beam décor were closed in with a warm light brown base colour tone based on the rust-coloured lost areas of the bowstring trusses.

Work on the walls began with the removal of foreign materials, especially the multiple superimposed layers of paper, and the removal of redecorations in the Dürer niche and in the soffit areas of the windows. Filling-in of plaster areas, some of them large, was carried out using the same techniques as for the original plaster, as with the ceiling. The original division of the rooms was recreated by reconstructing the lightweight wall separating the Roter Saal from the Dienerzimmer (Servants' Room), which was also plastered. Alongside the plastering work, the coats of stucco and attached elements were fully reconstructed, sometimes with the integration of preserved original parts. After the existing parts of the original décor had been secured and cleaned, retouching and partial redecoration were carried out in base colour tone only. Those repairs lying within the existing surfaces were matched to their aged condition using glazes.

A major objective of the project as a whole was restoring the original wallpaper, the surviving parts of which were located mainly on the west wall. First it was secured and restuck around the edges. The second red oil-paint layer could be separated from a grey oil-paint coat lying on top by means of solvent compression. As

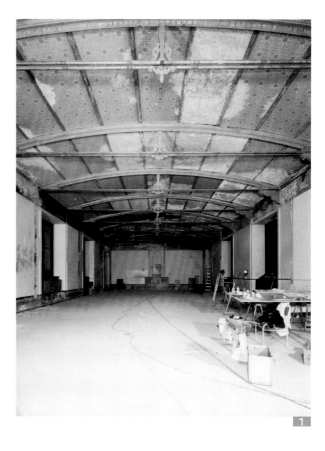

the second oil-paint layer had not been applied to areas behind the cabinets housing the collection, several square metres of the original vermillion distemper décor could be exposed here. Today, the surfaces which had been spared in this way reveal the hall's original coloration. At the end of the work, smaller gaps in the existing décor were filled in using base tone retouching.

Replacing the approximately 87% of the original paper which had been lost required extensive preparation and modelling. The aesthetic requirement for a transparent new layer, which ruled out repapering or a covering layer created using the original techniques, led to a transparent, machine-laminated paper being developed using damp-proof Japanese silk paper as a base. The colour tone is based on the second oil-paint layer, but the transparent paper makes it appear lighter and also makes the measures carried out on the supporting plaster visible.

In addition to this, extensive cleaning, securing, replacement and retouching work was carried out on the wall paintings above the windows, some of which were badly damaged (see the article on this in the chapter "Art in Building").

1 The Roter Saal (space 3.11): condition before restoration, 1996. *All photos: Wandwerk GmbH*

Restoration measures for the Dienerzimmer

As with the Roter Saal, extensive work to reduce salt levels and to fill gaps in the existing plaster was initially carried out in the Dienerzimmer. The transparent paper developed for the walls of the Roter Saal was also used to fill in the original paper on the ceiling, which had been almost entirely lost. The preserved remains of the original paper (approx. 5%) were reapplied to their original areas atop the remedial base paper. They provide evidence, to a limited extent, of the original, and now lost, design of the vaulting cell interiors with stencilled clay cylinder ornamentation. The division of the vaulting cells using painted light green surrounds between the bowstring trusses was completely reconstructed. The light grey-blue décor of the existing walls, large areas of which had survived intact, was exposed, secured and retouched in a slightly lighter base tone. New plastered surfaces, especially that of the newly installed partition wall between this room and the Roter Saal, were given a semi-transparent light grey-blue distemper coat textur-ed with a cross form.

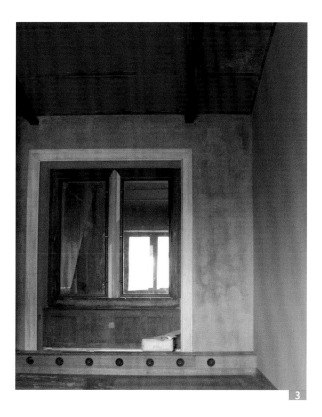

2 ▪ The Roter Saal: north wall with Dürer niche after restoration

3 ▪ The Dienerzimmer (space 3.11.1): restored anteroom of the Roter Saal

Flooring

ANKE FRITZSCH I MARTIN REICHERT I EVA SCHAD

The materials and forms of the original floors show the same sequence of evolution as the rest of the building. They graduate from the Egyptian department rooms' monolithic, non-patterned plaster screed terrazzo floors to the elaborate stoneware mosaics of the main storey, culminating in the special mosaic forms in the Nordkuppelsaal and the Mittelalterlicher Saal.

In contrast to the hard mineral flooring of the ground and main storeys, the floors of the former Kunstkammer and Kupferstichkabinett on the second storey (level 3) are prefabricated French parquet. The style, colour and material match the peculiarities of each room. The pattern relates to the space's structure, or echoes the design of the ceiling.

Water damage – and in some areas actual direct weathering – together with various mechanical impacts over the decades since the damage of the war have created a very complex damage profile, including cracks, delamination, loss of the securing bonding agents, gaps, bowing, loosening, peeling and deep localized washing out of the matrix. By the 1980s, the French parquet had been so badly damaged by dry rot that it had to be completely removed, except for a few surviving fragments. Damage to the flooring also overlapped with damage to the supporting ceiling constructions and the subfloors.

As well as factoring in this damage, the restoration concept had to take into account the expected volume of visitors and high localised loads caused by exhibitions, which would place greater strain on the flooring in future than when it was created and when it was previously in use. In addition, the fitting of the building's technical systems involved diverse interference with the flooring, meaning that intelligent solutions had to be found.

Essential planning alongside an extensive emergency stabilization campaign in 2003/2004 included load tests (for small areas and point loads), scientific studies and models and tests for various conservation processes. For material restoration purposes, the 2003 whole-area plaster screed and mosaic floor radar scan was largely ineffective. The technical and economic limitations on retaining the existing building fabric caused controversy both within the team and with external specialists. Despite the

1 The Mittelalterlicher Saal (space 2.04) – state of existing floor in 2000. *Source: DCA*

2 The Mittelalterlicher Saal – floor, restoration study by David Chipperfield Architects, 2003. *Source: DCA*

remaining uncertainties, the project team eventually decided to keep the original floorings in their entirety and to repair and restore them in situ using traditional processes and materials. Technologies used for manufacturing fired plaster and so-called marble cement were specially reactivated. The conservation work largely confirmed this decision. After reassessing the subfloor in the Niobidensaal and the Nordkuppelsaal during construction work, an isolated decision was made to take up the flooring in these rooms and to restore it in the workshop before laying it again. Within the existing rooms, completely or substantially stripped areas were recreated with exact reconstructions based on what had survived. Where there were insufficient finds to recreate the colour scheme, the recorded pattern was produced in grisaille. The marble cement flooring in the Nordkuppel was an exception to this. Unusually, the restoration concept for the whole space called for "archaeological" handling of the badly fragmented floor. The conserved existing floor was merely filled in with "neutral retouching" in light marble cement.

To maintain continuity with the original parts, the rebuilt sections of the ground and main storeys were floored using prefabricated slabs of cast stone concrete. The new level 0 (the basement) was floored with in-situ terrazzo. Following Stüler's plan, door thresholds, passages and Kabinette (small rooms) were given costly mosaic floors with white-and-grey marble "tesserae" to contrast with the large collection rooms.

On level 3 the historical rooms and all the new rooms were given solid smoked oak floorboards. The few remaining pieces of Badmeyer patent parquet were re-installed and, in the case of the Sternensaal, recreated with additions.

Stone in the Vestibül and in the Korenhalle

PETER BESCH

Vestibül (space 1.01), floor and columns

The floor of the Vestibül, a prestigious entrance area, was symmetrically patterned with different coloured marble and limestone slabs. The Silesian marble slabs that make up most of the surface were laid at an angle of $45°$ relative to the room's coordinates. The three sections were framed by red-violet-grey marble slabs (Lahnmarmor Unika A), which were in turn divided by black strips (Schuppach schwarz) along the walls and between the pillars. The Vestibül's ceiling rests on four Carrara marble (Fosse de Finocchioso) Doric columns, white with black veins.

The floor damage encountered here is only partly due to the wartime destruction of the main staircase hall. The damage profile and visible pre-war repairs show very early cracks in the flooring slabs. This damage – found mainly in the entrance and passage area and in the connecting passages to neighbouring rooms – was presumably triggered by mechanical damage during transport and by visitor traffic. The most recent theory is that the multi-layer floor construction of lightweight bricks set in lime mortar with each layer covered with harder fired plain roofing tiles was a causative factor, as were the sometimes very thin stone slabs of the floor, additionally set in too thin bed joints. The first extensive repair work took place in the 1930s.

The commonest kinds of damage were hollow spaces, loosening and peeling, light to severe surface dirt and loss of surface polish, but also the complete loss of whole

1 The Vestibül (space 1.01) after completion of restoration.
Photo: ProD

The Korenhalle (space 3.00)

Unlike the Vestibül, the platform area in the Koren-halle, made from Grosskunzendorf marble with a frame of green-black stone (serpentinite) and the connecting marble steps of the two-part staircase with its landing were so badly damaged that the whole floor had to be taken up. Due to extensive losses from the war, it was not possible to restore the whole stair. Fire damage and years of weathering, together with frost and thaw, had led to massively damaging mechanical and chemical processes.[1]

The surfaces were recreated by reducing the worst areas of encrustation and by careful cleaning using liquids. Replacement material for the damaged parts of the upper stair was taken from the remaining parts of the lower stair. Water jet separation technology mainly used in metalworking was used to cut out the patch pieces for restoring the stair-head surface's dark frame slabs. This process allowed the damaged areas of the original fabric to be cut out, following the line of the break and preserving as much of the material as possible. The cut was digitally marked out using CNC technology, in order to obtain a replacement that exactly fitted the gap. As a result, minimised patches could be manufactured for the scalloped breaks, their matching shapes fitting optimally into the original substance.

The restored flooring was put in place with the historic technology, while the subfloor was rebuilt entirely from scratch.

1 Gesellschaft für Baudiagnose und Schadensanalyse GmbH, investigation report "Dekorativ im Innenraum verbaute Natursteinbauteile – Marmorbauteile Raum 3.00", BBR-Archiv, IN-3.00-234-B

slabs. The north-west and south-west floor surfaces were badly damaged when the Treppenhalle (staircase hall) fell in. The remains were taken up and stored before restoration began.

The aim of the restoration measures was to restore and reconstruct the floor for future use as part of a museum with projected high visitor traffic while retaining the devastated historical fabric. Integrating floor-laid inner-building system wiring involved taking up the edge slabs completely and installing access channels in the inside surfaces of the floor. These slabs were laminated on their upper sides, secured true to their deformation and taken to the workshop for further restoration. The sub-floor was removed down to the load-bearing structure for inner-building system installation and then rebuilt. Some slabs with extensive cracking could not be reused at all or only in parts, i.e. not all could be restored to the load-bearing standard required. These slabs were replaced with new slabs made from a suitable replacement material. The slabs in the main thoroughfare zone, which would be subject to heavy loads in the future, had to be treated in the same way. This was because no realistic aesthetical-ly acceptable process for permanently bonding the substantial cracks existed.

Acquiring suitable replacement materials was very effort-intensive. In order to recreate the floor's overall appearance, the new material had to be as close as possible to the historical material. Despite considerable efforts, no new material for the red-grey framing (Unika A) could be found. Historic remnants from the Berliner Dom were eventually used.

Floor areas with minor damage were restored in situ, with each slab separately assessed for stability and expected load. Taking up and reinstalling all the slabs would certainly have led to a greater loss of the original substance.

2 Damaged area of a floor slab in the Korenhalle (space 3.00) cut out by waterjet separation technology

Terrazzo Floors on Levels 1 and 2

LARISSA PIEPO

The Neues Museum's terrazzo floors have a total surface area of approx. 2000 m². They are located on the ground floor and on the first floor of the building. On the ground floor all original floors are made of terrazzo, although some thresholds in the passageways do have stoneware mosaic or natural stone slab flooring. The Vestibül (the entrance area) is an exception. There, historic stone flooring created from several marble types has survived. On the first floor, about 30% of the floor surface is terrazzo. The floor design varies from room to room and may be uniformly mixed across the whole room or designed to echo the architectural pattern of column and support rows with changes in terrazzo colour and black separating strips, making it integral to the space. On the first floor, stoneware mosaics, marble cement friezes and natural stone medallions appear as added design features.

Manufacturing technique

Fired plaster with coarse gypsum components was used as a bonding agent for the terrazzo flooring. For the coloured terrazzo floors, the fired plaster was coloured with earth and iron oxide pigments, and crushed coloured stone was added as fine aggregate. This mortar mixture was spread across the floor surface and coloured stone granulate was scattered on it. The stones were stamped into the mortar mixture. After it had hardened they were polished until the stone granulate could be seen in section on the surface. The finely polished surface was presumably oiled after drying, intensifying the colour and giving the floor additional elasticity. The floor surfaces were finished with a wax polish.

The state of the terrazzo floors before the restoration

All floor surfaces were badly grimed. War damage meant that in some places they were badly washed out by direct weathering. In some cases the surface had been lost entirely. Cracks in the terrazzo surface allowed water to enter, destabilising the subfloor. Some of the floor surfaces had caved in or bowed, creating differences in level and abrupt rises of up to 7 cm. Some of the various gaps and breaks contained both historic and modern cement- and lime-based repair mortars. All floors had been restored at least once between the museum's completion in 1855 and

destruction in 1943. This had created a variety of historical terrazzo repairs, largely intact and matching the original flooring.

Restoring and reconstructing the terrazzo floors

The objective for the restoration measure was to re-create intact flooring equal to a museum's operation requirements and largely protected from further damage. Retaining the original terrazzo was the main priority. This included the historic repairs, considered part of the construction history. This objective meant extensive stabilising conservation measures for the original flooring. Conservation measures included cleaning the surfaces ready for levelling and consolidation, filling hollow spaces inside the floor structure, filling cracks, securing the bonding agents and taking up and reinstating bowed or caved-in surfaces. Badly weathered areas were retained after levelling the surfaces. After removal of repair mortars, pieces of iron and damaged older repairs, a load-bearing subfloor was created. Missing areas were filled in with

1 Crack injection around small cracks and historic terrazzo repairs to larger cracks before the restoration work, 2007. *Photo: Piepo & Partner*

2 Mittelalterlicher Saal (space 2.04), uncompleted reinstatement of the terrazzo circle, 2007. *Photo: Piepo & Partner*

fired plaster and stone granulate using the historical techniques. To adapt the repairs to the original parts, the fired plaster bonding agent was coloured with stone flour and colouring pigments. The stone granulates were also matched to the form and colour of the original material.

Terrazzo/Plaster Screed, Geological Identification of Aggregates

GERDA SCHIRRMEISTER

In the Vaterländischer Saal, the Flachkuppelsaal, the café, the Direktorenzimmer, the Ethnographischer Saal, the Gräbersaal, the Mythologischer Saal, the Mittel-alterlicher Saal, the Bernwardzimmer and the Moderner Saal, plaster screed floors with stone aggregates have survived. An investigation of the artistry and craftsmanship of the floors, together with their damage profile, is recorded in the restoration report "Terrazzo- und Gipsestrich-fussböden im Neuen Museum in Berlin" by Schubert, 2002. What was still needed for a suitable restoration of the existing floors was a specific geological or rather mineralogical identification and profile of the aggregates used, as well as their distribution and current sources.

The stone aggregates present were analysed in stages. First an overview was compiled of the different aggregate types for each type of surface in each individual room. The aggregates' composition and distribution are very diverse. Not only do they vary between the different surface types, they also vary within a single surface type depending on the day the work was carried out. After the principal had established 13 specimen surfaces (= specimen for cleaning) or reference areas in the ten rooms, these designated surfaces were each intensively investigated and documented.

3 Mittelalterlicher Saal, section of terrazzo after restoration of terrazzo surfaces and reconstruction of the mosaic, 2007. *Photo: Piepo & Partner*

1 Section of the reference area for the main (red) surfaces of the terrazzo floor in the Vaterländischer Saal (space 1.02) with aggregate types A (Carrara marble), B, C, D, H (various limestone types), E (serpentinite) and J (Giallo di Siena marble). The surface is moistened. *Photo: Gerda Schirrmeister*

The mineralogical profiling was done by moistening the individual aggregate types in situ and then looking at them under a lens. Where it was necessary and possible, samples of loose aggregates were taken for laboratory analysis. They were cleaned and, in some cases, polished. Thin sections were made of certain aggregates that could not be profiled macroscopically to be analysed under a polarising microscope. Any removed pieces, particularly Schubert's samples, were also assessed.

Using the sample preparations, comparative studies were carrried out using the collections of the Deutsches Natursteinarchiv Wunsiedel, the Bundesanstalt für Geowissenschaften und Rohstoffe in Berlin and the Institut für Angewandte Geowissenschaften at the Technische Universität Berlin in order to identify the individual aggregate types more specifically and choose suitable equivalent materials. For one type of aggregate samples of a comparative material were taken directly from the quarry and then made into preparations.

Detailed analysis of the aggregates came up with eleven main mineralogical types (A to L). Macroscopically, they were distinguishable from each other mainly by their specific coloration. These main types could be divided into subtypes, giving 20 identified types in total. These were predominantly limestones and marbles, with some serpentinite and isolated dolomitic marl, siltstone and basalt.

The distribution of the aggregate types on the individual specimen surfaces or reference areas was collated in a table for each one and recorded in photographs (see illustration). For each individual aggregate type on every surface investigated, stone types were recommended for the reconstruction.

Current sources were investigated for the selected equivalent materials. Actual availability and suitability was checked by making contact by telephone with potential providers and by assessing specimens.

The Marble Cement Floor in the Nordkuppelsaal

Larissa Piepo

The Nordkuppelsaal (space 2.10) is an octagonal space with four semicircular niches. It has no windows and is covered by a glass dome. The floor has a geometrical structure and its colour and decorations are elaborate. The geometrical pattern is created by bands of stoneware mosaic. The surfaces these create are covered with marble cement in different colours.

The mosaic is made out of individual laying slabs. They were manufactured to form a repeating pattern, and placed together in that pattern on site. Gypsum-lime mortar with sand aggregate – very soft and unstable – was used as bedding mortar. Gypsum mortar with coarse gravel aggregate was used as a support layer for the marble cement. This mortar was itself laid on top of a further thin bed of mortar and an even layer of bricks. (For "marble cement" working techniques, compare p. 223 ff. For mosaic techniques, compare with the "stoneware mosaic" article which follows).

The whole floor surface was badly soiled with dust, rust, putty and adhesives, as well as spots of tar and scraps of mortar. The mosaic bands used to pattern the floor showed sharp rises and falls in height between the individual mosaic tiles. Some tiles had come loose from the floor, or were broken into several pieces.

Parts of the marble cement's surface were badly weathered. It showed cracks, bowed and caved-in areas above hollow spaces and various breaks, as well as numerous historical additions that differed from the original surfaces in colour and transparency. There were also historical repairs in cement mortar and modern lime-based securing mortar. In the centre of the floor, beneath the dome, was a large gap. In total, about 30% of the floor had been lost.

Adhesion between the mosaic stones and the embedding mortar was largely insufficient. The mosaic's bed mortar was also badly damaged and low in bonding agents. Adhesion between the two layers of mortar was also insufficient.

The marble cement's support layer had also lost bonding agents, and had some hollow places. In the past, these defects had already led to some damage. The thin marble cement layer (in some places as thin as 2 mm) needed a stable sub-layer across the whole surface. In the absence of this layer, point loads would break individual parts.

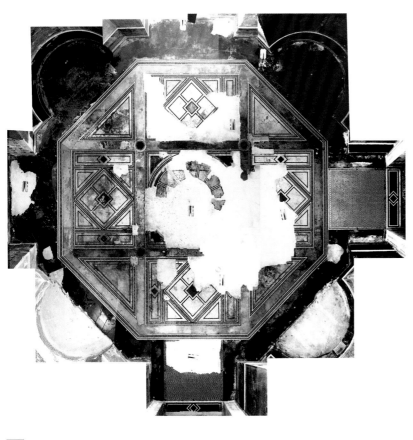

1 Nordkuppelsaal (space 2.10), initial state of the marble cement floor. *Photo: Piepo & Partner*

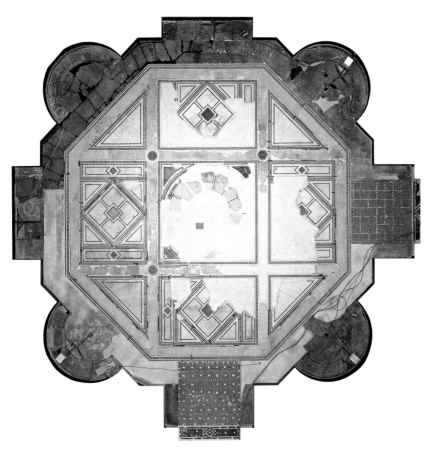

2 Nordkuppelsaal, reinstatement of floor segments. *Photo: Piepo & Partner*

Restoration

The restoration measures aimed to retain the historic floor including the surface deformations, cracks and traces of use, with no intention of actually reconstructing the original floor. To make the floor usable, gaps had to be filled in, but in a way that showed the differences between new and historical parts. Only the mosaic bands that divide the floor were reconstructed, in order to reinforce the floor surface's geometrical design.

To regain the floor's stability and functionality, it first had to be taken up so the subfloor and the support layers could be renewed. The stabilised pieces then had to be put back in exactly the right places.

After preliminary cleaning of the whole surface, the floor was taken up in separate segments. These were marked out along crack paths and mosaic bands. The mosaic corridors were marked out to be taken up based on the form of the original laying slabs. All segments were initially covered with a removeable laminate to protect their surface from damage. Slabs of polyurethane foam and Styrodur were then fixed on, true to the pieces' deformation. This allowed the segments to be lifted from the laying mortar by loosening of the mortar and gentle traction. Any mortar remaining on their undersides was removed. Cracks were filled and all segments were given a new support layer.

The segment faces were then freed of their lamination and cleaned so the surface could be worked. In the Nordkuppelsaal, a load-bearing subfloor was created and the segments were put back in position with precision based on measurement markings. Small gaps in the marble cement were filled in to match the original tone. The large gap in the middle of the room was given an off-white neutral fill.

Stoneware Mosaic on Levels 1 to 3

PETER VAN TREECK

The Neues Museum's original mosaic floors included the routes between the halls on level 1, all high-profile halls and their connecting passages on level 2, and the galleries on the east and west sides of the main staircase hall on level 3. The laying grid that created strictly geometric repeating patterns in the surfaces and the surrounding friezes and bands were designed by the architect, Friedrich August Stüler, and made by Berlin plasterers.

The mosaics used techniques and materials that were groundbreaking for their time. Their place in mosaic history – between the previously standard, classic "positive" laying technique, i. e. the direct setting of the "little stones" in the mortar bed, and the modern, "negative" technique of gluing the mosaic fragments on paper first and setting them in that way that came in after 1860 – is exceptional. In the Neues Museum, they were glued and then incorporated in cast gypsum-lime-sand mortar slabs which were then laid and jointed like tiles. Their surfaces were not ground. The mosaic material was miniature stoneware tiles made from dry-pressed clay fired at over 900°C, a new invention by the Berlin firm March from around 1845 manufactured in six main colours (white, yellow, red, black, blue and green, with different shades possibly caused by the manufacture) and in four different forms (squares with a side length of 2.2 cm, equilateral and isosceles triangles and rhombuses).

Using mortar mix largely consisting of plaster to lay mosaic is also unusual and, then as now, a challenge for mosaic makers. The so-called Berlin plaster of the laying slabs and the insetting mortar is similar to modern stucco

plasters. Using fired plaster for the subfloor and the compensation layer must also have been facilitated by the March firm's experience, although composition variations suggest further refinement during the construction process. There was no exact mixing ratio, and composition varies widely. In the Niobidensaal, Roman cement, also a very modern construction material at the time, was used, sometimes combined with brick grit and roof slates. The mosaic-terrazzo combination was also groundbreaking.

The floors needed repairs within the first few decades, but the larger-scale losses and damage were caused during the war or by weathering previous to the ruins being stabilised in 1986. A varied condition and damage profile resulted: total losses (the passages on the ground storey – 90 % – and the galleries on the second storey), loosened and adrift mosaic material (which was stored in 60 boxes) in some rooms, and extensively or slightly separated areas on some historic surfaces. The highly porous yellow miniature stone tiles had been badly damaged and worn by foot traffic. Bonding had been lost in various areas of the construction, with loosening between subfloor, setting mortar and laying slabs, sometimes together with cracks, and mosaic pieces coming unstuck from the laying slabs. Often they were held in place only by the joints between them.

The objective of the measures was to conserve the remnants and to restore and reconstruct using the original techniques, while keeping in mind future use and strain on the floor and the specific limits associated with conserving historic floor mosaics in buildings.

1 Stoneware mosaic, preliminary state of subfloor.
Photos: Peter van Treeck

2 Stoneware mosaic floor in the Römischer Saal (space 2.02), preliminary state

The difference between surfaces to be conserved in situ and surfaces to be taken up and put back using new mortar was mainly in the adhesion of the mosaic pieces. Where this had largely been lost, it was decided to take the surfaces up and mortar them together as new laying slabs, as consolidating the mats with dirt underneath was not technically possible except with synthetic resin-based gluing. The fact that tension decreases in areas next to slabs that were taken up caused further instability – due to properties of the material – meant that more areas had to be taken up than was foreseen in the initial assessment, and led to a significant change in the early Niobidensaal concept. Ultimately this hall's whole mosaic floor was taken up and subsequently put back to ensure that it would withstand the projected flow of visitors.

Two different techniques, analogous to "stacco" and "strappo", were used to take up the surface. Sometimes fragments were taken up rigid (because of deformation) together with the mortar bed (laying slab). However, the damaged laying slab mortar then had to be entirely ground off and re-poured, while the fragments' original joints and surface structure were preserved. Where individual pieces and larger damaged areas had to be filled in and colour-matched (in the Bacchussaal and the Römischer Saal), elements taken up in this way were laminated with glass slabs. Elsewhere, in the Niobidensaal, the fragments were taken up "soft", i. e. as a mat, after their level and alignment had been accurately measured. The lamination preserved the macrostructure of mosaic details, retaining the old "andamento" and the look of the surface. Damage-related deformations and large marks left by use were moderated during re-laying of the slabs.

After being cleaned using steam and sparingly applied organic acids and lyes, all of the loose historical material was reused to fill in parts of the wider surface. It was mixed with a proportion of new stoneware to create a uniform floor for the room. Reconstructed surfaces did however remain visible. Only the almost entirely lost friezes in the Moderner Saal were reconstructed by being filled in with a subdued colour scheme.

In line with the original technique, the pattern was glued in the negative fashion and cast in a frame as 3 cm-thick laying slabs with a mortar mixture made from plaster (stucco plaster similar to Berlin plaster from the 19th century), lime (calcium hydroxide) and sand (fine-grained quartz). The original retarding agent was presumably glue or tartar. For the renewal, tartaric acid (1 ‰ on plaster) was used. In mixing the mortar for laying the slabs on the fired plaster subfloor, the most advanced variations of the original mixtures, found for instance in the Bacchussaal, were used: the stucco plaster of the laying slabs, calcium hydroxide, hydrated lime, quartz sand 0.1 – 0.4, pit sand 0 – 2 and limestone chippings 1 – 3 as hydraulic components and retarding agents. This required a complex development and testing process. This laying technique's sequence was subject to the following constraints, among others: due to the very short processing time, only two to three slabs (depending on size) can be laid at a time, and shrinkage in the mortar of approximately 2 % has to be taken into account when calculating surface heights. Given required construction heights of between 3 and 6 cm, this was significant.

The chronology for combining the mosaic with the terrazzo varied. In the Moderner Saal, the reconstructed mosaic friezes were laid first and set the level and pattern for the terrazzo, while in the Mittelalterlicher Saal the mosaic frieze was fitted around the terrazzo remnants.

Modelled on the existing workmanship, pointing of the mosaic surfaces was performed with plaster mortar pigmented to match the laying slabs. Future use and

3 Stoneware mosaic, manufacture of laying slabs

4 Stoneware mosaic floor in the Niobidensaal (space 2.11), section U

maintenance issues made the surface finish of the mosaics very important. The old techniques were broadly kept to here also, using oil/wax mixtures refined in repeated in-depth tests.

French Parquet in the Majolikasaal and the Sternensaal

JENS OSTERWOLD

Majolikasaal (space 3.04)

The historic parquet construction was laid according to the Badmeyer patent process. This process allows French parquet to be laid without any fastenings visible from above. Thicker and thinner pine boards were glued together and secured with dovetail battens to form the supporting slabs. In the Badmeyer process, these battens also serve to retain the parquet to the base timbers. To form the wear layer, 8 to 9 mm thick rectangles or rhombuses of face veneer were stuck together atop the base wood so that the corners of each piece touched the joints. The rhombus form is an adaptation to non-rectangular ground plans. The above-mentioned panels were prefabricated in the workshop and glued together onsite. Gluing along the panels' length was done without dowels or springs. The panels are joined on their end-grain sides by a groove and external spring. After the parquet had been laid across the whole space, the mahogany bands were laid. Due to the widespread effects of moisture and the resulting pest attacks (dry rot) the base wood construction is almost entirely gone, apart from one panel. Many of the oak additional battens have come loose, been lost or destroyed by pests. The surface is badly worn through use and greyed or blackened by moisture impact. Reinstatement of parquet panel 1 as part of the historic floor covering consisting of three panels in total: laying within a flooring layer of single-strip boards to create a fully functioning floor in space 3.04. However, it was no longer possible to use the Badmeyer process to lay the panel due to the height of the bare floor. Reinstatement of the panel including shortening of the cruciform dovetail battens, fitting the subfloor to the new construction situation. Counter-veneer had previously been applied to the

underside to supplement the reduced dovetail battens. Veneer for repairs was salvaged from remaining tile fragments, doubled with new veneer and calibrated to the thickness of the surviving fabric using a wide belt sander. Then the rhombuses were marked out and pressed out using a veneer press. The panels' oblique angles were than formatted using a gauge block, and the mahogany bands were fitted. Before transport to the site, the panels were hand-ground using a grinding pad, cleaning without undue removal. The installed veneer was acoustically decoupled using granulated rubber insulation strips. After being secured, it was given a finish and coloured.

Any projecting edges were evened out with a smoothing lathe and by grinding. Then the whole surface was "smoothed" with a grinding pad only. Finally it was treated with lye and soaped.

Sternensaal (space 3.05)

The historic construction had been laid using the Badmeyer process. The room was divided into nine irregularly formed segments, each extending from the central rosette to a corner point. The segments were divided into individual elements/panels according to their length. They were individually veneered outwards from the central rosette in a fishbone pattern whose central axis of reflection bisects the corner. The central rosette's base wood construction consisted of several boards glued together and secured by two dovetail battens. A continuous moulded piece of wood was glued around the edge, projecting upwards 2 cm to form a support for the connecting segments. For this, boards were glued together in pairs, and then shaped to the space's form. These

1 Repairing the parquet in the workshop using salvaged material

2 Reinstated parquet floor with completed surface

inner part. Three segment-dividing mahogany bands of different lengths were then laid. These end in the outer mahogany ring of the central rosette, with a mitre cut. In the outlying zones, these bands are mitred in the same way as for the inner zone. A major bomb impact completely destroyed the western half of the parquet (segments 1 and 9). The segments that do exist – 2 to 7 and 10 – have been either ruined or badly damaged by weathering and severe dry rot. All of the base wood was beyond feasible restoration. Parts of the remaining top veneers were also badly damaged. The central rosette was detached from the historic base wood during the so-called emergency stabilization in the 1990s and secured on a modern supporting base.

In line with the overall restoration concept for the Sternensaal the original appearance of the French parquet was entirely restored, despite the very significant losses. Restoration and reconstruction were the same as for space 3.04, although multilayer wood slabs, a modern material, were used for support. In individual areas, some of the Sternensaal's salvaged veneer could be used, and veneer from space 3.04 was also used as a reserve. Due to the space's very complex geometry, the parquet was precisely strapped into place once the wall panels had been installed, optimised using CAD and formatted using a CNC-controlled machine. This allowed the small salvaged veneer pieces to be optimally integrated. The veneer was laid on flooring joists, with the same acoustic decoupling used as in the Majolikasaal. The surface was coloured (using wood stain) and soaped.

Sternensaal: panel wall cladding

Salvaged elements of the removed material were also used here. Where the wall cladding was missing (due to war damage or conversions in the early 20th century) it was reconstructed or, in the case of the north side, plain fitted cupboards were added. The original elements were cleaned and repaired with smoked oak veneer. The reconstructions were manufactured in the same way in terms of material and divisions. Colouring was only required in some cases. Paste wax was used as a finish.

elements were then glued together onsite and secured using dovetail battens. The individual segments were connected together by a tongue and groove.

The board used for this was pine. After the mounting of the individual segments, it was simply glued to them. The breadth of the edge strip is constant and adapted to the room's form. An 8–9 mm-thick top parquet wear layer was glued to the base wood. The segments were divided analogously to the continuous segmented boards. Different wood types – oak and mahogany – were used. Working circularly from the centre outward, mahogany bands of different widths were laid throughout the

4 Sternensaal, parquet after completion of restoration and laying

5 Sternensaal, reconstructed wall cladding

New Terrazzo, Level 0

PETER ANTONIOLI

In total, 1,420 m² of new terrazzo flooring were installed on level 0 of the Neues Museum (in spaces 0.01, 0.02, 0.04, 0.05, 0.06, 0.07, 0.10 and 0.11). Terrazzo floors are monolithic artificial stone floors manufactured in situ. Creating these floors is an age-old craft used with great artistic skill in ancient times in the Mediterranean. Itinerant Italian craftsmen brought this craft to Germany in the mid 19th century. Terrazzo floors can be found in many buildings of this period, sometimes elaborately crafted and often remarkably well preserved. There are few companies in Germany today able to master this old craft.

Terrazzo floors are usually constructed in two layers: the load-bearing subconcrete and the terrazzo facing layer. In the Neues Museum, a 12 cm-thick steel fibre-reinforced and compacted subconcrete layer was installed. The 3 cm-thick terrazzo facing layer is made from stone chippings and cement as a bonding agent – in this case, granulated marble in graded grain sizes from Lengefeld/Erzgebirge and Dyckerhoff weiss white cement. It was applied to the subconcrete with a bonding course in between and compacted by being rolled intensively using heavy manual steel rollers. After being left to harden for three to five days, the floor was wet-ground using a floor grinding machine. Diamond grinding tools of different grain sizes were used. Six grindings, working up from coarse grind to fine grind, were required. The floor was finished by being impregnated with wax.

The increased surface load (10 KN/m², with compression of 3.6 N/mm² on parts of the surface) had previously been tried on a 1.5 m x 1.5 m test surface. The pattern for the terrazzo floor had also been determined in advance. The colour and texture were matched to the large-format cut concrete slab floorings in the neighbouring spaces. A series of sample patterns produced an optical match with the cut concrete floorings. Joint rails made from bronze with a visible breadth of 5 mm were installed to divide the area. They were oriented on the pillars that form the grid. The bronze rails were ground down to floor level.

The resulting surfaces were 20–30 m² across, with a terrazzo floor's characteristic appearance: expansive and elegant.

1 The Schatzkammer (space 0.10): completed rolled and smoothed terrazzo floor. *Photo: Peter Antonioli*

New Mosaic, Levels 1 to 3

Reinhard Böckenkamp

In total, 1,420 m² of new terrazzo flooring were inst A marble similar in colour and composition to the original marble still remaining in the Neues Museum (the stone steps in the Treppenhalle) was to be used to create new mosaic floors. The aim of our work was a sense of connectedness and transition in the mosaic designs – in relation to the new cut stone in the exhibition spaces and the existing historic terracotta mosaics. A continuous dark frieze copied from the basic structure of the old floors encloses most of the newly made lighter surfaces. "Hellschlesischer Marmor" (light Silesian marble), often used for sculptures and floor and wall cladding in Berlin in the 19th century, was chosen for the mosaic's predominant lighter surfaces. It was quarried for the Neues Museum from a quarry in Slawniowice (formerly Gross Kunzendorf) in the Opolskie (or Oppeln) district near the Poland/Czech Republic border. It ranges from white to grey, like Italian Carrara, but it has a medium to fine crystalline structure, a sign of the high resistance that makes it different from Carrara.

In a stoneworking factory the blocks were converted to slabs 10 mm thick and measuring about 60 cm x 40 cm with a finely ground surface. In Toppo (Friaul) the slabs were then sawn into 23 mm-wide strips and finally mechanically cut into pieces of the same length. This produced quadratic pieces of stone with two opposing machine-sawn sides and two sides cut using old manual techniques, giving the floor mosaic a very organic, almost flowing look and at the same time demonstrating the blending of old and new techniques. The mosaic stones' format, 23 mm x 23 mm, matches the original terracotta mosaic stones they connect to in some places.

The iridescent mid-grey marble "Bardiglio Nuvolato", also from Tuscany, was used for the dark frieze that was laid around almost all lighter areas. The stones were transported from Italy to Berlin loose in boxes and then converted to mats for laying in the workshop.

After measurements onsite, we divided the total surface to be covered in each case into individual, numbered segments. Reproduced on paper, these formed the basis for creating the mosaic mats.

The laying plans were very important to the actual laying on the site. They guaranteed precise placement of the individual mats, allowing precise division of the surface to create a balanced visual effect.

The undersides of individual stones were stuck manually to a glass fibre mesh. The stones of each surface were laid linearly in one direction and were continually irregularly offset in relation to the neighbouring row in the other direction. These laying variants created an ancient Roman look and made the surface appear spacious and very organic.

The intention was to avoid cross-shaped joints between individual rows. The dark friezes of "Bardiglio" are always laid in four-row strips, surrounding the "Hellschlesischer Marmor" to an equal depth all round.

During the dividing-up process, the whole floor had to be adapted to the space's coordinates so that no half stones were visible at the walls and other interfaces. In some places where, for instance, the mosaic's distance from encroaching fixtures such as columns or niches

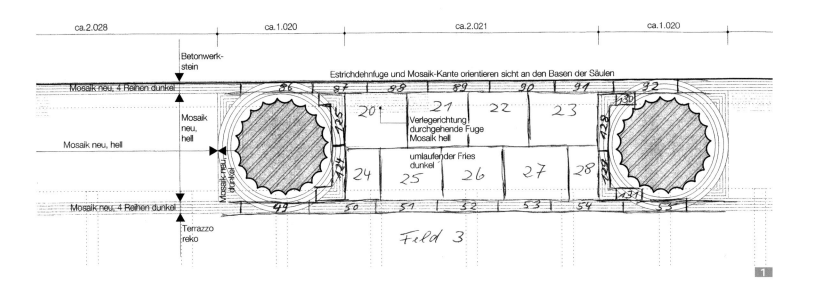

1 Laying plans (here: access to the staircase hall, space 2.07) are very important. They guarantee precise placement of the individual mats, allowing precise division of the surface to create a balanced visual effect. *Photos: Terracotta OHG*

was irregular, additional darker stones were used to fill in the gap.

The breadth of the lengthwise joints was adjusted for small deviations in the room measurements. Splitting of individual stones was avoided as far as possible.

Trapezoid surfaces where stones had to be arranged in a wedge shape to achieve the desired formation gave rise to exceptions several times where the old building's fabric met the new construction, or where the new mosaic met old mosaic or cut stone.

All surfaces were filled with screed before the mosaic was laid to create differences in height between the old and new buildings and to level the new mosaic with other flooring materials, creating a "gentle" transition. Construction-related expansion joints were bounded on both sides with oxidised bronze rails and worked into the mosaic flooring.

The actual laying of the mosaic onsite was done with the help of a laying plan. We used a white marble adhesive that would not colour the material. This adhesive bed was interlocked to a tooth depth of 6 mm with the mosaic's ground. The individual mosaic mats were laid on it and knocked into it.

An adhesive slurry was used to improve the bond between the ground and the adhesive bed. This was worked into the adhesive "wet on wet". All junctions with projecting edges, columns and niches had to be worked manually onsite. This sometimes involved breaking individual mosaic stones with a mosaic hammer to fit and laying them piece by piece.

The final grouting was done using a flexible stone grouting mortar with no discolorations. It was slurried in and evened out by repeated washing. The colour "Manhattan" was used for joints between the "Schlesischer Hell" and the dark "Bardiglio", and for junctions with wood floors, cut stone, existing mosaic, terrazzo and bronze rails. This grey tone has a moderating effect on the different materials and quietens the surface.

The initial planning, the laying of the mosaic and the technical construction work were undertaken by the firm Terracotta OHG, Böckenkamp & Leistikow, Potsdam. The mosaic mats were manufactured by the firm Cosmomusivo, Teichert – Fornasari GbR, Berlin. In total, we produced and laid approximately 210 square metres of new mosaic for the Neues Museum between February and November 2008.

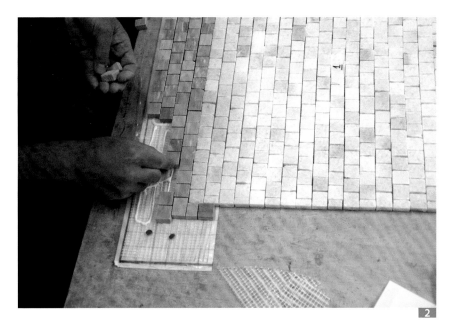

2 In the workshop, the undersides of individual stones were stuck manually to a glass fibre mesh. For all the surfaces, the stones were laid linearly in one direction and were continually irregularly offset in relation to the neighbouring row in the other direction. A dark frieze of four rows of "Bardiglio" surrounded the "Hellschlesischer Marmor" surfaces.

3 The actual laying of the mosaic onsite was done with the aid of a laying plan. The individual mosaic mats were laid on the adhesive bed and knocked into it.

Art in the Building

ANKE FRITZSCH I MARTIN REICHERT I EVA SCHAD

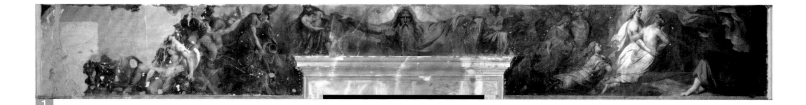

The lavish nature of the pictorial art in the decoration of the Neues Museum far exceeds that of all other contemporary public buildings in Prussia. The intention was to sweep the fine arts to a new heyday under the royal patronage of Friedrich Wilhelm IV and to found a "Berlin Sculpture and Painting School" of its own. Alongside eminent names like Wilhelm von Kaulbach, Friedrich Drake, August Kiss or Hermann Schievelbein we find an abundance of comparatively less well-known artists, some of them very young. These include, for example: Ferdinand Konrad Bellermann, Karl Eduard Biermann, Heinrich Bögel, George Catlin, Eduard Daege, Bonaventura Genelli, Müller von Göttingen, Carl Georg Anton Graeb, Gustav Heidenreich, Eduard Pape, Carl Friedrich Seiffert, Ernst and Max Weidenbach. Thanks to extensive source studies by Heiner Sommers, it has proved possible to evaluate the available archive material about the art incorporated into the Neues Museum's architecture, thus creating a basis for the first time for an evaluation of the mid-19ᵗʰ-century pictorial works that have been paid little attention hitherto. The pictorial-plastic, sculptural decoration was concentrated mainly on the façade – the Schievelbein frieze in the Griechischer Hof (Greek Courtyard) and the figurative elements of

cast-zinc decoration of the metal girder structure. The figurative painting ran through almost all the exhibition galleries on the ground and main floors in the form of friezes on the upper walls, culminating in the monumental images in the south dome and the main staircase hall.

The Second World War and its aftermath had completely destroyed a large number of pictorial works and badly damaged others. For example, of the main work within the artistic décor, Kaulbach's *Story of Mankind* in six pictures, only about 200 of the tiniest fragments could be rescued from the heap of rubble in the staircase hall. These will be displayed in the so-called Lapidarium in future. Numerous wall paintings were removed as part of the preparations for rebuilding in the 1980s, placed on temporary support sheets and stored away (for "Removing murals," see the Special Subjects chapter).

During the rebuilding process, the appropriate way to treat the surviving works of art from the architectural décor was discussed and agreed upon in a specially formed "working group for art in the building" made up of planners, restorers, representatives from the collections and the monument conservation office, but also outside specialists. More than 20 meetings were held under the expert chairmanship of Prof. Dr. Wolfgang Wolters

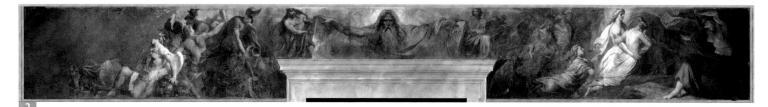

1 The Vaterländischer Saal (space 1.02): wall picture, state in 2000. *Photo: DCA*

2 The Vaterländischer Saal: wall picture, restoration study for neutral retouching. *Illustration: DCA*

between 2001 and 2006, examining and evaluating the existing approaches and devising strategies relating to the aesthetic aims of restoration. As in other fields of restoration planning, virtual simulations by David Chipperfield Architects helped to sharpen detail as part of the decision-making process, but also to show the restorer doing the work what was expected. Questions, some of them very complex, relating to conserving and replacing sections that had been removed, were discussed in a separate "working group for restoration techniques."

Stucco Relief on the East Tympanum

THOMAS LUCKER

The tympanum relief *History Instructing the Arts* on the east gable of the Neues Museum was executed in 1854 by the sculptor Friedrich Drake (1805–1882) using an applied stucco technique and a gypsum-lime mortar on brick cores. The freely applied high relief shows the allegory of History as a central female figure, flanked on both sides by allegorical representations of the arts (Architecture, Sculpture, Painting and Graphic Art). Some of the twice-life-size figures tower above the surrounding sandstone cornice. The relief was originally fully coloured with oil-bound paint.

At the time of restoration in 1997 the eastern tympanum relief was in a disastrous state. The protective paintwork, which had been regularly renewed until the 1930s, had largely weathered away. Interaction between the small degree of protection afforded by the narrow roofing cornice and continuous direct exposure of the entire sculpture to weathering had led to immense and profound damage to the original piece. Entire carved areas had been lost and the masonry behind them damaged as a direct result of the effects of war, and this led to the damage progressing at an accelerated pace as a result of open broken areas, the formation of cracks, exposed concrete reinforcement etc.

Saponification of the plaster areas and the accumulation of lime adhesive in areas near the surface, working together with frequently alternating frost and thaw had hardened the outermost applied layer and made it brittle, and at the same time had loosened areas lower down. Moisture had been able to penetrate freely, corroding existing reinforcement, which in its turn led to rust ruptures. A large number of missing areas had been replaced in the past with materials containing cement and bitumen. The apparent aim of stopping the rapid advance of weather damage had been turned on its head by choosing the wrong materials and by inexpert execution, thus accelerating the destruction process.

The aim of the 1997 restoration was to secure the relief material and the surviving original surfaces permanently. Given the poor quality of execution and the damaging materials used, it was necessary to remove the numerous secondary additions. This provided access to lower layers and made it possible to treat and restore some areas that had become detached with silicic acid ethyl esters and to fill cavities with Ledan injection mortar. The iron anchors and reinforcements assessed as key parts of the work of art were left in situ where possible after corrosion protection measures had been taken, and were replaced or repaired with stainless steel reinforcements only in isolated cases.

As long-term protection measures against the effects of direct exposure to the elements, missing areas were sealed off and a final application of white lead paint was used. The large-scale loss of original forms did not affect only the appearance of the relief. The greatly enlarged surface areas in the numerous damaged zones and the exposed iron remained as targets for future weather damage. It was decided that sealing off damaged parts and missing areas in the form of sculptural additions was a satisfactory aesthetic approach that would focus the technical aims. Here Drake's sculptural characteristics, the artistic context of the day and historic photographs were to be taken as the basic guidelines for the work. Additions modelled on the spot in clay could be used to make precise cast pieces by using negative moulds and placed in areas with work missing. Individual fragments

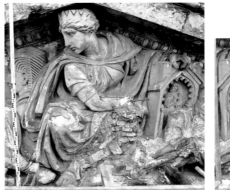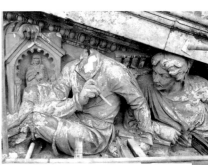

1 Allegory of History (left) and Painting (right), condition before restoration, 1997. *Photo: BBR*

Cast-Zinc Relief on the West Tympanum

GEORG J. HABER | MAXIMILIAN HEIMLER

The cast-zinc relief *Art Instructing Industry and Arts and Crafts* in the tympanum of the west gable was completed by 1862 to models by August Kiss and August Wredow. To the right and left of the winged Muse sitting in the centre are three figures on each side, with different tools and applied art objects. All the figures and larger attributes are separately made and attached to each other by soldering and screws. The relief is almost completely three-dimensional and very faithful in terms of detail. Casting was probably carried out in the Moritz Geiss zinc-casting workshops in Berlin. Each object is made up of relatively small cast parts (100 mm x 100 mm to a maximum of 400 mm x 600 mm). These were sand-cast with material from 4 to 8 mm thick and attached with tin-lead solder.

The choice of this new casting material goes back to Karl Friedrich Schinkel. As Schinkel's pupil, Stüler used zinc casting in large quantities for the Neues Museum, as he appreciated its advantages, such as rapid manufacture, reasonable pricing and low weight. The cast-zinc objects on the exterior were matched to the ensemble in terms of colouring, i.e. sanded to stone colour.

There is no clear answer to the question why the east tympanum was not created using this technique. One fundamental advantage – from an artistic point of view as well – is the fact that metal sculptures can be executed considerably more delicately and in more detail than when using stucco or stone.

with original surfaces were built into the cast parts. Larger missing areas, such as the head of the allegory of Painting or extensive parts of the allegory of History, were modelled directly from historical photographs using application mortar identical with the original.

Before the white lime paint was applied, loose paint had to be removed down to the stable second coat. The white lead paint – applied at first in late 1997 in two coats to provide temporary protection – was completed in a shade adjusted to match the overall appearance of the building when the east façade of the Neues Museum was being finished off in 2008.

2 Allegory of Painting, left: fitting the partially reconstructed left leg as a moulded cast part. *Photo: RaO* Right: condition after concluding restoration with the reconstructed head of the sculpture. *Photo: RaO*

3 Condition of the tympanum relief on the east gable after restoration was completed, 1998. *Photo: RaO*

The cast-zinc sculptures were worked on in situ in 1997/98, after extensive preliminary examinations by restorers and scientists. Key aspects here were securing the existing stock and conserving the zinc surfaces using insights provided by the section of the German Environmental Foundation concerned with conserving monuments made out of zinc in its current research. War and structural damage and also corrosion problems affecting the fixing devices were to be dealt with at the same time.

An endoscopic examination of the cavities had taken place as early as 1994, in order to establish the nature and condition of the fixing devices. The relatively good condition of the iron anchors was one important factor in deciding to restore the tympanum relief in situ. The metal analysis and metallography for the rest was carried out by the Rathgen laboratory (Prof. Dr. J. Riederer) in Berlin in 1995. All the cast-zinc tests showed an almost identical alloy composition, with 97 to 98 % zinc, 1.2 to 2.7 % lead, 0.2 % tin and slight traces of other metals. The solder was shown to have been a tin-lead solder with 52 % tin and 48 % lead.

The FEAD research and development office in Berlin undertook to examine the original paintwork on the zinc sculptures in 1997. It was no longer possible to show without any doubt that the first coat had been a sandstone effect, because of the large extent to which the paintwork had been removed by weathering and corrosion. By looking at the material found on other zinc figures on the exterior of the building, like the child figures, for example, it was deduced that in all probability the same painting technique and paintwork colouring had been used for the west tympanum.

After the endoscopic tests, the cavities behind the figures and in the plinth, which were crammed with biogenic deposits, were cleaned after creating small inspection apertures in the panelling; the rust was removed from the iron anchors and they were conserved with a special rust sealant system on a polyurethane base. So that settling and movement in the building could be compensated for more easily, expansion joints and sheet lead seals shaped to the back of the relief had to be placed in the tympanum's basic metal sheeting. Additions to the existing figures were confined to missing parts of the Muse's hair. A section showing remains of historical paintwork on the wing of the central figure was retained as a primary document and fixed with Paraloid B 72 before the conservation procedure was carried out on the relief. This had already been recoated in 1998 in a neutral shade of grey, using a modern coating system. A two-component keying surface on an epoxy resin basis suitable for zinc surfaces was used, and the temporary covering coat was

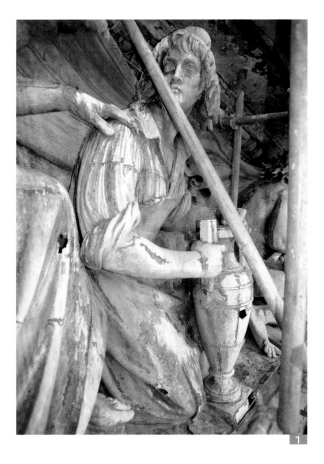

undertaken with a two-component clear coat on a polyurethane base in a neutral zinc-grey shade.

Here the aim was to protect the sensitive zinc surfaces reliably against weathering, with the option of finally matching the tympanum relief to the overall picture with an imitation stone coating after restoration work on the

1 West tympanum, "Potter" figure, condition before the preliminary examination in 1994: war damage and heavy weathering of the last colour paint layer, corrosion of the exposed zinc-casting surfaces. *Photo: Haber & Brandner GmbH*

2 West tympanum, the "Model-maker and Assistant" figures with capital: exposed cast-zinc surfaces before conservation in 1998. *Photo: Haber & Brandner GmbH*

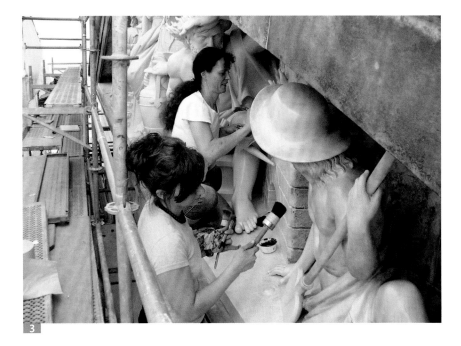

zinc. These cast-zinc objects were originally finished in a sandstone colour to match the ensemble.

The condition of the objects shows clear evidence of war damage. The sculptures are covered with bullet holes and cracks and have bits missing. The zinc material is particularly brittle at the edges of this mechanical damage, which makes it difficult to reshape and seal up damaged areas (fig. 1).

Also, in the case of the griffins, for example, damage to the outer skin of the kind described above had exposed parts of the internal iron structure to the elements unprotected, which led to severe corrosion damage and thus to lack of stability for the sculpture as a whole. All the cast-zinc elements suffered surface corrosion of their outer skin, and had thus lost their paint-work almost completely.

In restoring this group of objects the aim was to conserve the original stock and restore the originally intended appearance by reconstructing the lost decor and replacing missing parts in identical material. So first of all the objects were removed by experts and transported to the workshop. Here cracks and breaks were carefully corrected and sealed with solder, both to seal off the material and bind the surface. Bullet holes were to be left showing after restoration, however, as evidence of former damage and a testament of history, so these were not sealed flush but instead by soldering in shaped cast zinc replacement parts below the surface level (fig. 2).

Missing parts, for example the missing limbs, but also some figures of children that had disappeared completely, were replaced with copied casts. But as zinc shrinks in volume during the casting process, it was necessary to create correspondingly larger plaster models of the objects or parts of objects that were then used

west façade had been completed. The final coat was finally applied in 2008 after the surfaces had been carefully cleaned with an additional semi-matt covering coat in a two-component polyurethane acrylate combination in a basic sandstone shade. The creative paintwork giving the sandstone look was achieved by sophisticated application of a linseed varnish modified with tube oil paints and a matting addition.

Further reading
Mottner, P. and Mach, M. (eds.), *Zinkguss. Die Konservierung von Denkmälern aus Zink.* Arbeitshefte des Bayerischen Landesamtes für Denkmalpflege, vol. 98, Munich, 1999.

Metal Architectural Sculptures

Georg J. Haber | Mandy Reimann

Large numbers of decorative cast-zinc elements featured on the exterior of the Neues Museum, as well as sculptural architectural decoration in sandstone and stucco. On the roof of the museum, four cast-zinc griffins, the roof figure Art and three corner acroteria. On the façade of the west tympanum, the figures of children and some of the pilaster and corner pilaster capitals were made in cast

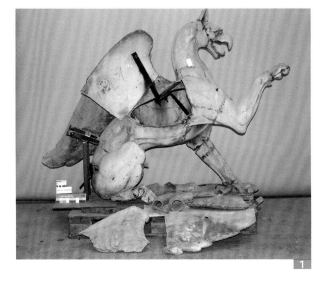

3 West tympanum, final painting of the zinc sculptures with pigmented oil varnish, photo taken while the paint was being applied in 2008. *Photo: Haber & Brandner GmbH*

1 Griffin before treatment. *Photo: Haber & Brandner GmbH*

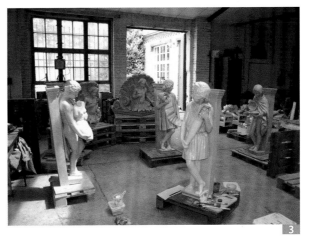

to make the mould. This made it possible to compensate for the zinc shrinkage, and the recast objects or parts of objects now correspond exactly with the size of the originals.

The original internal iron frames were damaged in a number of ways and no longer performed their static function adequately. Even so they were not replaced, but repaired and conserved as essential components of the historical objects. Partial reinforcement using flat iron and square metal stainless steel sections attached reversibly meant that the damaged iron support structures were reinforced only where necessary to restore their static function. The corroded outer skin, with the various kinds of coloured décor surviving only in fragments, was cleaned using particle jet processes. This removed both corrosion products and remains of the paintwork. One small paintwork specimen area was retained as evidence of the original paintwork structure, as well as a sample and detailed documentation of each object. For the final conservation and new paintwork on all the zinc surfaces, a tripartite corrosion protection system on a PVC acrylate base was applied. The final coat of sandstone-coloured paint was matched to the shade of sandstone colouring in the immediate vicinity by painting on an oil varnish (fig. 3), which additionally emphasized the three-dimensional quality of the objects by the varying thickness of the coats.

Natural Stone Sculptures on the Corner Projections

ALEXANDER BANKERT

The architectural sculpture on the Neues Museum is to be found on the north and south projections of the exterior façade and in the Griechischer Hof (inside the building). It includes 15 three-quarter figures with plinths on the projections representing the arts and sciences featured in the museum's collections, and also winged Victories. The figures were based on models by August Wredow, Carl Heinrich Gramzow, Wilhelm Stürmer and Heinrich Berges in 1846. Seven figures remained in situ on the façade below the cornice. Another seven figures were removed for safety reasons in the second half of the 20th century and stored on the museum site. Another figure, in several fragments, and various fragments of other figures were deposited in the external store in the Berlin suburb of Hohenschönhausen.

Spherical niche medallions showing Roman and Greek deities are arranged below the figures on the same axis. The figures are approx. 3.2 m high with plinth, and the frame diameter of the medallions is about 0.85 or 1.25 m. The stone is Elbe sandstone of the Posta variety. All the figures and medallions are compactly painted. While there were only scant remains of the contemporary paintwork in broken white shades, the visible finish is an oil-modified alkyd resin paint containing white lead in a shade of greyish green (pre-1945). Most of the damage to the architectural sculpture happened during the war. Some figures and the majority of the plinths were totally lost to bombing in 1945, and almost all the sculptures have lost some parts, e.g. heads, limbs or attributes, or large chips.

2 Detail: bullet hole sealed below surface level.
Photo: Haber & Brandner GmbH

3 Oil varnish on the cast-zinc sculptures.
Photo: Haber & Brandner GmbH

1

areas, in the form of highly viscose epoxy resin. Cracks, breaks and loose parts representing a risk were additionally secured with stainless steel pins in various dimensions. Filling was carried out conservatorially to secure, to consolidate the stock and to guarantee that water would drain off correctly, using a mineral-hardening substitute stone compound. Finally, the figures that had been removed were replaced and re-anchored on the façade on the plinths restored for the purpose.

It even proved possible to restore badly damaged figures such as the "Hermeneutics" (east façade, north projection, figs. 1, 2) to a state in which they could be placed in position. Reduced figures were completed by adding sculptural elements important to the whole image in the form of fragments that were believed lost, such as wings, urns and heads. Overall, it is possible to experience the sets of figures again as an aesthetically and substantially important component of the Neues Museum's façade after restoration.

The principal aim of the work was to conserve the existing stock. War damage remained largely recognizable as such. The work included removing the thick layers of recent paintwork and remaining dirt by dry and water-based methods after several applications of a CFC-free stripper fluid. In some places measures were needed to strengthen the structure. Where statically necessary, the frequently occurring cracks and crack systems were injected with epoxy resin, with the surface temporarily protected. Adhesive was applied at points where needed, or over entire

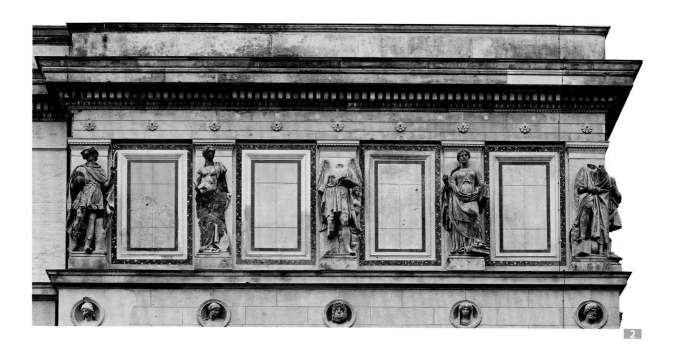

2

1 Badly damaged figure of "Hermeneutics" during the extensive conservation work. Here needle insertion is shown. *Photo: Alexander Bankert*

2 East façade, north projection: the figures of Geography, Hermeneutics, Science, History and Philosophy after the completion of the conservation work and the reinstallation of Hermeneutics. *Photo: Johannes Kramer/BBR*

The Schievelbein Frieze

In 1845, the sculptor Hermann Schievelbein was commissioned to create a relief frieze of *The Destruction of Pompeii* for the east, north and west walls of the Griechischer Hof in the Neues Museum. After his 1849 design model, Schievelbein sculpted a frieze with figures in gypsumlime stucco, which he finished in 1851. It was 65 m long and 1.7 m high, and placed at a height of approx. 12−14 m in the Griechischer Hof. It was installed using a multilayered application technique over preliminary drawings on a uniformly rendered ground. Marker crosses indicating transfer points can be seen both in the design model and in the completed version in the Griechischer Hof. The threequartersfull figures were attached to the masonry by iron anchors. The frieze was probably originally displayed untreated, but later the relief – probably to protect it against the effects of the weather in the unroofed Griechischer Hof – acquired uniformly creamcoloured white lead paintwork, which made it look like a work in marble.

The Schievelbein Frieze also suffered from bombardment in 1945, which largely destroyed the Neues Museum: a direct hit tore a hole about 5 m wide in the

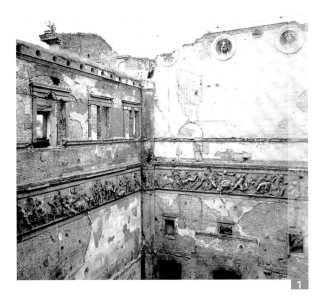

east wall of the frieze, destroying this area completely. Partial damage as a direct effect of war, manifest in profound losses of material and the collapse of parts of figures, such as heads, arms and legs, can also be found in numerous other sections. Cracks and loosening of the structure in the masonry of the building also affected the stucco frieze. The high relief remained anchored to the masonry throughout the period, and damage due to corroded anchors was the exception, which meant that

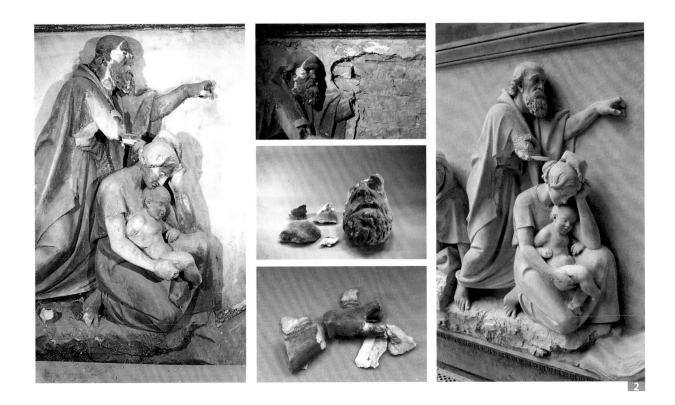

1 View of the Griechischer Hof with the damage sustained in the Second World War. *Photo: BBR*

2 The group of figures called "Hermann Schievelbein with Wife and Child." Left: Condition before restoration started, 1997. *Photo: BBR*. Middle row: Condition during restoration, 1997/98. *Photo: RaO*. Right: Condition after restoration had been completed, 2008. *Photo: RaO*

Realization
196|197

Securing parts of
the relief on the north
façade that were
threatening to collapse,
2002. *Photo: RaO*

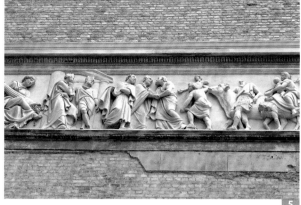

no complete figures fell off, but the direct effects of the weather led to considerable damage to the sculpture. Once the white lead paint had lost its protective function over time, in some places alveolar leaching could be seen in the top view of all unprotected and protruding areas, leading to complete loss of shape in many cases. Penetrating rainwater combined with frequently alternating freezing and thawing caused the individual application layers to become detached. These were not in any case

mechanically keyed together or to the relief ground in any significant way (usually the sculptor "combs" or "denticulates" the lower layers before they harden, in order to key them mechanically to the next layer; this happened to only a rudimentary extent among the relief figures, and not at all in the ground area, from which unanchored, flat images detached themselves). This separation of layers led to the loss of large areas of the original surfaces, leaving behind areas of sculptural design that were still identifiable, but often considerably distorted. Dramatic progressive damage with considerable loss of material developed as a result of exposure to the elements at the numerous points where fracturing was caused mechanically.

The Schievelbein Frieze was restored in several stages. The first campaign of the years 1997 to 1999 aimed first of all to consolidate and preserve the original material. This involved cleaning the surfaces of the frieze, with the exception of the intact layers of paintwork, treating corroded anchors, removing damaging secondary additions, filling cavities and glueing back parts that had detached themselves.

As it had to be assumed that the Griechischer Hof would have an almost outdoor climate for a long time – despite the temporary protective roof that was now in place , the court was not heated, and there was snow on the frieze in winter – it had to be secured as if it were an object exposed directly to the elements. Because of the characteristic damage – "layer separation" and "fractures" – the conservation programme included a plan for securing additional material with new attachment techniques, alongside the measures listed above. The concept dealt with securing edges, overlaying fractured areas, sealing alveolar efflorescence and missing parts, but not reconstructing lost figures or parts of figures. Hypothetical reconstruction was not to be undertaken overall. The mortar used was dyed with ochre pigments for identification.

4 View of the Griechischer Hof to the west, condition after restoration was completed, 2008. *Photo: Johannes Kramer/BBR*

5 South part of the west façade, condition after restoration was completed, 2008. *Photo: RaO*

Further consolidation measures for securing the surviving material came into play in the course of the second working phase from 2001 to 2002, when lime-bound filler material was introduced, loose parts glued back on again, pins were applied, edges secured and cracks sealed. In addition, material was strengthened and corroded iron treated.

The final work on the Schievelbein Frieze took place from February 2007 to April 2008. By now it had received full conservation treatment in the preceding campaign to secure it, and was a stable presence in the interior of the Griechischer Hof, which was now protected against the elements. All the measures undertaken in the last campaign were motivated by design considerations, restoration aesthetics and monument preservation, and intended to mute the heterogeneous look of the frieze. The damage to the frieze was not uniform: the west wall had largely survived intact, the north wall was badly damaged. Over five metres of the pictorial matter on the east wall had been destroyed by direct bomb hits, and some sculptural additions had been made during the first phase. All these factors made the Schievelbeinfries look less than homogeneous. As well as this, the surviving but very grey-looking coloured paintwork contrasted starkly with the numerous missing areas, where the almost white original mortar could be seen, and also the new, ochre additions.

As part of the final set of measures, particularly intended to calm and unify the overall appearance of the frieze, the upper and lower cornices, which had been damaged to different extents, were largely reconstructed. Sealed missing areas were examined and matched aesthetically where appropriate, or carefully sealed where nothing had been undertaken so far. Historical anchors, some of which protruded into the space in a bizarre way were embedded, and a final coat of coloured paintwork was applied in the form of a cream-white, semi-transparent lime wash.

The above-mentioned measures create a sense of lucid harmony and thus rendered the pictorial programme considerably more intelligible. At the same time traces of ageing and the direct effects of war and of the period when the building was a ruin can still be seen. Above all, the reversible light-coloured paintwork optimized the possibility of perceiving the relief frieze as a work of art in its own right, and of integrating it into the completed Griechischer Hof as a whole.

The Bellermann Wall Pictures in Space 1.02.2

ELKE RENNER

The landscape painter Ferdinand Konrad Bellermann painted two murals in the passage leading through from the south vestibule to the Vaterländischer Saal (National Hall) on the ground floor of the Neues Museum in 1851–1852. The two pictures "Opferstein bei Stubbenkammer" (*Sacrificial Stone near Stubbenkammer*) and "Hünengrab auf Rügen)" (*Megalithic Grave on Rügen*) provided a pictorial accompaniment to the museum exhibits on the theme of "Nordic Antiquities" and were intended to put visitors in the right mood. Unlike the murals in the Vaterländischer Saal, which were painted using a stereochromic technique, Bellermann's pictures used a wax technique on a multi-layer gypsum-lime plaster.

War damage to the museum building had meant that the masonry and the plaster layers of the *Megalithic Grave on Rügen* picture had been damp for years. This led to efflorescence, separating large areas of the plaster support from the wall, and individual layers of plaster from each other. The mineral salts were deposited under the layer of paint, which led to blistering and dishing.

Various measures were taken to strengthen and backfill the murals from 1987 to 1988. In the course of the further restoration process the missing areas were puttied and retouched. In the late 1980s, the site managers of the day decided to create a line of demarcation behind the east wall of the Vaterländischer Saal and to remove the structural elements under the former south dome. The murals were elaborately secured, then sawn out of the existing walls with the masonry, and put in store for

1 The wall picture "Hünengrab auf Rügen": integration of framework construction. *Photo: Elke Renner*

2 The wall picture "Opferstein bei Stubbenkammer" and masonry block in a special framework construction in the Höhenschönhausen depot. *Photo: Elke Renner*

several years in a building that had been made ready in the square in front of the Alte Nationalgalerie. When the rebuilding of the Neues Museum started, the masonry blocks with the paintings on them were then moved to a hall on the site of the former Ägyptischer Hof (Egyptian Courtyard), then examined and treated with a view to reinstalment.

Tests carried out on the murals showed that years of storage without air conditioning had damaged the masonry blocks. Before the masonry blocks were taken out they had been stabilized at the back with a 10 cm thick layer of epoxy resin and fitted into a frame structure with diagonal braces. Movement in the epoxy resin layer caused by fluctuating temperatures led to the formation of cracks within the masonry blocks. Geo-radiological tests made it possible to ascertain the extent of the cracks, and exactly how they ran. In the case of the masonry block backing the *Megalithic Grave on Rügen* mural, the cracks in the masonry ran through the plaster layers to the surface layer of paint. It was no longer possible to replace the mural with the masonry. The layer of

paint and the plaster support were secured and stabilized at the front with a multi-layered lamination structure. The epoxy resin layer and the masonry were then removed from the back, in several working stages. After each step the plaster support revealed at the back was secured with a layer on top of it and this was then connected to the lamination at the front. When the whole mural had been treated in this way it was taken out of the hall and into the Vaterländischer Saal. The plaster support was stabilized by embedding a stainless steel lattice structure that had been constructed in such a way that after the mural was lifted into the prepared niche it could be attached to the masonry behind by the lattice.

The cracks in the masonry supporting the *Sacrificial Stone near Stubbenkammer* mural had not penetrated to the paint and plaster layer, partly because this masonry was thicker. The masonry block could be reduced to a 24 cm wall for reinstallation purposes. A special frame structure to secure the masonry block was prepared in such a way that an attached chassis and stiffening diagonals fitted for additional reinforcement could be taken off again before replacement. The masonry block was stored in the Hohenschönhausen depot to await reinstallation. The mural was replaced in the prepared niche in April 2007. Two scaffolding towers in front of and behind the wall niche contained the mechanism for raising the masonry block. It was attached to the mechanism with special winches and chain constructions, raised into the prepared aperture in the wall and clamped to the end of steel girders.

The historic spatial and wall dimensions of the former passage were restored in this newly built section of the museum. The two wall pictures are back at their historical starting-point.

3 The wall picture "Hünengrab auf Rügen": removal of epoxy resin layer and brickwork from the rear side. *Photo: Elke Renner*

4 The wall picture "Hünengrab auf Rügen" after reinstalment in 2007, August 2008. *Photo: Peter Thieme/BBR*

Metal Structural Decoration

GEORG J. HABER | MANDY REIMANN

Technically necessary inserts such as steel girders and supply shafts were provided with decorative cladding in a variety of metals in the Neues Museum interiors. These included painted and sometimes gilded zinc sheet cladding on the top ceiling structure members, cast-zinc consoles to decorate the tie bar constructions (cast zinc, gilded and painted), gilded and painted sheet-zinc strips or brass strips to clad the ceiling beams and various shaft claddings in zinc or cast zinc and sheet iron. Given this wide range of cast-zinc and decorative sheet-metal objects, the variety of conditions in which they were found varied widely as well. These ranged from very well preserved bowstring truss decorations with large areas of gilding and paintwork, as found in the Niobidensaal (Niobides Hall, fig. 1), to severe war damage and the complete loss of the majority of the objects, as in the Roter Saal (Red Hall), for example.

The aim of the measures taken was to conserve the original stock as much as possible, and also to replace missing objects, making a clear distinction between originals and reconstructions by reticent colouring using neutral retouching paint.

The badly damaged ceiling beam cladding in the Roter Saal was removed and repaired after careful dry cleaning and fixing for the colour paintwork. An appropriately shaped sheet-zinc construction was introduced to support the fragile sheet-metal structure, and soldered to the original sheet-metal structure at the edges (fig. 2). Finally, neutral retouching paint was applied to the areas treated in this way, in the form of an oil-type scumble glaze (fig. 3).

Missing cast-zinc elements were reconstructed with cast copies of the appropriate parts. But as zinc shrinks when cast, a correspondingly enlarged plaster model of the objects or parts of objects had to be made. A mould was taken from the enlarged plaster model produced in this way and a zinc casting made. The rough casts were subsequently worked and chased. The cast copies were then retouched with an oil-type scumble glaze, appropriate

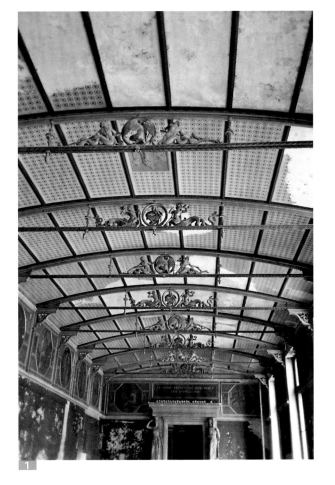

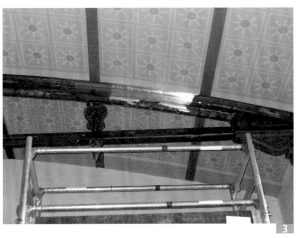

2 Sheet-zinc substructure for the severely damaged decorative metal construction in the Roter Saal (space 3.11). *Photo: Haber & Brandner GmbH*

1 Condition of the decorative cladding in the Niobidensaal (space 2.11), before restoration. *Photo: Haber & Brandner GmbH*

3 Neutral retouching of the sheet-zinc substructure in the Roter Saal. *Photo: Haber & Brandner GmbH*

to the whole concept. Here, too, it was considered important to distinguish between original and cast copy, for which reason the retouching was neutral.

For the reconstruction of the mechanically printed decorative sheet strips in brass or zinc, again a plaster model of the strips was produced first, and this provided a means of creating the positive and negative matrices – stable mould parts (negative and positive version) – that were always reduced on their top side by half the material thickness of the metal sheet to be printed. The flat sheet was placed between positive and negative mould and pressed into the required shape. Then the copied strips were fitted using the original technique and retouched in accordance with the restoration concept.

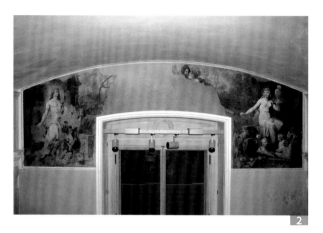

Wall Pictures in the Vaterländischer Saal

WOLFGANG GÄRTNER I KARL-HEINZ PETZOLD I
JULIA FELDTKELLER

The restoration history, which had not been favourable throughout, and above all the war damage and the progressive damage this set in train, had caused considerable damage and loss to the murals (created by painters Gustav Richter, Robert Müller and Gustav Heidenreich) based on the *Edda*, a cycle of Nordic legends. Even so, the surviving material was extensive enough to make the subject matter and creative intentions of the paintings comprehensible again as an overall picture.

The first intention of the treatment concept was to conserve the layers of plaster and paint by puttying, backfilling and impregnation. A decision also had to be made about how to handle the conservation measures carried out after 1989. Where they fulfilled their purpose, or could not be removed without damaging the original material, they were left in position.

The appearance of the murals was considerably improved by cleaning the surfaces of the pictures. This also included removing the mineral salts that had made their presence felt disturbingly in the form of white stains or bloom. Other discoloration and movement was due to the ageing of the materials themselves or to outside influences. Any of these features that had become part of the overall picture were left as part of the building's

history. Stains and shapes that were merely disturbing visually were matched to their surroundings by retouching so that they were no longer a distraction for the eye.

Restoring the plaster layer followed the aim of a complete and uniform reconstruction of the painting ground. Therefore additions and puttied areas had to match the original model as closely as possible in the material mixture and in the surface structure to be crafted.

The concept for restoring the paintings differed from this. On the one hand it required that the original work and the restored additions should be clearly distinguishable. On the other hand, the integration of the missing pieces in terms of colour had to go so far as to ensure that the painting made the dominant impression, and not the image presented by the damage. Fundamentally, restraint was to be the key factor in restoring the missing areas, as illustrated by the simulations produced by David Chipperfield Architects.

It would not have been possible to achieve the aim of the restoration with a neutral shade for all the paintings and pictorial zones. Instead the painting was matched to the particular demands of each area by using a uniform basic shade for the colour approximation to the painting in each missing part. The first retouching step

 1 The Vaterländischer Saal (space 1.02): "Baldur und Hulda" wall picture before restoration, with extensive damage to the plaster and paint layers. *Photo: Karl-Heinz Petzold*

2 The Vaterländischer Saal: final state of "Baldur und Hulda" wall picture. It was decided not to recreate the lost parts, but the retouching gives the picture a unified appearance. *Photo: Karl-Heinz Petzold*

therefore consisted of colouring the missing sections in a shade of grey-brown. Further scumbling then followed according to the surrounding colours, reducing the contrast between the old material and the addition both in colour shade and in brightness and saturation, until the addition finally disappeared behind the painting. Colour sometimes ran as a result in the larger missing areas.

The retouching was not intended to produce a homogeneous surface, but even so the effect was to be as even as possible. Structuring the applied paint was avoided, again meeting the requirement of restorative additions that were as reticent as possible, and did not assert themselves in their own right.

Wall pictures, wall surfaces and the exhibits presented on wall-mounted shelving were linked together with painted-on frames. These also include the red-green-white picture frames for the murals, which were constructed on the model of the few surviving remains.

Wall Pictures in the Römischer Saal and the Niobidensaal

UWE DE MAIZIÈRE I ALEXANDRA SKEDZUHN

The Niobidensaal, the Bacchussaal (Bacchus Hall) and the Römischer Saal (Roman Hall) are to be found on the main floor of the Neues Museum, on the east side of the building. These three rooms share a characteristic three-zone wall structure consisting of panel, middle wall and

upper wall. In both the Römischer Saal and the Niobidensaal the upper wall consists of a continuous wall frieze.

Römischer Saal (space 2.02)

The mural programme for the Römischer Saal shows views of Rome and its surroundings and also Pompeii, to designs by Stüler. The paintings were executed in oil-resin technique by the Berlin painters Eduard Pape and Carl Friedrich Seiffert.

Only one third of the cycle survived, because of war damage. A great deal of material remains in the north section of the room, while in the south section the murals have been lost almost completely. Large areas of the picture zone were weathered back to the load-bearing masonry.

The surviving murals showed damage from persistent exposure to damp, the accumulation of mineral salts damaging to buildings and earlier restoration measures. Areas of plaster of various sizes were missing, and there was flaking and some over-cleaned areas in the paint layer. After the painting had been conserved and secured by fixing and backfilling, and also by the removal of incompatible acrylate mortar, the missing plaster areas were sealed with lime mortar.

The nature of the plaster additions depended on the position of the mural in the room and on the extent to which the surrounding plaster had survived. In the northern part of the room and within the areas where the mural was missing, the added plaster was matched to the surviving material in texture and level, The remaining areas were rendered below the level of the rest, and somewhat more roughly. The retouching was in the shade of the old mural rendering throughout. Here the brightness was matched to the surrounding material.

Niobidensaal (space 2.11)

The function of the Niobidensaal was to show the transition from Hellenistic to Roman art, so the murals appropriately show figures from the world of Greek legend. The exceptions are a Romulus, creating the connection with Roman art, and an image of Cheops before Athene, which can be seen as a transition from Egyptian to Greek culture. The murals were painted by Carl Becker, August Theodor Kaselowsky and Adolf Henning, and also by Wilhelm Peters, to designs by Bonaventura Genelli.

When the Niobidensaal murals were executed in socalled stereochromic painting, this painting technique had only just been developed by Johann Nepomuk von Fuchs and Joseph Schlottauer, with Wilhelm von

3 The Vaterländischer Saal: detail of "Titania und Thor" wall picture during removal of surface dirt and older coats. *Photo: Karl-Heinz Petzold*

Kaulbach involved as well. Water-glass was used to bind the pigments. The painting is executed on hardened plaster with pigments soaked in water and then fixed in water-glass. At first glance the visual effect of this secco painting is like that of a fresco.

The murals in the Niobidensaal, with the exception of the paintings in the north-east and south-west corners, survived almost in their entirety. Water damage and the associated mineral accumulation led to the loss of layers of plaster and paint here. As well as this, the surface of the paint was blistering and sections of the skim plaster layer were bulging.

One of these murals provides a very good illustration of the aims of the conservation and restoration measures and how they were conducted ("Ajax", see fig. 2). It is between the fourth and fifth windows, and shows Ajax falling on his own sword after he was denied Achilles's weapons. Adolf Henning painted this picture.

The damage to the mural was treated conservatorially; cavities were backfilled and fixed. The excess film of fixant on the surface and the acrylate mortar on the sloped edges left over from earlier restoration measures were removed. The missing areas of plaster were sealed with lime mortar at the surface level of the existing material. The grain and texture of the rendering were adjusted to match the existing plaster.

As the original pictures have almost all survived in the Niobidensaal, the plan was to integrate the shades of the missing areas to a considerable extent. The retouching colour was matched to the surrounding picture areas, but was made a little brighter and a little greyer. This made it distinct from the original material, as well as almost completing restoring the legibility of the pictorial content.

Specific solutions were developed for the various problems in the Römischer Saal and the Niobidensaal, based on the completely different extent to which

1 Römischer Saal (space 2.02), mural "Circus Maximus in Rome". Top: condition in 1943. *Photo: Otto Cürlis. Source: Zentralinstitut für Kunstgeschichte – Photothek für die Bundesrepublik Deutschland.* Centre: condition in June 2006. *Photo: RaO.* Bottom: condition in December 2008. *Photo: Johannes Kramer/BBR*

2 Niobidensaal (space 2.11), mural "Ajax". Left: condition in 1943. *Photo: Otto Cürlis. Source: Zentralinstitut für Kunstgeschichte – Photothek für die Bundesrepublik Deutschland.* Centre: condition in June 2006. *Photo: RaO.* Right: condition in November 2008. *Photo: RaO*

original material had survived and taking into account the needs of the existing material and the aesthetic concepts for the room and sequence of rooms.

Further reading

David Chipperfield Architects, *The Neues Museum – Berlin. Restoration, Repair and Intervention*, catalogue for an exhibition in Sir John Soane's Museum, 2008, Hampton Printing Ltd., Bristol 2008

Irmer, B., "Ein Wandbild im Römischen Saal des Neuen Museum in Berlin. Dokumentation – Schadensanalyse – Konservierungs- und Restaurierungskonzeption," 1994. Thesis submitted on restoration in monument conservation at the Fachhochschule Potsdam

Neues Museum Berlin, Archivdatenbank http://archivdatenbank-nmu.de

1 The Nordkuppelsaal (space 2.10): sections of coffering with re-applied painting fragments. *All photos: Wandwerk GmbH*

Wall Pictures in the Nordkuppelsaal, in the Dome of the Apollo Niche, in the Ägyptischer Hof and in the Roter Saal

CARSTEN HÜTTICH | EBERHARD TAUBE

The Nordkuppelsaal (space 2.10)

The first row of the coffered sections of the dome with its pattern of eight sides were painted with circular pictures of geniuses in resin-oil-wax paint. The third row was painted with grotesques in casein tempera on lime plaster (by Eduard Daege, August Ferdinand Hopfgarten, Eduard Steinbrück and Adolf Schmidt). In 1980, the paintings were removed from this relatively intact space and stored. The wall paintings of the lunette sections in the shallow niches are painted with scenes of heroes from Greek mythology in resin-oil-wax paint on lime plaster. (The artists are named as Hopfgarten, Schmidt, Steinbrück, Daege, Bögel and Eltester, but the paintings cannot be individually attributed with any certainty.)

While the lunette pictures on the walls were treated only with simple conservation techniques owing to their good state of preservation, water and mineral contamination meant that significant technical and aesthetic efforts were needed to put the dome's coffer paintings back in place. The 24 pictures were freed from their temporary synthetic resin-bonded supports and securing inserts and were given a support structure to match the room's existing substance. The pictures were applied to the masonry with a fast, irreversible bond and integrated into the conserved dome using carefully adjusted reconstruction aids in the surrounding coffered stucco and plastering and retouching in the background area.

The dome of the Apollo niche (space 1.09.1)

The dome of the Apollo niche contains stencilled designs as well as freehand animal images and figural ornamental

2 The Nordkuppelsaal: re-applied grotesque painting in the dome

3 The Nordkuppelsaal: cleaning of a genius painting in the dome

4 Apollo niche
(space 2.09.1):
restored dome

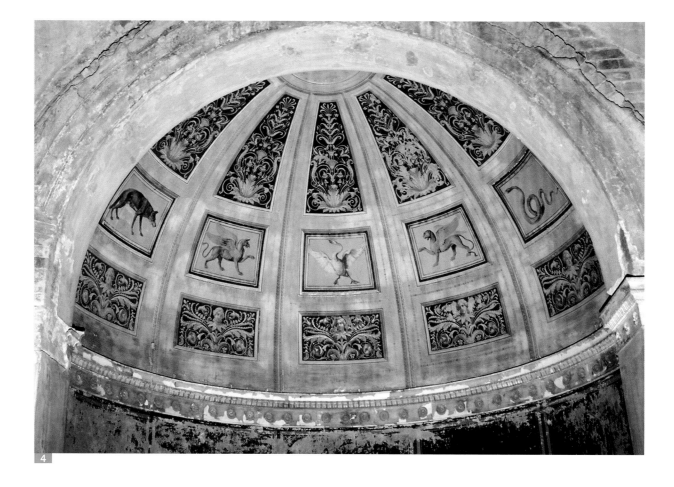

4

painting. It consists variously of casein tempera, resin-oil-wax paint and oil paint on lime-gypsum plaster. Nothing is known about the artists. The dome paintings survived in relatively good condition owing to their sheltered position. They required only a few stabilization measures carried out during an earlier restoration phase.

The Ägyptischer Hof (space 1.12)

The sole surviving wall paintings in the Ägyptischer Hof are paintings of famous Egyptian buildings and landscape scenes in resin-wax paint on lime-gypsum plaster on the east wall. The painters were Wilhelm Schirmer, Eduard Biermann, Carl Graeb, Eduard Pape and Max Schmidt. These paintings were relatively well preserved.

5

5 The Ägyptischer Hof (space 1.12): initial state of "Abu Simbel" wall picture

6

6 The Ägyptischer Hof: removal of wall picture "Steinbrüche von Selsele" in initial state

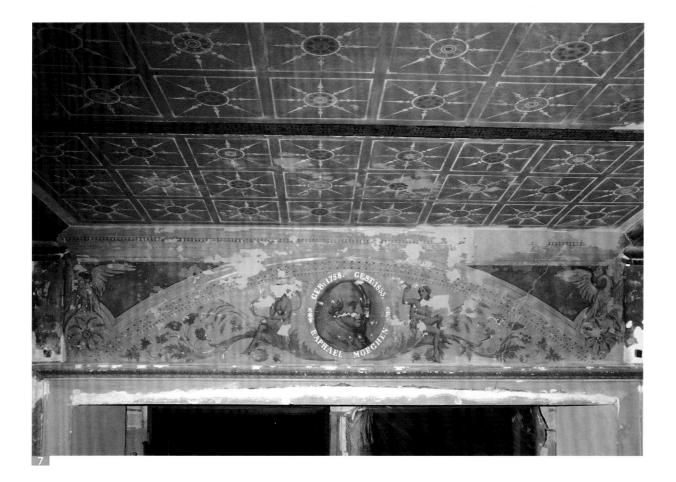

In addition to earlier securing measures, the paintings had previously been given a disfiguring grey overpainted layer. This was removed in some areas with the removal of the emergency lamination in 1996, although both are still present on the pictures. The viewer's aesthetic experience is disturbed by remains of the grey overpainting and the previous cleaning efforts. In the most recent restoration, the bonding of the pictures to the brickwork was improved, but the paint layer has not yet been cleaned.

The Roter Saal (space 3.11)

Above the windows of the Roter Saal, there are segmental arch-shaped lunette sections, stencilled and with illusionistic grisaille painting. A famous master engraver is depicted in the central medallion of each, surrounded by figural and floral ornamentation. The paintings were done in casein tempera. Three images on the west wall (Georg F. Schmidt, Robert Strange and Raphael Morghen) and one image on the east wall (Heinrich Golzius) have survived. Nothing is known about the artists.

Except for the total loss of the pictures above the northern portal, the wall pictures on the west wall are relatively well preserved. Here, the work mainly involv-

ed reducing layers of dirt, securing the paint layer and partial cementing and plaster repairs. Gaps in the painting were closed by retouching. The aesthetic objective was to largely integrate the gaps by carefully matched retouching in the background colour. Extensive salt reduction and plaster consolidation measures were also carried out on the picture on the east wall, which had survived in a fragmentary state and was irreversibly blackened. Only a lightened monochrome retouching in the background colour was applied for purposes of integration into the severely reduced wall picture stock of the east wall.

7 The Roter Saal (space 3.11): wall painting "Raphael Morghen": intermediate state during retouching

Special Subjects

WULFGANG HENZE

The Neues Museum has a large number of special features that make it different from other museums, but also distinguish it from other architectural monuments. This starts with the original choice and arrangement of the collections and exhibits. The king's architect, Friedrich August Stüler, defined the purpose of museums in his 1862 publication as both the *"enjoyment of beautiful works of art"* and conveying *"the clearest and most extensive view of the various art practices and epochs."*[1] Schinkel's "Altes" (Old) Museum served the enjoyment of art with its exhibition of ancient sculptures and Renaissance panel pictures, but the Neues Museum was intended to be educational and thus link up with the university institutes that were to be accommodated on the Museum Island according to the overall plans devised by Stüler and Ignaz von Olfers (Director General of the Royal Museums). In line with this, the most important collection in the Neues Museum was the plaster cast collection, which occupied the whole of the main floor.

The design principles also display a number of special features: Stüler realized a very wide range of ceiling forms in the Neues Museum. They ranged from the flat ceilings set on architraves in the Egyptian department, to coffered ceilings, barrel and calotte vaults and two different dome structures, culminating in the peak of vault development, a Gothic star-ribbed vault, though this could be executed only as a suspended wire-and-plaster structure. For the ceilings in the north section of the building, supported by bowstring girders, Stüler used a new ceiling support structure based on the tensile strength of iron, working to a theory devised by Building Academy Professor Carl Boetticher. Here Stüler co-operated actively with the mechanical engineer and cast-iron specialist August Borsig and with the engineer-architect Carl Wilhelm Hoffmann. A clear demonstration of Stüler's espousal of this architectural theory is the undecorated core shape of this construction principle in the anteroom to the Roter Saal (Red Hall).

But probably the most important feature of the Neues Museum is the use and development of the most modern technologies and construction techniques. Stüler mentioned the *"use of steam power to manage and lift heavy masses, and for preparing mortar"*[2] as a cost-reduction measure that would also speed up the building process. The building materials were transported in trucks on a kind of mine railway from the landing stage on the Kupfergraben to the wooden lift tower in the Haupt-treppenhalle (main staircase). Vertical transport was then by steam-powered lift, and further transport to the rigging positions was again by rail.

Numerous experiments were conducted to determine the strength of iron and the load-bearing capacity of the clay cylinder vaults and the iron ceiling structures, as well as the effects of heating with hot water. Innovative building materials and building techniques, which also needed some experimental work, were for example clay cylinders and light stones for the ceiling vaults, suspended wire-and-plaster ceilings, floor mosaics in dry-pressed compound earthenware, cement mortar, marble cement as imitation marble, smoothed stucco lustro and stereochromy (mineral colour painting).

Stüler's 1853 letter to the Upper Chamber of Finance in Potsdam, the Prussian state's financial control office, is typical of his attitude to the technical revolution:

"It should not go unmentioned either that while building the new museum extensive experimental work was carried out, in order to establish a view about new constructions and materials in general, or their particular application, or else to gain the necessary certainty about their special use in the new museum. No large building projects should refrain from the obligation to conduct such experiments in order to enrich their experience in building technology, for it is only here that the appropriate opportunities are offered.

What is more, new fabrications by significant builders, as soon as they prove themselves suitable to the purpose and promise widespread application together with cost reductions, should be supported by purchase even if the prices, because of the equipment needed and the acquisition of machines, initially exceed the true later value of the products."[3]

Removing Murals in the Vaterländischer Saal

WOLFGANG GÄRTNER | KARL-HEINZ PETZOLD |
JULIA FELDTKELLER

1 F A Stüler, Das Neue Museum in Berlin ,1862, part 1, p. 1
2 Stüler's audit to the Upper Chamber of Finance Potsdam of 21 June 1853,
 in Geheimes Staatsarchiv, Preußischer Kulturbesitz I. Rep. 137 II. H, no. 40,
 vol. 1, pp. 313 ff
3 Ibid.

The innovative nature of some manufacturing technologies of course meant occasional flaws in execution, and removing these was one of the challenges faced when rebuilding the Neues Museum. Another reason for unusual restoration techniques and the large number of them was that some rooms had been in ruins for decades, which had meant that surfaces were in quite different states of preservation. Restoration work ranged from conserving bricks and plaster that had been damaged structurally to reconstructive working techniques, in some cases using technology from the time of building.

The painted murals in the upper wall zones are part of the original decoration of the Vaterländischer Saal (National Hall). In 1988 and 1989 two of these murals were removed and transferred to a new support. Evidently the reason for removing them was that they were in particularly poor condition, which made it impossible to conserve them in the long term in situ. With the replacement of these murals, which had been under acute threat of decay, the preservation process was concluded. Since the removal of these two murals differed from removal processes for other objects, as did the replacement method that it occasioned, it will be described separately below.

"Urn Grave"

One of the two murals removed is the picture above the central doorway in the south wall. It is called *Urn Grave*, and was painted by Heinrich Bögel. A photograph taken of the removal process records the damage at the time. Over 50 % of the plaster supporting the picture had already been lost, and the remaining plaster had detached itself from the ground and was also threatening to drop off the wall.

The restorer who carried out the work, Yves Hessel, has provided a detailed written record of the removal and the work carried out subsequently. This explains how the plaster fragments rescued were reduced to a thickness of about 5 mm, fixed with synthetic resin and then fitted back together again to recreate the image on a bed of plaster reinforced with glass fibre. The restorer sealed the gaps with carefully matched plaster additions at a slightly lower level than the old stock, thus restoring the original format.

The sheet of plaster created in this way is 18-20 mm thick and is stable in its own right, not least because of the adhesive used, which contains plastic. It is not anticipated that the structure will change for the worse in conservation terms, and the quality of the restoration is convincing.

Both of these facts suggested that the painting should also be reinstalled in this form. The position was clear because of the niche at the edge of the image. The plaster sheet is attached with four screws. The joint running round the image was covered by the stucco frame.

1 Carl Wilhelm Hoffmann: Nachricht ueber die beim Bau des Neuen Museums angewendete Vorrichtung zum Auffahren der Materialien namentlich der Mauersteine, Werkstücke und Bauhölzer. *From: Notizblatt des Architekten-Vereins zu Berlin, 21 (1843), pp. 89 ff.*

1 Wall painting "Herta und Odin". The fragment was put back in place in two pieces after removal of the safety covering which had been stuck over it for transfer purposes. *Photo: Karl-Heinz Petzold*

In restoring the painting, a solution had to be found above all for the extensive area missing in the middle of the picture. As the central elements of the image were missing, it was not possible to understand either the iconography of the image itself nor the way in which it linked up with the lunette pictures on either side. The sequence of three epochs of early history – the stone, bronze and ice ages – was interrupted and the original idea of the mural programme of relating the exhibits in the gallery thematically thus only achieved the intended effect to a limited extent. In order to reveal the complex links in subject matter, it was decided that the restoration concept for the murals should not be applied in this case. Rather than completing the missing pieces in some neutral way, the *Urn Grave* was to be reconstructed in simplified form. The missing elements of the image were supplied in the form of a delicate grisaille painting. Photographs taken in the early 20th century and the digital manipulated versions of these produced by David Chipperfield Architects (DCA) served as a model. This

meant that the fragment could become part of the mural programme for the Vaterländischer Saal again, without having to conceal the reduced state in which the picture had survived.

"Herta und Odin"

Gustav Heidenreich's mural *Herta und Odin* required a different reinstalment procedure. It had been removed from the south field in the west wall in two parts, and had suffered much more complex damage. Both the plaster and the layer of paint had been attacked by minerals salts and damp and were separating from each other at different levels, which caused distortion of the picture surface, to a considerable extent in some cases. There were also small excrescences and large missing areas. The person responsible for removing the fragile remaining substance was Hartwig Pommer.

The mural as a whole was stabilized by placing it on a new support. However, it was necessary to add a layer of plaster to the back of it that was up to 35 mm thick in

2 Wall painting "Herta und Odin". Extensive retouching and reconstructed framing lines reconnect the fragments to form a whole picture. *Photo: Karl-Heinz Petzold*

3 Wall painting "Urnengrab". To restore the thematic connection, the image was reconstructed in grisaille painting based on old photographs. *Photo: Peter Thieme/BBR*

places. The timber structure that was additionally attached to the back turned out to be substantial in proportion to the dimensions – about 4 m² in each case – and weight of the two halves – each about 200 kg.

The secondary supports mentioned had to be removed prior to reinstalment. After several layers of securing material had been attached on the picture side to take over the support function, the timber sections were removed. The plaster could then be reduced to a thickness of about 10 mm. Given that the damaged areas overlapped, it was scarcely possible to get rid of the distortions. Regaining a flat picture surface was sacrificed in favour of preserving the material.

The removed panels, now thinner, were mounted on the wall, still secured on the picture side; their precise position had been established in advance. A mineral adhesive mortar was used for fixing. Pressure was exerted using a timber lath construction. This was attached to the wall by threaded rods and then the pressure exerted was adjusted appropriately. Once the mortar had hardened, the temporary support could be removed from the front. The rest of the work on this mural was done following the restoration concept used for the whole mural cycle.

Mineral Reduction for the Nordkuppelsaal

WANJA WEDEKIND | ANNETT BAUMEISTER | LARS SCHELLHASE

One of the most impressive spaces in the Neues Museum is the so-called Nordkuppelsaal (Northern Domed Hall). It was originally called the Greek Gallery, and has an octagonal dome about six metres high. It is a self-supporting brick structure consisting of eight large curved sections culminating in a round aperture, a skylight. These sections are broken down in their turn into richly stuccoed coffers. The coffer panels are decorated with putti and winged geniuses.

In 1875, 20 years after the museum was completed, the skylight aperture was enlarged to improve the lighting. The glass elements in the skylight and other parts of the roof were destroyed in the Second World War. The Nordkuppelsaal, like the rest of the ruined museum was exposed to the elements unprotected for years.

1 The sprinkler device structure in a dome segment.
Photo: Carsten Hüttich

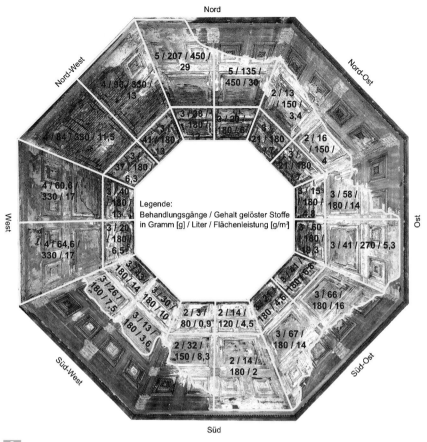

Nord

Nord-West

Nord-Ost

West

Ost

Legende:
Behandlungsgänge / Gehalt gelöster Stoffe
in Gramm [g] / Liter / Flächenleistung [g/m²]

Süd-West

Süd-Ost

Süd

5 / 207 / 450 / 29
5 / 135 / 450 / 30
4 / 96 / 350 / 13
2 / 13 / 150 / 3,4
3 / 38 / 180 /
2 / 20 / 180 / 6
4 / 84 / 390 / 11,5
4 / 180 /
3 / 180 /
21 / 180 /
2 / 16 / 150 / 4
37 / 180 / 6,3
3 / 180 /
21 / 180 /
4 / 60,6 / 330 / 17
3 / 40 / 180 /
3 / 15 / 180 /
3 / 58 / 180 / 14
3 / 20 / 180 / 6,5
3 / 60 / 180 /
3 / 41 / 270 / 5,3
4 / 64,6 / 330 / 17
3 / 26 / 180 / 14
180 / 7,5
3 / 30 / 180 /
3 / 180 /
3 / 66 / 180 / 16
3 / 13 / 180 / 3,6
3 / 10 / 180 /
2 / 37 / 80 / 0,9
2 / 14 / 120 / 4,5
180 / 4,8
2 / 32 / 150 / 8,3
3 / 67 / 180 / 14
2 / 14 / 180 / 2

2

The surviving murals were removed in the 1980s, put in store and replaced in the course of the current restoration work. In future, this central gallery will house the world-famous bust of Nefertiti.

Taking stock

The structural surfaces of the dome were in very different states when restoration work started. It was possible to establish the following by assessing the damage mapped in terms of quantity: 27 % of the surface of the dome was largely undamaged; the paintwork was lost on about 26 % of the surface, but the light-coloured fine stucco and plaster had largely survived; 17 % of the surface had weathered back to the coarse sub-layer of plaster; on about 30 % of the dome surface the masonry was visible. Here the original decoration was completely lost or had been removed as a precaution.

Mineral efflorescence was detected in large areas of plaster that had often fallen victim to the elements. Mineral salts detrimental to the structure, dislocated adhesive, damp penetration and frost splitting were identified as the principal causes of damage to the plaster and stucco.

The greatest degree of damage was to be found on the west and northwest sides of the dome. Here the original

stucco decoration had weathered away completely, and the brick structure completely exposed, apart from a small quantity of surviving mortar. The damage to this area can be explained by the prevailing wind and rain from the north-west. Even a provisional roof structure added in the 1980s – when restorers had already recorded and described the serious damage – failed to offer adequate protection (fig.1). The best-preserved surfaces are to be found on the lower south-western and north-eastern coffer fields (fig.2).

Before the demineralization treatment began, the various historical building materials were examined in terms of their water-absorbing capacity. Here it was particularly important to establish the so-called water absorption coefficients, also know as a w-value.

The original bricks used in the lower section of the dome are of average porosity. The bricks used in the area of the upper coffer fields towards the skylight aperture are considerably lighter and more porous, so they can absorb four times the quantity of water. Here a much harder mortar, with some hydraulic components, was used that has organic elements as well. It was probably a type of cement mortar. The stucco, made of lime-gypsum mortar, lies roughly between the two brick varieties in its water absorption coefficient.

Most of the mineral efflorescence was on the upper coffer fields in the east and the lower coffer fields in the west area of the octagon. This was subjected to photo-spectrometric and X-ray diffraction (RDX) tests to determine the mineral types and their distribution in the depth profile, and the mineral efflorescence recorded in the damage charts. The results showed that the minerals were mainly sodium sulphate ($[Na_2SO_4]$, with smaller proportions of calcium nitrate $[Ca(NO_3)_2]$.

Demineralization measures

The sprinkler process was used to reduce the minerals. This was developed to demineralize the tomb façades in Petra, Jordan. It has been successfully used in recent years on numerous individual items and façades, for example the Franciscan Monastery Church in Zeitz, the tombstones in the Bartholomäus cemetery in Göttingen and the Baroque church of Santa Mónica in Guadalajara, Mexico.

The sprinkler process uses a system of hoses and atomizers arranged in a grid pattern to spray the surface with water (fig.1). The porous mineral material absorbs liquid by capillary transport mechanisms. Excess water runs off the surface, is caught in a drainage system and tested for its electrical conductivity. These readings provide informa-tion about the ion content – the dissolved materials con-tent – in the eluent.

2 View into the north dome with treatment results. *Basis for photo: David Chipperfield Architects*

The highest concentration of dissolved matter occurs at the beginning of the sprinkling process. During the subsequent drying phase, the moisture and the minerals dissolved in it are transported to the surface of the material by capillary action. As the treatment proceeds the concentration steadily decreases, gradually settling down to a certain level. The concentration of dissolved matter in the first few litres of captured eluent increased clearly at first in every new sprinkling sequence, but as a rule did not rise as high as at the start of the previous run. At the end of the treatment the measured values stabilized, but were mostly still higher than those of the tap water used for the sprinkling.

In the case of the dome, depending on the size of the areas being treated, 60 litres of water were used per sprinkling run for the upper coffer fields, and about 100 for the lower, larger fields.

The desired penetration depth of the water can be controlled by the length of the sprinkling run, taking the w-values of the materials treated into account. The desired depth could be determined in advance from the mineral distribution results in the depth profile. The sprinkling was repeated cyclically, after drying, up to five times.

Areas in which the original painting had survived were not treated. The two areas were sealed off from each other with clay, and the water captured in plastic foil flashing.

The sprinkling caused mineral efflorescence on individual areas of the dome, often after the second run. Here the west area of the dome vault was most severely affected. The efflorescence was concentrated in areas of the surface that had already been damaged and meant no loss of original building stock. The sprinkling also caused fungus to grow along the topmost coffer zone, and this had to be removed by treatment with fungicide.

To make the results comparable, the quantity of water was related to the surface of the dome. During individual sprinkling cycles a tendency was noted for a slight increase to occur after the clearly reduced electrical conductivity at the end of the treatment. This indicated partial dissolution of adhesive from mortar and stucco. This assumption was confirmed by random samples of the eluent as it ran off. The first readings showed comparatively high nitrate (Na) and low sulphate (SO_4) values. The readings were taken with a portable photo-spectrometer and an ion-selective glass membrane electrode.

Evaporating eluent specimens established the quotient of actual mineral content and electrical conductivity using linear regression. In this way the quantities of salt extracted could be established approximately after the minerals that had been dissolved out had been removed from the tap-water used.

Evaluation of all the results showed that approximately 1500 g of mineral salts had been dissolved out of the vault surfaces. This means between 1g/m² and just under 20 g/m², depending on the degree of contamination in the surfaces treated. Overall, approx. 6,800 litres of water were used for the process. The largest quantity of substances by a long way came from the north area, and the smallest from the south. By way of quality control comparative deep bore dust tests were conducted, which showed significant mineral reduction.

Today the dome appears in reduced reconstruction form, restored to match the damage pattern. Both the former glory of the dome architecture and the story of its suffering and decay can be read here.

The Wire-and-Plaster Ceiling in the Bernwardzimmer

WULFGANG HENZE | PETER FRIESE | ANDREAS PROTZ

Of the two wire-and-plaster ceilings originally constructed in two smaller rooms in the Neues Museum, only the one in the Bernwardzimmer (Bernward Room, space 2.05) has survived in fragments in situ. These remains provide evidence of the earliest use of this technique in North Germany. The ceilings and the flaws in their execution document the difficulties involved in introducing a new process in the era of technical revolution in Prussia's building industry. The wire-and-plaster ceiling in the

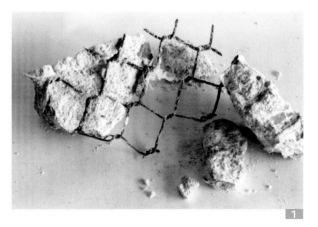

1 Electrochemically re-alkalized sample pieces. The violet coloration around the iron wires marks the re-alkalized areas. *Photo: FEAD GmbH*

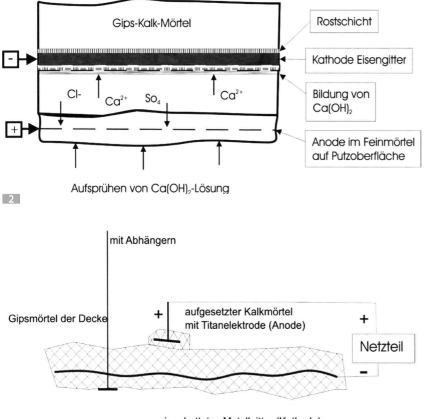

Gips-Kalk-Mörtel

Rostschicht

Kathode Eisengitter

Cl- Ca²⁺ SO₄ Ca²⁺

Bildung von Ca(OH)₂

Anode im Feinmörtel auf Putzoberfläche

Aufsprühen von Ca(OH)₂-Lösung

mit Abhängern

Gipsmörtel der Decke

aufgesetzter Kalkmörtel mit Titanelektrode (Anode)

Netzteil

eingebettetes Metallgitter (Kathode)

spanned by a vault between whose wrought-iron ribs the vaults are made from woven wire with a layer of plaster two inches thick. As is well known, the domed vault above the older chamber of the Chambre des Députés in Paris was constructed similarly [reconstruction of the Palais Bourbon, from 1828 by Jules de Joly], and also the coffered ceiling of the Walhalla near Regensburg [1830–32 by Klenze]."[1]

It was not until 1978 that the Berlin master-mason Carl Rabitz was awarded the first patent for wire-and-plaster for the manufacture of a "fireproof ceiling plaster under timber beams"; here the square wire mesh was tensioned by a winch. He used squeezed haired mortar as rendering. This meant that two essential improvements had been made to the technique used in the Neues Museum, and wire-and-plaster ceilings became a standard technique bearing the name Rabitz ceilings.

Wire-and-plaster in the Neues Museum

The construction of the wire-and-plaster ceiling in the Sternensaal, inspired by a Gothic star vault, was documented in some detail in 1847. Given that the technique was so new, the amount of work needed and the materials used were noted precisely for purposes of cost estimation and so that the experience of working with this technique could be passed on to other people.[2]

However, there is no precise record of the time when the wire-and-plaster ceiling in the Bernwardzimmer was constructed. But it must have been completed by 1850 at the latest, as that year a report was issued on the ceiling painting work on the second floor. The mortar casting technique used for the Sternensaal ceiling was not an option for the simple vault in the Bernwardzimmer, as the wire-and-plaster ceiling here was suspended very close to the shell ceiling. The load-bearing structure consists of flat iron arches about 1 m apart, to which the wire mesh was fixed. The builders' lack of experience shows in the way this work was carried out. They did not manage to tension the expanse of wire mesh, which must have made squeezing out and applying the plaster very difficult. This was simply because a wire with a hexagonal mesh was being used. The top side of the ceiling looks exactly like squeezed mortar, with the pattern of the wire mesh standing out clearly. The layers are built up from top to bottom as a squeezed mortar layer, then a lower rendered layer in gypsum-lime mortar, and the plaster skim layer, a maximum of 5 mm thick, which forms the support for the painting, in a smoothed and highly compacted lime mortar with very fine sand added, and a high proportion of adhesive. The wide range of mortar compositions shows that the technique had not been

Sternensaal (Star Hall) was destroyed, and the few surviving surface fragments were built into the reconstructed ceiling, which follows the original form.

The actual ceiling in the Bernwardzimmer, three massive vaults, has a static function, working against the thrust of the seven ceiling vaults in the neighbouring Moderner Saal (Modern Hall). The suspended ceiling, on the other hand, has a design function: in both form and decoration it repeats the ceiling vaults in the Moderner Saal, and its effect is carried over into the Mittelalterlicher Saal (Medieval Hall).

From wire-and-plaster to the Rabitz ceiling

Wire-and-plaster ceilings introduced a deceptive element into architecture: the surface of a light structure resembling a stage set conceals the real ceiling required by the statics of the building. Such ceilings create a design level that is in no way connected with the actual covering above the room (with the exception of the suspension points).

This technique was first used in North Germany in the Neues Museum, though examples existed in other countries, particularly in France. Stüler wrote in an 1862 publication: "the polygonal gallery for ecclesiastical objects [the Sternensaal], given the lack of adequate abutments, was

2 Test procedure for electrochemical re-alkalization of iron grid. *Illustration: FEAD GmbH*

3 Wire-and-plaster ceiling with system for long-term cathodic protection. *Illustration: FEAD GmbH*

mastered, and experiments had been done to find the best composition for the mortar. There are many patched areas and repairs. These problems are not mentioned in the written records.

Recarbonation and cathode protection

The wire-and-plaster ceiling in the Bernwardzimmer was very badly damaged in the war. Rainwater running in through the open ceiling had caused heavy corrosion in the iron mesh. As the bedding mortar is gypsum-based, ferrous sulphates had also formed, and their hygroscopic properties meant that the corrosion process persisted on a permanent basis. When conserving the remaining areas of ceiling, the problem arose of putting a stop to the continuing corrosion of the iron mesh. The aim was to remove the layer of ferrous sulphate from the mesh without taking off the mortar and cleaning the iron mechanically. Laboratory tests on abandoned pieces of the wire-and-plaster ceiling showed that it was possible to remove the sulphate from the immediate vicinity of the corroded wire and to create a protective alkaline milieu for the iron.

To do this, the iron mesh was set to be the cathode, and grids of V2A steel were applied to form the anode by pressing them on from below with viscose sponges. The whole arrangement was regularly sprayed with $Ca(OH)_2$ solution, in order to make sufficient load carriers available. In the adjacent electrical field the negative-charge sulphate ions move to the anode (external grid), and calcium hydroxide accumulates in the immediate vicinity of the wire mesh. Monitoring tests showed that now more soluble ferrous sulphates were present in the immediate vicinity of the rusty iron grid.

As the suitability in principle of the process had been proved by lab tests on different scales, the whole of the ceiling that was still in position (about 20 m²) was

4

treated in this way. The arrangement sketched in fig. 3 was chosen for this treatment of the full wire-and-plaster ceiling.

Before fitting the anode system, the wire-and-plaster ceiling was moistened lightly by spraying on a calcium hydroxide solution. A stable stainless-steel grid served as the anode, and was at the same time used to press the intermediate layer (viscose sponge) against the surface of the wire-and-plaster ceiling. To prevent ferrous oxides formed at the anode penetrating the viscose sponge and reaching the wire-and-plaster ceiling, and possibly discolouring it, a thin layer of white lime hydrate was placed between the viscose sponge and the anode. The entire system was pressed against the surface of the wire-and-plaster screen by props, and kept continuously moist over a three-week period by spraying it with calcium hydroxide solution from time to time.

Even though the advancing corrosion of the wire mesh was certainly greatly checked by the electrochemical re-alkalization, there was still a risk that the wire-and-plaster ceiling could be soaked with condensation or spray water during the rebuilding and restoration work. To prevent this, a system for cathodic protection of the wire mesh was installed. (This is a method widely used to prevent corrosion in harbour facilities and ship's hulls.) To this end, a direct current was established and constantly maintained between an external electrode (anode) and the iron parts that needed protection against corrosion (cathode). Small expanded metal plates of platinated titanium approx. 5 cm² in size were used as anodes for the wire-and-plaster ceiling. They were attached to the upper surface of the wire-and-plaster ceiling with special mortar on a grid of about 25 cm x 25 cm and connected to each other electrically. The wire mesh and the supports were also connected electrically and set as the cathode.

In order to be able to respond to a raised moisture content and resultant extra corrosion during the building work, the current was constantly measured using a data logger and regularly analyzed. Renewing plaster mortar and the preset moisturization did indeed lead to a considerable increase in the current, but non-critical values were re-established over a period of three weeks. If current had not been passed through the ceiling there is no doubt that hygroscopic ferrous sulphates would have formed in this period, with subsequent corrosion of the inserted wire mesh. Once all the work was completed the wire-and-plaster ceiling was practically dry, so that the current flow was greatly reduced. Once the building is air-conditioned for use, the air humidity in the area of

4 Bernwardzimmer: detail of the wire-and-plaster ceiling.
Photo: Johannes Kramer / BBR

the ceiling should not to rise to more than 70%, so the system will no longer need to be in constant use.

1 F A Stüler, Das Neue Museum zu Berlin, Berlin, 1862, n.p.
2 Cost estimate for the cast star vault in Hall No. 1 in the third storey, 27 June 1847, in Geheimes Staatsarchiv – Preußischer Kulturbesitz, I. Rep. 137 II. no. 41, pp. 1–3

Galvanoplastic Copper Cladding for the Main Portal

WULFGANG HENZE |
GEORG J. HABER | MAXIMILIAN HEIMLER

Luigi Galvani accidentally discovered the phenomenon of frogs' legs twitching under the influence of electric current in 1791, thus giving his name to the early electro-chemistry, or galvanism. This unleashed "galvanomania" during which innumerable scientists, inventors, laymen and charlatans copied his experiments all over Europe, developed them further and published accounts, theories and postulations. Their number included people as famous as Alexander von Humboldt ("Experiments about the stimulated muscle and nerve fibres and postulations about the galvanic processes of life," 1797) and Alessandro Volta, who postulated physical-chemical causes for Galvani's discovery as early as 1792. When water was broken down using electric current (by Sir Anthony Carlisle and William Nicholson in London in 1800), the discovery of electrolysis, galvano-technology slowly started to develop. Johann Wilhelm Ritter from Jena reconstructed the water breakdown experiments (also in 1800) and established that copper is deposited by passing electric current through copper sulphate. And still in the same year, William Cruikshank described the cathodic separation of sodium by the electrolysis of a cooking salt solution. In 1805, Lodovico Gasparo Brugnatelli gilded a silver coin galvanically for the first time. Sir Humphry Davy of the Royal Institute in London broke down a potassium hydroxide melt electrolytically in 1807, presenting potassium for the first time, followed by other alkaline and alkaline earth metals. This was again followed by a plethora of publications and descriptions of experiments, theories about electrolysis and, of course, quarrels about who made which discovery first.

Michael Faraday expounded the basic laws of electrolysis in 1832, and created the nomenclature that is still valid today (electrolyte, electrodes, cathode, anode, ion, anion, cation). Technical exploitation still lagged well behind all this intensive and complex theoretical discussion about electrolytic processes. In 1836, John Frederick Daniell, professor at King's College London, developed the first constant galvanic element with a zinc anode in zinc sulphate solution and a copper cathode in a copper sulphate solution, with the two half-cells separated by a diaphragm. Warren de la Rue described as early as 1836 how copper separated on to the cathode of a Daniell battery adapted perfectly to its shape.

The same observation was made by Thomas Spencer, a Liverpool entrepreneur and by Moritz Hermann Jacobi, professor of civil architecture in Dorpat (now Tartu). Both are frequently mentioned in the same breath as the inventor of galvanoplastics. Jacobi produced his first galvanoplastic copy in 1837. In 1839, having taken up an appointment in St. Petersburg, he published his findings in the *Philosophical Magazine*, a London periodical with a long tradition, and then finally in 1840 in his book *Die Galvanoplastik*, published in St. Petersburg. Jacobi's galvanic apparatus worked on the principle of the Daniell element: a vessel filled with dilute sulphuric acid, fitted with a pig's bladder as a diaphragm on its underside and containing the zinc anode, was plunged into a vessel containing the shape to be coated with copper in a concentrated copper sulphate solution as cathode. Its surface was made conductive with a metallic coating. Anode and cathode were connected. The diaphragm was intended to be placed about 5 cm from the mould, as evenly as possible, which meant that it was not actually possible to make full sculptures by this method.

Jacobi's publications now pushed galvanic technology ahead, and it developed into a new branch of industry within a very few years. Initially, three techniques emerged: the manufacture of figures, ornaments etc. as the product of solid galvanic deposits (usually copper) – galvanoplastics; thin galvanic deposits of other metals, e.g. silvering and gilding – galvanostegy; and the manufacture or duplication of printing plates – galvanography. The best-known firms, albeit ones mainly concerned with galvanostegy, were Charles Christofle in Paris and George Richards Elkington in Birmingham. Werner Siemens was granted a patent for galvanic gilding and silvering in Prussia in 1842, and sold it to the Berlin new silver manufacturers Gebr. Henigger.

Probably the first person in Berlin to carry out galvanoplastic work on a larger scale was Eugen Feodor Freiherr von Hackewitz (1809–1861). He founded a

galvanoplastics business in 1844, under the auspices of Friedrich Wilhelm IV. The same year he supplied the Allgemeine Deutsche Gewerbeausstellung (General German Trade Exhibition) in the Berlin Zeughaus as well as the art exhibition that took place at the same time in the Academy building (Marstall) with a wide range of galvanoplastic products. *"Among objects on show, there is no doubt that the bust of His Majesty the King created by the galvanoplastic method, along with the 4-foot-high column and plinth are the most magnificent of all the galvanoplastic work that has been seen here to date. The thickness of the copper deposit and the manufacture of the statue in hollow form justify the hope that with continuing experiments the exhibitor will also succeed in presenting completely free statues by galvanoplastic means, and that galvanoplastics will satisfy all the demands made upon it in the most outstanding fashion."* Apart from Hackewitz, only the Braunschweig press bookshop Friedrich Vieweg und Sohn showed galvanoplastic work, in this case mainly devoted to the duplication of woodcuts and copperplate printing plates.

In 1848 the "Verein zur Beförderung des Gewerbefleisses" (Association for the Promotion of Trade Diligence) gave an award to a galvanoplastic figure from Hackewitz's Institute that had been submitted as a competition entry in 1847. The robed female figure was about 30 inches high (785 mm) and prefabricated in high galvano in five individual sections and also put together by a galvanic process, so it did not exactly fit the competition brief – creating a complete, hollow sculpted figure by galvanic methods. Freiherr von Hackewitz's Galvanoplastic Institute suffered from the events of the March revolution in 1848, and Hackwitz retreated to Western Pomerania.² Before selling the workshop to a certain Julius Winkelmann, who used to be his foreman, he had had 80 employees. They initially continued to run the Hackewitz workshop at 46 Reinickendorfer Strasse, and it soon went under the name of the "Royal Galvanoplastic Institute."

In 1850, he put in a bid for the cladding of the main entrance door of the Neues Museum,³ and this was completed in 1852. Some of Winkelmann's work has survived in Potsdam: for example, a colossal head of the Juno Ludovisi dating from 1849 in front of the north side of the New Orangery; the figure of Christ offering blessing in the atrium of the Friedenskirche, a copy after Thorvaldsen dating from 1951; and the figure of Meleager after an ancient statue, c. 1855, in the Sicilian Garden of Sanssouci Park.⁴

The best-known early galvanoplastic object is certainly the Gutenberg monument in Frankfurt am Main. Georg Ludwig Kress, who devoted himself to galvanoplastics in St. Petersburg from 1840 to 1845, at Jacobi's suggestion, created the three main figures for the Frankfurt monument, each about 3 m high, in high galvano between 1950 and 1853 – here too by depositing individual parts and then assembling them. Rudolf Christian Böttger, who taught physics and chemistry in the Frankfurt Physics Association, is also mentioned in the context of the Gutenberg monument and the development of galvanoplastic techniques.

After Werner von Siemens invented the dynamo in 1866, creating large galvanoplastic works became more effective. Starting in the 1890s, large series were produced, especially in the Württembergische Metallwarenfabrik. One obvious example of the technique, which then became widespread, is the copy of Schlüter's equestrian statue of the Great Elector in the Bodemuseum.

The main portal of the Neues Museum – existing fabric and findings

The oak doors have a framework and panel construction. The portal's outer surfaces are overlaid with galvanoplastic copper cladding with ornamental and figural decoration. The doors have a frame of smooth, rolled-copper base sheeting approximately 3.5 mm thick. This sheet-copper frame is surrounded by a doorframe also made of sheet copper. The frame sheeting on the door and the doorframe is soft-soldered at the back. It is also stabilized with riveted and additionally soldered brass angles at irregular intervals. The soldering joints are convex and plastered. On the outer edge, the door cladding is framed with leaf edging. This edging, which runs over a pedestal edge on the bottom side, is galvanoplastic with a pattern section length of 60 cm to 96.5 cm. The outer edge is soldered to the sheeting on the doorframe, and the inner edge is soldered to the frame sheeting on the door. The inner edge is additionally riveted to the frame sheeting on the door at intervals of 110 to 150 mm. A plate is affixed to the left-hand door. Like the outer frame on the portal doors, the cleat is galvanoplastic. It is moulded with leaf decoration and was mounted using rivets and soldering.

Each of the portal doors has five separate sculptural reliefs created from copper electrotypes. These different-sized relief panels were each galvanized whole in an acid copper bath. Cast-brass astragals accompany the leaf edges of the frame. Brass screws on the undersides of the astragals give them a better anchorage in the galvanic layer. The relief's galvanically precipitated copper layers are 1.0 to 2.0 mm thick. The galvanic precipitation on the relief has a fairly even thickness, but it is thicker on the raised parts than the deeper parts. This is why tin-lead solder was generously applied on the rear side to stabilize

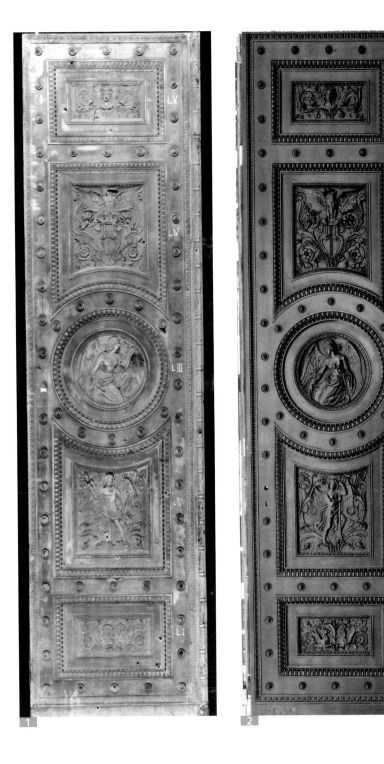

these weak points and the mouldings. Some of the figures also have soft-soldered tin/lead poured on the back to stabilize them. In places, traces of rosin cement from mounting and fine metal chasing work on the electrotypes remain.

The reliefs were set into the recesses in the door cladding and soldered around the edges. They were additionally fixed on their reverse sides using soldered-in brass threaded rods, copper-plated iron clamps and brass nuts. The copper cladding was mounted on the oak timber core with hidden screw connections involving 123 rectangular iron base plates, each with a projecting threaded rod, screwed to the wooden core. After the copper cladding, with positioned drilled holes, was applied, 123 decorative rosettes on the outer side made from copper-plated cast brass were used as nuts to screw the cladding to the wooden doors.

Surface treatment/patination/conservation

From the results, it was clear that the whole of the doors' copper cladding had been galvanically copper-plated a second time after the electrotype reliefs were joined to the base sheeting, as damage in the smooth areas showed the thicker base sheeting beneath a thin copper skin. The copper-plating was intended to hide the soldering seams and other construction marks and serve as a base for the uniform red-brown bronze patina finish. This surface treatment has been largely preserved beneath the top layer of dirt and corrosion. As described by Friedrich Adler, the finished copper cladding was "bronzirt."[5] However, no details of this process were given. There is no evidence of a transparent top finish layer (of, for instance, beeswax or varnish) to complete the surface treatment, although there probably was one originally.

Damage profiles

After the Second World War, both doors were stored inside the Neues Museum in sometimes very unsuitable conditions. This led to damage to the wooden inner construction and to encrusted corrosion layers forming on the copper surfaces. The bullet holes show that the corrosion and encrustation developed after the war, that prior to this the doors' metal surfaces were cared for. Inexpert storage of the doors led to deformation of the copper cladding, caused by warping of the oak part of the doors. These deformations led to cracks in the soldered joints and segments becoming covered with copper. Transporting the doors led to further deformations and cracks in the copper skin. Both portal doors have bullet holes and other projectile damage to the copper cladding. There was, however, no other damage

1 Stationary wing of entrance portal: initial state, 1998.
Photo: Haselau

2 Moveable wing of entrance portal after restoration, 2001.
Photo: Haselau

to record, except for the broken beaded rod on the lower relief of the right-hand door.

Corrosion damage/patina

Both portal doors showed a comparatively thick encrusted corrosion and dirt build-up acquired during storage after the war. Interestingly, this patina was clearly separated from the original surface, which was only corroded in places. Around the undercut ornament and relief areas, however, the patina was thicker, with flaky deposits and encrustation. Specimen surfaces showed that these patina layers could be removed with comparative precision using scalpels and scraping knives, brushes and glass-fibre etchers to reveal the copper surface with its bronze patina tone preserved until storage. The relatively well-preserved electrotype surfaces beneath the corroded crusts suggested the portal cladding had previously been preserved. Red rust discoloration was due to corroding steel projectiles, although inexpert storage of the portals had also led to corrosion damage on the iron door fittings and mountings. The iron threaded rods and base plates that secured the copper fittings to the wooden core were heavily corroded, making the rosettes difficult to free.

Scientific tests

Scientific tests were performed by Prof. Dr. Josef Riederer at the Rathgen research laboratory in Berlin to answer questions about the manufacturing process, the materials used and how the damage had developed. Examination of the galvanic copper-plating on one of the pins securing the astragals showed that the copper content was almost 100%, typical for copper electrotype. Samples of the rolled copper sheeting turned out to be comparatively pure copper with low levels of lead and tin. Analysis of a solder sample from the underside of an electrotype relief showed that a tin/lead solder alloy with a low melting point had been used. Samples of the light green patina on the upper surfaces proved to be basic copper sulphate/antlerite, a typical corrosion product for copper and bronze surfaces exposed to the elements.

Securing and transferring the copper cladding

The portal doors' copper cladding was removed from the door surfaces by carefully loosening the rosettes in its surface and the wood screws in the surrounding doorframe sheeting. For the next stage, two exactly fitting steel moulding constructions mounted so as to turn around an axis were developed, to which the unstable metal cladding could be transferred to be restored on both sides.

Revealing

The surfaces of the frames (rolled sheet metal with galvanoplastic decorative trim) and the de-mounted reliefs were cleared manually. The exposing work was varied, involving a mixture of methods matched to the state of each surface. The first phase was to thin the corrosion layers down to the electrotype surface and its red-brown patina using scalpels and specially adapted scraping knives. This procedure gave particularly good results for the smooth rolled-sheet-metal surfaces. So that the remaining thin patina layer was affected as little as possible, the fine work was done using glass-fibre etchers and fine grinding fleece. After preliminary work with the scalpel, the corrosion encrustation on the undercut areas of ornamented decorating strips and reliefs was further reduced using a micro-blasting machine and plastic granulate. Prior to the war the surface was largely revealed in this way. Where the original electrotype skin had been attacked by corrosion, the corroded crust was irreversibly bonded to the red-brown patina. The "bronzing" had also been destroyed by heavier corrosion on the edges of mouldings and in the recessed parts of the reliefs. The backs of the frame sheeting and electrotype reliefs were given a preliminary clean with brass brushes. Corrosion products and salt efflorescence along the old soldering seams were removed using the micro-blasting machine.

Sealing of bullet holes, cracks and gaps

The larger dents, buckled places and edge zones of bullet holes were carefully fixed, while smaller dents were left as traces of the doors' history. Exactly fitting pieces of sheet

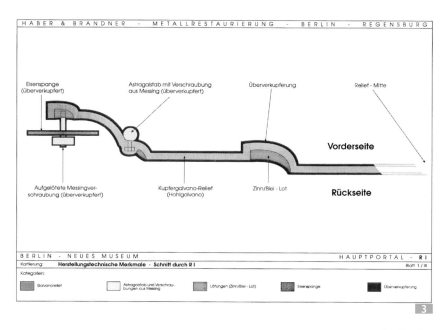

3 Mapping: characteristics of manufacture techniques.
Source: Haber & Brandner GmbH

copper were soldered into the gaps caused by bullet impacts. A soft solder with a low melting point was used so as not to endanger the many-layered electrotype skin. A copper-plated and patinated replacement for the missing astragal was cast in bronze based on the original model. Finally, the gaps in the surface were given an imitation patina and matched to the exposed red-brown patina's tone.

Installation

The galvanoplastic reliefs were set into the recesses in the base sheeting once more and fixed in with reversible metal adhesive. As they were originally, the relief sections had to be secured with new brass corrosion-resistant clasps and threaded rods made to match the construction. The badly corroded iron mounting plates set into the wooden core were replaced with new brass plates with brass threaded rods. Finally, the copper cladding was transferred to the oak doors, which had also been restored, and fixed in place.

Conservation

The Neues Museum's main portal also presented particular problems for conservation. The portal surfaces, created using the (at the time) entirely new artistic technology of galvanoplasty, had been given a "bronzed" finish to look like "real" cast bronze.

This was one reason why, after sampling, the project team decided to use micro-crystalline wax, long used for conserving in bronze restoration. The micro-crystalline

wax was applied to the warmed surface as an emulsion several times and compacted by rubbing down. The reverse sides of the electrotype reliefs and base sheets were also given a wax coating. Aside from reversibility and good corrosion protection, there were aesthetic reasons for this decision. Conserving with wax gives the main portal's metal fittings the characteristic slight metallic gleam of a carefully tended bronze surface, which was presumably Friedrich August Stüler's intention.

1 Amtlicher Bericht über die allgemeine Deutsche Gewerbe-Ausstellung zu Berlin im Jahre 1844, Berlin 1845–46, part 2, section 1, p.353, at http://www.digitalis.uni-koeln.de/gewerbeaus/gewerbeaus_index.html
2 From the family chronicle of Dilloo – von Hackewitz (1) 1800 to ca. 1860, at http://www.dillo.de/chroni1.html
3 Cost estimate dated 8 June 1850, in Zentralarchiv der SMB-PK, I BV 123, p. 105.
4 For the early manufacturing techniques for works of art in Berlin, see Haber & Brandner GmbH, Berlin – Neues Museum, Hauptportal, Dokumentation der Restaurierungsmaßnahmen an der galvanoplastischen Kupferverkleidung der Türflügel, April 2000, appendix 6
5 Adler, F., "Das Neue Museum in Berlin," in Zeitschrift für Bauwesen, Berlin, 1853, p. 28.

Ceiling and Architrave Papers in the Mythologischer Saal

THOMAS LUCKER

The Mythologischer Saal (Mythological Hall) on the Neues Museum's north-east ground floor was part of the Egyptian collection's exhibition room, displaying sarcophagi, mummies and burial offerings. In line with the principles of the building's design, the images on the walls and ceilings illustrated the themes of the presented exhibits. The ceiling and architrave papers that characterized the room were created in 1852 by Gebrüder Weidenbach from an overall design by Richard Lepsius, making them part of the Neues Museum's original furnishings. The astronomical calendar representations in yellow paint on a blue background on the ceiling paper are copied from burial chamber and temple ceilings from Thebes and Dendera. The paper on the architrave fronts of the pillar rows shows the gods of the hours and of the calendar in polychrome on a grey background.

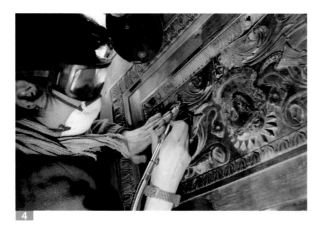

4 Removal of corrosion products and encrustation.
Photo: Haber & Brandner GmbH

First the bottom layer of paper and then the actual paper was glued to the supporting plaster. The distemper paintings on the primed paper background were carried out within the Neues Museum. A paste containing starch was used to apply the paper. While there is evidence of animal glue for the painted layer on the ceiling paper, the bonding agent for the architrave paintings was presumably casein.

The original plan was for all the ceiling and architrave papers to remain in situ during the rebuilding of the Neues Museum and to be conserved there. However, essential work on the Mythologischer Saal's whole ceiling construction in 2002 meant that the paper in this hall had to be removed and placed in temporary storage. In 2007, the RaO Technologie KG was commissioned initially to assess and modify the existing plan for restoring and replacing the paper and, after the new concept had been agreed, to carry out the work.

The initial state of the painted paper was very bad. The ceiling installed in 1936 left an irregular pattern of numerous gaps in the ceiling paper (holes made for the ceiling anchors). At this time, the architrave paper was entirely removed beneath the intermediate ceiling. Unfavourable climatic conditions and damp penetrating the building after 1945 severely damaged the fabric of the paper and the paint layer. There is also evidence of intermittent heavy fungal mould colonisation. The badly damaged paper only survived at all because of the stabilization campaigns carried out from 1991 to 2002 and the associated paint securing and disinfection measures. Securing paper was also applied over large surfaces of ochre painting on the insufficiently fixed ultramarine ceiling paper background. As all the paper was threatening to fall, it was secured with stays until its removal in 2002.

Based on the data available from scientific and restoration examination reports and records of measures already carried out as well as their own examinations and test sequences, the paper team was able to begin implementing a refined innovative approach to restoring and replacing the approximately 250 m² of ceiling and architrave paper at the end of 2007 after a relatively short planning phase.

Work was divided into three phases. After several weeks of preparation in the workshop, these could be carried out simultaneously. The cleaning, treating with biocides and securing of paint layers on paper fragments took place in the workshop. When all the fragments of one of the Mythologischer Saal's five ceiling sections had been restored, they were reinstalled. The facings were then removed immediately. Finally, the gaps were filled in with precisely shaped coloured paper, and the repairs to the paper were retouched to finish.

Earlier investigations of microbe contamination and possible toxins in the material showed no evidence of health risks associated with the paper. When, in spite of

1 View of the Mythologischer Saal ceiling before the paper was removed, 2004. *Photo: ProDenkmal GmbH*

2 Detail of the ceiling before the paper was removed, 2000. *Photo: Steinhart*

this, restorers presented with symptoms during initial work, protection measures such as the wearing of protective suits with an air supply were immediately taken. Several laboratories' further investigations into contamination of the paper found largely non-viable fungi, which probably caused allergic reactions in the team, particularly during the dry cleaning, which produced a lot of dust. The subsequent securing work bound all harmful dust-borne substances, ensuring that there would be no danger involved in replacing the paper or for subsequent users of the museum. After adhesive remains had been removed from the undersides, all paper and other materials used were additionally treated with biocides to prevent reactivation of dead biomass and renewed contamination.

The conservation focused on securing and fixing the ultramarine and grey backgrounds, which were only weakly bonded to their supporting papers. Their bonding was also weak within the paint layers. This had to be done before the securing paper laid over the background pieces could be removed. Owing to the largely overfixed ochre painting on top of the blue paint layer, treating the face of the paper was not possible. Soaking the rear side of the paper with isinglass and then levelling it on the low pressure table mobilized old securing agents, thereby reducing the surface tension. Taken as a whole, this sufficiently secured the background. One positive side-effect was the significant reduction of surface dirt, as the mobilization of old securing agents led to some dirt particles that had been trapped by them in the past sinking deeper into the paint layers.

Reinstatement involved laminating the pieces of paper on the rear side and laying them on a frame spanned by a sheet of film. The lamination served as an intervention layer between the ceiling and the paper support. Measuring marks on the ceiling sections and architraves allowed the paper fragments to be positioned exactly. They were glued using tylose and wheat starch in a 1:4 ratio. The regular grid of damage marks on the ceiling detracted unacceptably from its overall aesthetic appearance. Gaps in the paper were filled in flush with the surface using monochrome coloured paper intarsia or pulped paper cement and matched to their surroundings by brushed retouching, which did not entirely conceal the earlier damage.

After the work had been completed, the ceiling and architrave paper once more had a uniform appearance, while the traces of ageing and previous interventions remained visible.

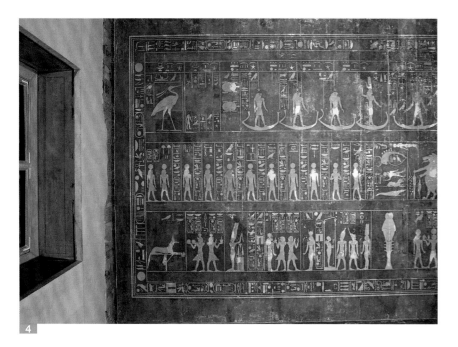

Marble Cement
(Door and Window Jambs)

JÖRG BREITENFELDT

When a restoration survey of the ruined Neues Museum was launched in the 1980s, the artificial marble used for the architectural articulation elements and the floors raised questions that were not cleared up in detail until a diploma thesis appeared in 1995.[1] In the course of further studies commissioned by the Bundesamt für Bauwesen und Raumordnung (Federal Office for Building and Regional Planning) at that time, and as part of the author's own research, it finally became possible to answer essential questions about the manufacture and technological and craft application of this special material.

These results were later to become part of the Neues Museum restoration concept, making it possible to opt for restoring all the marble cement surfaces in the Neues Museum faithfully to the original. Consequently marble cement came to be produced again as a construction material specially for the rebuilding of the Neues Museum. This is all the more remarkable, as the material had not been manufactured in the quality used in the museum in the mid-19th century since 1900 at the latest. Production of a related material was also abandoned in the 1960s (so-called marble plaster). And with the end of production, all the craft experience in working with it was lost as well.

In the year 2006, the company called Restaurierung am Oberbaum, working with the Berlin stucco firm Rost, was commissioned to restore and partially reconstruct all the marble cement wall surfaces in the Neues Museum, and to restore the floor incrustation tiles in the Niobidensaal. Approximately 40 restorers and stucco plasterers were employed in total on this restoration work over a period of almost two years. The work was successfully concluded early in 2009.

An early reference to the origins of marble cement is to be found in the memorandum sheet of the Architekten-Verein zu Berlin in 1842. According to this, the first attempts to produce the material were made in France in about 1838. The firm that had originally developed the material for the production of mosaic stones soon went bankrupt because of an "undue spirit of speculation".[2] Then later two patents were registered in England, presumably making this invention their own. The manufacture and use of the material is described in detail in instructions written in 1850: "[…] one treats plaster blocks as they come out of the kiln with an alum solution

[…] or stirs powdered plaster up with such a solution – and then fires it for a second time in the plaster kiln or in the crucible, until it is red hot. A persistent and even temperature is crucial here. – The plaster treated with alum and fired for the second time has a matt, milky-white or weakly biscuit-coloured appearance, and is easily pulverized. […] If the plaster flour is mixed with water, the water is bound in, but the product does not have any hardness to speak of. Hardening is only appropriately produced if the plaster treated with alum and fired is not mixed with water, but with an alum solution (containing 1/12 or 1/13 of alum). Plaster casts made by this method remain moist for a little longer, but take on a hardness comparable with that of alabaster and marble, and acquire a kind of translucence especially in thin parts and edges, which gives them the aspect of these stones. […]"[3]

At the same time as using the material imported from England (Keene's marble cement), the well-known Berlin clayware manufacturer Ernst March carried out successful experiments in copying the material. But the "Deutscher Marmorcement", as it came to be known, was not of the same high quality as its English counterpart. It looked more like ordinary stucco marble, as it lacked the deeply transparent quality. This material was also used for some parts (columns and pilasters) in the Neues Museum, for reasons of cost.

The first mention of the English marble cement in Berlin and Brandenburg was in 1843. Attention was drawn to this "new kind of cement" in a communication from J. B. White & Sons, a London marketing company. In a building document of the museum there is a set of

1 Detail of a marble cement pilaster in the Roter Saal before restoration, December 2006: Here the aim of the measures taken was to remove the later upper layers and to retain the aged and authentic surface of the material. *All photos: RaO*

2 Restored marble cement portal in the Roter Saal, November 2008

handwritten instructions for Keene's Patent Marble Cement used in the Neues Museum:[4] "This cement, which is harder than any other kind, is used only in the interior of the building, and is supplied in two qualities, coarse and fine. The fine variety is of a delicate white hue, and if treated appropriately can carry a polish as high as that of statue marble. [...] The coarse or second sort is used to decorate walls where particular strength and durability are needed. Using it instead of wood [for] cornices, architraves and panel casts or similar wall dressing is highly advantageous. [...]"[5]

Actually no other marble imitation material before or after matched the quality of marble cement. This makes it seem all the more regrettable that it was forgotten so quickly. Certainly using the material was a great challenge then as now, being very different from earlier experience and methods in the amount of effort needed.

As constantly shown in correspondence between the architect Friedrich August Stüler and his principal supplier C. Hagenest, problems occurred when using this English product. Even though it should be mentioned that the workers of the day had scarcely any practical experience of this special material, this was not the cause of all the problems.[6]

For example, the main problem was that stains appeared on the walls decorated with marble cement. This problem was never completely mastered, as can be seen from the original surfaces. As discovered during the current work as well, the stains mentioned by Stüler can be traced back to two factors that really cannot be controlled completely. One is that slight impurities (various metallic oxides) in natural raw plaster material and different grounds used are responsible for stains, and the other is that small structural deviations in the material that inevitably come into being when the craftsmen are working

the cement by hand cause different nuances, transparent effects and degrees of shininess.

Another example of questions that remained unresolved when the museum was built are the fine cracks formed in the material after a time. These are not ageing phenomena that appear for technical reasons, as was assumed even when the restoration was at the planning stage. We now know that the fine cracks must be counted as one of the special features, and that these are even one of the chief aesthetic characteristics of marble cement.

The restoration work in the Neues Museum itself aimed to tie all the necessary extra work into the existing stock, paying particular attention to the aged and authentic surfaces. This meant that a particularly careful and innovative working method was needed for the restoration and for additional structures, as not all craft techniques could be used to an equal extent because the original building stock had to be protected.

Overall, the restoration procedures used were extremely complex. Many questions about the best work-

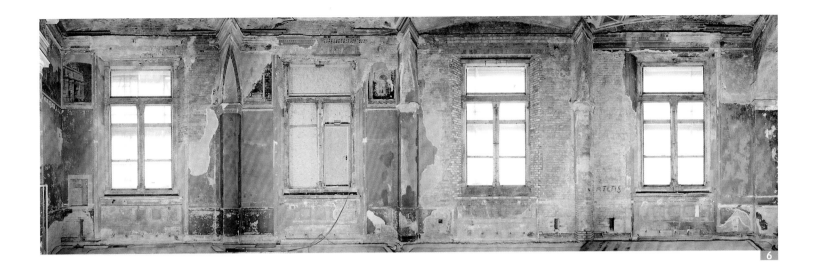

ing techniques and treatment of the material were not resolved until the practical work was actually under way. Time and again, new restoration processes and variants were tested and applied. Today, in the context of the restoration of the marble cement in the Neues Museum it is justifiable to speak of the rediscovery of a lost 19ᵗʰ-century craft and material technique.

1 J. Breitenfeldt: Der Marmor-Cement im Neuen Museum von Berlin. Eine spezielle Materialtechnik des 19. Jahrhunderts. Diploma thesis at the HAWK Hochschule für angewandte Wissenschaft und Kunst – FH Hildesheim, 1995.

2 C. Krefeler: Ueber gehärteten Gyps. In: Architekten-Verein zu Berlin [ed.], Notizblatt des Architekten-Vereins zu Berlin no. 1942, 1ˢᵗ ed., Berlin 1842, pp. 49–52.

3 Carl Hartmann: Die Kalk und Gypsbrennerei, so wie die Mörtel und Stuckbereitung nach ihrem neuesten Standpunkte, Quedlinburg/Leipzig 1850

4 See in: Acta der Bau-Commission des Neuen Museums über Marmor Cement, Geheimes Staatsarchiv Preußischer Kulturbesitz 1848

5 K. Klaener: Keen´s Marmor Cement. In: Acta der Bau-Commission des Neuen Museums über Marmor Cement, Geheimes Staatsarchiv Preußischer Kulturbesitz 1852, sheet 56

6 See in: Acta der Bau-Commission des Neuen Museums über Marmor Cement, Geheimes Staatsarchiv Preußischer Kulturbesitz 1848

6 East wall in the Römischer Saal before restoration: The marble cement panels were very badly damaged. The whole panelled area had to be completely removed and reinstalled during restoration. *Photo and photomontage of May 2006: RaO*

→ Photos pages 226 | 227:
Moderner Saal (Space 2.06) in January 2005 (with view to the top into the western Kunstkammersaal, Space 3.06) and in January 2009.
Photos: Johannes Kramer/BBR

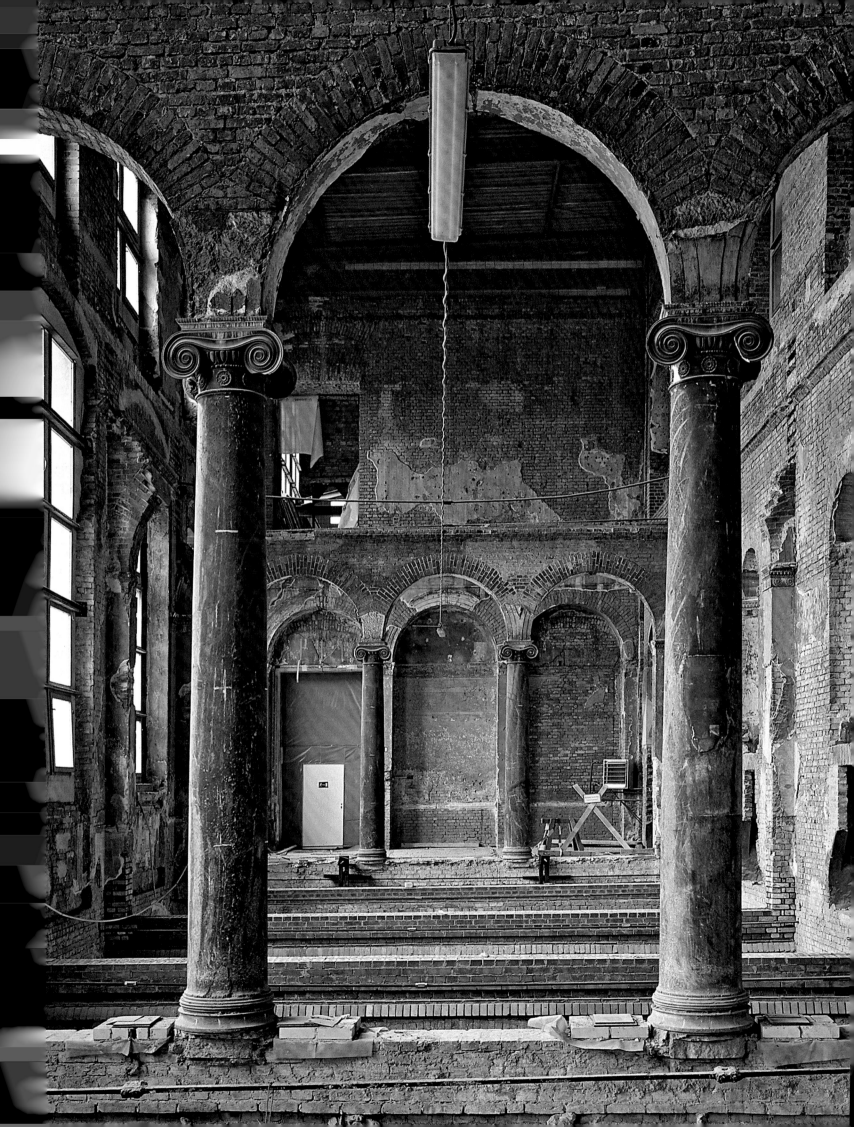

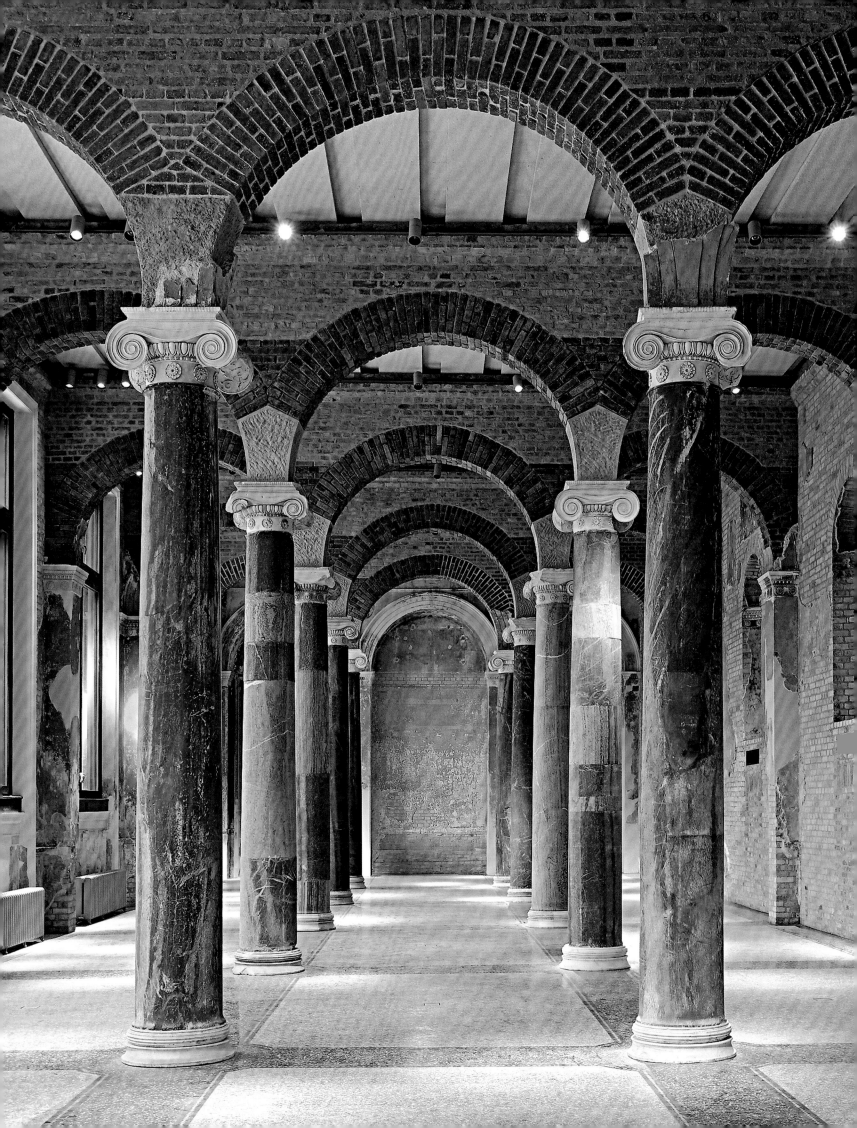

Authors

Peter Antonioli, master terrazzo and concrete block layer, project manager, Pätow-Steegen (p. 187)

Alexander Bankert, qualified restorer (UAS), Schildow (pp. 195–196)

Annett Baumeister, qualified restorer, Wandwerk GmbH, Berlin (pp. 211–213)

Peter Besch, civil engineer, project manager of ProDenkmal GmbH, Projektierungsgesellschaft für Denkmalpflege, Berlin/Bamberg (p. 126, pp. 147–148, 177–178)

Reinhard Böckenkamp, master craftsman, Terracotta OHG – Böckenkamp & Leistikow, Potsdam (pp. 188–189)

Jörg Breitenfeldt, M.A., qualified restorer, project manager, Restaurierung am Oberbaum, Berlin (pp. 223–225)

Michael Bruckschlegel, qualified restorer (UAS), project manager, Nüthen-Restaurierungen GmbH & Co. KG, Erfurt (pp. 160–161)

Max-Florian Burkhardt, stonemason, project manager of "Reconstruction Neues Museum – Stonework" on behalf of Schubert Steinmetz- und Steinbildhauer GmbH, Dresden (pp. 143–145)

Sonia Cárdenas, qualified senior restorer, ARGE Süd-West GbR, Michendorf (pp. 172–173)

David Chipperfield CBE, Professor, honorary Ph.D., architect, principal of David Chipperfield Architects, London/Berlin/Milan/Shanghai, professor at the Staatliche Akademie der Bildenden Künste, Stuttgart, and the Escuela Tècnica Superior d'Arquitectura, Barcelona (pp. 56–59)

Günther Dürr, free-lance restorer, Freiburg im Breisgau (pp. 154–155)

Gerhard Eisele, Professor, consultant engineer and expert on safety precautions for, and renewal of, existing and historic buildings, partner of Ingenieurgruppe Bauen, Karlsruhe/Mannheim/Berlin/Freiburg, professor of architectural monument conservation at the Potsdam University of Applied Sciences (pp. 82–89, 90–94)

Michael Eissenhauer, Ph.D., art historian, director general of the Staatliche Museen zu Berlin (pp. 8–9)

Julia Feldtkeller, Ph.D., free-lance art historian and restorer, Tübingen (pp. 154–155, 202–203, 209–211)

Michael Freytag, architect, team manager "Neues Museum – New Building", associate of David Chipperfield Architects, Berlin (pp. 136–137)

Matthias Friedrich, civil engineer and expert consultant, office manager of Thermische Bauphysik, project manager "Neues Museum" at Ingenieurbüro Axel C. Rahn GmbH Die Bauphysiker, Berlin/Hamburg (pp. 101–105)

Peter Friese, Ph.D. (rer.nat.), head of laboratory, FEAD GmbH (research and development lab for renovation of old buildings and monument conservation), Berlin (pp. 215–216)

Anke Fritzsch, architect, team manager "Neues Museum – Restoration", associate of David Chipperfield Architects, Berlin (pp. 151–153, 176–177, 190–191)

Peter R. Fuchs, Ph.D., archaeologist, Department of Archaeology, Landesdenkmalamt Berlin (Berlin Office of Monument Conservation) (pp. 44–47)

Wolfgang Gärtner, free-lance restorer, Berlin (pp. 154–155, 202–203, 209–211)

Katharine and Wieland Geipel, qualified restorers (UAS), Katharine & Wieland Geipel Dipl. Restauratoren (FH) GbR, Berlin (pp. 170–171)

Hermann Graser jr., stonemason and stone sculptor, restorer of stone carvings and sculptures, managing director of Bamberger Natursteinwerk Hermann Graser GmbH & Co. KG, Bamberg/Dresden/Potsdam (pp. 145–146)

Barbara Große-Rhode, qualified architect, head of the Museum Island project management section at the Federal Office of Building and Regional Planning, Berlin (pp. 50–55)

Ayten Güleryüz, restorer, planner and site manager, ProDenkmal GmbH, Projektierungsgesellschaft für Denkmalpflege, Berlin/Bamberg (pp. 119–120)

Georg J. Haber, Ph.D., restorer, executive director of Georg Haber & Joh. L. L. Brandner GmbH, Regensburg/Berlin (pp. 192–194, 194–195, 201–202, 217–220)

Julian Harrap, DipArch RIBA FRSA, architect – focus on monument conservation, principal of Julian Harrap Architects, London (pp. 60–64)

Jörg Haspel, Professor, Ph.D., art historian, qualified architect and urban planner, director of the Berlin Office of Monument Conservation (pp. 8–9, 14–21)

Maximilian Heimler, M.A., restorer, project manager of Georg Haber & Joh. L. L. Brandner GmbH, Regensburg/Berlin (pp. 192–194, 217–220)

Anne Hengst, architect, David Chipperfield Architects, Berlin (pp. 95–100)

Wulfgang Henze, qualified architect, monument conservation project manager, Museum Island project section at the Federal Office of Building and Regional Planning, Berlin (pp. 128–130, 133–135, 208–209, 213–216, 216–217)

Norbert Heuler, qualified architect, Department for the Preservation of Art and Architectural Monuments at the Berlin Office of Monument Conservation (pp. 69–73)

Volkmar Hillig, qualified engineer (UAS) in stone technology, project manager and head of subsidiary, Bamberger Natursteinwerk Hermann Graser GmbH & Co. KG, Bamberg/Dresden/Potsdam (pp. 145–146)

Gisela Holan, Ph.D., head of "building/technology/services" department, General Directorate Staatliche Museen zu Berlin – Prussian Cultural Heritage (pp. 31–37)

Carsten Hüttich, qualified restorer, project manager, Wandwerk GmbH, Berlin (pp. 166–168, 205–207)

Andreas Klein, stone sculptor and restorer, Potsdam (pp. 148–149)

Werner Lorenz, Ph.D., civil engineer, principal of Prof. Dr. Lorenz & Co. Bauingenieure GmbH, Berlin, professor at the Brandenburg Technical University in Cottbus, head of the History of Construction Technology and Conservation department (pp. 38–43)

Thomas Lucker, restorer, Restaurierung am Oberbaum, Berlin (pp. 191–192, 197–199, 220–223)

Bernhard Maaz, Ph.D., art historian, deputy director of the Nationalgalerie, Berlin (pp. 22–30)

Uwe de Maizière, qualified senior restorer, Restaurierung am Oberbaum, Berlin (pp. 161–162, 203–205)

Tobias Mann, manager of Dreßler Bau GmbH, Aschaffenburg (pp. 138–140)

Gertrud Matthes, qualified architect, project manager "Tendering", Museum Island project management section at the Federal Office of Building and Regional Planning, Berlin (pp. 132–133)

Florian Mausbach, qualified architect and urban planner, president of the Federal Office of Building and Regional Planning, Bonn/Berlin (pp. 8–9)

Eva Maria Niemann, architect, project manager of "Neues Museum Berlin", Museum Island project management section at the Federal Office of Building and Regional Planning, Berlin (pp. 76–81)

Wolfgang Orth, Ph.D. in civil engineering, principal of Dr.-Ing. Orth GmbH, office for soil mechanics and foundation engineering, Karlsruhe (pp. 90–94)

Jens Osterwold, qualified civil engineer, manager of M-O-L Tischler- und Bau-GmbH, Bülower Burg (pp. 185–186)

Hermann Parzinger, Professor, Ph.D., holder of several doctorates honoris causae, archaeologist, president of the Prussian Cultural Heritage Foundation, Berlin (pp. 8–9)

Michael Petzet, Professor, Ph.D., monument conservationist, president of the German national committee of the International Council on Monuments and Sites (ICOMOS), Munich (pp. 10–11)

Karl-Heinz Petzold, free-lance restorer, Tübingen (pp. 202–203, 209–211)

Larissa Piepo, qualified senior restorer at Piepo & Partner Steinrestaurierung GbR, Hanover (pp. 179–180, 181–182)

Martin Pomm, architect, project architect, ProDenkmal GmbH, Projektierungsgesellschaft für Denkmalpflege, Berlin/Bamberg (pp. 126–127)

Andreas Protz, qualified engineer (materials technology), managing director of FEAD GmbH, Berlin (pp. 215–216)

Axel C. Rahn, Professor, civil engineer and expert consultant, principal of Ingenieurbüro Axel C. Rahn GmbH Die Bauphysiker, Berlin/Hamburg (pp. 101–105)

Martin Reichert, architect, project architect for Neues Museum, Director David Chipperfield Architects, Berlin (pp. 151–153, 176–177, 190–191)

Mandy Reimann, qualified restorer, Georg Haber & Joh. L. L. Brandner GmbH, Regensburg/Berlin (pp. 194–195, 201–202)

Elke Renner, qualified restorer (UAS), free-lance restorer, Berlin (pp. 199–200)

Klaus Ricken, qualified restorer, head of the Restauratorenkollektiv Schwarzer/Ricken GbR, Berlin (pp. 140–143)

Thomas Riemenschneider, electrical engineer (technical acoustics), office manager for building and interior acoustics, Ingenieurbüro Axel C. Rahn GmbH Die Bauphysiker, Berlin/Hamburg (pp. 101–105)

Dunja Rütt, qualified senior restorer, Restaurierung am Oberbaum, Berlin (pp. 156–158)

Larissa Sabottka, Ph.D., art historian, archivist and building researcher, ProDenkmal GmbH, Projektierungsgesellschaft für Denkmalpflege, Berlin/Bamberg (pp. 123–125)

Eva Schad, architect, project architect for Neues Museum, Director David Chipperfield Architects, Berlin (pp. 151–153, 176–177, 190–191)

Günter Schade, Professor, Ph.D., art historian, former deputy director general of the Staatliche Museen zu Berlin (pp. 31–37)

Lars Schellhase, qualified restorer, free-lance restorer, Rangsdorf and project manager, Wandwerk GmbH, Berlin (pp. 166–168, 211–213)

Stefan Schiefl, qualified restorer (UAS), planning and site manager, ProDenkmal GmbH, Projektierungsgesellschaft für Denkmalpflege, Berlin/Bamberg (pp. 120–123)

Gerda Schirrmeister, Sc.D., qualified geologist, stonemason consultant firm, Berlin, (pp. 149–150, 180–181)

Anette Schulz, qualified senior restorer, Restaurierung am Oberbaum, Berlin (pp. 158–160)

Olaf Schwieger, qualified senior restorer, ARGE Süd-West GbR, Michendorf (pp. 163–166)

Josef Seiler, consultant engineer, partner of Ingenieurgruppe Bauen, Karlsruhe/Mannheim/Berlin/Freiburg (pp. 82–89, 90–94)

Alexandra Skedzuhn, qualified senior restorer, Restaurierung am Oberbaum, Berlin (pp. 168–170, 203–205)

Klaus Steffens, Professor, Sc.D. (engineering), civil engineer, principal of Prof. Dr.-Ing. Steffens Ingenieurgesellschaft mbH (PSI), Achim (pp. 82–89)

Annette Sturm, qualified senior restorer, Restaurierung am Oberbaum, Berlin (pp. 156–158)

Eberhard Taube, qualified restorer, project manager, Wandwerk GmbH, Berlin (pp. 173–175, 205–207)

Hans-Peter Thiele, qualified engineer, co-ordinator of technical services projects, Department of Domestic Engineering, Federal Office of Building and Regional Planning, Berlin (pp. 106–115)

Peter van Treeck, professor emeritus of monument restoration, art historian, partner of Gustav van Treeck Bayerische Hofglasmalerei Werkstätten für Mosaik und Glasmalerei GmbH, Munich (pp. 183–185)

Birgit Tuchen, Ph.D., archaeologist, free-lance cultural scientist, Tübingen (pp. 44–47)

Claudia Vollmann, qualified restorer (UAS), planner and site manager, ProDenkmal GmbH, Projektierungsgesellschaft für Denkmalpflege, Berlin/Bamberg (pp. 118–119, 125)

Wanja Wedekind, qualified restorer, Wandwerk GmbH, Berlin (pp. 211–213)

Dietrich Wildung, Professor, Ph.D., Egyptologist, director of the Egyptian Museum and Papyrus Collection, Berlin (pp. 65–68)

Index

Terms, material, architectural components

Absorbers 105

Acoustics (room acoustics) 101, **104 f.**
Acoustics analysis 101, 104 f.

Acrylate mortar 203 f.
Acrylic-resin (saturation) 122

Aesthetic models 153
Aesthetic objective 207

Aggregates (screed) **180 f.**

Air outlet **110, 111**
Air-conditioning 17, **108 ff.**

Alabaster 224

Alkyd-resin paint 121, 126 f., 196

Alpenweiss Rosé (dolomite marble) 150

Alum 123, 223 f.

Alunite gypsum 119

Architectural concept **56 ff.**
Architectural concrete 138
Architecture 22 ff.

Archive room book **153**

Artificial lighting 108, 109, **113**

Ashlar bond 126

Assembling kits 39

Awarding of restoration work **131 f.**

Backfilling 140, 142, 162, 168, 171, 173, 202 f.

Badmeyer patent 177, 185

Balsamic oil varnish 96

Bardiglio Nuvolato (marble) 188 f.

Barium hydroxide 164, 174

Barrel vaults 41, **85,** 136

Basalt 181

Base tone retouching 174

Bedding mortar 124, 129, 181, 215

Beeswax 122

Berlin plaster 183 f.

Bianco Carrara Ordinario 150

Biocide 221, 222

Birkenwerder Yellow (tile) 79, 160

Blistering 122, 123

Blower door tests 99, 104

Boric salt cartridges 96

Bowstring girders – cf. bowstring trusses 16,
 39 ff., 121, 125, 129, 136, 208
Bowstring trusses – cf. bowstring girders 62,
 168, 173 ff., 201

Brass (claddings) 42, 43, 125
Brass (hard-soldered sheet) 98
Brass (marquetry) 95, 185 f.
Brass (sheets) 121

Brick (crushed) 141

Bricks (handmade) 78, 79
Bricks (of special types) 62, 136
Brickwork, bricks 41, 56, 59, 76, 78 f., 85, 88,
 118, 123, 126, 129, 130, 136 f., 140 ff., 144, 177,
 181, 183

Bronze (imitation) 121, 125, 218 f.
Bronze (metal) 96, 99, 187, 189, 220
Bronze (sculpture) 46

Calcium hydroxide 216
Calcium nitrate 212

Campan Melange (marble) 87, 147, **148,** 149

Carbon-fibre tape 62, 136

Carrara marble 87, 147 f., 177, **180**

Casein 120, 121, 122, 126, 142, 155, 166, 168, 221
Casein distemper 121, 156, 158
Casein emulsion 155
Casein tempera 121, 205 f.
Casein-based paint 120 f., 126, 166, 168

Cast radiators 111
Cast zinc allegories 24, **194 f.**
Cast-iron 88 f., 95, 173
Cast-iron (structural components) 28, 40 f.,
 83, **88 f.,** 95, 125, 136 f., 146, 170, 173
Cast-zinc consoles 200

Cathodic protection 214, **215**

Cavities 122, 149, 191, 193, 198, 203

Celadon green 121

Cellulose derivative glue 156

Cement 187
Cement mortar 142, 181

CFD simulation 115
CFRP plates, ribs **88**, 137

Charter of Burra 77
Charter of Lausanne 70, 77
Charter of Venice 9, 11, 56, 69, 77
Charter of Washington 77

Cinnabar 121

Clay 124, 128, 183
Clay cylinders (ceiling) 41, 129 f., 136
Clay pots (ceiling) 78, 79, **84 ff.**, 123

Climate-control 99, 101 f.
Climate-control system 101 f.

Colophony 122

Colossal statues 65, 77, 166

Competition 19 ff., 36, **50 ff.**, 131

Complementary restoration **19**

Concept of repair / of completion 59

Concrete 46, 83, 88, 90, **138 ff.**, 187
Concrete-piles 35
Concrete, polished 138
Concrete (pre-cast) 59, 136, 138

Conservation 151
Conservation (archaeological) 151
Conservation building site 9

Construction contract procedures (VOB) 132
Construction design 40
Construction physics **101 ff.**
Construction process 39, 76
Construction site 38
Constructional design concept 32

Consultation procedure **50 ff.**

Copper 216 ff.
Copper claddings, galvanoplastic **216 ff.**
Copper fittings 219
Copper sheet 219, 220

Copper sulphate 216, 219
Copper sulphate solution 216
Copperplate printing plates 217

Corner acroteria 194
Corner projections **195**

Craquelure 154

Cut stone 125, 137, 143, 145, 188 f.

Cyclododecane 174

Daylight / natural light 113

Décor, decoration **22 ff.**
Décor restoration work **151 ff.**
Decorative scheme 22

Demineralization treatment 132, 155, **212 ff.**

Dimensioning methods 40

Dismantling 35

Distemper (casein) 156, 158
Distemper (glue-bound) 156, 173 f.
Distemper paintings 221

Documentation 9, 79

Dolomite marble 150
Dolomitic marl 181

Doors (original) **95 ff.**

Double-glazed casements (window) 103 f.

Dyckerhoff weiss (white cement) 187

Early history **14 ff.**

Earth pigments 121, 141, 179

Endoscopic examination 124

Epoxy resin 142, 193, 196, 200

Erzgebirge marble 138

Exhibition concept 22, 66, 84, 121

Existing structural shell 136 f., 183 ff.

Expert commission 19, 193

Extensive retouching 210

Ferrous oxides 215

Fire safety 96, 99, **100**

Flattened cupola vaults 85

Floorboard 177, 185

Fosse de Finocchioso 177

Foundation 22, 31, 35, 38, 83 f.
Foundation (remediation) **83 f.**
Foundation (wooden piles) 83, 90, 92
Foundation slab 83, 92 f.

French parquet 176, **185 ff.**

Frost body **90 ff.**

Galvano-technology 216
Galvanography 216
Galvanostegy 216

Gauging tests 122

Geison 144

German regulations for contracts – cf. VOB, VOF, VOL 129

Glass fibre mesh 188, 189
Glass fibre-polyester needles 142
Glass-and-iron roof 40

Glaze 122, 130, 142, 154, 156 ff., 160 f., 164, 169, 170, 171, 173, 174, 201

Glue (gelatine) 96, 97, 123, 184

Gold leaf 121, 126

Granulated rubber 185

Griffin **195**

Grisaille painting 156, 177, 207, 210

Grosskunzendorf marble 178

Ground freezing **90 ff.**

Guidelines (conservation/restoration) 20, 69, 71, 73, 77 f.

Gum arabic 121

Gypsification 141
Gypsum 118, 119, 121, 123 f., 179
Gypsum mill 120
Gypsum mortar – cf. Plaster mortar 85 f., 136, 142
Gypsum plaster – cf. Plaster 118 f.
Gypsum-lime mortar 129, 181, 183, 191, 212, 215
Gypsum-lime plaster 158 f., 199, 206
Gypsum-lime stucco 197

Haired mortar 215

Hard wax 99, 104

Heating **111**
Heating system 106 f., **111**

Hellschlesischer Marmor 188 f.

History of ideas **22 ff.**

Humidity rate **103**

Ice-age marsh bubble 31, 35

In-situ stabilization 35

Injection 155

Iron 42, 191
Iron (cast) 28, 88 f, 95, 158, 170
Iron (fittings) 96, 98
Iron (framework) 39 f.
Iron (structure) 16 ff., 39 ff., 136, 170, 194, 195

Iron (wrought) 41, 46, 125, 129
Iron anchors 191, 193, 197
Iron beams 40, 125, 173
Iron girders 89, 136 f.
Iron oxide 120, 123, 179
Iron oxide pigments 179
Iron rails 38
Iron sheet 201
Iron technology **82 ff.**

Japanese silk paper 174
Japanese tissue wallpaper 173

Keene's marble-cement 119, 223 f.

Lahnmarmor Unika A 177

Lastrico floor 123

Laying of the foundation stone 16 f., 35 f.

Lead (bearings) 143, 149
Lead (pigment) 120, 121
Lead (plates) 149

Leather upholstery 96

Ledan 142, 174, 191

Lengefelder Marmor Weiss (dolomite marble) 150

Lightweight techniques 136

Lime 118, 184
Lime casein glaze 142
Lime hydrate 216
Lime mortar 118, 122, 126, 140 f., 149, 160 f., 177, 191, 203 f., 214
Lime paint 192, 199
Lime plaster 122, 141, 174, 206
Lime slurry 79
Lime spatters 118
Lime-casein glaze 142
Lime-gypsum plaster 199, 205
Limestone 83, 87, 123, 126, **150**, **180**
Limestone 83, 87 f., 123, 126, **150**, 177, 180, 181, 184
Limestone (imitation of) 119

Linseed oil 142
Linseed oil (varnish) 95 f.

Load-bearing capacity (verification) **82 ff.**

Long-term plan 32, 87, 123, 126 f., 137, 144, 146, 148 f.

Lye-proof pigments 122

Magnesium sulphate 162, 164, 174

Mahogany 172, 185 f.

Mapping (of damaged/restored parts) 96, 97, 118, 153
Mapping of existent original parts 78, 153

Marble (natural stone) 28, 46, 47, 62, 65, 87, 120, 123, 126, 138 f., 147, 148, **149 f.**, **177 ff.**, **187 ff.**
Marble-cement 62, 63, 98, **119 f.**, 126, 138 ff., 177, 179, 181 f., **223 ff.**
Marble-cement (floors) **181 f.**
Marble-cement (reconstruction of) **223 ff.**
Marble-cement (technique) **119 f.**
Marble powder 118, 174

Marmorino **118 f.**

Masonry ceilings **84 ff.**

Mastic 122

Metal girder 127, 190

Micro-blasting 220
Micro-crystalline wax 220

Mine railway 208

Mineral wool 99

Mosaic tiles (embedding) 129

Moulds (iron) 39

Multilayer wood (plywood) 186

Nara Document on Authenticity 70, 73

Natural lighting **113**

Natural stone 87, 132, 136, 179, **195 f.**

Neutral retouching 156, 157, 177, **190**, 201 f., 210, 223, 224

Non-destructive analysis 62, 88

Oak 95 f., 98, 177, 185, 186, 219, 220, 222
Oak (smoked) 177, 186
Oak (veneer) 95

Oil varnish 194, 195
Oil-bound paint 192, 194, 205
Oil-resin technique 203
Oil-type glaze 201
Oil-wax paint – cf. resin-oil-wax-paint 205
Oil-resin-wax tempera 119

Opus rustica 126

Original mortar 192, 199

Original techniques 159

Overpainting 154, 156

Oxalic acid 98 f.

Paint Finishing Systems **120**

Paraloid B 72 193

Parisian grilles 129

Photoshop presentation 63, 79, 153

Photospectrometric tests 212

Pigments 119, 123, 124, 141, 179
Pile foundations 35, 39, 83

Pine 95, 185 f.

Pit sand 118, 184

Plaster 137, 140
Plaster (external facade) 140 ff.
Plaster (interior wall surfaces) **118 ff.**
Plaster (marble-cement) **224**
Plaster (marble plaster) 132
Plaster (terrazzo floors) 176, **179 f.**
Plaster casts 24, 27
Plaster mortar 183 f.
Plasterwork (façade) 79

Polyurethane 182, 193
Polyurethane acrylate combination 194

Portland cement 142

Posta sandstone 127, 149, 196

Povonazzeto marble 126

Pre-cast components (concrete) **138 ff.**

Preparatory investigations 118 f.

Preservation theory 151

Prussian capped ceiling 40

Pyrenean marble 87

Qualified craftsmen's register 133

Quartz sand 118, 184

Rabitz ceiling 214, 215

Radar scan 176

Radar screening 124

Railway **38**

Rain test 99, 104

Rathenow red 79

RDX 212

Re-alkalization (electrochemical) 213, 214, 216

Recarbonation **215**

Reconstruction 17 f., 56, 57, 70, **147 f.**, 151, 177, 179, 183

Record of wooden components 96

Refurbishment 8 f.

Regulations for free-lance contracts **131 f.**

Relative humidity 101 ff.

Rendering techniques **118 ff.**

Reopening of the Neues Museum 20

Reproduction **60 ff.**, **151 ff.**

Resin lacquer 95, 96, 98

Resin-oil-wax paint 205

Restoration **60 ff.**, **151 ff.**
Restoration concept 151

Retarding agent 184

Retouching 79, 135, 151, 153 ff., 164, 167 ff., 174, 175, 177, 199, 201 ff., 207

Retouching paint 201

Reverberation time 104, **105**

Rolling ceiling **139**

Roman cement 183

Roofing tiles 177

Rosewood (veneer) 95, 98

Ruin 8

Saalburg Königsrot 150

Safety glass (CSG) 99
Safety measures 19, 35

Sail vaults 41

Sand 124, 142, 184
Sandblasting 137 ff.
Sandstone 32, 87, 123, 126 f., 137, **144**, 146, 148 f.
Sandstone, varieties Cotta and Posta 127

Saturation (Acrylic-resin) 122

Schuppach schwarz 177

Screed (cement) 124
Screed (plaster) 86, 87, **123 f.**, 176, 180, 189

Second-hand brick 136 f., 140, 158

Securing mortar 181

Serpentinite 148, 178, 180, 181

Settlement measuring **83 f.**

Silicic acid ester 143
Silicic acid ethyl ester 191

Siltstone 181

Silver nickel 95

Site management 35

Slate powder 141

Sodium sulphate 212

Spiral staircase (iron) 173

Sprinkler process 212

Staining – gold 121
Staining – wood 98, 186
Stainless steel 35, 96, 146, 149
Stainless steel (anchors) 146
Stainless steel (framework) **199**
Stainless steel (inserts, dowels, sections) 35,
 149, 195
Stainless steel lattice structure 200
Stainless steel pins 196

Stains – on stone by salt efflorescence or
 impurities 130, 202, 224 f.

Standardizing (of structural parts) 39

Star vault 40

Start of construction (official) 36, 77

Statuario (marble) 148, 150

Steel 35, 40, 41, 83, 85, 88, 91, 99, 144, 146,
 148 f., 187
Steel construction 40 f.
Steel dowels 83, 149
Steel girders 41, 201
Steel plates 88
Steel prop 148
Steel reinforcement 35, 187

Stereochromic technique 122, 199

Stone flour 180
Stoneware mosaic **183 ff.**

Storage 96, 138, 143, 146, 149

Strength profile 122

Structural stabilisation **83 f.**

Stucco lustro 118 f., 154

Subconcrete 187

Support structure planning 84

Tartaric acid 184

Technical facilities **106 ff.**
Technical services **106 ff.**

Teflon strips 149

Tempera 119

Terracotta 127, 137, 188

Terrazzo 123 f., **179 ff.**, **187**

Teschendorf sand 142

Tesserae (marble) 177

Test bodies **85 f.**
Test vault **86 f.**

Thermal insulation (of window-glazing) 99

Thin section 124, 150, 181
Thin-bed laying 129

Tiles (mosaic, floors) 120, 123 ff., 128 f., 168,
 177, 181, 183, 223
Tiles (production of) 128

Tin 193
Tin-lead solder 192, 193

Topping-out ceremony 21, 77

Trading and craft regulations 133

Trass mortar 149, 161

Tratteggio technique 169

Trompe-l'œuil 120, 127

Underground service pipes 111

Unika A (marble, Lahn) 177

Utility lines (original) 62

Violett Vogelsberg 150

Viscose sponge 215, 216

VOB (German construction contract
 procedures) 132
VOF (German regulations for free-lance
 contracts) 131 f.
VOL/A (German regulations for contracts and
 the execution of construction works) 129

Wallpapers (ceiling papers) **122 f.**

Walnut (veneer) 95, 98

Water-glass 118, 122

Wax (on wood) 98
Wax paint 121
Wax polish 179, 187

White lead 195
White lead paint 191 f., 197

Windows **95 ff.**

Wire lath and plaster ceiling 16
Wire-and-plaster 208, 214 ff.
Wire-and-plaster ceiling 156, 158, 164, **208,**
 213 ff.

Wire-mesh 40

Wood protection (chemical) 96

Wooden piles (foundation) 83, 90, 92

Working group for restoration techniques 191

Workshop (project planning) 20, 77

World Heritage 9, **69**
World Heritage Convention **69**
World Heritage List **69**

Wrought-iron 41, 46, 125, 129

X-ray diffraction (RDX) 212

Yellowing 154

Zinc 96, 127, 193 f.
Zinc (cast) 24, 96, 125, 192, 193, 201
Zinc claddings 42, 43, 170, 201
Zinc relief 24, **192 ff.**
Zinc sculpture **195 f.**
Zinc sheet 125, 200

The Neues Museum: areas, spaces, interiors

Ägyptische Abteilung (Egyptian Department)
 158 f.
Ägyptische Sammlung (Egyptian Collection)

24, 31, 34, 46, 66 f., 156, 220
Ägyptischer Hof (Egyptian Courtyard) 6, 18,
 28, 31, 39, 41, 52, 65, 67, 78, 109, 115, 121 f.,
 138 f., 200, **205 f.**
Ägyptisches Museum (Egyptian Museum) 8,
 17, 18, 33 f., 52, 65, 68
Air-conditioning and ventilation centre 112
Amarna Collection 17, 19, 63
Anteroom to Roter Saal – cf. Dienerzimmer
 173, 175, 208
Antiquities Collection 8, 34
Apollo Hall – see Apollo Saal
Apollo niche 205 f.
Apollo projection **143**
Apollo Saal 67
Apse (Greek Courtyard) 17, 19, 140
Apse (Mittelalterlicher Saal) 136, 140
Arched arcade 61
Architectural sculptures, metal **194 f.**
Architectural sculptures, natural stone **195 f.**
Bacchus Hall – see Bacchussaal
Bacchussaal (Bacchus Hall) 52, 61, 87, 95, 97 f.,
 119, 149, 150, **161 f.**, 184, 203
Bacchussaal door 95 f., 98
Bernward Room – see Bernwardzimmer
Bernwardzimmer (Bernward Room) **163 f.**,
 180, **213 ff.**
Brandenburgische Kunstkammer 24
Bridge link, old bridge to Altes Museum,
 Pergamonmuseum 17, 19
Café 32, 107, 157, 180
Caryatid Hall – see Korenhalle
Central heating and cooling plant 111
Central projection 23, 141, 144
Child figures 193, 194 f., 197
Collection of plaster casts 24, 168, 208
Colonnades 8, 19, 24, 31, 45 f., 72, **136 f.**, **145 f.**
Colossal statues 65, 77, 166
Columns (passage connecting with the main
 stair hall) **147 ff.**
Copper engraving collection 173
Corner acroteria 194
Corner projections 24, 195
Courtyard – see Forumshof
Courtyards – cf. Egyptian and Greek courtyard
 8, 15 f., 19, 23, 28, 29, 33, 65, 66, 139 f.
Dienerzimmer (servants' room) –
 cf. anteroom to Roter Saal 121 f., **173 ff.**
Director's office – see Direktorenzimmer

Direktorenzimmer (director's office) 157,
 180
Dürer niche 174, 175
East colonnade – cf. colonnades 145
East façade **15**, 24, 45, **141**, **192**, **196**
East gable 24
East tympanum **191**, 192
East wing 17
Egyptian Collection – see Ägyptische Samm-
 lung
Egyptian Courtyard – see Ägyptischer Hof
Egyptian Department – see Ägyptische Ab-
 teilung
Egyptian Museum – see Ägyptisches Museum
Ethnographical Collection – see Ethnogra-
 phische Sammlung
Ethnographical Hall – see Ethnogaphischer
 Saal
Ethnographische Sammlung (Ethnographical
 Collection) 17, **156 f.**, 170
Ethnographischer Saal (Ethnographical Hall)
 61, 126, **157 f.**, 180
External façades **140 ff.**
Façades **140 ff.**
Figures of the arts and sciences (corner-
 projections) **195**
Flachkuppelsaal (Flat-domed Hall) 17, **85**, 121,
 156, 180
Flat-domed Hall – see Flachkuppelsaal
Forumshof (Courtyard) 24
Gable of the staircase hall 35
Geison (west side) 144
Gothic Hall – see Gotischer Saal
Gotischer Saal (Gothic Hall) – cf. Sternensaal
 (Star Hall) 40
Gräbersaal (Sepulchral Hall) 107, 122, **158 f**,
 180
Greek Courtyard – see Griechischer Hof
Greek Hall – see Griechischer Saal
Green Hall – see Grüner Saal
Griechischer Hof (Greek Courtyard) 17, 19, 23,
 28, 65, 139, 147, 190, 195 ff., **199**
Griechischer Saal (Greek Hall) 67, 125, 211
Griffins **195**
Grüner Saal (Green Hall) 173
Haupttreppenhalle – (main starcase hall) 23,
 38, 122, 125, 137 f., 140, 147, **160 f.**, 173, 177,
 183, 190, 208
Historical Hall – see Historischer Saal

Historischer Saal (Historical Hall) 67

Kaulbach frescoes 8, 136

Kitchen and bar 157

Kolonnadengarten 72

Korenhalle (Caryatid Hall) 16 f., 126, **178**

Kunstkammer 17, 23, 28, 41, 113, 125, **170 f.**, 176

Kunstkammersaal (Art Chamber Hall) 113, **170 f.**, 224

Kupferstichkabinett 28, 34 f., **170 f.**, 176

Lapidarium 77, 190

Main portal **216 ff.**, 220

Main staircase hall – see Haupttreppenhalle

Majolica Hall – see Majolikasaal

Majolikasaal (Majolica Hall) 41, **170 f.**, 185, 186

Medieval Hall – see Mittelalterlicher Saal

Metal structural decoration **200 f.**

Mezzanine storey 17, 19

Mittelalterlicher Saal (Medieval Hall) 120, 121, 124, **136**, **137**, **147 f.**, 163 ff., 176, 180, 184

Modern Hall – see Moderner Saal

Moderner Saal (Modern Hall) 87, 125, 126, 147 ff., 163 f., **165 f.**, 180, 184, 214, 225

Museum of Pre- and Early History 8, 33, 34, 52, 65

Mythologischer Saal (Mythological Hall) 40, 41, 67, 81, 108, 122, **158 f.**, 180, **220 f.**

National Hall – see Vaterländischer Saal

Natural stone sculptures **195 f.**

Niobidensaal (Niobides Hall) 22, 27, 41, 52, 61, 68, 80, 105, 106, 107, 108, 109, 110, 113, 118, 119, 120, 121, 122, 124, 127, 161, 168 ff., **169**, 177, 183 f., 201, 203 ff., 223

Niobides Hall – see Niobidensaal

Nordic Hall – see Nordischer Saal

Nordischer Saal (Nordic Hall) – cf. Vaterländischer Saal 26

Nordkuppel (North Dome) 152, 177

Nordkuppelsaal (Northern Domed Hall) 67, 68, 115, 119, 125, 152, **166 f.**, 176, 177, **181 f.**, 205, 211

North façade 47, 141, 198

North projection 196

North wing 17, 41, 43

North-west wing 35, 59, 82, 83, 137, 138

North-west quadrant 31, 52

Passage (leading from the south vestibule to the Vaterländischer Saal, space 1.02.2) **199 f.**

Red Hall – see Roter Saal

Restoration workshops 32

Roman Hall – see Römischer Saal

Römischer Saal (Roman Hall) 28, 52, 67, 110, 119, 122, 126, 129 f., 152, 153, **161 ff.**, 183, 184, **203 f.**, 224, 225

Roof figure 24, 194 f.

Roter Saal (Red Hall) 107, **120**, 121, 122, 123, **173 ff.**, 200, 201, **205 ff.**, 208

Sarkophagsaal (Sarcophagus Hall) 156

Schievelbeinfries (Schievelbein frieze) **23**, 28, 29, 65, 77, 190, **196 ff.**

Sepulchral Hall – see Gräbersaal 108, 122, 158 f., 180

Servants' room – see Dienerzimmer

South colonnade 145

South dome – see Südkuppel

Southern Domed Hall – see Südlicher Kuppelsaal

South facade 90, 94, 104

South portal **143**

South projections 195

South wing 17, 156

South-east dome 32

South-east wing 161

South-eastern projection 17, 138

Spherical niche medallions (at corner projections) 195

Staircase – cf. Haupttreppenhalle 8, 15 ff., 19, 23, 24, **25 f.**, 31, 33, 35, 38, 52, 54, 59, 68, 76, 78, 82, 109, 114, 115, 122, 125, 126, 136, 137, 138, 139, 140, 144, 145, 147, 177, 178, 183, 224

Star Hall – see Sternensaal

Sternensaal (Star Hall) – cf. Gotischer Saal 28, 39, 40, 67, 121, 172 f., 185 f., 214

Stucco relief **191**

Südkuppel (south dome) 8, 15, 35, 77, 161 f., 190, 199

Südlicher Kuppelsaal (Southern Domed Hall) 31, 115

Transverse colonnade – cf. Colonnades 145

Triple windows **144 f.**

Utility lines (original) 62

Vaterländischer Saal (National Hall) 26, 67, 106, 120, 121, 122, 125, 126, 154 f., 180, 190, 199, 200, **202 f.**

Vestibül (Vestibule) 61, 76, **89**, 95, 96, 98, 119, 121, 126, 149, 150, **154 f.**, **177 f.**, **179**, **199**, 224

Vestibule – see Vestibül

Victories 195

Wall cladding (Sternensaal) **186**

Wall paintings 22, 28, 29, 78, 121 f., 190, 205, **207**

Wall pictures **200**, **202**, **203 ff.**, **205 ff.**

West façade 24, 103, 104, 114

West side 140 ff.

West tympanum 192 ff.

West wing 18

Window jambs 144

Locations, buildings, institutions

Academy of Arts, Berlin 22, 27

Altes Museum, Berlin 8, 10, 14, 15, 16, 17, 19, 23, 26, 29, 31, 32, 39, 41, 45, 50, 52, 53, 65, 66, 67, 68, 71, 72, 136

Antikensammlung (Antiquities Collection), Berlin 8, 34

Antiquities Collection – see Antikensammlung

Archaeological Promenade, Berlin 20, 55, 59, **65 ff.**

Arsenal – see Zeughaus

Arts and Crafts Museum, Berlin 34

Baroque church of Santa Mónica, Guadalajara, Mexico 212

Bastion (city fortifications), Berlin 44

Belvedere on Pfingstberg hill, Potsdam 79

Berlin Dom 10, 72, 178

Berlin Monument Council (Landesdenkmalrat) 19

Berlin Schloss 10, 11, 14, 56

Berlin State Conservation Office – see Landesdenkmalamt Berlin

Berlin Stock Exchange (Börse) 14

Bode-Museum, Berlin 8, 10, 14, 17, 31 ff., 65, 72

British Museum, London 29

Central Committee of the SED 33

Charlottenburg residence (Schloss), Berlin 14

Cologne Cathedral 15

Cultural ministers' conference 70 f.

Eastern Asian Collection, Berlin 33 ff.

Entrance building (Museum Island), Berlin 11, 14, 19, 32, 55

Ephraimpalais, Berlin 44

Equestrian statue of the Great Elector, Berlin 217

Fischerinsel, Berlin 14

Forum Romanum, Rome 15

Franciscan Monastery Church, Zeitz 212

Frauenkirche, Dresden 56

Frick Collection, New York 29

Friedenskirche (atrium), Potsdam 217

Friends of the Neues Museum 77

Garden House, Berlin – see Lusthaus

Goethe house (birthplace), Frankfurt am Main 56, 59

Granite bowl (Lustgarten), Berlin 72

Gutenberg monument, Frankfurt am Main 217

Hohenschönhausen Depot 35, 143, 145, 195, 200

Humboldt Forum, Berlin 11

ICCROM (International Centre for the Study of the Preservation and Restoration of Cultural Property) 69

ICOMOS (International Council on Monuments and Sites) 9, **10 f.**, 69 f., 72 f., 79, 81

Institute of Monument Conservation 33

Iron Bridge, Berlin 72

Islamic collection section, Berlin 35 f.

IUCN (International Union for Conservation of Nature) 69 ff.

James Simon Gallery, Berlin 76

Kaiser Wilhelm Gedächtniskirche, Berlin 56

Kaiser-Friedrich-Museum, Berlin – see Bode-Museum

Kaiserdom, Aachen 71

Königliche Museen 33

Landesdenkmalamt Berlin (Berlin State Conservation Office) 77, 19, 151

Lustgarten (Pleasure Garden), Berlin 8, 10, 14, 15, 31, 65, 72

Lusthaus (Garden House), Berlin 14

Magnushaus, Berlin 72

Minister of culture, GDR 32 f.

Modernist housing estates, Berlin 71

Monbijou Bridge, Berlin 72

Museum Island, Berlin – see Museumsinsel

Museum of Modern Literature, Marbach 79

Museum of Pre- and Early History, Berlin 33 ff.

Museumsinsel (Museum Island), Berlin 8 ff., 14, 15, 17, 20, 22, 23, 31 ff., 44, 50, 52, 55, 59, 65, 70 ff., 76 ff., 83, 90, 101, 208

National Gallery (Alte Nationalgalerie), Berlin 8, 10, 14, 15, 29, 31, 32 45, 46, 47, 50, 61, 71, 72, 145, 199

New Orangery, Potsdam 217

Orangery – see Pomeranzenhaus

Packhof area, Berlin 14

Packhof, Berlin 14 f., 19

Palais Bourbon, Paris 214

Pergamon Museum, Berlin 8, 10, 14, 17, 19, 29, 31 ff., 47, 50, 52, 53, 62, 65 f., 72, 83, 90, 168

Pinakothek, Munich 56, 136

Pleasure Garden, Berlin – see Lustgarten

Pomeranzenhaus (orangery), Berlin 14, 44

Pompejanum, Aschaffenburg 79

Potsdam residence (Schloss) 14

Prussian Cultural Heritage Foundation (Stiftung Preußischer Kulturbesitz) 11, 20, 50, 52, 76

Rathgen research laboratory, Berlin 193, 219

Rheinsberg residence (Schloss), Rheinsberg 14

Royal Palace on the Acropolis (design Schinkel) 15

Sculpture collection galleries, Berlin 34 f.

Senate department of urban development and the environment 19

Sicilian Garden of Sanssouci Park, Potsdam 217

Sir John Soane's Museum, London 79

Spree Island, Berlin 11, 14 ff.

Stadtbahn viaduct, Berlin 72

State Museums (Staatliche Museen), Berlin 9, 17, 32 ff., 50, 77, 81

Tomb façades, Petra, Jordan 212

Tombstones, Bartholomäus cemetery, Göttingen 212

UNESCO 69 ff.

Urban residence in the Friedrichsforum, Berlin 14 f., 19

Villa Albani, Rome 168

Walhalla, near Regensburg 214

Wissenschaftlicher Kunstverein zu Berlin 22

Zeughaus (Arsenal), Berlin 10, 26, 72, 217

Persons

Adler, Friedrich 127, 218

Amenhotep III (Amenophis III) 67

Bächer, Max 50

Badstübner, Ernst 19, 21

Becker, Carl 203

Bellermann, Ferdinand Konrad 190, 199

Berges, Heinrich 195

Biermann, Karl Eduard 190, 205

Boetticher, Carl 42, 43, 128, 208

Bögel, Heinrich 190, 205

Börsch-Supan, Helmut 71

Borsig, August 38, 39, 40, 41, 76, 128, 208

Brugnatelli, Lodovico Gasparo 216

Burckhardt, Jacob 29, 30

Carlisle, Anthony 216

Carus, Carl Gustav 29

Catlin, George 190, 205

Chipperfield, David (Chipperfield Architects) 9, 20, 21, 36, 50 ff., 56, 65, 67 f., 77 ff., 81, 111, 191, 202, 210

Christofle, Charles 216

Cruikshank, William 216

da Vinci, Leonardo 26

Daege, Eduard 190, 205

Daniell, Frederik 216

Davy, Sir Humphrey 216

de Joly, Jules 214

de la Rue, Warren 216

de Lucchi, Michele 66

Dehio, Georg 56, 59

Diepgen, Eberhard 72

Dieterichs, Friedrich Wilhelm 44

Döllgast, Hans 56, 136

Dorgerloh, Hartmut 19, 28

Drake, Friedrich 24, 29, 190, 191

Dürer, Albrecht 26, 173

Eiermann, Egon 56, 136

Elkington, George Richards 216

Eltester, Leopold von 205

Engelhard, Wilhelm 29

Faraday, Michael 216

Fidicin, Ernst 44

Friedrich II (the Great) 44

Friedrich Wilhelm I (Großer Kurfürst) 14, 217

Friedrich Wilhelm IV 8, 10, 11, 14, 22, 76, 121, 190, 217

Galvani, Luigi 216

Gebeßler, August 19

Gehry, Frank 50 ff.

Geiss, Moritz 192

Genelli, Bonaventura 190, 203

Golzius, Heinrich 206

Graeb, Carl Georg Anton 190, 205

Gramzow, Carl Heinrich 195

Grassi, Giorgio 20, 50, 51, 52
Great Elector (Großer Kurfürst) – see
 Friedrich Wilhelm I
Hagenest, C. 120, 224
Harrap, Julian 20, 59, 77 f., 81
Hassemer, Volker 71
Hegel, Georg Wilhelm Friedrich 16, 28
Heidenreich, Gustav 190
Henning, Adolf 203
Herder, Gottfried 24
Hessel, Yves 209
Hirt, Aloys 28
Hoffmann, Carl Wilhelm 38, 76, 89, 106, 128,
 208
Hoffmann, Hans-Joachim 36
Hoffmann, Ludwig 14
Holan, Gisela 36, 151
Homer 25
Hopfgarten, August Ferdinand 205
Hübsch, Heinrich 128
Itzig, Daniel 44
Jacobi, Moritz Hermann 216
Kaselowsky, August Theodor 203
Kiss, August 24
Knoblauch, Carl Heinrich Eduard 129
Knopp, Werner 52
Kress, Georg Ludwig 216
Krestev, Todor 72
Kugler, Franz 29
Labrouste, Henri 41, 42
Lenné, Peter Joseph 14
Lenoir, Alexandre 10
Lepsius, Richard 16, 21, 220
Levy, Samuel Salomon 44
Levy, Sara – cf. Widow Levy
Long, Richard 66
Luther, Martin 26
March, Ernst 124, 128, 183, 223
March, Sophie 128
Matsuura, Koichiro 72
Mausbach, Florian 9, 52
Menzel, Adolph 22
Messel, Alfred 14, 29
Morghen, Raphael 206
Müller von Göttingen 190
Müller, Robert 202
Navarro Baldeweg, Juan 50
Nefertiti (Nofretete) 62, 67, 68, 212
Nicholson, William 216

Nicolai, Friedrich 44
Nofretete – see Nefertiti
Otto I 5
Pape, Eduard 190, 203, 205
Persius, Ludwig 22
Peters, Wilhelm 203
Piranesi, Giovanni Battista 56, 61, 63
Pommer, Hartwig 210
Posener, Julius 42
Prosser, Richard 128
Rabitz, Carl 214 f.
Raphael 26
Rauch, Christian Daniel 24
Regis, Johann Gottlob 29
Reichwald, Helmut F. 19
Richter, Gustav 202
Riederer, Josef 193, 219
Ritter, Johann Wilhelm 216
Ruskin, John 56
Sahure 65, 66
Schinkel, Karl Friedrich 8, 10, 14 f., 22 f., 26,
 28 f., 38, 42 f., 60, 192, 208
Schirmer, Wilhelm 205
Schlickeysen, Carl 129
Schlottauer, Joseph 203
Schlüter, Andreas 217
Schmidt, Adolf 205
Schmidt, Georg F. 206
Schmidt, Max 205
Schnaase, Carl 29
Schuller, Manfred 19
Schultes, Axel 50, 51
Schulz, Moritz 46
Schwanthaler, Ludwig 24
Schweger und Partner 50
Schweiger, Georg Wilhelm 44
Seiffert, Carl Friedrich 190, 203
Sommer, Heiner 190
Spangenberg, Gerhard 50, 51
Spencer, Thomas 216
Steinbrück, Eduard 205
Strack, Johann Heinrich 14, 29, 30
Strange, Robert 206
Stüler, Friedrich August 8, 14, 15, 16, 17, 22,
 24 ff., 29, 31 ff., 38 ff., 42 f., 53, 59, 61 f., 76,
 78, 95, 106, 119 ff., 126, 128 ff., 136 f., 160,
 177, 183, 192, 203, 208, 214, 220, 224 f.
Stürmer, Wilhelm 195
Sulzer, Johann Georg 44

Teje (Tiye) 67
Thorvaldsen, Bertel 24, 217
Titus 25
Tiye – see Teje
Touaillon, Louis 46
Venezia, Francesco 50, 51
Volta, Alessandro 216
von Bode, Wilhelm 10, 29, 36
von Buttlar, Adrian 9
von der Horst, Julius August 44
von Fuchs, Johann Nepomuk 203
von Gärtner, Friedrich 79
von Hackewitz, Feodor Freiherr 216, 217
von Humboldt, Alexander 45, 216
von Humboldt, Wilhelm 24
von Ihne, Ernst 14
von Kaulbach, Wilhelm 16, 25, 31, 161, 190, 203
von Klenze, Leo 40, 214
von Ledebur, Leopold 170
von Olfers, Ignaz 22, 28, 44, 76, 208
von Siemens, Werner 216, 217
Waagen, Gustav 29
Waesemann, Hermann Friedrich 106
Weidenbach, Ernst 190, 220
Weidenbach, Max 190, 220
Widow Levy 44 ff., 76
Winckelmann, Johann Joachim 23, 42, 43
Winkelmann, Julius 217
Wolters, Wolfgang 9, 19, 21, 79, 191
Wredow, August 192, 195
Wright, Samuel 128

Reconstruction of the Neues Museum Berlin

Project Team:

Clients
Prussian Cultural Heritage Foundation, Berlin
Professor Hermann Parzinger Ph.D., doctorates honoris causae
Norbert Zimmermann, Joachim Rau, Cordula Thüring

Users
Staatliche Museen zu Berlin
Gisela Holan Ph.D., Rüdiger Timmermann, Belinda Blum, Hans-Jürgen Harras, Carsten Güth;
Egyptian Museum and Papyrus Collection
Professor Dietrich Wildung, Ph.D., Olivia Zorn, Ph.D.;
Museum of Pre- and Early History
Professor Matthias Wemhoff, Marion Bertram, Ph.D.;
Antiquities Collection
Professor Andreas Scholl, Ph.D., Martin Maischberger, Ph.D.

Berlin Office of Monument Conservation
Professor Jörg Haspel, Ph.D., Norbert Heuler, York Rieffel

Project management
Federal Office of Building and Regional Planning, Berlin, Section Museum Island Project Management
Head of section: Barbara Große-Rhode
Project manager: Eva Maria Niemann
Fachreferat Gebäudetechnik
Project co-ordinator Technical Services: Hans-Peter Thiele

Project co-ordination
Ernst & Young Projektsteuerungsgesellschaft, Berlin
Project manager/scheduling: Gerlinde Krüger
Cost monitoring: Alexandra Laugksch

Design and final planning
David Chipperfield Architects, London/Berlin
Gesellschaft von Architekten mbH
Design: Professor David Chipperfield CBE, doctor honoris causae, with Alexander Schwarz
Project architects: Martin Reichert, Eva Schad

Consultant restorers
Julian Harrap, London

Costing
Nanna Fütterer †, Berlin

Site management
Lubic & Woehrlin, Berlin
Senior site manager: Gottfried Paul

Planning/co-ordination of restoration
ProDenkmal GmbH, Berlin/Bamberg
Project managers: Uwe Bennke, Peter Besch

Structural design
Ingenieurgruppe Bauen, Karlsruhe/Berlin
Professor Gerhard Eisele, Sylvia Glomb

Structural design analysis
Consultant engineers Specht, Kalleja & Partner, Berlin
Hartmut Kalleja, , Sc.D. (engineering), Nasrim Kallin

Experimental structural analysis
Ingenieurgruppe Bauen, Karlsruhe/Berlin, with Prof. Dr.-Ing. Steffens Ingenieurgesellschaft mbH, Achim, in co-operation with the Institut für Experimentelle Statik, Hochschule Bremen

Site investigation
Ingenieurgesellschaft Prof. Dr.-Ing H. Müller-Kirchenbauer & Partner GmbH, Berlin
Project manager: Peter Pflaume

Freezing
Dr.-Ing. Orth GmbH, Ingenieurbüro für Bodenmechanik und Grundbau, Karlsruhe
Project manager: Wolfgang Orth, Sc.D. (engineering)

Investigator freezing
Professor Marc Gutermann, Sc.D. (engineering), Bremen

Fire precaution technology
Ingenieurbüro Hartmut Preiß, Berlin

Construction physics
Ingenieurbüro Axel C. Rahn GmbH Die Bauphysiker, Berlin/Hamburg
Professor Axel C. Rahn, Matthias Friedrich, Thomas Riemenschneider

Existing windows
ARGE Rothe & Kramp GbR, Görlitz
Erika Rothe, Guido Kramp, restorers

Existing doors, wooden doors (new)
Tischlerei Dirk Meier, Theeßen
Dirk Meier, Sebastian Rabach

Co-ordination of safety and hygienic measures
Gesellschaft für Sicherheits- und Umwelttechnik mbH, Berlin
Matthias Failing, Horst Stechel

Structural survey
Ingenieursozietät Rek, Schwenk & Partner, Berlin
Christof Rek, Axel Ziemann

Planning of electrical and safety systems, and of lift technology
KMS Beratungs- und Planungsgesellschaft mbH, Berlin
Project manager: Wolfgang Fuchs

Technical planning water supply, drainage, fire-extinguishing, heating, service-water heating, air-conditioning, kitchen installations, control and monitoring technology
Jaeger, Mornhinweg & Partner Ingenieurgesellschaft mbH, Stuttgart/Berlin
Hans Ullrich Jaeger, Walter Ruschel, Ernst Göppel, Volker Großmann

Thermal and flow simulations
Müller-BBM GmbH, Planegg
Project manager: Gunther Pültz, Sc.D. (engineering)

Daylight and artificial lighting design
Kardorff Ingenieure Lichtplanung, Berlin
Project manager: Gabriele von Kardorff

Exhibition design
Studio Michele de Lucchi, Milan/Rome
Professor Michele de Lucchi, with Giovanna Latis and Davide Angeli

Restoration of structurally fixed exhibits, Egyptian Museum
Restaurierung am Oberbaum, Berlin
Thomas Lucker, Dana Bisping-Isermann

Orientation & information, new media, ticket-issuing, ticket-office and control systems
Polyform Büro für Graphik- und Produktdesign, Berlin
Project manager: Karl Stark

Landscaping of ambient areas
Levin Monsigny Ges. von Landschaftsarchitekten, Berlin
Nikolas Levin, with Conceptlicht, Traunreut (lighting design)
Helmut Angerer

Building data:

Gross floor area	19,600 m²
Gross interior volume	121,500 m³
Main usable floor space	9,200 m²
Construction costs	c. €118 million

Start of planning	January 1999
Start of construction	November 2003
Turn-key hand-over	March 2009
Reopening	October 2009

Contributing firms and restorers (selection):

Pre-existing and rebuilt structural shell, façades and colonnades

Existing structural shell/colonnades/new structure
Structural work: ARGE Rohbau Neues Museum Berlin, Dywidag Bau GmbH/Dreßler Bau GmbH (ADD), Dresden/Berlin
Project and site management (structural work): Steffen Müller, Sc.D. (engineering), Dreßler Bau GmbH

Restoring external façade plasters
Firm of Wrobud Zabytki and Restauratorenkollektiv Schwarzer/Ricken GbR, Berlin
Project manager: Klaus Ricken, qualified restorer

Stone façades
Schubert Steinmetz- und Steinbildhauer GmbH, Dresden
Site manager stonework: Max-Florian Burkhardt, stonemason

Stone in the colonnades
Bamberger Natursteinwerk Hermann Graser GmbH & Co. KG, Bamberg/Dresden/Potsdam
Project manager: Volkmar Hillig, qualified engineer (UAS) in stone technology

Stone in the interior spaces: columns in spaces 2.06 und 2.07
ARGE Weiß, Späthe, Haug, Berlin
Project manager and restorer in charge: Torsten Weiß, stone restorer

Stone in the interior spaces: repair of column 04 in the Mittelalterlicher Saal
Andreas Klein, master stone carver and restorer, Potsdam

Tests on selected stonework materials
Gerda Schirrmeister, Sc.D., qualified geologist and stone consultant, Berlin

Groups of rooms – plaster and décor restoration work

The Vestibül and the Vaterländischer Saal
ARGE Vestibül/Vaterland, Berlin
Senior restorer: Wolfgang Gärtner, free-lance restorer, Berlin

Spaces 1.04 to 1.06
Restaurierung am Oberbaum, Berlin
Senior restorers: Dunja Rütt and Annette Sturm, qualified restorers

The Gräbersaal and the Mythologischer Saal
Restaurierung am Oberbaum, Berlin
Senior restorer: Anette Schulz, qualified restorer

The Haupttreppenhalle
Nüthen-Restaurierungen GmbH & Co. KG, Erfurt
Project manager: Michael Bruckschlegel, qualified restorer (UAS)

The Bacchussaal and the Römischer Saal
Restaurierung am Oberbaum, Berlin
Senior restorer: Uwe de Maizière, qualified restorer

The Mittelalterlicher Saal, the Bernwardzimmer and the Moderner Saal
ARGE Süd-West GbR, Michendorf
Senior restorer: Olaf Schwieger, qualified restorer

The Nordkuppelsaal
Wandwerk GmbH, Berlin
Senior restorer: Lars Schellhase, qualified free-lance restorer, Rangsdorf

The Niobidensaal
Restaurierung am Oberbaum, Berlin
Senior restorers: Alexandra Skedzuhn and Alexandra Stajkoski, qualified restorers

The eastern and western Kunstkammersaal, the Majolikasaal and the three adjoining small galleries
Katharine & Wieland Geipel Dipl. Restauratoren (FH) GbR, Berlin
Principal: Wieland Geipel, qualified restorer (UAS)

The Sternensaal
ARGE Süd-West GbR, Michendorf
Senior restorer: Sonia Cárdenas, qualified restorer

The Roter Saal and the Dienerzimmer
Wandwerk GmbH, Berlin
Senior restorers: Eberhard Taube and Carsten Hüttich, qualified restorers

Flooring

Stone in the Vestibül and in the Korenhalle
ARGE Weiß, Späthe, Haug, Berlin
Senior restorer: Torsten Weiß, stone restorer

Terrazzo floors on levels 1 and 2
Piepo & Partner Steinrestaurierung GbR, Hanover
Senior restorer: Larissa Piepo, qualified restorer

Terrazzo/plaster screed, geological identification of aggregates
Gerda Schirrmeister, Sc.D., qualified geologist and stone consultant, Berlin

The marble cement floor in the Nordkuppelsaal
Piepo & Partner Steinrestaurierung GbR, Hanover
Senior restorer: Larissa Piepo, qualified restorer

Stoneware mosaics on levels 1 to 3
Gustav van Treeck Bayerische Hofglasmalerei Werkstätten für Mosaik und Glasmalerei GmbH, Munich
Senior restorer: Joana Pomm, qualified restorer

French parquet in the Majolikasaal and the Sternensaal
M-O-L Tischler- und Bau-GmbH, Bülower Burg
Overall management: Jens Osterwold, qualified civil engineer
Technical management: Volker Manski, master carpenter

New terrazzo, level 0
Peter Antonioli, master terrazzo and concrete stone layer, Pätow-Steegen

New mosaic, levels 1–3
Terracotta OHG – Böckenkamp & Leistikow, Potsdam
Project management and execution: Thomas Leistikow, tiler
Execution: Reinhard Böckenkamp, master tiler

Art in the building

Stucco relief on the east tympanum
Restaurierung am Oberbaum, Berlin
Senior restorer: Jörg Breitenfeldt, qualified restorer, M.A.
Senior sculptor: Thomas Lucker, restorer

Cast-zinc relief in the west tympanum
Georg Haber & Joh. L. L. Brandner GmbH, Regensburg/Berlin
Project manager: Georg J. Haber, Ph.D., restorer and Maximilian Heimler, restorer, M.A.

Metal architectural sculptures
Georg Haber & Joh. L. L. Brandner GmbH, Regensburg/Berlin
Project manager: Georg J. Haber, Ph.D., restorer

Natural stone sculptures on the corner projections
Alexander Bankert, qualified restorer (UAS), Schildow

The Schievelbein frieze
Restaurierung am Oberbaum, Berlin
Senior restorers: Jörg Breitenfeldt, qualified restorer, M.A.; Thomas Lucker, restorer; Jan Hamann, restorer; Pablo Ortiz Eppe, qualified restorer

The Bellermann wall pictures in space 1.02.2
Elke Renner, qualified restorer (UAS), Berlin

Metal structural decoration
Georg Haber & Joh. L. L. Brandner GmbH, Regensburg/Berlin
Project manager: Georg J. Haber, Ph.D., restorer and Jana Drost, qualified engineer

Wall pictures in the Vaterländischer Saal
ARGE Vestibül/Vaterland, Berlin
Senior restorer: Wolfgang Gärtner, free-lance restorer, Berlin

Wall pictures in the Römischer Saal and the Niobidensaal
Restaurierung am Oberbaum, Berlin
Senior restorers: Uwe de Maizière and Alexandra Skedzuhn, qualified restorers

Wall pictures in the Nordkuppelsaal, in the dome of the Apollo niche, in the Ägyptischer Hof and in the Roter Saal
Wandwerk GmbH, Berlin
Senior restorer (Roter Saal): Eberhard Taube, qualified restorer
Senior restorers (other halls): Carsten Hüttich, qualified restorer and Lars Schellhase, qualified and free-lance restorer, Rangsdorf

Special subjects

Removing murals in the Vaterländischer Saal
ARGE Vestibül/Vaterland, Berlin
Senior restorer: Wolfgang Gärtner, free-lance restorer, Berlin

Mineral reduction for the Nordkuppelsaal
Wandwerk GmbH, Berlin
Senior restorer: Lars Schellhase, qualified free-lance restorer, Rangsdorf

The wire-and-plaster ceiling of the Bernwardzimmer
FEAD GmbH, Berlin
Project manager: Andreas Protz, qualified engineer (materials technology)
Head of laboratory: Peter Friese, Sc.D.

Galvanoplastic copper cladding for the main portal
Georg Haber & Joh. L. L. Brandner GmbH, Regensburg/Berlin
Project manager: Georg J. Haber, Ph.D., restorer and Maximilian Heimler, restorer, M.A.

Ceiling and architrave papers in the Mythologischer Saal
Restaurierung am Oberbaum, Berlin
Senior restorer: Thomas Wieck, qualified restorer
Workshop manager, paper restoration: Daniela Skopova, qualified restorer
Microbiological survey, restoration of paint coats: Jens Klocke, qualified restorer

Marble cement (door and window jambs)
Restaurierung am Oberbaum, Berlin
Senior restorers: Jörg Breitenfeldt, qualified restorer, M.A.; Swantje Saadhoff, qualified restorer